DAVID OCTAVIUS HILL
AND
ROBERT ADAMSON

CATALOGUE OF THEIR CALOTYPES
TAKEN BETWEEN 1843 AND 1847 IN THE COLLECTION OF THE
SCOTTISH NATIONAL PORTRAIT GALLERY

Sara Stevenson

EDINBURGH 1981
NATIONAL GALLERIES OF SCOTLAND

ACKNOWLEDGEMENTS

I wish to acknowledge the great help given in the writing of this catalogue by the following institutions and individuals: Mrs Barbara Borthwick, Mr A M Mackenzie and Mrs Katherine Michaelson who first organised the Portrait Gallery's collection, Glasgow University Library, the National Library of Scotland, Edinburgh Public Library, New College Library. I am also considerably indebted to my colleagues at the Scottish National Portrait Gallery for their help and criticism and especially to Miss Christine Haddow and Mrs Sheila Smith who typed the manuscript.

Designed by HMSO Graphic Design/Edinburgh
Printed in Scotland for H.M.S.O. by McNaughtan & Sinclair Ltd. D'd No, 8352836 7/81.
Typesetting by Hewer Text Composition Services.
Origination by Gordon Watt Ltd.

ISBN 0 903148 37 4

Chronology: Photography and Robert Adamson

The partnership of David Octavius Hill (1802–1870) (*fig 1*) and Robert Adamson (1821–1848) (*fig 2*) is justifiably one of the most famous in photographic history. The remarkable success achieved by the two men came from a combination of technical and artistic excellence which has rarely been equalled.

The events leading up to this partnership are by now common knowledge.[1] The bare facts are these. During the 1830s, the Frenchman, Louis Jacques Mandé Daguerre and the Englishman, William Henry Fox Talbot were engaged on parallel experiments to fix the image seen in a *camera obscura* in some permanent fashion. In 1839, Daguerre managed to sell the process he had devised to the French government and announced the invention at the beginning of the year. Feeling challenged by this announcement and possibly jealous that Daguerre would be regarded as the sole inventor of the photographic process, Fox Talbot

announced and patented his calotype process in the same year.

Daguerre's photographs were single images printed direct onto a silvered copper surface, which had been exposed to iodine fumes, by the action of the sun on the chemicals. At its best, the daguerreotype was remarkable for its clarity and minute detail. The obvious disadvantages were that, without the use of a reversing prism, the picture was transposed left to right like the image in a mirror and further resembled a mirror in its silvered reflecting surface. The calotype was the first paper process and the first process to have both a negative and a positive. The paper used was good quality writing or drawing paper – Robert Adamson commonly used Whatman's Turkey Mill – which was impregnated with a solution of nitrate of silver and iodide of potassium and then with a solution of gallonitrate of silver. The sensitised paper was placed, preferably slightly damp, in the camera and exposed in bright light for seconds or minutes, depending on the time of day and the atmospheric

1 **David Octavius Hill** 1802–1870
 at the door of Rock House
 calotype

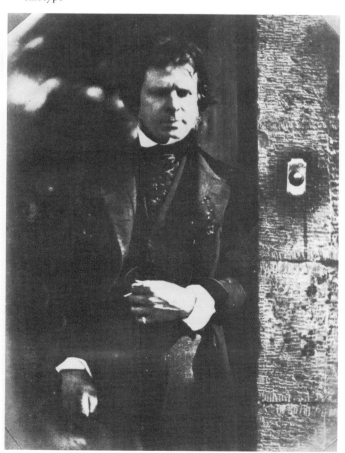

2 **The Adamson family**
 Dr John Adamson 1810–1870, on the left, Robert Adamson
 1821–1848, on the right
 calotype

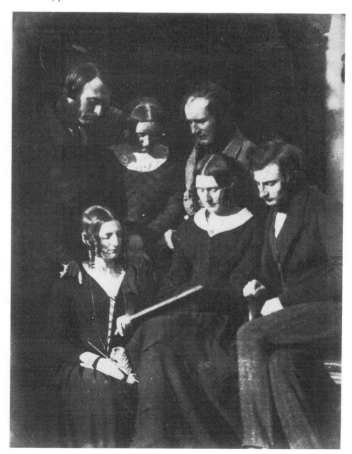

conditions. The early photographers discovered, to their surprise, that the apparent strength of the light was no sure guide to the length of exposure time. The same chemical formula which would take an image within seconds in London could take minutes in Rome or the Alps: spring and autumn light were more effective than summer light. Once exposed, the negative was washed again with gallonitrate of silver, placed in a frame with another sheet of sensitised paper and exposed to light again. Robert Adamson seems to have used exposure times of half an hour to two hours, depending on the clearness of the negative. The positive was then fixed with sodium hyposulphate, the discovery of the astronomer, Sir John Herschel, who was much concerned in the early photographic experiments. The calotype negative could be waxed to make it more transparent but it could not rival the daguerreotype in detail. Minor imperfections in the paper bedevilled the process and most calotype negatives as a matter of course required the stippling out of spots where the chemicals had reacted to some impurity or failed to be absorbed. The practical advantage of the process was that the negative enabled the image to be reproduced many times, as opposed to once, and at a lower cost. The charm and character of the calotype derived from the massed effects of light and shade and the rich tone of the better prints, which can vary from a purplish-brown to a russet as well as the unappealing yellowish sepia commonly regarded as typical of the process.

The calotype came to Scotland through the interest of Sir David Brewster (1781–1868) (fig 3), the physicist, who was in correspondence with Fox Talbot. In St Andrews, where Brewster was Principal of United College, he, Major Playfair and Dr John Adamson (1810–1870) (fig 2) experimented with varying degrees of success and in May 1841, John Adamson took the first successful portrait photograph in Scotland. Although Fox Talbot had not patented the calotype process in Scotland, he was nevertheless concerned that someone should practise it on a professional basis. Dr John Adamson's younger brother Robert, who had apparently tried an apprenticeship as an engineer only to find that his health was too poor to cope with it, was proposed and ' . . . well-drilled in the new art by his brother'.[2] In January 1843, the *Edinburgh Review* reported: 'Mr Robert Adamson, whose skill and experience in photography is very great, is about to practise the art professionally in our northern metropolis.' In May, Robert Adamson moved into Rock House, halfway up the Calton Hill at the east end of Princes Street, and opened his studio.

Chronology: the Disruption of the Church of Scotland and David Octavius Hill

On 18 May 1843, dissension within the Church of Scotland which had been growing over a number of years reached a climax when 150 ministers walked out of the General Assembly. The main point at issue was the increasing power of the owners of presentations to livings to put in ministers against the will of the Presbyteries. Certain clerical appointments had been the subject of prolonged dispute in the law courts. Various judgements for and against the Presbyteries' rights of veto had resulted in an elaborate legal tangle of suspended ministers appealing to the church and the civil courts. By the time of the 1843 Assembly, the party in favour of the rights of veto had already planned the formation of a Free Church and the Protest which they read to the Assembly before walking out was almost a formality. The disruption of the Church was not a spontaneous, but a carefully planned and even dramatic, occasion, though nonetheless sincere.

Henry, Lord Cockburn had been one of the judges involved in the court cases and had helped to pass a judgement in favour of the rights of veto, but he was by no means a whole-hearted supporter of the Free Church. He was, however, like many others at the time, very impressed by the Disruption. The breaking away of dissenting groups

3 **Sir David Brewster** 1781–1868
calotype

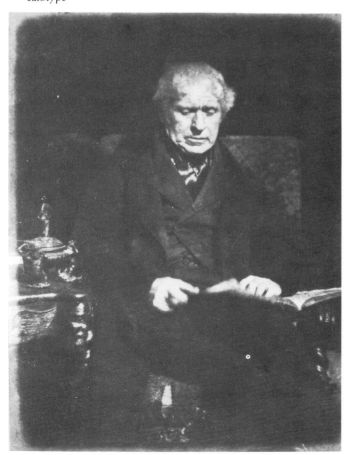

4 *The Signing of the Deed of Demission*
 by David Octavius Hill
 oil painting
 in the collection of the Free Church of Scotland

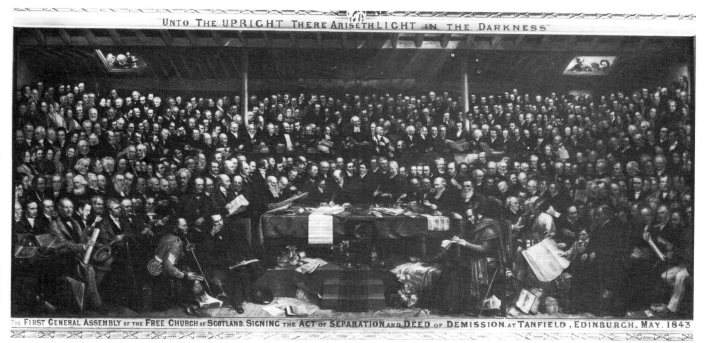

5 **The first design for the Disruption Picture showing the
 Rev Dr Thomas Chalmers preaching**
 by David Octavius Hill
 pen and wash drawing
 in the collection of the National Gallery of Scotland

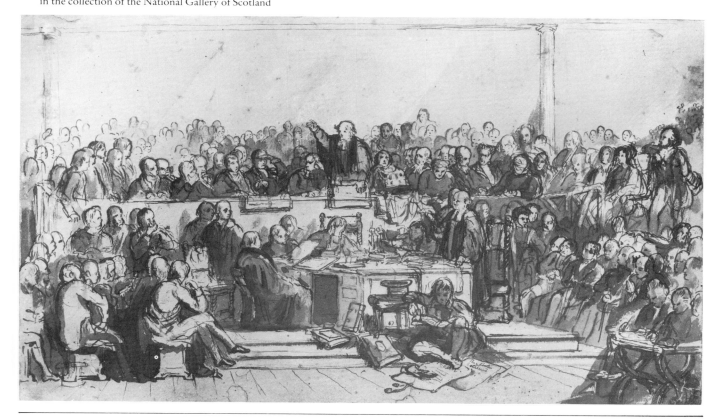

from the Church of Scotland was not in itself extraordinary or new. The impressive aspect of this particular group of dissenters was that they were the men of standing and not the natural revolutionaries, the young and unendowed. 'It has been often said that Presbytery is not a religion for a gentleman; and it is certainly true that hitherto such of our gentlemen as have not been of our Church were nearly sure to be found among the Episcopalians. This is the first time that our gentry are not only not ashamed of Presbytery, but not ashamed of it with the additional vulgarity of unendowed dissent.'[3]

Lord Cockburn made two other remarks about the occasion which help to explain the impact on their contemporaries when about a third of the clergy left the Church: '. . . when this is done under no bodily persecution, with no accession of power, but purely from dictates of conscience, the sincerity of which is attested by the sacrifice not merely of professional station and emoluments but of all worldly interests, it is one of the rarest occurrences in moral history. I know of no parallel to it . . . They have abandoned that public station which was the ambition of their lives, and have descended from certainty to precariousness, and most of them from comfort to destitution, solely for their principles. And the loss of the stipend is the least of it . . . It is the loss of station that is the deep and lasting sacrifice, the ceasing to be the most important man in the parish, the closing of the doors of the gentry against him and his family, the altered prospects of his children, the extinction of everything that the state had provided for the decent dignity of the manse and its inmates.'

The emotion and excitement aroused by the Disruption affected, amongst other people, the landscape painter and Secretary of the Royal Scottish Academy, David Octavius Hill. The artist was personally connected with the event through his brother-in-law, the Rev Dr Robert Macdonald, and was sufficiently moved to wish to paint a large-scale

6 *John Knox dispensing the Sacrament at Calder House*
 by Sir David Wilkie
 unfinished oil painting
 in the collection of the National Gallery of Scotland

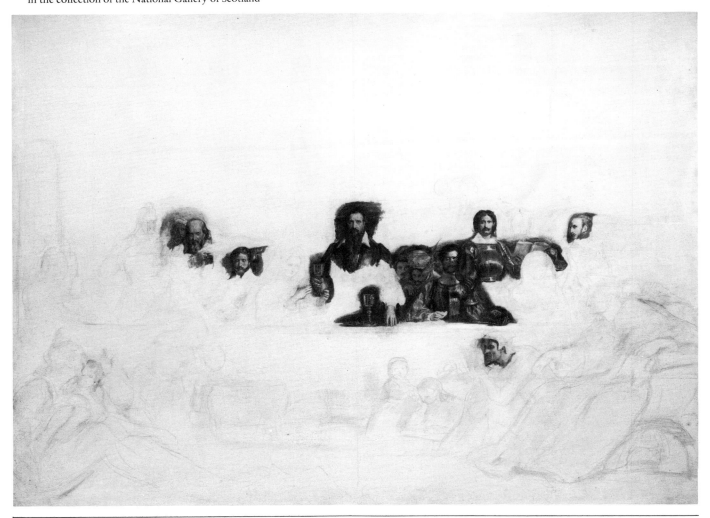

picture (*figs 4* and *5*). Lord Cockburn undoubtedly reinforced his intention by saying to him the following day: 'There has not been such a subject since the days of Knox – and not then!'[4] Cockburn's remark is particularly interesting because it suggests that he and Hill were thinking of Sir David Wilkie's unfinished large painting of John Knox dispensing the Sacrament, which had been purchased by the Royal Scottish Academy the previous year (*fig 6*).

D O Hill announced his project publicly within six days of the Disruption, when he advertised an engraving after the proposed painting:

It is respectfully intimated, that arrangements have been completed for the Production and Publication, at as early a period as it can be properly effected, of

AN ENGRAVING

To be executed in the highest style of art, and on a scale commensurate with the deep interest, extent, and importance of the subject,

REPRESENTING
THE FIRST GENERAL ASSEMBLY
OF THE
FREE PRESBYTERIAN CHURCH OF
SCOTLAND
From a Picture to be painted by
D.O. Hill Esq., R.S.A.

The Picture, the execution of which, it is expected will occupy the greater portion of two or three years, is intended to supply an authentic commemoration of this great event in the history of the Church. It will represent the Assembly at one of the most interesting points of the proceedings, and will contain Portraits, from actual sittings, in as far as these can be obtained, of the most venerable fathers, and others of the more eminent and distinguished ministers and elders; as also, of the members of the Deputation from the Presbyterian Church of Ireland, – and of the representatives of various bodies of Evangelical Dissenters, who sympathize with, and approve of, the present movement of the Church, – and of other personages who have taken or may yet take part in the eventful proceedings of the Assembly.

— — — — — —

PROPOSED SIZE OF THE ENGRAVING

Thirty-eight inches broad, with its proportionate height, thereby giving full scope for the effective introduction of the Portraits.

— — — — — —

PRESENT PRICE TO SUBSCRIBERS

The impressions to be delivered strictly in the order of Subscription. Artist's Proofs, £12.12s – Proofs before Letters, £8.8s – Proofs £5.5s – Prints £2.12s 6d.

Mr ALEXANDER HILL, 67, PRINCES STREET
Publisher to the Royal Scottish Academy of Painting &c, has been instructed with the conducting of the Publication, to whom orders for the Engraving may be addressed.[5]

The advertisement appeared again on 1 June, and on 17 June, when the following paragraph was added:

Every facility was afforded to the Artist, during the sittings of the Assembly, in the selection of situations from which he could command the best views of the proceedings, and both then and since for his obtaining Portraits of the individual members. Ample assurances of a continuation of those opportunities necessary for enabling him to bring his undertaking to a successful issue, have been made to him in the most influential quarters.[6]

The sketches done by Hill for the picture show varying degrees of confidence (*fig 7*) but we have no particular reason to suppose that he suffered any serious doubts over his ability to complete it. However, the difficulty of obtaining the portraits of a fair proportion of the people present would have undoubtedly concerned him.

At some stage before 9 June, Sir David Brewster, who was involved with the Free Church, spoke to D O Hill. In a letter to Fox Talbot dated 3 July, he explained: 'A grand historical picture is undertaken by a first rate Artist, to represent the *first General Assembly of the Free Church*. I got hold of the artist – showed him the Calotype, & the eminent advantage he might derive from it in getting likenesses of all the principal characters before they were dispersed to their respective homes. He was at first incredulous, but went to Mr. Adamson, and arranged with him preliminaries for getting all the necessary portraits.'[7] On 9 June, Hill sent out a letter to the Rev Dr Robert Gordon inviting him to sit for his portrait '. . . with a view to its being made use of in Mr Hill's projected Historical Picture of "the First General Assembly of the Free Protesting Church of Scotland" . . . The preliminary studies of the Portraits for this work will in the first instance be made by the use of the Daguerreotype and Calotype – and as Mr Hill has made the necessary arrangements with Mr Adamson a gentleman recommended to him by Sir David Brewster as an adept in the latter process, he requests that Dr Gordon will consent to meet him at Mr Adamson's house – Calton Stairs . . . on Saturday the 10th Instant between the hours of 10 AM. and 2 PM. or on the Monday, Tuesday, or Wednesday following at the same time. The sitter is detained only a very short time – the whole process being effected in a few minutes. Should none of these days suit Dr Gordon's

7 **Study for the Disruption Picture**
by David Octavius Hill
chalk drawing
in the collection of the National Gallery of Scotland

convenience Mr Hill will make it his business to attend any other day and hour he may appoint.'[8] At first sight, this letter is a manuscript in Hill's own hand, but Dr Gordon's name has been added in a different ink, which makes it clear that it is a lithographed circular. Presumably, Hill sent out a reasonable number of these letters and he and Adamson took a substantial group of calotypes for the Disruption Picture during these four days.

The amended advertisement for the Disruption Picture published on 17 June did not mention the calotypes and it is possible that at this stage Hill was far from confident of their usefulness. However, any doubts had certainly dispersed by the beginning of July when Hugh Miller (1802–1856), the geologist and journalist, wrote his enthusiastic account of 'The Calotype' for *The Witness* newspaper.[9] Hugh Miller had posed as a 'bonneted mechanic' leaning on a tombstone in the Calton cemetery below Rock House and was highly delighted with the resulting calotype. He had apparently also seen the calotypes taken for the Disruption Picture, including one of the Rev Dr Thomas Chalmers, the first Moderator of the Free Church Assembly, and one of the group studies. These pictures would have been included in the first exhibition of Hill and Adamson's work which they announced a bare month after starting work together in an advertisement published on 8 July:

> Mr D.O. HILL'S PICTURE
> OF
> THE FIRST GENERAL ASSEMBLY
> OF
> THE FREE PROTESTING CHURCH OF
> SCOTLAND
>
> A large number of the preliminary Studies and Sketches for the above National Picture, as also of a projected Series of Portraits of Clergymen and Laymen of the Free Protesting Church of Scotland, comprising nearly the whole of the Calotype Pictures executed jointly by Mr ADAMSON and Mr HILL, will be exhibited Privately at
> Mr A. HILL'S GALLERIES
> 67, PRINCES STREET
> On Wednesday 12th inst, and following week.[10]

Hill's interest in the calotypes is shown by this advertisement to have developed beyond their use as studies for one picture and he was already taking an interest in the medium for individual portraits. Clear evidence that the artist and the calotypist found it profitable to work together is found in Sir David Brewster's letter to Fox Talbot of 9 July, in which he says: 'Mr. D. O. Hill the Painter is in the act of entering into partnership with Mr. Adamson, and proposes to apply the Calotype to many other general purposes of a very popular kind, and especially representing diff. bodies & classes of individuals. I think you will find that we have, in Scotland, found out the value of your invention not before yourself, but before those to whom you have given the privilege of using it.'[11] The remarkably short time of a month in which Hill went from incredulity to joining Adamson in partnership is in itself proof of their immediate success.

The Working Partnership, 1843 to 1847

In the first six months of their association up to the end of 1843, Hill and Adamson were taking photographs characteristic of the whole of their working partnership. For instance, they were already taking calotypes of Greyfriars' Churchyard and the Newhaven fishermen and women which were then, and have been since, considered amongst their finest work. Sir David Brewster wrote again to Fox Talbot on 18 November 1843: 'I wish I could send you some of the fine Calotypes of ancient Church yard Monuments, as well as modern ones taken by Mr Adamson, and also specimens of the fine groups of Picturesque personages which Mr Hill and he have arranged and photographed. Those of the Fishermen and women of Newhaven are singularly excellent. They have been so overwhelmed with work that they have not been able to send me a Collection which they have promised.'[12] *Edinburgh 60* and *65*, the one dated August 1843 and the other September 1843, with Hill as one of the figures, are examples of this early work.

In September of that year, the two men attended the second Assembly of the Free Church which was held in Glasgow, and there is reason to suppose that by the end of the year they had taken most of the studies for the Disruption Picture. Seven of the calotypes taken in 1843 were exhibited by Hill in the Royal Scottish Academy's exhibition in 1844. These were all portraits: Sir William Allan, Rev James Julius Wood, Sir David Brewster, a Lady, Charles Edward Stuart (*fig 8*), Mr Williamson, huntsman to the Duke of Buccleuch, and George Meikle Kemp. The choice of calotypes shows a combination of art with sentiment, since George Meikle Kemp was accidently drowned early that year.

Somewhere between February and August 1884, Hill and Adamson decided that it would be profitable to work in

8 **Charles Edward Stuart** 1799–1880
calotype

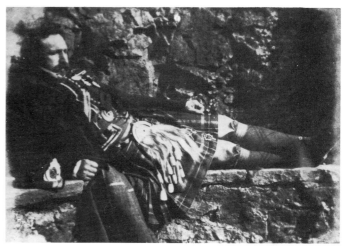

closer association and Hill moved up from Inverleith Row, some distance to the north of Princes Street, and into Rock House. The reason for this may well lie in an advertisement which they printed in the *Edinburgh Evening Courant* on 3 August, which states their intention of publishing the calotypes in bound volumes rather than as individual prints:

> Preparing for publication
> A Series of Volumes, composed of Pictures executed solely by the agency of Light, in the department of Photogenic Drawing called "Calotype" the discovery of Henry Fox Talbot, Esq., of Lacock Abbey, F.R.S., &c.
> The subjects selected and arranged by
> D.O. Hill Esq., R.S.A.
> Secretary of the Royal Scottish Academy of Painting &c
> The Chemical Manipulations by
> Mr. Robert Adamson, late of St. Andrews.
> ——————
> The Volumes will be produced in a style of great elegance on a paper the size and quality of "Roberts' Views in the Holy Land".
> Vol. 1. The Fishermen and Women of the Frith of Forth.
> Vol. 2. Highland Character and Costume.
> Vol. 3. The Architectural Structures of Edinburgh.
> Vol. 4. Do. Do. of Glasgow, &c.
> Vol. 5. Old Castles, Abbeys, &c in Scotland.
> Vol. 6. Portraits of Distinguished Scotchmen.
> Price of Each Volume Five Guineas.
> The number of Copies, from the nature of the art, must necessarily be very limited.
> Orders may be addressed to Messrs. Hill and Adamson, at their Calotype Studio, Calton Hill Stairs, Edinburgh, or to Mr. A. Hill, 67, Princes Street.[13]

Either because the price was too high or because there were already doubts about the stability of the calotype process, this ambitious project came to nothing. Curiously enough, the only volume devoted to a specific subject which was published was of views of St Andrews, which does not figure on this list.

Before the beginning of August, Adamson had taken on an assistant. The King of Saxony and his entourage indulging in a semi-incognito tour of Britain, dropped in at Rock House without warning on 2 August. 'His Majesty determined upon having a group drawn containing the whole of the travelling party. The sunshine was all that could be wished, all the necessary preparations were made and the camera obscura twice employed. Unfortunately the master himself was not in the way, and an assistant was obliged to conduct the process. The result was not very successful.'[14] The one calotype in the Portrait Gallery's collection taken on this occasion is, indeed, technically dull and artistically depressing (*Group 228*).[15] Whether this assistant had been with Adamson from the start is not clear. The lack of skill in this one calotype might imply that he was relatively new to the job but it can be as easily attributed to his shock at the sudden and unheralded appearance of a king in the studio.

More certain evidence that the business was expanding lies in the three large-scale cameras which Robert Adamson must have acquired in 1844. The largest of these took calotypes approximately 16 × 13 in (405 × 330 mm), the

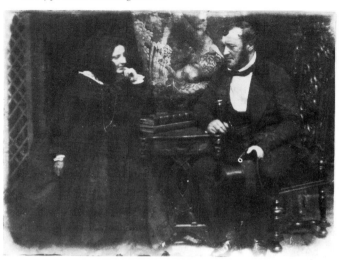

9 **Sheriff and Mrs John Thomson Gordon**
calotype taken on 8 August 1845

second 12 × 10½ in (300 × 270 mm) and the third 12 × 9 in (300 × 230 mm). About forty of these negatives are dated or datable and the first date on the negative of the Rev Dr Welsh with Mr Dunlop (*Group 263*) is 13 June 1844; the last is 8 August 1845 on the groups of Sheriff and Mrs Gordon (*Groups 115* and *116*) (*fig 9*). The large prints, which when technically good are remarkably handsome calotypes, unfortunately proved difficult to handle. The worst problem was that of fully impregnating the paper, and with twice the size of paper there was twice the risk of imperfections. The increased size also meant longer exposures and an increased risk of distortion. As a result, a fair proportion of the collection of 141 large negatives in Glasgow University Library are poor and it may be significant that the bulk of them was left behind in Rock House when Hill moved in 1869. The scale of the cameras must have presented a problem in carriage, despite which Hill and Adamson took the largest to Linlithgow, Durham and York and the second and third to Merchiston Castle School several miles south-west of Edinburgh. The Merchiston Castle photographs may be dated 1844 by the calotype of the Rev Dr Thomas Chalmers and his grandson (*Group 63*), which Hill later used as the study for a painting (*fig 26*). The group of negatives taken on this occasion includes not only the atmospheric groups of the Chalmers family (*Group 64–68*) but a few large groups of schoolboys (*Edinburgh 38*). Charles Chalmers, who was the brother of the Rev Thomas Chalmers and the headmaster of the school, was amiable enough to permit Hill to arrange some five or six of these photographs.

In September of 1844, Alexander Christie (1807–1860), the director of the Ornamental Department of the Trustees' Academy in Edinburgh, carried over to France a large collection of Hill and Adamson's work. These were presented by the scientist, Dominique-François Arago to the Académie des Sciences in Paris, apparently at the instigation of the painter, Ary Scheffer. The report on the

meeting said: 'M. Arago a mis sous les yeux de l'Academie de très belles épreuves sur métal, executées à Lyon par M. Thierry, et une nombreuse collection d'épreuves sur papier provenant des procédés de M. Fox Talbot. Les épreuves sur papier ont été faites à Edimburgh par les soins de MM. Adamson et Hill, et à l'aide d'une chambre noire exécutée sous la direction immédiate de sir David Brewster. En adressant ces épreuves à M. Arago par l'intermédiaire de M. Christie, professeur de dessin à l'Institut royal d'Edimburgh, M. Ary Scheffer les qualifiat de merveilleuses.'[16] The report suggests, from its description of Thierry's daguerreotypes as 'very beautiful' and the calotypes as 'numerous', that the French reaction was not wholly enthusiastic but Ary Scheffer, at least, was very impressed.

At the end of September, Hill organised a major expedition to York, where the British Association was holding its annual meeting. He obtained Fox Talbot's permission to take calotypes on this occasion and it is to be presumed that the large calotypes of Durham (*Landscape 8*) were taken on the journey. The group of photographs taken at York is not amongst Adamson's best work, possibly because he had prepared the paper in advance, when the best

results were achieved with freshly prepared paper. They photographed most of the participants at the conference between 28 September and 4 October, with an expedition to Bishopthorpe, the home of the Archbishop of York, where they photographed him and his family. Sadly, there does not appear to be a calotype of Fox Talbot by Hill and Adamson, but the other major figure in the history of early photography present at York, the astronomer Sir John Herschel, probably was photographed by them on this occasion (*fig 10*).

In mid-October, the painter William Etty arrived unexpectedly in Edinburgh with his brother Charles and his niece. Charles Etty, who was a sugar planter in Java, had returned to Britain for the first time in thirty-one years and his delighted brother had carried him up to Edinburgh to show him the three major paintings purchased by the Royal Scottish Academy and hanging in the Royal Institution: *The Combat*, photographed on a large scale by Hill and Adamson, *Benaiah slaying two lion-like men of Moab* and *Judith*. William Etty had a very high reputation at the time and the Academy organised a hurried reception for him. D O Hill plainly took advantage of the occasion to invite the Ettys up to Rock House to be photographed (*fig 11*).

10 **Probably Sir John Frederick William Herschel** 1792–1871
 carbon print from the calotype negative

11 **William Etty** 1787–1849
 calotype taken on 16 October 1844

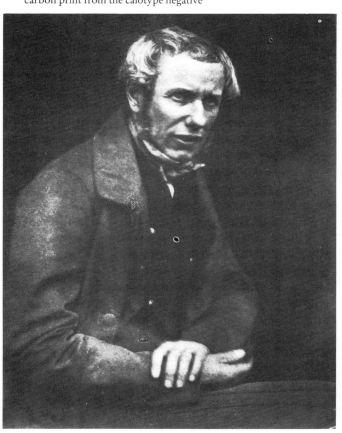

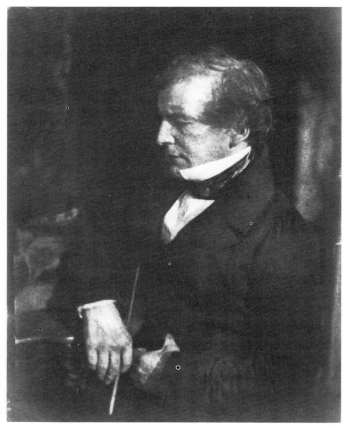

Another celebrated but more exotic visitor to the capital this October was the Afghan, Mohun Lal. He had accompanied the diplomat and traveller, Sir Alexander Burnes, to Bokhara during the 1830s and had become devoted to him. During the fighting in Kabul in 1841, Burnes was killed but Mohun Lal had managed to preserve his papers. In 1844, he travelled from Afghanistan to Montrose in the company of Captain Gleig of the East India Company to deliver the papers to Burnes's father. On 24 October he was reported in Edinburgh, where he was given an official tour of the city 'dressed in a magnificent Hindoo costume'[17] and was, like the Ettys, enveigled up to Calton Hill to have his portrait taken.

D O Hill's enthusiasm for photography was noted on a public occasion at the end of that month. On 29 October, a dinner was given to Dr William Pyper before he left to take up an appointment in St Andrews. One of the speeches was given by a friend of Hill, John Thomson Gordon, and included this passage: 'He did not wish to particularize individuals, but in proposing a bumper to the Scottish Academy, he might be allowed to join with it the name of his excellent friend Mr Hill, whose brush had often been dipped in the sunbeam, but who now painted with the sunbeam itself. (This allusion to Mr Hill's novel application of the calotype to artistic purposes was received with great applauses.)'[18]

Hill and Adamson exhibited ten of the calotypes taken in 1844 at the Royal Scottish Academy's 1845 exhibition. These were the Hon Lord Robertson, the Bishop of Ripon (Charles Longley), Dr George Cook, the Rev Andrew Gray, A Newhaven fishwoman, William Etty, John Stevens, An artist, Colonel (Sir Adam) Ferguson and A Newhaven Pilot (fig 12). As with the previous year, the choice of exhibits is divided between celebrities, memorial portraits – the Rev Dr George Cook had died in May 1845 – and picturesque characters. This suggests that Hill had a higher opinion of the portraits than of the landscape calotypes but it may only mean that he wished to show something different from his landscape painting.

Early in 1845, D O Hill gave evidence of an interest in the technical side of photography when he was elected a member of the Royal Scottish Society of Arts (now the Royal Society of Edinburgh – the word 'Arts' was used in the sense of the technical sciences rather than the 'Fine Arts'). During the 1840s, the Society saw the presentation of a series of papers on the development of photography. People like the optician, Thomas Davidson, who made Adamson's cameras, Mungo Ponton and R B Smith put a stream of ideas before the Society and Robert Adamson himself had shown his photographs there in June 1843.

One of the major events of 1845 was the completion of the Scott Monument, which was photographed by Hill and Adamson in August (Edinburgh 11). This neo-Gothic monument had been designed and built by George Meikle Kemp, and the statue of Sir Walter Scott intended for the monument was currently being carved by Sir John Steell in his studio in Randolph Place. It was felt, however, that the monument and the statue were by themselves inadequate and, in 1844, a series of Waverley Balls was started to pay for the laying out of the grounds and filling the empty niches with statues related to Scott's writings. The 1845 and 1846 balls are of particular significance because they are known to have involved the Edinburgh artists and in some measure, Hill and Adamson. On 1 April 1845, the fancy dress ball saw the staging of six tableaux vivants: 'Prince Charles Edward in the Cave after the painting by Thomas Duncan', 'Balfour of Burleigh and Henry Morton in the cave', 'The Glee Maiden after the painting by Robert Scott Lauder', 'A Scene from The Betrothed – The Lady taking the place of the soldier on guard', 'The Last Minstrel striking his harp to the last lay' and 'The statue of Sir Walter Scott', presumably after Steell's design.[19] The following year the arrangers of the tableaux were named as the painters Alexander Christie, E W Dallas, James Ballantyne and Kenneth Macleay, with E Glover of the Theatre Royal. On that occasion, there were seven tableaux: 'William of Deloraine taking the book from Michael Scot's tomb', 'The Antiquary buying fish from Meg Mucklebackit', 'The Fair Maid of Perth', 'Montrose writing

12 *The Newhaven Pilot*
calotype

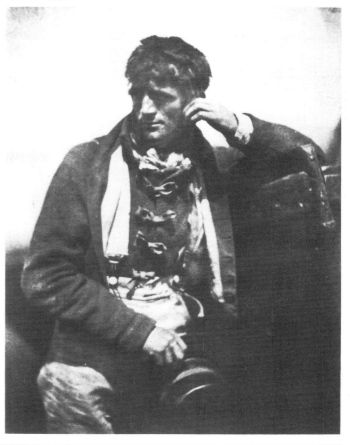

a despatch after the battle of Inverlochy', 'The Pirate cast ashore', 'The Templar carrying off Rebecca', and 'The White Lady of Avernal appearing in the fountain'.[20] The most obvious connection between the calotypes and the Waverley Balls is the group of photographs of Patrick Byrne, the blind Irish harper who took the part of 'The Last Minstrel' in 1845 (*fig 13*). D O Hill may even have been involved in directing the *tableaux* that year since the Duncan painting of *Prince Charles Edward asleep in the cave* belonged to Alexander Hill, who exhibited it in 1846. Hill did arrange a number of costume groups (*fig 14*) as subjects from Walter Scott's novels *The Abbot* and *The Antiquary* but as Scott was of enormous importance in the British art and literary world of the time, there is no very strong reason to suppose that these have any connection with the Waverley Balls or the Monument.

Amongst the picturesque strangers in Edinburgh that year was Mr Finlay, the deerstalker to Campbell of Islay, who was photographed on 17 April. In taking this group of calotypes, Hill may have been considering the potential volume on Highland Character and Costume advertised the previous year. More exotic than the calotypes of Finlay is the series of the Rev Peter Jones or Kahkewaquonaby, 'Waving Plume', a Methodist missionary and chief of the Ojibeway Indians (*fig 15*). He had come to Britain to raise funds for manual labour schools designed to promote civilisation and Christianity among the Indians. Kahkewaquonaby and his English wife, Eliza, were in Edinburgh on 27 July, when he preached in Dr Thomas Guthrie's and Dr Robert Candlish's churches, and on 29 July, when he addressed a public meeting. Both he and his wife were photographed at Rock House on 4 August.

1846 was an unusually fine year; so extraordinarily mild was the weather that the strawberries were ripening near Edinburgh in early February. Robert Adamson was able to start photography in January. He took the calotypes of John Christian Schetky, the marine painter, with his daughter (*Groups 229* and *230*) on 5 January, though Hill has confused the issue by drawing on the negative a little cluster of leaves on the bare creeper in the background.

During this year, Hill seems to have been making a serious attempt to market the large quantities of calotypes he and

13 **Patrick Byrne** 1797 (?)–1863
as the *Last Minstrel*
calotype taken in April 1845

14 **William Borthwick Johnstone, William Leighton Leitch
and David Scott as the** *Monks of Kennaquhair*
calotype

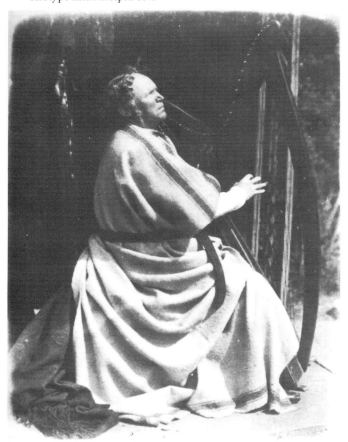

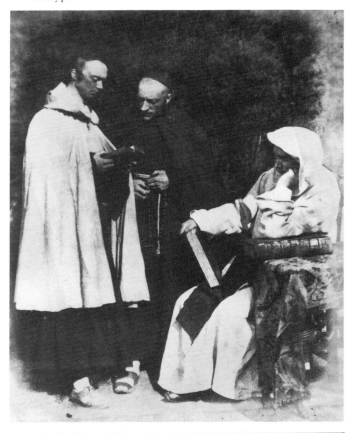

Adamson had already taken, in mixed albums. The calotypes he exhibited in the Royal Scottish Academy were described merely as 'specimens of a volume of Calotypes now preparing for publication'. He was trying to interest John Murray, the London publisher, in the venture and had sent a collection down to him. William Dyce expressed his intention of going to see them in a letter to Hill: 'I . . . have . . . been unable to pay a visit to Murray's to see your Calotypes which I have no doubt are most beautiful things: but I hope to be at liberty in ten days or so and then promise myself the pleasure of a sight of them. I go to Westminster from Chelsea by steamer and return the same way so that Albemarle Street is out of my course, but if it were not, my time of passing and repassing would be too early or too late for a visit. I wish I could have a lesson from you in your art. There is a terrace on the top of my house admirably suited for this purpose – and I think great use ought to be made of the process in preparing [?] studies of drapery etc.'[21] John Murray's reaction to the calotypes was expressed in a letter

15 **Rev Peter Jones, or Kahkewaquonaby**, 1802–1856
 calotype taken on 4 August 1845

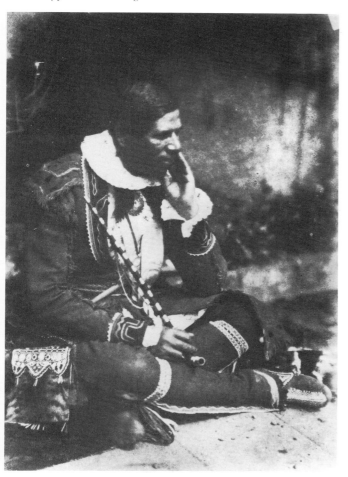

to Fox Talbot on 19 May, when he made the interesting wish that 'it were possible for Mr Hill to act in conjunction with you. There are points in which your Calotypes have the decided superiority over his – there are others in which I think he excels, especially in obtaining artistic effects. A combination of the two would be a step in advance.'[22] *The Quarterly Review* had a sufficiently high opinion of the Edinburgh calotypes to say: 'To Mr Fox Talbot the happy invention is owing, but that artistic application of it, which has brought these drawings to their present picturesque perfection, required the eye of an artist, and for this the public is indebted to Mr D. O. Hill of Edinburgh, in conjunction with Mr Adamson, a young chemist of distinguished ability. It is to be hoped that Mr Talbot, in justice to his own genius, will soon invite these gentlemen to London – where they would find rather more interesting, though certainly not more grotesque subjects, than the fat Martyrs of the Free Kirk – as yet seemingly their favourite subjects.'[23] The epithet was uncalled for but there can be no doubt that Hill and Adamson had taken far too many calotypes of the dissenting ministers, certainly more than Hill could ever fit into his painting.

During 1846, Hill started work on another large picture for the railway engineer, John Miller (*fig 23*). This was a view of Edinburgh from the Castle and involved a number of calotype studies. In April, Hill and Adamson took a group of calotypes of the Gordon Highlanders stationed in the Castle, with general views of the city from the Castle. Interestingly enough, David Roberts ordered one of the calotypes of the Highlanders for use as a study in his own painting of Edinburgh, which was exhibited at the Royal Academy in 1847.

Halfway through 1846, there is a curious falling off in the calotype activities in Rock House. The calotypes which are dated or datable prove to have been taken largely between 1843 and mid-1846, when the number of dated photographs drops steeply. With other evidence, it seems that the bulk of the known 3,000 images had been photographed by that time and that their major period of activity was the phenomenally short period of three years rather than the four and a half years previously supposed. Robert Adamson's health did not deteriorate suddenly at the end of 1847. D O Hill wrote to David Roberts on 12 August 1847: 'Adamson has been so poorly for many months that our calotype operations have gone on but slowly, hence the delay in sending you your 12 whole lengths – which I now forward – and for which as you wish to pay we mulct you at a crown a piece.'[24] The partnership is likely also to have suffered from the competition of Edinburgh's second professional calotypist, who figures in the Edinburgh Street Directory for 1846 to 1847. This was James Ross, who set up his business in the National Monument, a three-sided, unfinished imitation of the Parthenon on Calton Hill, above Rock House and even better placed to catch the light. From the coincidence in time, that James Ross appears just when Adamson's activities are halting, it may be that Ross had

been Adamson's assistant. James Ross was a man of considerable technical competence and invention, much involved with the advance of the albumen process in the 1850s, and could well have been trained by Adamson.

At the end of 1847, Robert Adamson's health broke down completely. He returned to his family in St Andrews and on 14 January he died, leaving D O Hill bereft of a partner and a friend.

The Hill–Adamson Partnership

A rough chronological account of the three or four years of Hill and Adamson's partnership goes no distance towards explaining its success. The main problem in discussing the personalities of the two men and the roles they played is that Robert Adamson is a shadowy figure. John M Gray's account of his early life building model engines suggests that he was a potentially competent engineer, who was only stopped by weak health from pursuing that career.[25] The few calotypes of him look like a man either ill or lacking in confidence and he was very likely both. His partnership with the socially secure and confident David Octavius Hill may even have pushed him further into obscurity. The one thing we can be sure of was that Robert Adamson was a superb technician and brought the calotype process to a remarkable pitch. The rich tone and quality of the prints have survived intact in many of the examples now in the Portrait Gallery's collection. This quality was singled out for approval by Professor Robert Hunt in 1856, when the Prince Consort had just set up a committee to look into the problem of fading in photographs. Hunt made the following remarkable statement:

'. . . when *properly prepared*, A PHOTOGRAPHIC PICTURE WILL NEVER FADE.

This assertion depends upon hundreds of experiments, made with products which were amongst the earliest of the examples of fixing with the hyposulphate of soda, the personal gifts of Sir John Herschel, and of others, by Hill and Adamson of Edinburgh . . . The experiments consisted in suspending the photograph with and without glass, in a room exposed to the full influence of sunshine, and under the effects, at one period, of the humid and saline atmosphere of Plymouth and Falmouth, and subsequently to that of the metropolis, a similar set being preserved in portfolios. In some examples, the pictures rapidly disappeared, in others they resisted all the influences of light and moisture for years . . . Some of Mr Talbot's, of Mr Owen's earliest works, of Hill and Adamson's pictures made in 1844, and a few others, however, now before me, have endured full exposure for many years, without any change in their original degrees of intensity.'[26]

One of the reasons that D O Hill's character dominated Robert Adamson's is the elementary consideration of age. When they met, Adamson was twenty-one, Hill was forty-one. Adamson was an inexperienced young man just starting his working life and Hill was fully mature, an artist of considerable reputation and an efficient administrator of the Royal Scottish Academy. It is unlikely Hill would have deliberately swamped Adamson's personality since he had a reputation as a generous man. We have no method of knowing how far Adamson would have gone by himself but it is surely significant of a retiring nature that Hugh Miller's article on 'The Calotype', published early in July 1843, begins with a paragraph on the lack of noise made by great inventions in their infancy. 'Phrenomesmerism and the calotype have been introduced to the Edinburgh public about much the same time; but how very differently have they fared hitherto! A real invention, which bids fair to produce some of the greatest revolutions in the fine arts of which they have ever been the subject, has as yet attracted comparatively little notice; an invention which serves but to

16 **James Nasmyth** 1808–1890
calotype

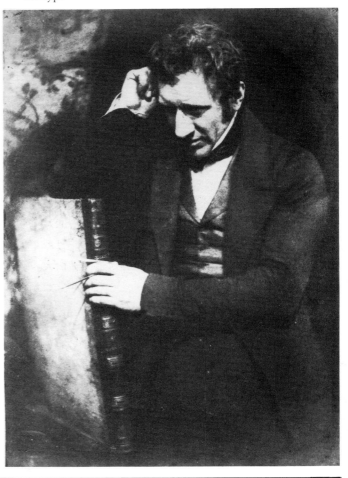

demonstrate that the present age, with all its boasted enlightenment, may yet not be very unfitted for the reception of superstitions, the most irrational and gross, is largely occupying the attention of the community, and filling column after column in our public prints. We shall venture to take up the quieter invention of the two as the genuine one . . .'[27] It cannot be a coincidence that the publicity and excitement about the calotype process in Edinburgh only started after Hill joined Adamson in partnership in June 1843.

In his temperament, Hill undoubtedly brought great benefit to the partnership. The engineer James Nasmyth (*fig 16*), in his autobiography, wrote of him in words echoed by Hill's other friends: 'His name calls up many recollections of happy hours spent in his company. He was in all respects the incarnation of geniality. His lively sense of humour, combined with a romantic and poetic constitution of mind, and his fine sense of the beautiful in Nature all in all, a most agreeable friend and companion. "D. O. Hill" as he was generally called, was much attached to my father [the

17 **Professor James Spence** 1812–1882
calotype

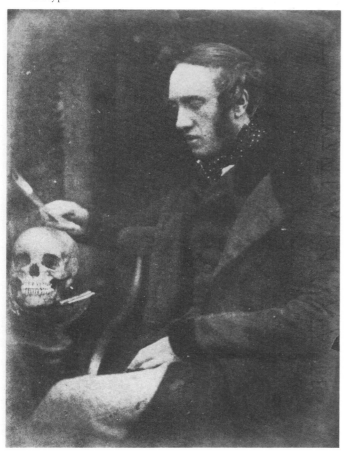

landscape painter, Alexander Nasmyth]. He was a very frequent visitor at our Edinburgh fireside and was ever ready to join in our extemporized walks and jaunts, when he would overflow with his kindly sympathy and humour . . . Altogether he was a delightful companion and a staunch friend, and his death made a sad blank in the artistic society of Edinburgh.'[28] The pleasure of Hill's company undoubtedly attracted many of the interesting and celebrated people who figure in the calotypes up to Rock House. A biographical account of D O Hill which appeared in the *Art Journal* in 1850, when he was no longer involved directly in photography, makes this point: '. . . it is not too much to say that his suavity of manner and absence of all affectation have made him as popular a man, as his paintings have added to his fame as an artist. His quiet and unassuming residence on the Calton Hill is visited by the best men of the day with pleasure, and left by them with regret.'[29] The element of pleasure introduced by Hill cannot be over-estimated in its effect on the calotypes. His ability to persuade his friends and even new acquaintances to enjoy rather than suffer the calotype process is clearly visible in the attitudes and expressions of his sitters, which avoid the frozen tension of so many early photographic portraits. The worst example of photographic depression amongst the portraits comes in the calotypes of James Spence (*fig 17*), the surgeon, who was photographed on three separate occasions, doubtless to Hill's and Adamson's increasing desperation; the subject turns out to have been notoriously resistant to pleasure, 'a man of what may be termed an anxious temperament and a somewhat tristful disposition', known to his students as 'Dismal Jimmy'.[30]

What might almost be termed an amateur enjoyment of photography appears in groups like 'Edinburgh Ale' (*Group 27*) or 'The Morning After "He, Greatly Daring, Dined"' (*fig 18*). People like Henry, Lord Cockburn, another of Hill's friends, clearly looked forward to the calotype sessions and regarded them in the nature of entertainment, as the following letter written to Hill indicates: 'Will you be free next week? Should we not have another Calotype day – Is Allan in Town? And Harvey? [Sir William Allan and Sir George Harvey] Any day next week will do for me. As soon as I hear from you I shall try to get some figures engaged; but the Grouse and the Queen have rather thinned the Town.'[31]

A more practical side to the partnership lay in the respective circles of the two men. Robert, as the brother of Dr John Adamson, was one of the original scientific circle to experiment with photography, along with Major Playfair and Sir David Brewster, in St Andrews. He was, in effect, Brewster's protégé. Sir David was very influential and probably directed a lot of business to Rock House. He had a large collection of photographs and carried examples around with him to show to other people. The King of Saxony's travelling party met him at Taymouth Castle, where Sir David was able to recommend a visit to Robert Adamson. Carl Gustav Carus reported: 'Professor Brewster in Taymouth, had previously exhibited to the King a number

of these specimens, and had also presented me with some of them at the same time, particularly directing our attention to this atelier.'[32] Knowledge of Adamson's and Hill's progress in 1843 comes substantially from Sir David Brewster's enthusiastic reports to Fox Talbot.

D O Hill, as a painter and Secretary of the Royal Scottish Academy, had the advantage of a large circle of acquaintance among the artists and their patrons. His knowledge of administration undoubtedly helped in the organisation of the business and provided him with a sound footing and understanding of procedure when working up interest in the calotypes. Significantly, it was Hill, the artist, and not Adamson, the scientist, who wrote to Fox Talbot asking permission to take photographs at the scientific meeting of the British Association at York in 1844. D O Hill was also directly familiar with publishing. As a young man, he had been responsible for a series of landscape illustrations concerning the life of Robert Burns, which was printed by the new process of lithography and published by John Blackie in Glasgow. This volume, *The Land of Burns*,

appears in a number of the calotypes as a useful prop. Hill and Adamson 'published' the calotypes in two ways, as single prints laid on card with an engraved credit line in the same manner as engravings, and in bound volumes. In the publishing side of the business they were assisted by Hill's brother, Alexander, who was a publisher and print seller in his own right. Alexander Hill was the official publisher to the Academy and also purchased pictures with the idea of engraving from them. His most ambitious project in the 1840s was the publishing of an engraving by Frederick Bacon of Thomas Duncan's *Prince Charles Edward entering Edinburgh after the Battle of Prestonpans*. The engraver worked on this for three years and Alexander Hill's continuing pride in the result can be seen in the photograph of him taken by Alexander McGlashan in 1862, where he is holding the framed engraving (*fig 19*). Alexander Hill joined D O Hill and Robert Adamson in publishing the calotypes and some of these appeared over his imprint as well as from the Calton Hill studio.

D O Hill's professional experience provides a severe

18 *The Morning After "He, Greatly Daring, Dined"*
D O Hill and Professor James Miller
calotype

19 **Alexander Hill** 1800–1866
with the engraving after Thomas Duncan's picture *Prince Charles Edward entering Edinburgh after the battle of Prestonpans*
by Alexander McGlashan
collodion photograph taken in 1862
sold at Sotheby's 4 December 1972

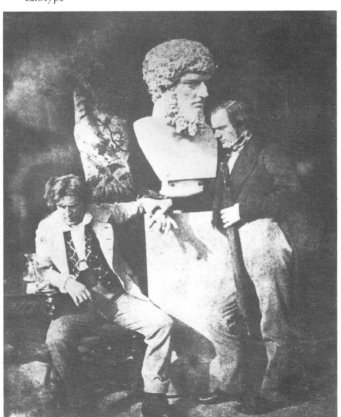

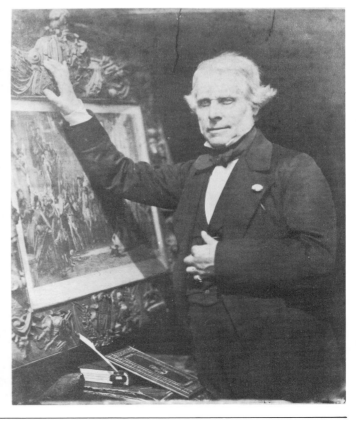

contrast with Robert Adamson's lack of it. Paradoxically, it was an advantage to the success of the calotype venture that Adamson had no other career behind him. The early professional photographers mostly came to photography from some other line of work, often one that was threatened by the new process – such as miniature painting or engraving. This led to many of them dividing their time between two or more professions and constantly looking over their shoulders at their original trade. Although we know that there were more photographers in the city, the Edinburgh Street Directories for the 1840s show only Robert Adamson until 1846–7, when James Ross appears as a calotypist. James Howie, a miniature painter who was working also as a daguerreotypist from 1840 or 1841, did not even admit to it as a subsidiary profession in the Directory until 1854–5. The three daguerreotypes by Howie in the Portrait Gallery's collection are singularly undistinguished. Robert Adamson brought to the calotype process his whole attention, which resulted in very high quality work.

A further advantage of the partnership was Adamson's tenancy of Rock House. Early photographic 'studios' required to be out of doors. In the crowded centres of London or Edinburgh, where space was valuable and buildings tall and liable to obscure daylight from gardens, these studios were apt to be relegated to the roof tops. The engraving after Joseph Ebsworth's water-colour of Edinburgh seen from the top of the Scott Monument in 1846 gives us a bird's eye view of the studio employed by James Howie (*fig 20*). Two sitters, who have just climbed up four flights of narrow stairs and apparently out of a skylight onto sloping tiles, are perched on hard chairs close to the edge of the roof and in front of the chimney stack (note the chimney about to fall on their heads). Any chance of their looking relaxed or happy in front of the camera was naturally doomed from the start. The Rock House studio is set halfway up the Calton Hill on the south side at a level well above Princes Street. There, a client could sit in a sheltered garden away from the strong winds and smoke of Edinburgh. Simply in catering for the comfort of his sitters, Robert Adamson had a head start over the competition.

20 **Detail of a view of Edinburgh from the top of the Scott Monument in 1845 showing James Howie's rooftop studio**
by Joseph Ebsworth
lithograph in the collection of Edinburgh Public Library

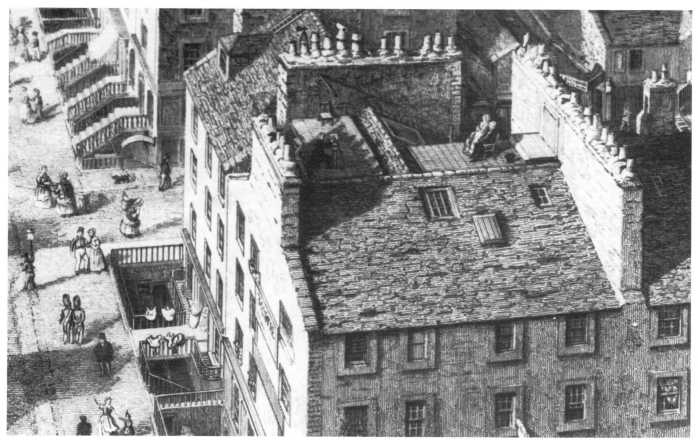

There can be no doubt that the two men individually had considerable gifts to bring to their partnership. It is likely that they found each other's company stimulating; that Hill's enthusiasm and organising ability galvanised Adamson into greater activity and that Adamson's skill excited D O Hill into more visual experimentation. There is certainly no reason to suppose that the partnership can be dissected as the mere sum of their separate talents. Their calotypes were of a remarkable technical and artistic quality only a few years after photography had been invented. The sophistication of their photographs, which can happily stand comparison with the later and more versatile processes, argues in favour of the idea that their working relationship developed and extended the abilities of both men.

Art and the calotype

It was a happy coincidence which led D O Hill to take an interest in the calotype process. The circular letter to the Rev Dr Gordon, quoted above, is evidence that he was considering the use of both calotypes and daguerreotypes as 'sketches' for the Disruption Picture. However, having once seen the calotype process, he recognised its artistic possibilities and entered rapidly into the partnership with Robert Adamson. The prospectus for the Thomas Annan photographs of the finished Disruption Picture, published in 1866, makes the qualified claim: 'It is worthy of notice, in passing, that the Portraits made chiefly for this Picture, in 1843 by Mr Hill and his late friend, Mr Robert Adamson of St Andrews, by the then newly discovered Photographic Process of Mr Fox Talbot, called the Calotype or Talbotype, – until then almost unknown or unapplied as a vehicle of artistic thought and expression, – were mainly the means of first raising the process to the rank of a Fine Art, or rather to that of one of its most magical and potent auxiliaries.'[33] The anonymous text for this prospectus was presumably written by, or at least written from, information supplied by Hill, who expressed a similar sentiment in a letter to David Roberts in January 1849 about the presentation of the albums of calotypes to the Royal Academy in London: 'The one *selfish* object I had in view in presenting them is gained, in their being in your library to demonstrate that we had at an early period of the art done it some service. I need not say I am otherwise more gratified in believing I have caused any gratification to the members of the Academy.'[34]

D O Hill was not alone in believing that he broke new ground in applying the calotype to 'artistic purposes'. Professor Robert Hunt could say as late as 1848: 'Photography has not yet been taken up by an artist with a view to its improvement, except by Mr. Hill, of Edinburgh, whose groups of the Newhaven fishermen, executed by the Calotype process have been universally admired.'[35] This is not to say that other early photographers were not interested in being 'artistic' but their methods of procedure were

somewhat different. Henry Collen, the miniature painter who took out the first calotype licence in 1841, first made the calotypes and then painted on top of them. Claudet, who followed Collen as a licensee, had an artist on his staff and their joint efforts were described as follows: 'The improvements recently introduced by M. Claudet into the process of Calotype (more properly Talbotype) are absolutely wonderful. Likenesses are now produced upon paper, which are then placed before a competent artist, who "touches them up", and makes of them PORTRAITS. Many advantages are thus obtained – not the least is that the sitter is put to no farther inconvenience or loss of time than 20 seconds, the period which the sun takes to make the unerring outline . . . [the calotypes are then] wrought upon by an accomplished miniature painter, Mr Mansion. No human hand has ever obtained such brilliant effects as these.'[36] In other words, in the hands of the professional photographers, the calotype was first made by a simple mechanical process and only then turned into a 'work of art'. D O Hill was organising the photographs as works of art *before* they were taken. Such touching up as he did was either the removal of spots or supports, or the reinforcing of lines of drapery, hair and so forth, with an occasional decorative flourish – a few added leaves, a star or a book title (the water-coloured calotype of Miss Susan Watson is a solitary aberration and may well not be Hill's work). This means that Hill regarded the calotype itself as an artistic process rather than as something which would be turned into art by painted additions.

One photographer whose work may reasonably be compared with Hill's, although it is not of the same distinction, is William Collie. He was taking photographs of local working women in Jersey in 1847. The *Art Journal* in June of that year reported: 'Mr. W. Collie of Belmont-House, Jersey, an artist of repute, has forwarded to us some examples of "Calotypes" taken from life. They are copies chiefly of the market women of the island, whose expressions, countenances, and picturesque costumes are well suited for the purpose. We have seen nothing at all comparable to them, except those of Mr. D.O. Hill of Edinburgh; in both cases we have proofs how greatly this interesting art may be improved in the hands of artists. The calotypes of Mr. Collie are wonderfully accurate: each may be indeed a model for a painter: proving how emphatically Art may be assisted by Nature. Some of those before us are likenesses; and we may be justified in describing them as even in this respect highly satisfactory; for a degree of refinement has been obtained of which the art has seemed incapable.'[37] D O Hill was sufficiently interested in Collie's photographs to have included one of his prints in the four albums, which were otherwise exclusively his and Adamson's work, in the Royal Scottish Academy's collection (*fig 21*). A group of ten of Collie's calotypes, which is now in the Portrait Gallery's collection, may also have belonged to Hill.

D O Hill, in common with others in the art world, was

impressed by the calotype process as one capable in itself of great beauty. The very lack of precision in detail was regarded as a virtue. 'The rough and unequal texture throughout the paper is the main cause of the calotype failing in details before the Daguerreotype . . . and this is the very life of it. They look like the imperfect work of man . . . and not the much diminished perfect work of God.'[38] The calotype process with its broad masses of light and shade coincided neatly with contemporary taste in art. Portrait painters, especially, favoured a generalised treatment with the emphasis on the sitter's head and less on the surrounding background and the clothes. The calotype produced results of this kind both because of the imperfect smoothness of the paper and because the focal range of the lens made the image more precise in the central area.

Comparisons were commonly made between the calotypes and Rembrandt's etchings. John Harden, the water-colourist, remarked in November 1843: '. . . the pictures produced are as Rembrandt's but improved, so like his style & the oldest & finest masters that doubtless a great

21 **Market woman in Jersey**
by William Collie
calotype taken about 1846
ex collection Royal Scottish Academy

progress in Portrait painting & effect must be the consequence.'[39] In 1845, the marine painter, Clarkson Stanfield, thanked Hill for an album of the calotypes with the words: 'They are indeed most wonderful and I would rather have a set of them than the finest Rembrandts I ever saw.'[40] Interestingly enough, the process was attracting the comparison in the *Edinburgh Review* for January 1843, before Hill met Adamson: 'We have now before us a collection of admirable photographs executed at St Andrews by Dr and Mr Robert Adamson, Major Playfair and Captain Brewster. Several of these have all the force and beauty of Rembrandt, and some of them have been pronounced by Mr Talbot himself to be among the best he has seen.'

The unexpected compliment to the calotype which appeared more than once was that it proved the truth of the past masters. Hugh Miller wrote about Hill and Adamson's calotypes in 1843:

In glancing over these photographic sketches, one cannot avoid being struck by the silent but impressive eulogium which nature pronounces through their agency, on the works of the more eminent masters . . . Artists of a lower order are continually falling into mere mannerisms – peculiarities of style that belong not to nature, but to themselves, just because, contented with acquirement, they cease seeing nature. In order to avoid these mannerisms, there is an eye of fresh observation required – that ability of continuous attention to surrounding phenomena which only superior men possess; and doubtless to this eye of fresh observation, this ability of continuous attention, the masters owed much of their truth and their power. How very truthfully and perserveringly some of them saw, is well illustrated by these photographic drawings. Here, for instance, is a portrait exactly after the manner of Raeburn. There is the same broad freedom of touch; no nice miniature stipplings, as if laid in by the point of a needle – no sharp-edged strokes: all is solid, massy, broad; more distinct at a distance than when viewed near at hand. The arrangement of the lights and shadows seems rather the result of a happy haste, in which half the effect was produced by design, half by accident, than of great labour and care; and yet how exquisitely true the general aspect! Every stroke tells, and serves, as in the portraits of Raeburn, to do more than relieve the features: it serves also to indicate the prevailing mood and predominant power to the mind. And here is another portrait, quiet, deeply-toned, gentlemanly, – a transcript apparently of one of the more characteristic portraits of Sir Thomas Lawrence. Perhaps, however, of all our British artists, the artist whose published works most nearly resemble a set of these drawings is Sir Joshua Reynolds. We have a folio volume of engravings from his pictures before us; and when, placing side by side with the prints the sketches in brown, we remark the striking similarity in style that

prevails between them, we feel more strongly than at perhaps any former period, that the friend of Johnson and of Burke must have been a consummate master of his art.[41]

A shorter but similar remark was made seven years later by Professor Robert Hunt reviewing the British Association meeting in Edinburgh: '. . . another set communicated by Mr Hill, the joint productions of that talented artist and of the late Mr Adamson, were remarkable for the picturesque character of the groups, and the general disposition of the parts in every feature. These were not merely portraits or copies of still nature, but they formed studies of a higher artistic character and exhibit effects which prove the truth of the elder masters in the arrangement of their lights and shadows.'[42]

The coincidence of contemporary taste with the qualities of the calotype was extremely fortunate. British art circles were still under the influence of portrait painters like Reynolds and Raeburn, genre painters like Wilkie and landscape painters like Turner. Viewed from another standpoint, the calotypes were far less impressive. Carl Gustav Carus, who was an amateur artist and the biographer of Caspar David Friedrich, was not prepared to take them seriously as an art form. Carus, whose eye was attuned to the clarity and luminosity of Friedrich's painting, chose Raphael rather than Rembrandt as a comparison and found the calotype wanting:

We found a large number of specimens hung up here [Rock House], – landscapes, architectural pictures and portraits. Many of them had a peculiar charm! Such immediate copies of nature have always given me ample material for reflexion. It it not easy to get a better idea of how much a real work of art, – that is, the representation of the idea in the soul of an artist, carried out originally and with method, *must of necessity* differ from nature, than by comparing a really beautiful portrait – Raphael's Fornarina, for example – with a head copied by this process. The free work of art can and ought indeed to represent everywhere *less* and at the same time *more* than nature, – the mere copy only gives the shadow of nature itself, and therefore remains soulless, unsatisfying and rigid. All this however does not prevent the neatness, exactness, perfectness, and the peculiar want of style, but at the same time want of affectation, of these latter specimens from possessing a peculiar charm for the artist: and I found all these old ideas confirmed on the present occasion.[43]

Dr Carus had, of course, made up his mind in advance and the poor calotype taken by Robert Adamson's assistant in his and D O Hill's absence could do little to change his opinion (*Group 228*).

Carus's argument about the artist's idea being superior to nature was by no means a new one. One of the problems faced by photography in its bid to be considered an art was that the arguments had been formulated in advance and it was actually possible to quote such authorities as Sir Joshua Reynolds when attacking photography. For example: 'If we suppose a view of nature represented with all the truth of the *camera obscura*, and the same scene represented by a great artist, how little and mean will the one appear in comparison of the other, where no superiority is supposed from the choice of subject. The scene shall be the same, the difference only will be in the manner in which it is presented to the eye.'[44] D O Hill was fortunate in that he was able to counter these arguments by means of his use of the calotype process which had a degree of generalisation and even imprecision, quite different from the sharp, clear and unsuggestive images that Reynolds was seeing in the *camera obscura*. The portrait photographs which Hill produced by this method had many of the characteristics which were admired at the time as showing the ideal or intellectual side of the painted portrait.

Daguerreotypes, on the other hand, were much closer in appearance to the kind of image Reynolds was criticising. The daguerreotype, in its smoothness and finish, resembled a skilful waxwork figure. It provided an accurate record of the physical appearance of the sitter but rarely conveyed anything more profound. In contrast, the calotype had more in common with the first vital notations made by the portrait painter in a preliminary drawing or rapid painted study, perhaps rough in execution but redolent of life and character. It is noteworthy that at least one daguerreotypist, J J E Mayall, attempted to evade the distracting overall precision which labelled the daguerreotype as 'non-art' by taking portraits through a revolving toothed wheel which blurred the edges of the picture. The *Art Journal* of 1853, reviewing this so-called 'crayon' daguerreotype, said the results were 'truly artistic'.[45]

When the calotype process was overtaken in the 1850s by the albumen and collodion processes, whose greater smoothness and transparency made paper photography more like the daguerreotype, photography came increasingly under attack. This can partly be explained by the loss of novelty. The new processes were easier and cheaper, and by the late 1850s photography had become a considerable industry. In 1857, the *Art Journal* was complaining: 'Photography has become so far popularized that its practice may be at times considered a public nuisance. In the suburbs of London, particularly at the east end, the streets are impassable with 'touters' of rival establishments, who with showy gilt frames in hand, intercept all passengers, and almost drag them into their dens. An enormous trade is carried on upon Sunday at all hours, in defiance of public decency. It has really now become a matter for police interference, both on grounds of propriety and public comfort.'

However, it was not just the increasing vulgarity or the growing competition suffered especially by the engravers and miniature painters which led to the attack.

Paradoxically, the increased mechanical perfection of photography reduced its resemblance both to art and to nature. One of the defects of calotype and daguerreotype photographs considered simply in their ability to copy nature was explained by Robert Hunt in 1852, who invented a lady for the purpose: '. . . possessing a somewhat jaundiced face and yellow hair – we will imagine her to wear a dark blue bonnet – and, not remembering if we shall offend against Mrs Merrifield's laws of "Harmony of Colour in Ladies' Dress" [a series of articles which had appeared in the *Art Journal* in previous months], we will allow our fancied fair one to wear a violet silk dress, a purple mantle, and give them an abundant trimming of yellow or bright gold colour. The daguerreotype or calotype portrait of such a lady would have a *dark* almost mulatto face and black hair, the dress and the mantle would only be different tones of white, and the yellow trimming an intense *black*. This peculiar result – which we should never expect by any system of *à priori* reasoning, is proved to be dependent upon the interfering influences of light – those colours which produce the most intense illumination giving the smallest amount of chemical action and the contrary.'[46]

22 **Lady Elizabeth Eastlake** 1809–1893
calotype

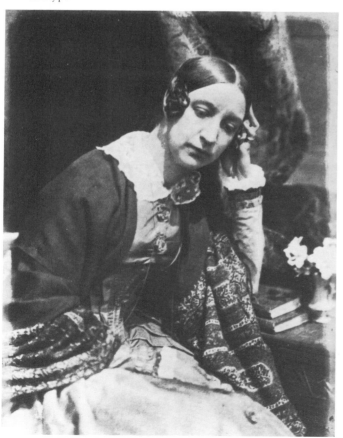

The calotype process by its nature relied on the art of suggestion: like a sketch, it provided material that the eye and the imagination could build on. The more obviously accurate collodion process by presenting a greater appearance of reality made the continuing photographic inadequacies, such as the problem of reproducing colour in equivalent tones of dark and light, more obvious. The art-historian and critic, Lady Elizabeth Eastlake, had enjoyed posing for Hill and Adamson's calotypes in the 1840s (*fig 22*). Writing in 1857, she criticised the collodion process at some length:

The science therefore, which has developed the resources of photography, has but more glaringly betrayed its defects. For the more perfect you render an imperfect machine the more must its imperfections come to light: it is superfluous therefore to ask whether Art has been benefited, where Nature, its only source and model, has been but more accurately falsified. If the photograph in its early and imperfect scientific state was more consonant to our feelings for art, it is because, as far as it went, it was more true to our experience of Nature. Mere broad light and shade, with the correctness of general forms and absence of all convention, which are the beautiful conditions of photography, will, when no further is attempted, give artistic pleasure of a very high kind; it is only when greater precision and detail are superadded that the eye misses the further truths which should accompany the further finish.

For these reasons it is almost needless to say that we sympathize cordially with Sir William Newton, who at one time created no little scandal in the Photographic Society by propounding the heresy that pictures taken slightly out of focus, that is with slightly uncertain and undefined forms, "though less *chemically*, would be found more *artistically* beautiful". Much as photography is supposed to inspire its votaries with aesthetic instincts, this excellent artist could hardly have chosen an audience less fitted to endure such a proposition. As soon could an accountant admit the morality of a false balance, or a sempstress the neatness of a puckered seam, as your merely scientific photographer be made to comprehend the possible beauty of "a slight *burr*."[47]

We know that D O Hill regarded the calotypes as art in their own right. He published them as individual prints and in albums and he exhibited them with his landscape paintings in the Royal Scottish Academy. When he entered into partnership with Robert Adamson, Sir David Brewster reported that he 'proposes to apply the Calotype to many other general purposes of a very popular kind, and especially to the execution of large pictures representing diff. bodies & classes of individuals'.[48] Some of his intentions went awry, such as the projected volumes on specific subjects; others may only be represented by one or two prints, such as the

calotype of the woman with the goitre (*Unknown Woman 14*) or the fossil which may indicate an interest in scientific illustration.

Hugh Miller's article on 'The Calotype' written at the commencement of Hill's partnership with Adamson spoke of the future of photography: 'Another very curious result will be, in all probability, a new mode of design for the purposes of the engraver, especially for all the illustrations of books. For a large class of works the labours of the artist bid fair to be restricted to the composition of *tableaux vivants*, which it will be the part of the photographer to fix, and then transfer to the engraver.'[49] Hill probably had this in mind at the time and may well have discussed the subject with Miller. His earlier career had involved him in painting or drawing specifically for the engravings of illustrated books, notably *The Land of Burns*. Whether he thought of the calotypes as 'drawings' for engravings or as a possible substitute for engravings is not always clear. In some cases, such as the calotypes of the Velasquez engravings or the paintings by William Etty, Raeburn and Thomas Duncan (*Art 1–7*), Hill was obviously experimenting with photography as a direct form of reproduction. In other cases, like the costume groups of Walter Scott subjects, he could have intended the calotypes either as source material or as finished book illustrations.

The most obvious point is D O Hill's original intention when he was introduced to Robert Adamson. The example of Sir George Hayter's *The Reform Bill*, a big picture with over 400 portraits, lay before Hill when he undertook to paint the Disruption. Hayter's picture had taken ten years to complete, mainly because of the artist's difficulties in obtaining sittings from the protagonists. The calotype process enabled Hill to take most of the portraits he required for the Disruption Picture before the end of 1843. But, unfortunately, despite the brilliant use he made of the process, the painting itself made very slow progress and totally lost the liveliness of the photographs. The calotype so excited Hill's interest that he arranged for more portraits, capable of standing in their own right, than the required number of studies for the picture. In the event, it took Hill more than twice as long as George Hayter to finish his painting.

However, Hill was not working full-time on the Disruption Picture and during the 1840s he used the

23 *Edinburgh from the Castle, 1847*
 by David Octavius Hill
 oil painting
 in the collection of the National Gallery of Scotland

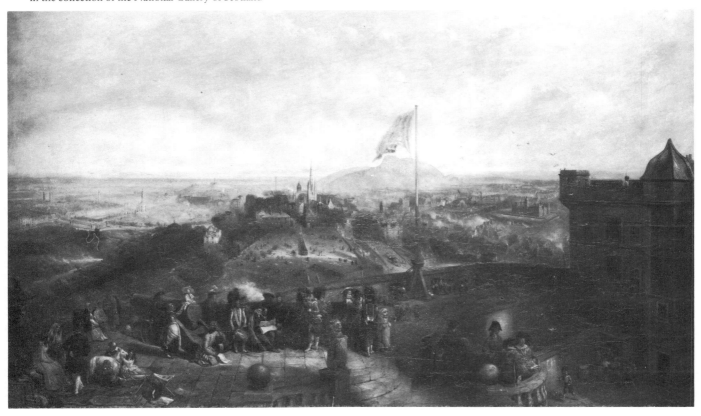

24 **42nd Highlanders in Edinburgh Castle,** April 1846
calotype used as a study for fig 23
ex collection Royal Scottish Academy

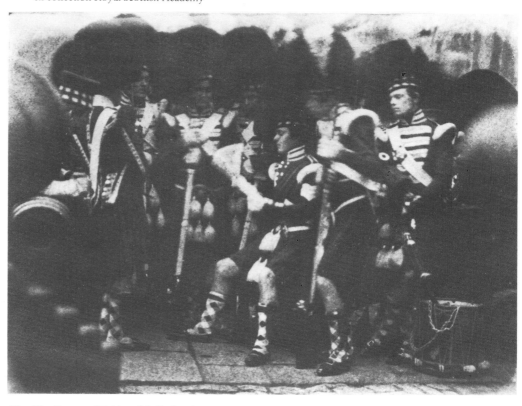

25 *The Braes and Bridge of Ballochmyle*
by David Octavius Hill
oil painting
in the collection of Sir Claud Hagart-Alexander, Bart

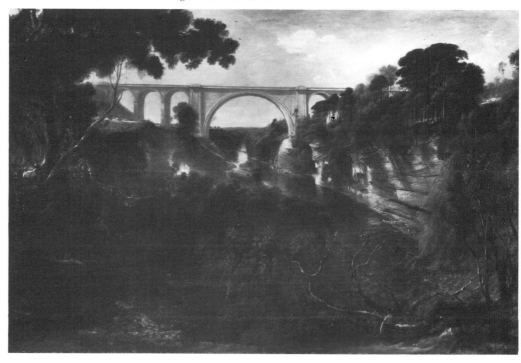

calotypes as studies for a number of other paintings. One of these was *Edinburgh from the Castle, 1847* (*fig 23*), for which he and Adamson took calotype views and groups of the 42nd Highlanders in April 1846 (*fig 24*). Hill also used one of the groups of fishwives and a calotype of the piper John Ban MacKenzie for the foreground figures in this painting. David Roberts, who was painting a view of Edinburgh at the same time, asked his friend David Ramsay Hay to purchase one of the calotypes of the soldiers in November of 1846, for use in his picture.[50] The series of calotypes of the Ballochmyle Viaduct and studies of the vegetation in the valley (*Landscape 28–36*) were probably taken by Hill without Adamson's assistance during 1847 or 1848, when the final stone of the viaduct was laid. These were intended as studies for two paintings, one for the engineer, John Miller, and other for the landowner, William Maxwell Alexander (*fig 25*). Although in this case the calotypes are technically incompetent, the final paintings are much more assured.

A third example of Hill's direct use of the calotypes is the posthumous portrait of the Rev Dr Thomas Chalmers with his grandson (*fig 26*). The original calotype (*Group 63*) was applauded as the best of the portraits of Chalmers in the *North British Review* in February 1848: 'Mr Hill's calotypes we like better than all the rest; because what is in them is true, is absolutely so, and they have some delicate renderings which are all but beyond the power of any mortal artist; for though art is mighty, nature is mightier – "it is the art of God". The one of the Doctor sitting with his grandson "Tommy" is to us the best – we have the grandeur of his form – his bulk – like one of the elder gods.' This article may have persuaded Hill to begin his painting. The calotype is focussed on the figures and has none of the background, but for this Hill may have used a large calotype also taken in 1844 in the grounds of Merchiston Castle, of trees and the wall with the door. The finished painting is not wholly satisfactory: the garden has charm and the figure of Chalmers is reasonably well painted, but the boy's head at the centre of the picture is badly drawn. In the original calotype, the child has moved slightly and his head is

26 **Rev Dr Thomas Chalmers and his grandson**
 by David Octavius Hill
 oil painting

27 **Rev Dr Thomas Chalmers and his grandson**
 by John Le Conte after D O Hill
 lithograph

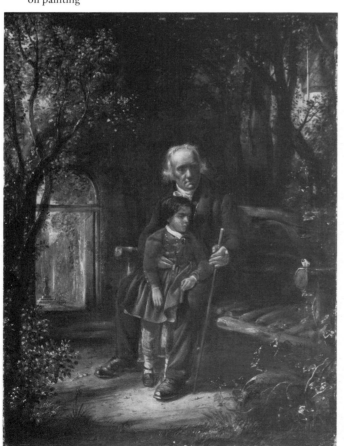

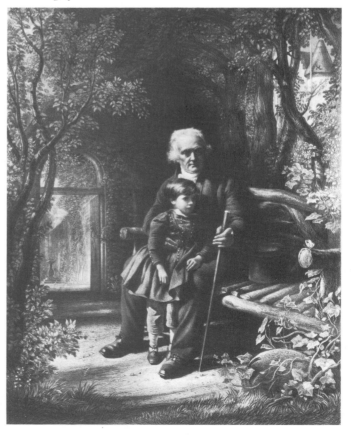

blurred, which gave Hill trouble when he came to translate it into paint. Alexander Hill, who may have asked Hill to paint the picture and subsequently owned it, commissioned John Le Conte to engrave it. Le Conte obviously worked with both the calotype and the painting and his engraving is, interestingly enough, a far better translation of the calotype than Hill achieved (fig 27).

Occasional remarks made by other artists interested in the calotypes reveal that others beside Hill were making use of them. John Harden, for example, was intending to send his daughters drawings from the calotypes as Christmas presents in 1843. His letters also show the direct interest of the President of the Royal Scottish Academy, Sir William Allan. On 23 November 1843, Harden wrote describing the calotypes and added: 'I have sat and stood for a likeness & hope it will be approved of. Sir Wm Allan arranged my standing attitude.'[51] A comparison between this standing attitude and the portraits of Sir William Allan makes it highly likely that Allan arranged his own pose as well. The armour in these portraits presumably came from Sir William

Allan's own large collection and he may well have been involved in the other calotypes where it appears (see, for example, *Miss Ross* and *Master James Miller*). Sir William Allan had travelled in Russia collecting costume and armour, which he used in his romantic Eastern paintings. During the 1840s, he exhibited three Circassian pictures, including *Morning: Circassians on the Watch* in 1846. The calotype which is usually called 'Afghans' (fig 28) was once called 'Study – Circassian Armour' and may well prove to have been arranged or requested by Allan as a sketch for his painting. In 1845, Sir William Allan exhibited a portrait of Mohun Lal. Since he had only been in Edinburgh for a few days in 1844, it is likely that Allan either commissioned the calotypes of him or, at the least, that he made use of them.

Obviously, with the Edinburgh artists working in a fairly small circle, some of the possible connections between the calotypes and contemporary paintings will turn out to be simple coincidence. Hill and the other painters were using similar titles for their pictures even before the Rock House studio was set up. There is no reason to believe, for instance,

28 *Afghans* or *Circassian Armour*
 calotype

29 **Thomas Duncan** 1796–1870
 self-portrait
 oil painting
 in the collection of the National Gallery of Scotland

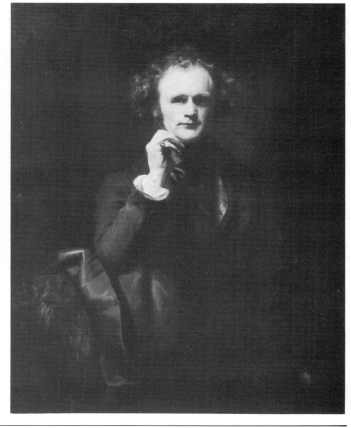

that the painting exhibited by Daniel Macnee in 1844 with the title *A Love Reverie* bears any relation to either of the calotypes given this name (*Lady Eastlake c* and *Newhaven 17*). Moreover, since a creative artist regards a study as something to be used as a basis for thought and consideration rather than just copied direct, it is not always clear whether apparent visual resemblances between the calotypes and the paintings of the period have any real foundation.

Thomas Duncan exhibited a self-portrait in the 1845 Royal Scottish Academy exhibition, where it was seen by Lady Eastlake. Her Journal recounts: 'Out to the Exhibition – a surprising gap between Scotch and English art. Only Duncan, in his one picture of himself, can compete with the English school, and that far surpasses it: a most wonderful picture, evidently showing that he has learnt much from the calotypes – so broad, broad, and true. He is Rembrandt's best pupil, and yet does not imitate his master; also, like Rembrandt, the picture was best in the head, ill-drawn in the figure'[52] (*fig 29*). In these remarks, Lady Eastlake brings out the problem in estimating the influence of calotypes on the art world. Although it is easy enough to see where an artist has translated an image directly from a calotype to the canvas, it is more difficult to see where he has been influenced in general terms.

Contemporaries saw the calotypes as educationally useful for artists, teaching them accurate perspective or providing correct studies for drapery. They were also admired for their truth. The surprise shown that the calotypes proved the truth of artists like Rembrandt and Raeburn is in itself evidence that this early photography was, at the very least, persuading artists to look again. Painters like Clarkson Stanfield, David Roberts and James Drummond (*fig 30*) owned and admired albums of Hill and Adamson's calotypes and this admiration was likely to affect their painting. D O Hill thought of the calotypes in this educational and influential sense and aimed to build up a study collection for the use of artists in the Royal Scottish Academy. He reported to David Roberts in 1852: 'Our Academy have been making [illegible] important additions to their Library of late and I think this department will begin to receive more attention. They have received with [acceptance?] a project of mine to form a Calotype department of the Library of which I have formed the basis with 500 of my own. I think I have influence enough with not a few of the Calotypists to get copies of their best. These we propose to preserve in [beautiful?] volumes. Look one day to see this an important feature of our collection.'[53]

30 **James Drummond** 1818–1877
calotype

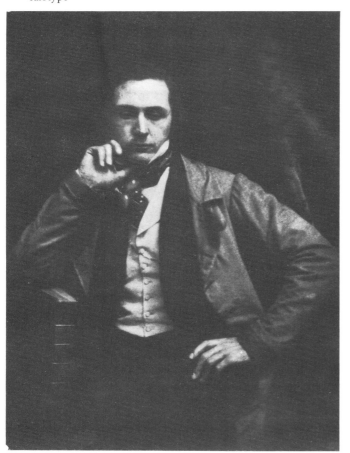

D O Hill after Robert Adamson's death: photography and the Disruption Picture

Robert Adamson's death in January 1848 necessarily left the calotype business in some confusion. The letter D O Hill wrote to Samuel Carter Hall, the editor of the *Art Journal*, in August of that year expressed the difficulty:

I have indeed given you fair occasion to say I have used you discourteously in not replying to your former note – but when I assure you I had no such intention, my misdemeanour will I trust be diminished in your eyes and be found *only culpable negligence*. Your former note I got just as I was setting off to paint in the country where I remained some time, and as a settlement of my Calotype affairs was then pending between me and the friends of my late friend and partner [illegible] Robert Adamson, I put off writing to you, thinking then a very short period would enable me to write you definitely on the subject of your letter – either as the *sole* proprietor of the Calotypes – or as having given up my interest in them altogether. Still this matter is unsettled – and I arrived in Edinburgh only an hour ago (when I found your note of the 19th) having come a distance of 100 miles solely to get this calotype affair of ours arranged, but not meeting Mr Adamson's brother as I expected *here*, I fear I will have to return to

the country tomorrow without my errand having been accomplished.

I trouble you with all this in order to explain to you that I not being the [illegible] proprietor of the Calotypes, cannot say what I would wish to say – namely that you are welcome to make use of them for the Art Union Journal – and therefore I must speak for Mr Adamson's relations who with myself have been put to heavy expenses by these our Calotype interests. I would propose that you pay [illegible] sum as you think the Journal can afford for the use of them – say if please 25 guineas for 10 or at these rates. These might consist of Allan, Etty – (Gibson of Rome – Steell – Henning – Ritchie – sculptors) Kemp (architect of Scott Monument) Roberts Leitch Harvey Macleay Stevens &c. I [illegible] procure you portraits done in this way of our best artists here. As I write my eye lights on portraits of the individuals who might find appropriate niches in your gallery & the one is the highly intellectual youngest son of old Nasmyth the father of Scottish Art, & his other son the artist of the steam hammer & pile driving engine as well as an admirable amateur artist a Great genius. The other is Mrs Jamison of both of these I have beautiful portraits.[54]

In the event, either because he found Hill's terms too expensive or because the negotiations took too long, Hall only used the calotypes of William Etty and William Allan with his short biographies of artists in the *Art Journal*.

Robert Adamson's illness had slowed him down if not stopped him from working during 1847, and possibly from mid-1846. Although there were a number of photographers in Edinburgh, most were amateurs and the professionals were few and undistinguished. The one good calotypist was James Ross, who had set up business in 1846 or 1847 and had by the following year joined in partnership with John Thomson, the daguerreotypist. If Hill had wanted to continue an active photographic studio, he would have had considerable trouble finding a suitable partner. He eventually bought out the Adamsons' interest in the calotypes, but presumably told John Adamson that he did not intend to continue photography, and it was at this stage that Dr Adamson persuaded Thomas Rodger to take up photography in St Andrews.

D O Hill was now only concerned to market the prints he had in stock. He wrote to John Scott of Colnaghi's in London a long and detailed letter on the mounting and binding of volumes of the calotypes and sent him a hundred as specimens. Any interest John Scott showed, however, did not make a substantial difference to Hill's stock. As late as 1851 it was obviously still large enough to cause him concern. At the Great Exhibition, he exhibited the calotypes which were offered for sale at five shillings each. The melancholy tone of his letter to David Roberts in January 1852 is not the voice of success: 'I shall also see to your having a batch of calotypes – it may be some little time ere I can get them looked out – but it is a promise which shall

gladly be redeemed. I am glad you have not tired of them. I had some hope the Chrystal Palace Fine Arts Jury would have awarded me a medal for my artistic application of this process – and I am still of the opinion they should have done so – it would have been some consolation for much time and money spent, I hope not foolishly, in making the art respectable.'[55]

Hill did not lose interest in photography with Adamson's death. A series of photographs of him and his daughter, which were taken in the mid-1850s by Dr John Adamson or his protégé, Thomas Rodger, demonstrate his continuing involvement (*fig 31*). When the Photographic Society of Scotland was formed in 1856, he was one of the original members with other artists like George Harvey and Kenneth Macleay and he exhibited no less than seventy-seven calotypes at their first exhibition. His brother continued to publish photographs such as Roger Fenton's Crimean War photographs, which he exhibited in 1855. In 1861 and 1862, D O Hill undertook his second photographic partnership with Alexander McGlashan, the engraver and printer, and produced with him 'Contributions towards the further

31 **David Octavius Hill**
by Dr John Adamson or Thomas Rodger
collodion photograph taken in August 1855
in the collection of the Royal Scottish Museum

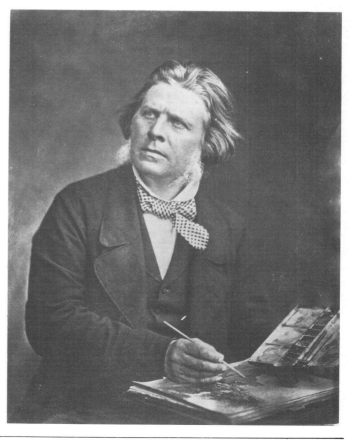

development of Fine Art in Photography', a group of collodion portraits and subject pictures. A set of fifteen of these is now in the Metropolitan Museum and individual prints are in the Portrait Gallery's collection (*fig 32*). These photographs are usually criticised as weak and conventional in comparison with the calotypes and it is true that the overly clear definition of the collodion process destroyed the unified composition possible with the more generalised calotypes.

In 1862, Hill's life took a turn which may have distracted him from photography whether or not he felt satisfied with McGlashan's work. His beloved only daughter, Charlotte, died and he himself married for the second time. His bride was Amelia Robertson Paton, sister of the painters, Joseph Noel Paton and Waller Paton. Hill wrote to his sister-in-law: '. . . she will make me finish the picture';[56] and Amelia, a sculptor living in the same small house as a landscape painter and an unfinished picture of over 400 ministers, more than eleven feet long, had a vested interest in persuading Hill to finish it. Without doubt, the Disruption Picture must have been a source of increasing depression to

him and there was justice in the remark made by the *Art Journal* in 1867 when the painting was on exhibition: 'Mr D.O. Hill has, with a heroism unsurpassed in the history of Art, completed his picture of "The Signing of the Deed of Demission".'[57]

The most laborious productions are rarely the most beautiful or successful. The success of the picture was seriously damaged by the lapse of twenty-three years since the excitement of the Disruption, and Hill was only able to sell the painting for £1,500 to the Free Church, rather than the £3,000 he had hoped for. The passage of time had also made nonsense of the original subscription list for the mezzotint proposed by Hill. He turned to the idea of photographic reproduction and commissioned Thomas Annan to make carbon prints of the painting, which he did with a specially-made camera produced by John Henry Dallmeyer.

The main reason that the painting itself is unsatisfactory is that the individual portraits do not hold together. The painting is composed of a series of groups and single portraits and has an uncomfortable resemblance to a

32 John Taylor Brown and Dr John Brown
by D O Hill and Alexander McGlashan
collodion photograph taken in 1861 or 1862

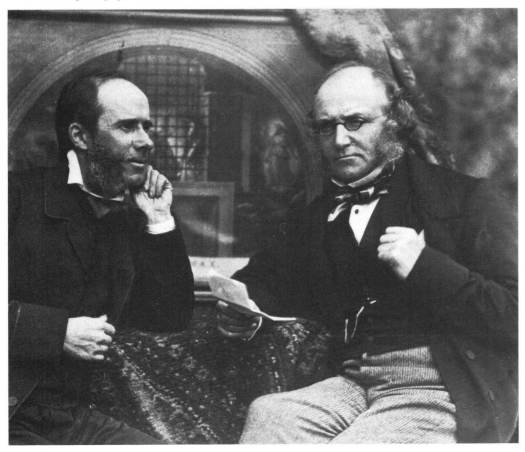

photomontage. The excitement of the calotype process had the unfortunate effect of ruining Hill's picture, because the more calotypes he took, the more accurate and recognisable faces he had to add to the painting. As almost all of the calotypes he used were portraits in their own right, the form of the painting was dictated by the 400 portraits rather than the general composition dictating the way the figures were treated. A comparison between the well-knit composition of Hill's original drawing showing Chalmers preaching and the final picture shows the deterioration in the design.

The second reason for the uneasiness in the painting lies in Hill's own character. Contemporary comparisons between his landscapes and those of the better painter, Horatio McCulloch, make the point that while McCulloch's painting was often technically in advance, Hill's was the more poetic and ideal. As James Nasmyth wrote, after Hill's death, this did not necessarily have a beneficial effect on his work: 'He was a skilful draughtsman, and possessed a truly poetic feeling for art. His designs for pictures were always attractive, from the fine feeling exhibited in their composition and arrangement. But somehow, when he came to handle the brush, the result was not always satisfactory – a defect not uncommon with artists.'[58] With the aid of the calotypes, Hill produced a painting which was intellectual rather than narrative and 'historical' rather than sectarian, including many people who were not present in 1843 and many who were only loosely connected with the event. He further confused the issue by updating the portraits of people he still knew in the 1860s, with the uncomfortable result that some of the faces belong to the 1840s and others, like his own and Dr George Bell's which have sprouted white whiskers, belong to the 1860s.

After twenty-three years of work, the Disruption Picture was not a great success but the extraordinary relief of finishing such a labour was reflected in Hill's painting. The *Art Journal* for the following year printed a highly laudatory review of his new landscape, *Dumbarton from Kirkton Hill*, ending: 'We do sincerely hope, now that Mr Hill has broken the ice anew (so to speak), since his long enchainment to labour of another kind – we mean the weary Disruptive Portraiture which must have lain like an incubus on his genius – he will come forth like a giant enfranchised to refresh his own eyes and afterwards to arrest ours, with many of nature's glorious *coups d'oeil*, such as that now before us.'[59] Sadly, this resurgence of energy was short-lived; Hill succumbed to rheumatic fever and was forced to retire. He and his wife moved to a house in Newington in the southern outskirts of Edinburgh. There, on 17 May 1870, David Octavius Hill died.

33 *In Memoriam*
 Edinburgh from Calton Hill, with Robert Adamson's camera on the
 left slope and Rock House on the right
 by David Octavius Hill
 oil painting in the collection of Edinburgh City Art Centre

NOTES TO THE INTRODUCTION

Previous publications on D O Hill and Robert Adamson, on which this Catalogue is based, are as follows:

Calotypes by D. O. Hill and R. Adamson . . . Selected from his collection by Andrew Elliot text by John Miller Gray and others, 1928

Katherine Michaelson *A Centenary Exhibition of the Work of David Octavius Hill 1802–1870 and Robert Adamson 1821–1848*, 1970

David Bruce *Sun Pictures the Hill–Adamson calotypes*, 1973

Colin Ford and Roy Strong *An Early Victorian Album. The photographic masterpieces (1843–1847) of David Octavius Hill and Robert Adamson*, 1976

1 see for example Helmut and Alison Gernsheim *L. J. M. Daguerre*, 1968 and H J P Arnold *William Henry Fox Talbot*, 1977

2 letter from Sir David Brewster to Fox Talbot, August 1842, quoted in Colin Ford *op cit*, p16

3 *Journal of Henry Lord Cockburn 1831–54*, vol II, p26

4 quoted in the prospectus for the photographs by Thomas Annan of the finished picture *An Historical Picture Representing The Signing of The Deed of Demission painted by D. O. Hill R.S.A.*, [no author], 1866, p4

5 *The Witness*, 24 May 1843

6 *Ibid*, 17 June 1843

7 letter from Sir David Brewster to Fox Talbot, 3 July 1843, quoted in Colin Ford *op cit*, p22

8 letter in New College Library

9 *The Witness*, 12 July 1843

10 *Ibid*, 8 July 1843

11 see note 7

12 manuscript letter from Sir David Brewster to Fox Talbot, 18 November 1843, in the Science Museum, London

13 *Edinburgh Evening Courant*, 3 August 1844

14 Carl Gustav Carus, translated by S C Davison, *The King of Saxony's Journey Through England and Scotland in the year 1844*, 1846, p337

15 a second group photograph in the New College albums is no better

16 quoted in Heinrich Schwartz 'The Calotypes of D. O. Hill and Robert Adamson: Some Contemporary Judgements' *Apollo*, February 1972, p124

17 *Edinburgh Evening Courant*, 24 October 1844

18 *Ibid*, 29 October 1844

19 *Ibid*, 1 April 1845

20 *Ibid*, 10 March 1846

21 manuscript letter from William Dyce to D O Hill, 1846, in the Royal Scottish Academy

22 letter from John Murray to Fox Talbot quoted in H J P Arnold *op cit*, p145

23 quoted in H J P Arnold *op cit*, p145

24 manuscript letter from D O Hill to David Roberts, 12 August 1847, present whereabouts unknown. I am indebted to Miss Helen Guiterman for informing me about this and other correspondence relative to David Roberts

25 *Calotypes by D. O. Hill and R. Adamson . . . Selected from his collection by Andrew Elliot*, text by John Miller Gray and others, 1928, calotype number II

26 Robert Hunt 'On the Fading of Photographic Pictures' *Art Journal*, 1856

27 *The Witness*, 12 July 1843

28 *James Nasmyth, Engineer. An Autobiography*, edited by Samuel Smiles, 1883, p350

29 *Art Journal*, 1850, p309

30 John D Comrie *History of Scottish Medicine*, 1932, vol II, p673

31 manuscript letter from Lord Cockburn to D O Hill, 16 August 1847, in the Royal Scottish Academy

32 Carl Gustav Carus *op cit*, p336

33 quoted in the prospectus for the photographs by Thomas Annan *op cit*, p3

34 manuscript letter from D O Hill to David Roberts, January 1849, in the National Library of Scotland Acc 7723

35 Robert Hunt 'Photography' *Art Union Journal*, 1848, p136

36 *Art Union Journal*, 1845, p171

37 *Ibid*, 1847, p231

38 letter from D O Hill to Mr Bicknell, 17 January 1848, quoted in Colin Ford *op cit*, p30

39 quoted in Daphne Foskett *John Harden of Brathay Hall 1772–1847*, 1974, p52

40 *Edinburgh Review*, January 1843, p327

41 *The Witness*, 12 July 1843

42 review of the British Association meeting by Robert Hunt *Art Journal*, September 1850

43 Carl Gustav Carus *op cit*, p337

44 Sir Joshua Reynolds *Discourses Delivered to the Students of the Royal Academy*, 1905, p360

45 *Art Journal*, 1853, p260

46 Robert Hunt 'Photography' *op cit*

47 untitled article by Lady Elizabeth Eastlake *Quarterly Review*, 1857, p457

48 letter from Sir David Brewster to Fox Talbot, 3 July 1843, quoted in Colin Ford *op cit*, p23

49 *The Witness*, 12 July 1843

50 manuscript letter from David Roberts to David Ramsay Hay, 17 November 1846, in the National Library of Scotland Acc 3522

51 quoted in Daphne Foskett *op cit*, p52

52 *Journals and Correspondence of Lady Eastlake*, edited by Charles Eastlake Smith, 1895, p157

53 manuscript letter from D O Hill to David Roberts, 18 November 1852, in the National Library of Scotland Acc 7723

54 manuscript letter from D O Hill to Samuel Carter Hall, 21 August 1848, in the Edinburgh Public Library

55 manuscript letter from D O Hill to David Roberts, 14 January 1852, in the National Library of Scotland Acc 7723

56 quoted in Katherine Michaelson *op cit*, p15

57 *Art Journal*, 1867, p121

58 *James Nasmyth, Engineer. An Autobiography*, edited by Samuel Smiles, 1883, p 350

59 *Art Journal*, 1868, p65

CATALOGUE

General Notes

The Scottish National Portrait Gallery's collection of calotypes by David Octavius Hill and Robert Adamson came from four main sources. The first, in 1928, was a bequest by James Brownlee Hunter who had purchased his collection in Dowell's auction rooms in 1917. This bequest, described by Hunter in his Will as 'fully say 2,000 Calotypes', includes four albums which had previously belonged to James Drummond and J Irvine Smith. In 1937, the Gallery bought four other albums from Charles Finlay's Trust. The second major bequest came from the collection of the bookseller, Andrew Elliot, through his son Dr A M Elliot who arranged the gift in 1950. Andrew Elliot's collection of about 500 negatives and 700 prints was inherited from D O Hill's brother, Thomas Hill, and presumably went with Hill when he left Rock House. The other large group of negatives apparently stayed in Rock House and was inherited by the later photographers who worked there. The heirs of Alexander Inglis who occupied Rock House from 1876 eventually sold this other group to Robert Dougan who himself sold it to Glasgow University. The present catalogue makes reference, where appropriate, to the Glasgow collection. In 1975, the Royal Scottish Academy sold its five albums of the calotypes and seventy-two of these were bought back by the Portrait Gallery in association with Edinburgh District Council and the Royal Scottish Museum – twenty-nine of the seventy-two are now in the Gallery's collection. The Portrait Gallery has also on loan at present the album of Hill and Adamson's calotypes which belonged to Henry Bicknell.

The negatives and the original positives are mostly on Whatman's Turkey Mill paper. Some of the negatives are waxed for greater transparency. The notations on the negatives are apparently in several hands including Hill's and some seem to have been written at a later date, probably by Andrew Elliot – for this reason, the identifications on the negatives are not always accurate. The technical notations are much abbreviated and casually scribbled so their transcription in the Catalogue cannot always be precise, but where there is doubt it has been indicated.

The later positives include albumen, carbon and photogravure prints. The carbon prints were seemingly commissioned for public sale by Andrew Elliot from Thomas Annan's firm about 1880 and from Miss Jessie Bertram between 1910 and 1920. James Craig Annan produced the photogravures in the 1890s. The albumen prints are not accounted for. A biographical notice of Andrew Elliot, which was published in the *Scottish Field* in April 1918, states: 'It has been a hobby of Mr Elliot's to print and mount early specimens of calotypes by Dr. R. Adamson [*sic*] of St Andrews and D. O. Hill, R.S.A., of which he possesses the original negatives.' Elliot was probably responsible for the positives described in the Catalogue, for want of a more precise term, as 'later calotypes'. These are commonly printed on smoother paper and are muddier in tone than the originals.

The cameras used by Robert Adamson took photographs in seven different sizes, which are numbered as 1 to 6 in the Catalogue in the interests of brevity:

Size 1, 16 × 13 in (430 × 326 mm)
Size 2, 11¾ × 10½ in (299 × 267 mm)
Size 3, 11¾ × 9 in (299 × 228 mm)
Size 4, 8¼ × 6 in (208 × 157 mm)
Size 5, 6¼ × 4½ in (156 × 115 mm)
Size 5a (which may easily be confused with Size 5) 6⅝ × 4⁵⁄₁₆ in (164 × 110 mm)
Size 6, 4 × 3¹¹⁄₁₆ in (94 × 89 mm)
The smallest, Size 6, was probably only used at the start of Hill and Adamson's association.

Men

*The catalogue of Men serves also as an index to the
groups and figures in the landscapes*

JACOB ABBOT 1803–1897
American preacher, Congregational clergyman, educator

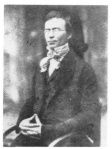

a 1 calotype
 Print size 5. Calotype used for the Disruption Picture.

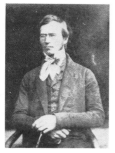

b 2 calotypes
 Print size 5.

ALEXANDER ADAMSON
died 1888
Of Burnside
See also Groups 3 to 8

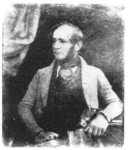

a 1 negative, 1 modern print
 Negative size 4, inscribed 'A Adamson June 28 44 / DF / Sun'.

D M ADAMSON
Presumably David M Adamson, solicitor

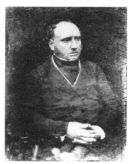

a negative, 1 modern print
 Negative size 4, inscribed 'D M Adamson Esq Nov 16–44 / 306 [or '304']'.

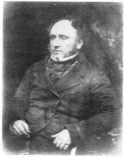

b 1 later calotype
 Print size 4, inscribed on the reverse 'Valentine's printing'.

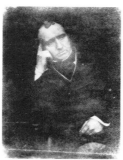

c negative, 1 modern print
 Negative size 4, chemical stain on head, inscribed '24 / G'.

Dr JOHN ADAMSON
1810–1870
Of St Andrews; chemist, produced the first successful calotype in Scotland, taught his brother, Robert, and Thomas Rodger.
See also Groups 5 to 8

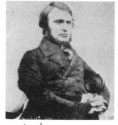

a 1 calotype
 Print size 6. Print inscribed, from negative, 'March 11th 1843'.
 Presumably by Robert Adamson and taken in St Andrews.

b negative, 2 later calotypes
 Negative size 4, inscribed 'Dr Adamson Aug 14 / DF'.

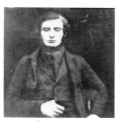

c 1 later calotype
 Print size 4.

ROBERT ADAMSON 1821–1848
Calotypist
See also Groups 3 to 8

a 1 calotype
 Print size 6. Reverse inscription from negative '12 / 3 min long [?]'.
 Calotype presumably by John Adamson.

b 2 calotypes
 Print size 4.

DANIEL AINSLIE

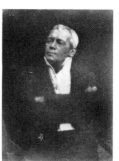

a 2 calotypes, 1 later calotype
 Print size 5.

Rev Dr JOHN AINSLIE
1808–1895
Of Dirleton and St Andrews; Free Church minister

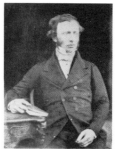

a 1 calotype
 Print size 5.

Rev ROBERT AITKEN
1787–1845
Of Willison Church, Dundee; Free Church minister

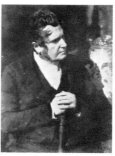

a 1 calotype, 1 later calotype
 Print size 4. Calotype used for the Disruption Picture.

SAMUEL AITKEN
Bookseller, Dean of Guild, friend of Thomas Carlyle

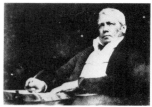

a 1 calotype
 Print size 5.

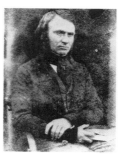

b 2 calotypes, 1 later calotype
 Print size 5.

WATTY ALEXANDER
Golfer
See Group 62

Rev WILLIAM ALEXANDER
1808–1890
Of Duntocher; Free Church minister, clerk of the Presbytery of Dumbarton
See Presbytery Groups 6 and 7

JAMES ALISON

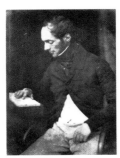

a 1 carbon
Print size 4.

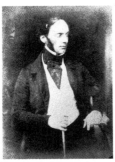

b 1 later calotype
Print size 4.

c negative, 1 modern print
Negative size 4, inscribed 'Alison / 306 [*or* 304]', watermark and minor spots touched out in wash.

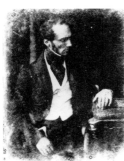

d negative, 1 modern print
Negative size 4, inscribed 'James Alison Esq July 9 – 44 / Gum / DF', marks touched out in pencil.

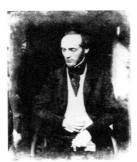

e negative, 1 modern print
Negative size 4, inscribed 'James Alison Esq July 3 – 44 / Gum'.

Probably Rev JOHN ALLAN
1798–1885
Of the Union Chapel of Ease, Aberdeen
See also Groups 191 and 200

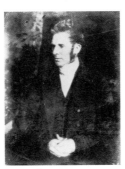

a 1 calotype
Print size 4.

Sir WILLIAM ALLAN 1782–1850
President of the Royal Scottish Academy, history painter
A calotype of Sir William Allan was exhibited in the Royal Scottish Academy in 1844

a 1 calotype
Print size 5. Calotype engraved by Maclure, Macdonald and Macgregor.

b negative, 1 calotype, 1 later calotype
Negative size 4, inscribed 'Allan'.

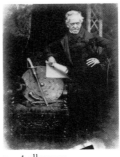

c 1 albumen
Print size 4. This calotype is likely to have been arranged by Allan himself and taken in November, 1843, see note on *John Harden a.*

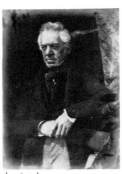

d 2 calotypes
Print size 4.

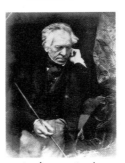

e 1 calotype, 1 print, perhaps a later calotype
Print size 4.

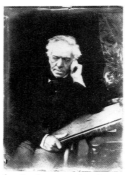

f 6 calotypes, 1 carbon
Print size 4.

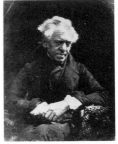

g 1 print, perhaps a later calotype
Print size 5. Inscription printed off from negative 'Sir W Allan'.

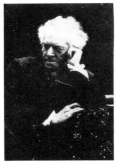

h negative, 1 calotype
Negative size 5, inscribed 'Sir W Allan', waxed.

Captain ROBERT BARCLAY-ALLARDYCE 1779–1854
Of Urie; celebrated pedestrian

a 1 calotype
Print size 4.

Rev Dr JOHN ANDERSON
1796–1864
Of Newburgh; Church of Scotland minister, archaeologist and geologist

a negative, 1 calotype
Negative size 4, inscribed '28 Dr Anderson Newburgh', minor spots touched out in wash.

b negative, 1 modern print
Negative size 4, inscribed 'Dr
Anderson / DF'. Image obscure,
not illustrated.

c negative, 1 modern print
Negative size 4, inscribed 'REV
DR ANDERSON / DF'. Image
obscure, not illustrated.

d negative, 1 modern print
Negative size 4, inscribed 'Rev
Dr Anderson Newburgh'.
Image obscure, not illustrated.

BOB ANDREWS
Of Perth; golfer
See Group 62

– ANNESLEY

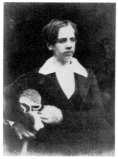

a 1 albumen
Print size 5.

Professor DAVID THOMAS ANSTED 1814–1880
Professor of Geology at King's
College, London
*The following calotypes were taken
at the British Association meeting in
York, between 28 September and 4
October, 1844*

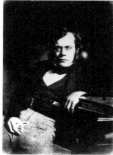

a 2 calotypes
Print size 4.

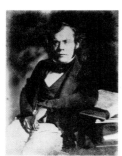

b 1 calotype
Print size 4.

Sir RALPH ABERCROMBY ANSTRUTHER 1804–1863
Of Balcaskie
See also Group 228

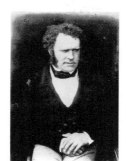

a negative, 1 calotype
Negative size 4, inscribed 'Sir
Ralph', small marks touched
out in pencil and wash.

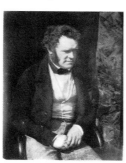

b 1 carbon
Print size 4.

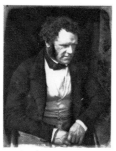

c 1 calotype
Print size 4. Negative in the
collection of Mr John Craig
Annan.

Sir WYNDHAM CARMICHAEL ANSTRUTHER 1793–1869
Baronet
See also Group 228

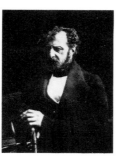

a 1 calotype
Print size 5.

JAMES ARCHER 1822–1904
RSA, portrait and subject painter

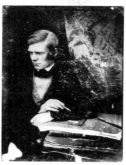

a negative, 1 modern print
Negative size 4, inscribed
'Archer May 15/45 / 16', small
spots touched out in wash, One
of the books under Archer's
elbow is Turner's *Liber
Studiorum*.

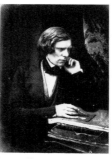

b 1 albumen
Print size 4.

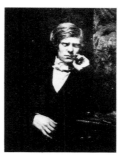

c 1 calotype
Print size 5.

'Lord Provost AUSTIN ARLINTON' (?)
See Presbytery Group 3

Rev Dr DAVID ARNOTT 1803–1877
Of St Giles, Edinburgh; Chaplain
to the Royal Scottish Academy

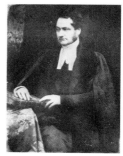

a negative, 2 calotypes
Negative size 4, inscribed 'Dr
ARNOTT OF ST GILES', a
few minor spots touched out in
wash.

b negative, 1 modern print
Negative size 5, inscribed 'Dr
Arnott / DF', hair drawn in and
minor spots touched out in
wash.

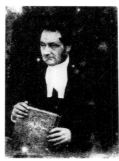

c negative, 1 modern print
Negative size 5, inscribed 'Dr
Arnott', minor spots touched
out in wash.

Rev DAVID ARTHUR 1812–1888
Of Stewarton; Free Church
minister
See Presbytery Group 18

Dr JEAN HENRI MERLE D'AUBIGNE 1794–1872
Of Geneva; 'a leader of ecumenical Protestantism', author of *The History of the Reformation*, visited Scotland in 1845 with Frederic Monod, q v, and spoke to the Free Church Assembly on 28 May.

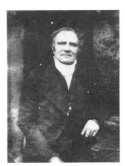

a 1 calotype
Print size 4.

b 1 calotype
Print size 4.

DAVID AULD
Of Ayr

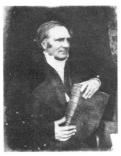

a negative, 1 modern print
Negative size 4, inscribed '2h / DOH [?]'.

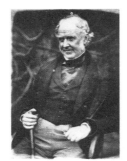

b 2 calotypes
Print size 4.

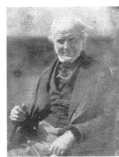

c negative, 1 calotype
Negative size 4, inscribed 'Mr Auld / 2h / 30', waxed.

JAMES AYTOUN
Of Kirkcaldy; manufacturer, Chartist and radical candidate for Edinburgh, 1839–1841

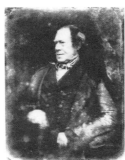

a negative, 1 modern print
Negative size 4, inscribed '½ / 15', minor spots and headrest touched out in pencil and wash.

b 5 calotypes, 1 carbon
Print size 4.

Professor WILLIAM EDMONSTONE AYTOUN 1813–1865
Advocate, Professor of Rhetoric and English Literature at Edinburgh University, poet and humorist

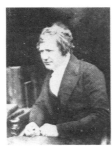

a 1 calotype
Print size 5.

Rev THOMAS BAIN 1815–1884
Of Mortlach and Coupar Angus; Free Church minister

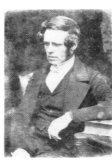

a 1 calotype
Print size 4.

– BAINES
Curator of the York Museum
See also Groups 16 and 17

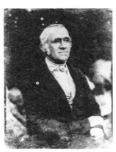

a negative, 1 modern print
Negative size 4, inscribed 'York Mr Baines Curator of Sept 28 44', minor spots touched out in wash. Calotype taken during the British Association meeting in York.

GEORGE BAKER
See also Groups 18 to 22

a 1 calotype
Print size 4. Negative in Glasgow University Library.

WILLIAM BAKER
See also Groups 18 to 22

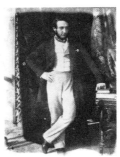

a negative, 1 calotype
Negative size 4, inscribed 'Mr Baker Aug 29/45 / ex1h ¾ Gum [*or* Sun] Str / 300 G'.

JAMES BALFOUR
Of Pilrig
See also Groups 23, 24, 218 and 219

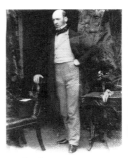

a 1 calotype
Print size 4. Variant negative in Glasgow University Library dated June 8, 1846.

Rev Dr LEWIS BALFOUR 1778–1860
Of Colinton, Edinburgh; Church of Scotland minister
See Groups 25 and 26

JAMES BALLANTYNE
1808–1877
Author and stained glass artist
See also Groups 27 and 28

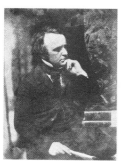

a 1 calotype
 Print size 4.

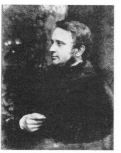

b 2 calotypes
 Print size 4. Negative in the
 collection of Mr John Craig
 Annan.

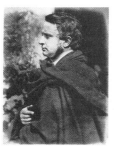

c 2 later calotypes
 Print size 4.

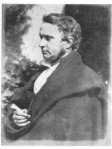

d 2 calotypes, 1 later calotype, 2
 carbons
 Print size 4.

Professor **JAMES
BANNERMAN** 1807–1868
Professor of Apologetics and
Pastoral Theology at New College,
Edinburgh
See also Presbytery Group 14

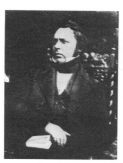

a 2 calotypes
 Print size 5.

JOHN MACLAREN BARCLAY
1811–1886
RSA, portrait painter

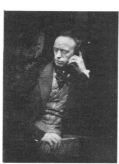

a 1 calotype, 1 carbon
 Print size 4.

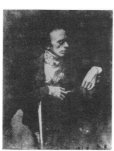

b negative, 1 modern print
 Negative size 4, inscribed 'J M
 Barclay Aug 22 / DF / Gum [*or*
 Sun]'.

Captain **ROBERT BARCLAY**
1779–1854
*See Captain Robert Barclay-
Allardyce*

Rev – BARKER

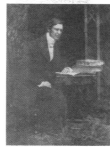

a 1 calotype
 Print size 5.

**Sir HENRY THOMAS DE LA
BECHE** 1796–1855
Director of the ordnance geological
survey, founder of the Geology
Museum and the School of Mines
and President of the Geological
Society

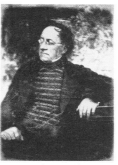

a negative, 1 calotype
 Negative size 4, inscribed 'De
 La Beche', minor spots and
 headrest touched out in pencil.
 Calotype taken at the British
 Association meeting in York
 between 28 September and 4
 October, 1844.

LAYMAN BEECHER 1775–1863
American Presbyterian, President
of the Lane Theological Seminary,
father of Harriet Beecher Stowe

a 2 calotypes
 Print size 4. Calotype used for
 the Disruption Picture.

Rev Dr JAMES BEGG 1808–1883
Of Liberton; Moderator of the Free
Church Assembly, 1865
*See also Groups 31, 206 and 207 and
Presbytery Groups 12, 13 and 14*

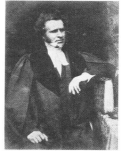

a 2 calotypes
 Print size 4. Negative in
 Glasgow University Library.

Dr GEORGE BELL
One of the founders of 'ragged
schools', Commissioner in Lunacy,
friend of D O Hill
*See also Groups 27, 28, 32 to 35, 135
to 138 and 142*

a 1 calotype
 Print size 4. Negatives of variant
 poses in Glasgow University
 Library inscribed 'Dr Bell in
 Court Dress'.

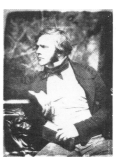

b 2 calotypes
 Print size 4. Calotype used for
 the Disruption Picture with the
 addition of white whiskers.

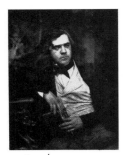

c 1 carbon
 Print size 4.

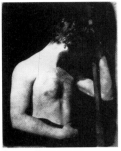

d 1 calotype
 Print size 4.

HENRY GLASSFORD BELL
1803–1874
Advocate, Sheriff of Lanarkshire,
man of letters, friend of D O Hill

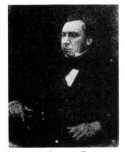

a negative, 2 albumens
 Negative size 5, inscribed
 'Sheriff Bell'.

Colonel OSWALD BELL
1803–1882
Married Robert Adamson's sister,
Isabella, in 1847
See also Groups 7, 8 and 36

a 4 later calotypes
 Print size 4.

b 1 calotype
 Print size 4. Negative in
 Glasgow University Library.

Rev THOMAS BLIZZARD
BELL 1815–1886
Of Leswalt, Wigtownshire; Free
Church minister
See also Group 35

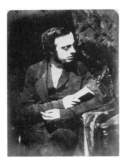

a 5 calotypes
 Print size 4. Calotype used for
 the Disruption Picture.

Sir JOHN BERTRAM

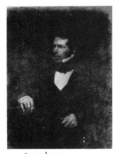

a 1 carbon
 Print size 4.

Sir HENRY LINDESAY
BETHUNE 1787–1851
Baronet, of Kilconquhar, Major-
General, fought in Persia,
instructed the Crown Prince of
Persia and made Master General of
the Artillery by the Shah in 1834

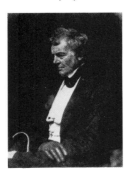

a negative, 1 albumen
 Negative size 5, inscribed 'Sir H
 Bethune'.

– BLACK (1)
See Group 40

– BLACK (2)
See Group 40

Rev – BLACK
Of Kirkcaldy
See William Kirkaldy

Professor ALEXANDER BLACK
1789–1864
Professor of Divinity at Marischal
College, Aberdeen and Professor of
New Testament Exegesis at New
College, Edinburgh
See Presbytery Group 1

HERBERT BLACKIE

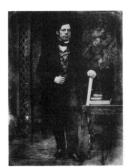

a negative, 1 modern print
 Negative size 4, inscribed 'Mr
 Herbert Blackie / 15 ¼ ex1h',
 small stains touched out in
 pencil.

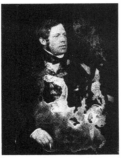

b negative, 1 modern print
 Negative size 4, inscribed
 'HERBERT BLACKIE / 15',
 lower half stained.

JOHN BLACKIE 1781–1874
Of Glasgow; publisher
See also Group 41

a *negative, 1 modern print*
 Negative size 5, inscribed 'John
 Blackie Esq Glasgow 21 Oct
 1843 / D6', waxed. Image
 obscure, not illustrated.

JOHN BLACKIE 1805–1873
Publisher
See also Group 41

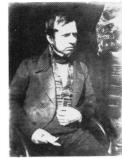

a negative, 2 calotypes, 1 albumen
 Negative size 4, inscribed '15',
 small spots touched out in
 pencil, waxed. The volume on
 the right is *The Land of Burns*,
 which was illustrated by Hill
 and published by Blackie.

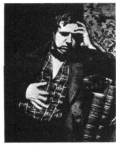

b 2 calotypes
 Print size 4. Negative in
 Glasgow University Library.
 The volumes are *The Land of
 Burns; with Hill's name added
 to the spine on the negative and
 Turner's Liber Studiorum.*

Professor JOHN STUART
BLACKIE 1809–1895
Professor of Greek at Edinburgh
University, voluminous writer of
poetry and criticism, friend of
D O Hill

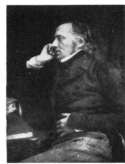

a 2 calotypes, 1 carbon
 Print size 5.

JOHN BLACKWOOD
Stockbroker

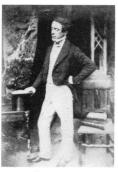

a 1 calotype
Print size 4. Negative in Glasgow University Library dated August 9, 1844.

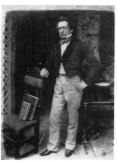

b 1 calotype
Print size 4. Negative in Glasgow University Library dated August 9, 1844.

ROBERT BLACKWOOD
1808–1852
Publisher

a 1 carbon
Print size 4.

Dr BLAIR

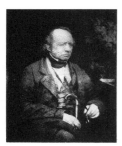

a negative, 1 carbon
Negative size 4, inscribed 'Dr Blair March 28/4 [] / 15 ½', stained, area of coat and table shaded in pencil.

b 1 calotype
Print size 4. Image obscure, not illustrated.

WILLIAM BLAIR
Also called 'Lockhart' on the negatives, possibly a confusion with J G Lockhart

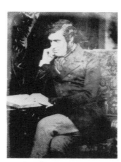

a 1 calotype
Print size 4. Negative in Glasgow University Library.

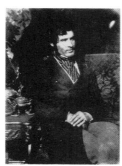

b 1 calotype
Print size 4. Negative in Glasgow University Library.

Sir JOHN PETER BOILEAU
1794–1869
Baronet, archaeologist

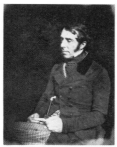

a negative, 2 calotypes
Negative size 4, inscribed 'York Sir John P Boileau Oct 1–44'. Calotype taken at the British Association meeting.

ARCHIBALD BONAR
Manager of the Edinburgh and Leith Bank
Also called 'Rev Andrew Alexander Bonar 1810–1892'
See also Presbytery Groups 21 and 22

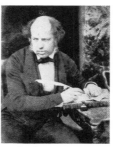

a 1 calotype
Print size 4. Negative in the collection of Glasgow University Library inscribed 'Mr Bonnar banker June 15 4 [4?]'.

Rev Dr HORATIUS BONAR
1808–1889
Of Kelso and Edinburgh; Free Church minister, author of religious poetry
See also Group 217

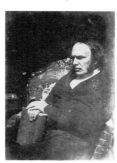

a 4 calotypes
Print size 4. Calotype used for the Disruption Picture, taken in Glasgow.

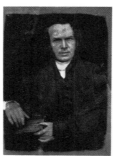

b 1 calotype
Print size 4. Negative in Glasgow University Library dated September 18.

Rev Dr JOHN JAMES BONAR
1803–1891
Of St Andrew's Church, Greenock; Free Church minister

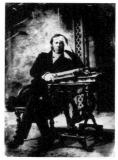

a negative, 1 modern print
Negative size 5, head support touched out in wash, book and shirt heightened in brown wash, waxed.

Captain BORTINGHAM
Of the Leith Fort Artillery
See Military 9 and 10

Dr JAMES BOYD 1795–1856
Senior master of the High School, Edinburgh

a 1 carbon, 2 later calotypes
Print size 4.

JOHN CAMPBELL, 2nd MARQUIS OF BREADALBANE
1796–1862
Strong supporter of the Free Church
See Group 42

– BREWSTER

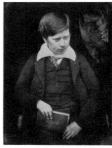

a negative, 1 modern print
Negative size 4, inscribed 'Brewster Sept 2/45 / 15 1½ / Salt W [?]'.

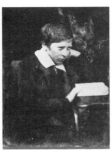

b negative, 1 modern print
Negative size 4, inscribed
'Brewster / DF', jacket shaded
in and headrest touched out in
pencil.

Sir DAVID BREWSTER
1781–1868
Physicist, calotypist, Principal of
United College, St Andrews and
Vice-Chancellor of Edinburgh
University. Introduced D O Hill to
Robert Adamson
*A calotype of Brewster was
exhibited at the Royal Scottish
Academy in 1845
See also Group 42*

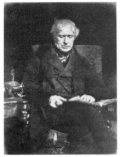

a 3 calotypes, 1 later calotype
Print size 4.

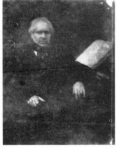

b 1 carbon
Print size 5.

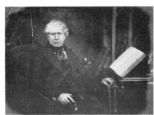

c 1 calotype
Print size 4.

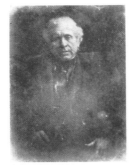

d 1 albumen
Print size 5.

Rev Dr JAMES BREWSTER
1777–1847
Of Craig; Free Church minister,
Chartist, elder brother of Sir David
Brewster

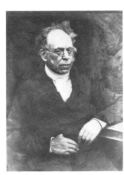

a 2 calotypes
Print size 4.

THOMAS BREWSTER

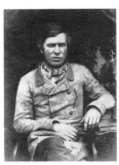

a negative, 1 calotype
Negative size 4, inscribed 'Mr
Thos. Brewster / 15 ex ¾ /
rough Gum [*or* 'Sun']', chemical
marks on face, hands and
background touched out in
pencil.

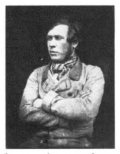

b negative, 1 modern print
Negative size 4, inscribed
'Mr Thos Brewster Aug 15/45 /
[DS ?] / ex1h', chemical marks
touched out in pencil.

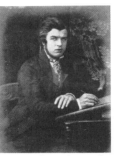

c 2 carbons
Print size 4.

JAMES BRIDGES 1785–1865
Solicitor, Free Church elder

a negative, 1 calotype, 1 later
calotype
Negative size 5, inscribed 'Jas
Bridges 71', waxed.

– BRODIE

a negative, 1 modern print
Negative size 4, inscribed
'Brodie Glasgow 21 Oct 1843 /
D1'.

Called 'BRODIE'

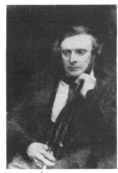

a 2 calotypes
Print size 5.

Rev JAMES BRODIE 1800–1878
Of Monimail; Free Church
minister

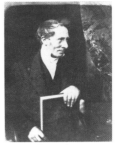

a 2 calotypes
Print size 4.

JOHN LAMONT BRODIE

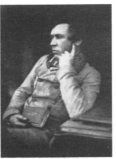

a negative, 1 later calotype
Negative size 4, inscribed 'xx
Wm – Brodie RSA (sculptor?)
Aug 21/45 / ex ¾ 15'; 'Wm',
'RSA' and '(sculptor?)' in a later
hand, small spots touched out in
wash.

b 1 calotype
Print size 5.

Dr BROWN
See Groups 45 to 47

– BROWN (1)
See Groups 43 and 44

– BROWN (2)
See Groups 55 to 57

– BROWN (3)
See Groups 48 and 49

Rev ALEXANDER WATSON BROWN
Of St Bernard's; Free Church minister
See also Groups 48 and 49 and Presbytery Groups 12 to 14 and 19 to 20

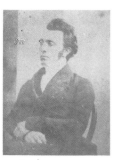

a 1 calotype
 Print size 5, cut down.

Rev Dr CHARLES JOHN BROWN 1806–1884
Of West St Giles, Edinburgh; Free Church minister

a 1 calotype
 Print size 5.

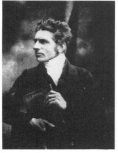

b 1 calotype
 Print size 5. Calotype used for the Disruption Picture.

Rev DAVID BROWN 1803–1897
Professor of New Testament Exegesis and Principal of Free Church College, Aberdeen

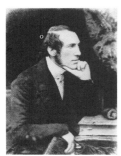

a 1 calotype, 1 later calotype
 Print size 4.

Rev HUGH MCBRYDE BROWN died 1866
Of Lochmaben; Free Church minister
See also Presbytery Group 2

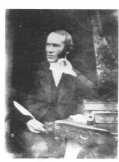

a 1 calotype
 Print size 4.

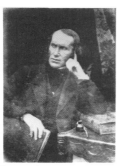

b 1 calotype
 Print size 4. Negative in Glasgow University Library inscribed 'Rev Brown Lochmaven May 21 44'.

Rev Dr JOHN BROWN 1784–1858
Of the Broughton Place United Presbyterian Church, Edinburgh

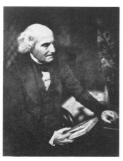

a 1 calotype, 2 carbons
 Print size 4. Calotype used for the Disruption Picture.

b 1 calotype, 1 carbon
 Print size 4.

JOHN BROWN

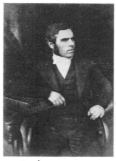

a 1 calotype
 Print size 4.

Rev R BROWN
See Groups 53 to 57

Sir RICHARD BROWN
See also Groups 53 and 54

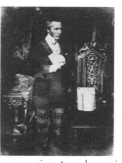

a negative, 1 modern print
 Negative size 4, inscribed 'Brown / DF'. Variant negative in Glasgow University Library inscribed 'Sir Richard Brown Nov 21 4 []'.

Rev ROBERT JAMES BROWN 1792–1872
Professor of Greek at Aberdeen University
See Groups 50 to 52

Dr SAMUEL MORRISON BROWN 1817–1856
Chemist, wrote on the atomic theory
See also Group 109

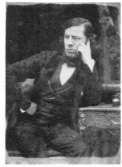

a 1 calotype
 Print size 4. Negative in Glasgow University Library dated May 21.

JOHN BROWN

b 3 calotypes
 Print size 4.

Rev Dr THOMAS BROWN 1776–1847
Of St John's Church, Glasgow; Moderator of the Free Church Assembly, 1843

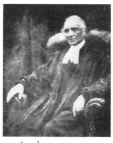

a 1 calotype
 Print size 5.

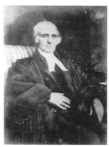

b 1 calotype
 Print size 5.

– BRUCE
See Groups 58 and 59

Rev Dr JOHN BRUCE 1794–1880
Of St Andrew's Church, Edinburgh; Free Church minister
See also Groups 60 and 61 and Presbytery Groups 12 to 14

a negative, 1 calotype, 1 later calotype, 1 carbon
 Negative size 5, inscribed 'REV JOHN BRUCE', waxed.

b negative, 1 modern print
 Negative size 5, inscribed 'Rev J
 Bruce / xxx'.

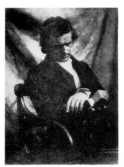

c 1 carbon, 1 print, possibly a
 later calotype photograph of the
 negative
 Print size 5.

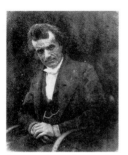

d negative, 1 later calotype, 1
 carbon
 Negative size 5, inscribed 'n3
 25–16 (40) Bruce', minor spots
 touched out in pencil.

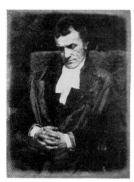

e 1 calotype
 Print size 4.

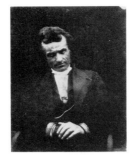

f negative, 1 carbon
 Negative size 5, inscribed '24
 Bruce / 25 16 (60)', lines round
 mouth lightened in pencil and
 stock touched up in brown
 wash.
 Calotype probably used for the
 Disruption Picture.

Rev Dr WILLIAM BRUCE
Of the Infirmary Street United
Presbyterian Church, Edinburgh

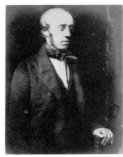

a 1 calotype
 Print size 4.

Dr BRYCE

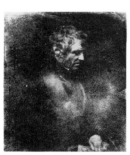

a negative, 1 modern print
 Negative size 4, inscribed 'Sir –
 Bethune' in a later hand. Variant
 negative in Glasgow University
 Library inscribed 'Dr Bryce'.

Rev Dr JAMES BRYCE
1792–1861
Of Gilcomston, Aberdeen; Free
Church minister
See Presbytery Group 1

ROBERT BRYSON
1778–1852
Chronometer and clockmaker of 66
Princes Street, Edinburgh

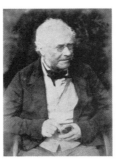

a 1 calotype
 Print size 4.

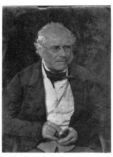

b 1 later calotype
 Print size 4.

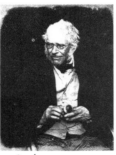

c 2 calotypes
 Print size 4.

Rev WILLIAM BUCHAN
1806–1869
Of Hamilton; Free Church
minister

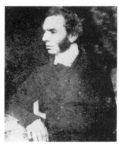

a negative, 1 calotype
 Negative size 5, inscribed 'Rev
 Mr Buchan of Hamilton 22 Oct
 / D2', waxed. Print cut down.

– BUCHANAN

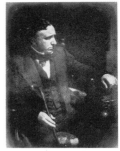

a negative, 1 calotype, 1 later
 calotype
 Negative size 4, inscribed 'Mr
 Buchanan / 24'.

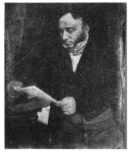

b negative, 1 modern print
 Negative size 4, inscribed
 'Buchanan Sept 11 44 / DS 14',
 minor spots touched out in
 wash, edge of negative touched
 up in pencil and edge of paper in
 Buchanan's hands drawn in in
 wash.

Dr GEORGE BUIST 1805–1860
Editor of the *Bombay Times*,
Inspector of the Bombay
Observatories, founder of the
Bombay Reformatory School of
Industry

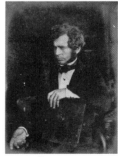

a 2 calotypes
 Print size 4.

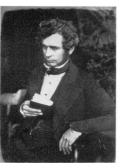

b 2 calotypes
Print size 4. Negative in
Glasgow University Library
dated November 25, 1845.

Rev Dr JABEZ BUNTING
1779–1858
General Secretary of the Wesleyan
Missionary Society

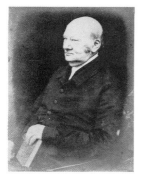

a 2 calotypes
Print size 4.

b 5 calotypes
Print size 4. Negative in the
collection of Mr John Craig
Annan.

FRANCIS BURKE
Accountant, of 40 York Place,
Edinburgh

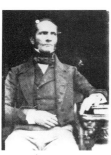

a 1 calotype
Print size 5.

JOHN BURKE

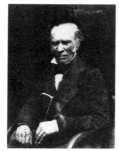

a 1 calotype
Print size 5.

Colonel JAMES GLENCAIRN BURNS 1794–1865
Youngest son of Robert Burns,
returned from India in the summer,
1844

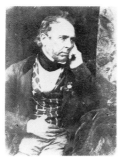

a 2 calotypes
Print size 4. Negative in
Glasgow University Library.

b 4 calotypes
Print size 4. Negative in
Glasgow University Library.

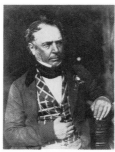

c 1 albumen
Print size 4. The volume under
Burns' hand in this and the
following is *The Land of Burns*
illustrated by Hill.

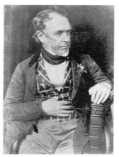

d 1 calotype
Print size 4.

Rev Dr ROBERT BURNS
1789–1869
Principal of Knox College,
Toronto, 1845
See Group 70

Rev Dr WILLIAM HAMILTON BURNS 1779–1859
Of Kilsyth; Free Church minister

a 1 calotype, 2 later calotypes
Print size 4. Calotype used for
the Disruption Picture.

Dr JOHN MACDONALD BURT 1811–1868
President of the Royal College of
Physicians of Edinburgh, 1863–
1865
See also Group 106

a 1 calotype
Print size 5.

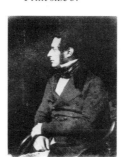

b 1 calotype
Print size 5.

EDWARD BURTON
Engraver

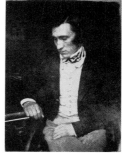

a 2 calotypes, 1 later calotype
Print size 4. Negative in
Glasgow University Library.

ARCHIBALD BUTTER
1805–1885
Of Faskally

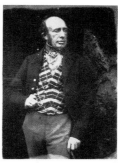

a 4 calotypes, 1 printed in reverse
Print size 4.

b negative, 1 modern print
Negative size 4, inscribed
'[illegible] through Gum / 15',
badly spotted, spots partly
drawn out in a pencil.

PATRICK BYRNE 1797(?)–1863
Irish harpist, in Edinburgh April 1, 1845, when he played the harp and appeared in a tableau of 'The Last Minstrel striking his harp to the last lay' at the Waverley Ball

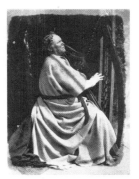

a 5 calotypes
 Print size 4.

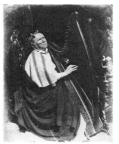

b 4 calotypes
 Print size 4.

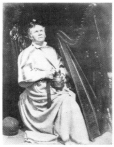

c negative, 1 calotype, 1 later calotype
 Negative size 4, inscribed 'Byrne The Irish Harper / 33', waxed.
 The harp is inscribed 'JOHN EGAN'.

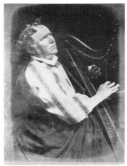

d 3 calotypes
 Print size 4.

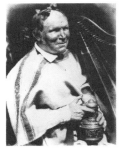

e 2 calotypes
 Print size 4. Negative in New College Library.

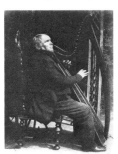

f 1 calotype, 1 later calotype
 Print size 4.

W CADDEL

a negative, 1 modern print
 Negative size 5, inscribed 'Mr W Caddel / D6 1¼ / A'.

ROBERT CADELL 1788–1849
Publisher of Walter Scott's works
See Groups 201 and 202

D S CAFE
Cupper (ie blood-letter) to the Royal Infirmary, Edinburgh
Also called 'D S Cafe of Cupar'

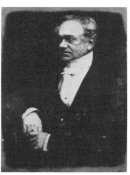

a negative, 1 calotype
 Negative size 4, waxed.

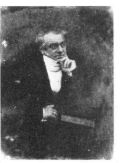

b negative, 1 modern print
 Negative size 4, inscribed '17 ¾ / Str'.

THOMAS SMITH CAFE
born 1793
Landscape painter, exhibited a portrait of D S Cafe in the Royal Scottish Academy, 1849

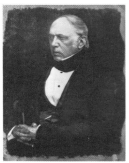

a 1 calotype
 Print size 4.

Rev JOHN CAIRNS 1818–1892
United Presbyterian minister
Also called Rev Adam Cairns died 1881

a 2 calotypes, 1 carbon
 Print size 4.

b 1 carbon
 Print size 4.

JOHN RUTHERFORD CALVERT died 1854 (aged 50)
Solicitor

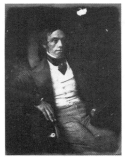

a 1 calotype
 Print size 4.

Rev Dr ANDREW CAMERON 1823–1877
Editor of the *Free Church Magazine*
See Presbytery Groups 23 to 25

ALEXANDER CAMERON CAMPBELL 1812–1869
Of Monzie; Member of Parliament, strong supporter and elder of the Free Church

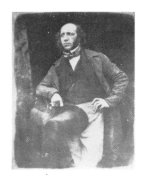

a 1 calotype
 Print size 2. Negative in Glasgow University Library.

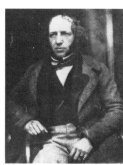

b 1 calotype
 Print size 5.

Captain DAVID CAMPBELL
Of Shehallion
See Group 62

JOHN FRANCIS CAMPBELL
1822–1884
Of Islay

a 1 calotype, 1 print in an
unidentified process
Print size 4.

Called 'THOMAS CAMPBELL'

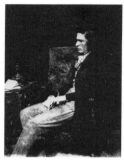

a 2 calotypes
Print size 5.

Rev Dr ROBERT SMITH
CANDLISH 1807–1873
Of St George's, Edinburgh; main
organiser of the Free Church,
Professor of Apologetics and
Principal of New College,
Edinburgh, 1862

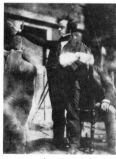

a negative, 1 modern print
Negative size 5, inscribed
'Candlish / 30–5', hands, book
and stain at side touched up in
brown wash. Calotype related
to a sketch of Candlish speaking
to the Assembly, in the
National Gallery of Scotland.

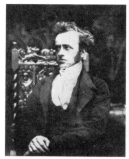

b negative, 2 calotypes
Negative size 5, inscribed
'Candlish / 71', touched up in
pencil on the face and hair and in
brown wash on the shirt and
hands; the touching up of the
hands, at least, would appear to
have been done after the prints
were made. Calotype used for
the Disruption Picture.

Rev Dr ABRAHAM
CAPADOSE 1795–1874
Of the Hague

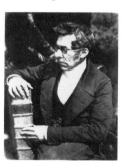

a 7 calotypes
Print size 4. The book is
inscribed 'BIBLIA SACRA IN
LING. ORIG. CUM VERS.
LAT. INTERLIN.' Calotype
used for the Disruption Picture.

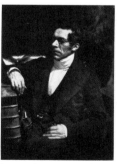

b 1 calotype, 1 carbon
Print size 4.

Rev JAMES CARMENT
1816–1880
Of Comrie; Free Church minister
See Presbytery Group 4

WILLIAM C CARMICHAEL
Of Madras College, St Andrews,
appointed to the Edinburgh Royal
High School, 1844; friend of Sir
Walter Scott

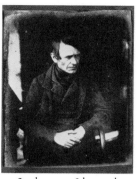

a 2 calotypes, 2 later calotypes
Print size 4.

Dr ROBERT CARRUTHERS
1799–1878
Literary critic, biographer and
editor of the *Inverness Courier*

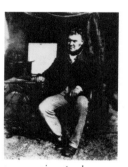

a negative, 1 calotype
Negative size 5, inscribed
'Carruthers'.

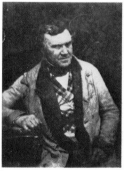

b negative, 1 print, possibly a later
calotype
Negative size 5, inscribed 'xxx
Carruthers', waxed.

BROWN CARSTAIRS

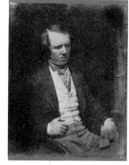

a negative, 1 modern print
Negative size 4, inscribed 'Mr
Brown Carstairs June 15–44 /
304 Last', chemical spots
touched out in pencil and wash.

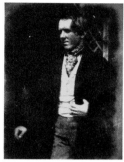

b negative, 1 calotype
Negative size 4, inscribed 'Light
Mr Brown Carstairs June 15 44 /
Gum / DS', minor spots
touched out in wash.

ALBERT CAY
Wine and spirit merchant and
stockbroker of George Street,
Edinburgh

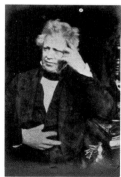

a 1 calotype or later calotype
Print size 4.

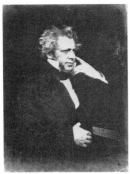

b 1 calotype and 1 calotype or later calotype
Print size 4. Inscription printed off from negative 'Albert Cay March 45'.

JOHN CAY 1790–1865
Sheriff of Linlithgow, member of the Edinburgh Calotype Club

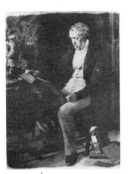

a 1 calotype
Print size 4.

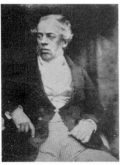

b 1 calotype
Print size 4.

JOHN CAY 1820–1892
Solicitor, son of Sheriff Cay

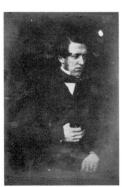

a 2 calotypes
Print size 4.

b negative, 1 modern print
Negative size 4, inscribed 'Cay March 12–45 / DU LL'.

ROBERT DUNDAS CAY
1807–1888
Solicitor, brother of Sheriff Cay

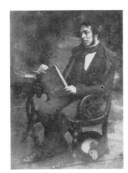

a 1 calotype
Print size 4.

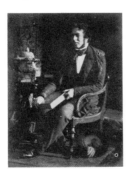

b 1 calotype
Print size 4.

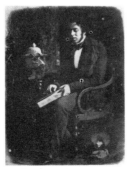

c 1 calotype
Print size 4.

CHARLES CHALMERS
died 1864
Headmaster of Merchiston Castle School, brother of Rev Dr Thomas Chalmers
See also Presbytery Groups 12 to 14, 19 and 20

a 1 calotype
Print size 5.

DAVID CHALMERS
See Group 67

JOHN CHALMERS
See Groups 67 and 68

Rev Dr THOMAS CHALMERS
1780–1847
Free Church leader, first Moderator of the Free Church Assembly, Principal of New College, Edinburgh
See also Groups 63 to 66 and Presbytery Groups 12 to 14

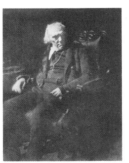

a 1 calotype, 4 later calotypes, 1 carbon
Print size 3, cut down.

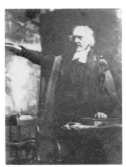

b 1 calotype
Print size 5. Calotype related to Hill's original design for the Disruption Picture of Chalmers preaching.

c 1 later calotype
Print size 5.

d 3 calotypes, 2 later calotypes, 1 albumen
Print size 5. Calotype probably used for the Disruption Picture.

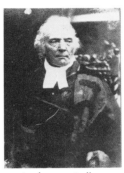

e 1 calotype, 1 albumen
Print size 5.

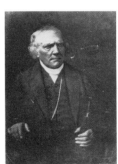

f 1 later calotype
Print size 5. Calotype engraved by R C Bell for the *Free Church Magazine*, 1848.

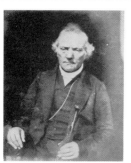

g 1 calotype, 1 later calotype
 Print size 5.

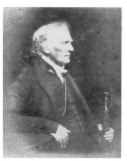

h 6 calotypes, 2 later calotypes
 Print size 5.

ROBERT CHAMBERS
1803–1871
Author and publisher

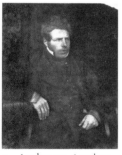

a 1 calotype, 1 carbon
 Print size 4.

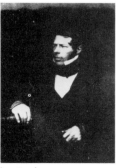

b 1 calotype
 Print size 4.

JOHN CHANTER
'A great patentee of London'
*The following calotypes were taken
at the British Association meeting in
York, 1844*

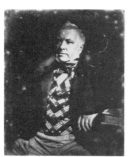

a negative, 1 modern print
 Negative size 4, inscribed 'xx
 Chanter Octo 2 / ‡ fine quality /
 24', headrest touched out in
 pencil.

b negative, 1 later calotype
 Negative size 4, inscribed 'Mr
 John Chanter Octo 2 / D6',
 headrest and marks touched out
 in wash and pencil.

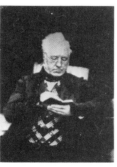

c negative, 2 calotypes
 Negative size 4, inscribed 'York
 Chanter Octo 1–44'.

JAMES AUCHINLECK CHEYNE
died 1853 (aged 58)
Of Oxendean and Kilmaron;
solicitor

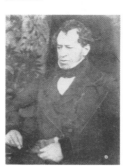

a 1 later calotype
 Print size 4, cut down.

Rev THOMAS GRIEVE CLARK
1819–1882
Of Aggra, Bombay and Odessa;
Free Church missionary
See also Group 69

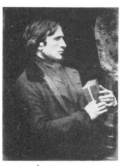

a 1 calotype
 Print size 4.

W G CLARK
See Presbytery Groups 21 and 22

Rev Dr PATRICK CLASON
1789–1867
Of Buccleuch Church, Edinburgh;
Joint Clerk with Rev Thomas
Pitcairn of the Free Church
Assembly in 1843, Moderator in
1846
*See also Group 70 and Presbytery
Groups 12 to 14 and 19 to 22*

a 1 calotype
 Print size 5. Calotype
 apparently used for the
 Disruption Picture with a beard
 added.

JOHN CLOW
Of Liverpool; merchant and art
collector

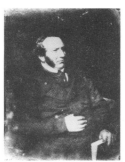

a negative, 1 modern print
 Negative size 4, inscribed
 'March 31 / DS ⁷/₈'.

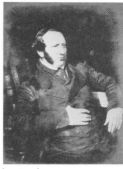

b 2 calotypes
 Print size 4.

– COCHRANE

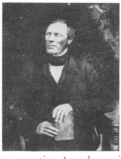

a negative, 1 modern print
 Negative size 4, inscribed
 'Cochrane Apr 20/46 / Gum [*or*
 Sun]', spots touched out in
 pencil.

b negative, 1 later calotype
 Negative size 4, inscribed
 'Cochrane Apr 20/46 / 18',
 small spots touched out in
 pencil.

HENRY, Lord COCKBURN
1779–1854
Judge, Solicitor-General for
Scotland
See also Groups 71 to 75

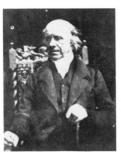

a 2 calotypes, 1 carbon printed in
 reverse
 Print size 5. Calotype used for
 the Disruption Picture.
 Negative in Glasgow University
 Library.

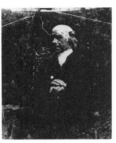

b negative, 1 modern print
 Negative size 5, inscribed '5 /
 Cockburn', waxed.

GEORGE COMBE 1788–1858
Solicitor, phrenologist and social
reformer

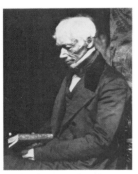

a 3 calotypes, 1 carbon
 Print size 4.

b 1 calotype
 Print size 4.

JOHN CONNELL
See also Group 76

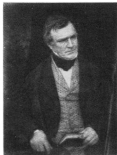

a 1 calotype, 2 carbons
 Print size 4.

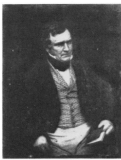

b negative, 1 modern print
 Negative size 4, inscribed 'Mr
 John Connel Nov 2 / 304', lines
 of jacket drawn in in pencil.

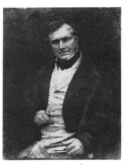

c negative, 1 calotype, 1 modern
 print
 Negative size 4, inscribed 'Mr J
 Connell / DF', lines of jacket
 drawn in in pencil.

– COOK

a negative, 1 modern print
 Negative size 4, inscribed
 'Cook', small spots touched out
 in pencil.

Rev Dr GEORGE COOK
1772–1845 (died on 13 May)
Professor of Moral Philosophy at
St Andrews University
*A calotype of Dr George Cook was
exhibited at the Royal Scottish
Academy in 1845*

a negative, 7 calotypes
 Negative size 4, inscribed 'Dr
 Cook', jacket, face, hair and
 draperies extensively touched
 up in pencil. From the calotypes
 it is not clear that all the
 touching up was done in the first
 instance, some may have been
 added later.

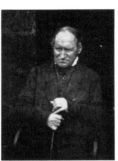

b 1 calotype, 1 carbon
 Print size 4.

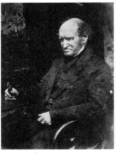

c 4 calotypes
 Print size 4.

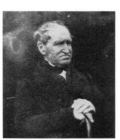

d 1 calotype
 Print size 6. Calotype probably
 by John or Robert Adamson.

Rev Dr JOHN COOK 1807–1874
Of Haddington; Church of
Scotland minister

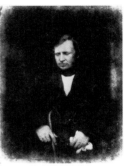

a negative, 3 calotypes, 1 calotype
 or later calotype
 Negative size 4, inscribed 'Dr
 Cook Haddington July 12–44 /
 DF', considerable pencil
 shading on coat, line of hair
 touched up, waxed.

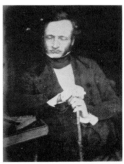

b negative, 1 modern print
 Negative size 4, inscribed 'Dr
 Cook of Haddington July
 12–44'.

c 1 calotype
 Print size 4.

Captain CORSTORPHINE
*Probably Alexander Corstorphine
of Pittowie in Fife, Justice of the
Peace, served in the Royal Navy
and the East India Company
See Group 265*

– COWAN
See Group 114

– COWAN
Sons of Lord John Cowan
See Groups 77 to 79

CHARLES COWAN 1801–1889
Of Valleyfield; papermaker,
Member of Parliament for
Edinburgh, 1847 to 1859

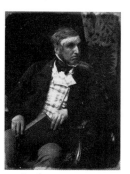

a　1 calotype
　　Print size 4.

JOHN Lord COWAN 1798–1878
Judge
See also Groups 77 to 79

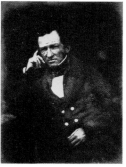

a　2 calotypes
　　Print size 5. Calotype used for
　　the Disruption Picture.

Captain COX
*Probably Captain Henry Cox born
1793, who commanded the
coastguard station at St Andrews*

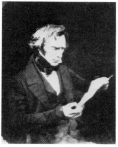

a　negative, 1 calotype
　　Negative size 4, inscribed
　　'Captain Cox / 304', lines of
　　jacket drawn in in pencil.

Rev Dr COX
Of America
*Presumably Samuel Hanson Cox
1793–1880, Presbyterian
clergyman, educator and a founder
of New York University*

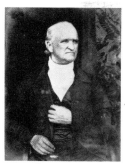

a　2 calotypes
　　Print size 4.

Rev ROBERT CRAIG
died 1865 (aged 68)
Of Rothesay; Free Church minister

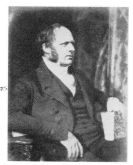

a　1 calotype
　　Print size 4.

Sir PHILIP CRAMPTON
1777–1858
Baronet, President of the Royal
College of Surgeons, Surgeon
General to the Forces and Surgeon
in Ordinary to George IV and
Queen Victoria

a　negative, 1 calotype
　　Negative size 4, inscribed
　　'ex½h / D2+', supports and
　　spots touched out in pencil,
　　waxed.

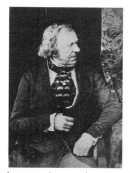

b　negative, 1 calotype, 1 later
　　calotype
　　Negative size 4, inscribed 'xx',
　　spots touched out in pencil,
　　waxed.

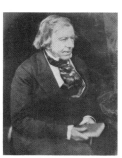

c　1 calotype
　　Print size 4.

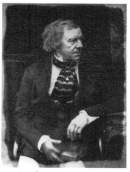

d　negative, 2 calotypes
　　Negative size 4, inscribed 'xxx',
　　spots touched out in pencil,
　　waxed.

**WILLIAM HOWIESON
CRAUFURD** 1781–1871
Of Craufurdland; leading Free
Churchman and elder

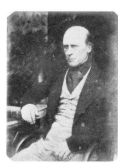

a　1 calotype
　　Print size 4.

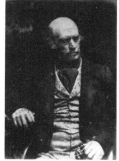

b　1 calotype
　　Print size 4. Calotype used for
　　the Disruption Picture.

Major CRAWFORD
Of the Leith Fort Artillery
See Military 8 to 10

JAMES CRAWFORD 1808–1863
Solicitor, Deputy Clerk to the Free
Church Assembly
See Presbytery Groups 21 and 22

**Professor THOMAS JACKSON
CRAWFORD** 1812–1875
Of Glamis; Professor of Divinity at
Edinburgh University, Moderator
of the Church of Scotland
Assembly, 1867

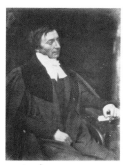

a　1 calotype
　　Print size 4.

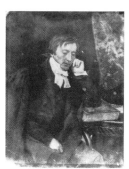

b　negative, 1 modern print
　　Negative size 4, inscribed 'Rev
　　T Crawford of Glammis /
　　Gum', spots touched out in
　　pencil.

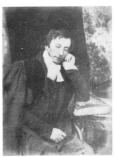

c negative, 1 later calotype
Negative size 4, inscribed
'Crawford May 27', spots
touched out in pencil, clerical
bands drawn in in wash.

DAVID MAITLAND MAKGILL CRICHTON 1801–1851
Of Rankeillour; enthusiastic
supporter of the Free Church,
editor of the *Fife Sentinel*

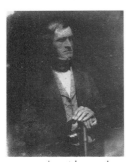

a negative, 1 later calotype
Negative size 5, inscribed 'xxx
Light', waxed.

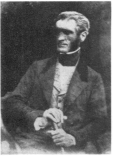

b 1 calotype
Print size 5. Calotype engraved
by R C Bell for *Memoir of
David Makgill Crichton* by
James William Taylor, 1858.

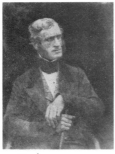

c 2 calotypes
Print size 5.

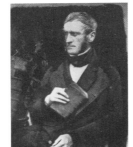

d 6 calotypes
Print size 4.

Rev Dr WILLIAM CUNNINGHAM 1805–1861
Principal of New College,
Edinburgh, 1847, Moderator of the
Free Church Assembly, 1859
See also Groups 80, 206 and 207

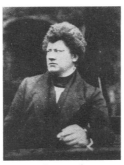

a negative, 1 calotype
Negative size 5, inscribed
'Cunningham', spots touched
out in wash. Calotype used for
the Disruption Picture.

ALEXANDER CURRIE
died 1868
Principal Clerk of Session, Sheriff
of Banffshire

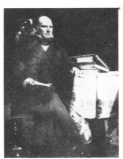

a 1 calotype
Print size 5.

FOX MAULE, 11th EARL OF DALHOUSIE 1801–1874
Privy Councillor, Free Church
elder

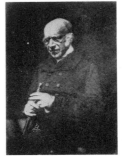

a 1 calotype
Print size 4.

W DALLAS
*Perhaps William Dallas 1805–1851,
solicitor*

a 1 calotype
Print size 4.

PATRICK DALMAHOY
1798–1872
Of Bowerhouses; solicitor

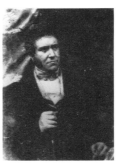

a negative, 1 modern print
Negative size 5, inscribed
'Dalmahoy', waxed.

Rev Dr ALEXANDER DYCE DAVIDSON 1807–1872
Of the West Church, Aberdeen;
Free Church minister
See Presbytery Group 1

Rev GEORGE DAVIDSON
1791–1873
Of Latheron; Free Church minister
See Group 81

Dr JOSHUA DAVIDSON

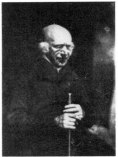

a 2 calotypes
Print size 5.

b 2 calotypes
Print size 5.

Rev JOHN DEMPSTER
1768–1847
Of Denny; Free Church minister

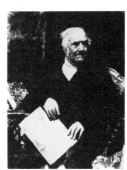

a 1 calotype
Print size 4.

b 1 calotype
Print size 4.

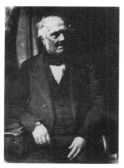

c 1 calotype
 Print size 4.

Rev Dr JAMES DENHAM
Of Londonderry; Irish
Presbyterian minister

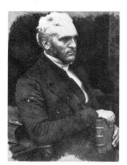

a 1 calotype
 Print size 4.

b 2 calotypes
 Print size 4.

– DENNISTOUN

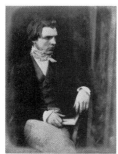

a negative, 1 calotype
 Negative size 4, inscribed 'Mr
 Dennistoun July 12–44 / Gum',
 cravat drawn in in wash, spots
 touched out in pencil.

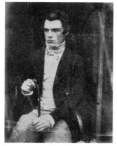

b negative, 1 calotype
 Negative size 4, inscribed 'Mr
 Dennistoun July 12–44', smears
 touched out in pencil.

Rev DAVID DEWAR 1798–1885
Of Fochabers; Free Church
minister

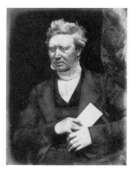

a 4 calotypes
 Print size 4. Calotype used for
 the Disruption Picture.

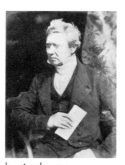

b 1 calotype
 Print size 4.

Rev MATTHEW DICKIE
1800–1863
Of Dunlop and Beith; Free Church
minister
See also Presbytery Group 18

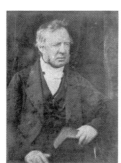

a 2 calotypes, 1 later calotype
 Print size 4.

– DICKSON (1)
See Group 82

– DICKSON (2)
See Group 132

Dr DICKSON

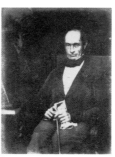

a negative, 1 modern print
 Negative size 4, inscribed 'Dr
 Dickson', lines of stock and
 forehead drawn in in pencil.

b 1 calotype
 Print size 4.

DAVID DICKSON 1793–1867
Of Hartree; advocate, Free Church
elder

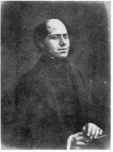

a 1 calotype
 Print size 5.

– DILL (1)
See Group 40

– DILL (2)
See Group 40

Rev JAMES DODDS 1812–1885
Of Dunbar; Free Church minister

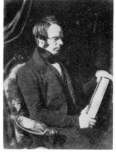

a 1 calotype
 Print size 4.

Rev THOMAS DOIG 1796–1866
Of Torryburn; Free Church
minister
See Presbytery Groups 10 and 11

– DONALDSON
Architect

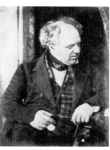

a 2 calotypes
 Print size 4.

Professor JOHN DONALDSON
died 1865
Professor of Music at Edinburgh
University

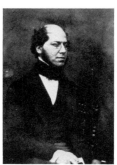

a 1 later calotype
 Print size 4.

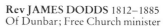

b 3 calotypes
 Print size 4.

– DORNOCH
See Groups 107 and 108

– DOUGLAS (1)
See Groups 23, 24, 218 and 219

– DOUGLAS (2)

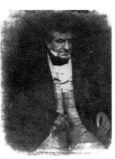

a negative, 1 modern print
Negative size 4, inscribed 'Mr Douglas Sept 12 / Gum [*or* Sun] / 136 [?]'.

Called 'DOUGLAS'

a 1 calotype or later calotype
Print size 5.

Dr DOUGLAS

a 1 calotype
Print size 5.

WILLIAM DOULL
Solicitor, with the firm of Bridges and Doull

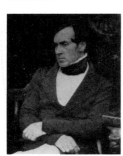

a 1 calotype
Print size 4.

DOMENICO DRAGONETTI
1763–1846
Double-bass player
See Group 84

Rev D T K DRUMMOND
1799–1888
Of St Thomas's English Episcopal Chapel, Rutland Place, Edinburgh; Acting Secretary of the Edinburgh Auxiliary of the Church of England Missionary Society

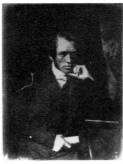

a 3 calotypes
Print size 4. Calotype used for the Disruption Picture with the portrait aged.

HENRY HOME DRUMMOND
1783–1867
Of Blair Drummond; Member of Parliament

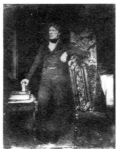

a negative, 1 modern print
Negative size 4, inscribed 'Home Drummond Esq Oct 16–44 / DF'.

b negative, 1 modern print
Negative size 4, inscribed 'Home Drummond Oct 16 / DF'.

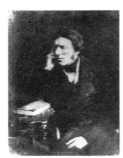

c negative, 1 modern print
Negative size 4, inscribed 'Home Drummond Esq MP Oct 21'.

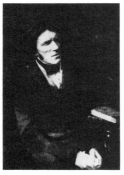

d negative, 1 carbon printed in reverse
Negative size 4, inscribed 'Home Drummond Esq MP Oct 21 44', marks on face touched out in pencil.

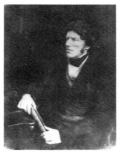

e negative, 1 modern print
Negative size 4, inscribed 'Home Drummond Esq MP Oct 21 / DS'.

f negative, 1 calotype
Negative size 4, inscribed 'Home Drummond Sept 12–44 / DS', marks on face touched out in wash.

JAMES DRUMMOND
1816–1877
RSA, history painter, curator of the National Gallery of Scotland, member of the Photographic Society of Scotland, owned 2 albums of Hill and Adamson calotypes (now in the Scottish National Portrait Gallery).

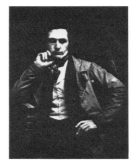

a 1 calotype, 1 later calotype, 1 carbon
Print size 4.

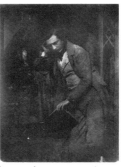

b 4 calotypes, 1 carbon
Print size 4.

c 1 albumen, 2 carbons
Print size 4.

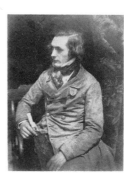

d 1 later calotype
Print size 4.

CHARLES DRYSDALE
See also Group 85

a negative, 1 modern print
Negative size 4, inscribed
'Drysdale / Light Sun M.26 /
DF'.

GEORGE DRYSDALE
See also Group 85

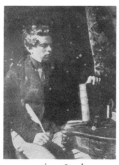

a negative, 2 calotypes
Negative size 4, inscribed
'Drysdale May 25 / 304', area
rubbed out in pencil, watermark
touched out and small spots on
face and hands touched out in
wash.

PATRICK DUFF 1791–1881
Town Clerk of Elgin, geologist

a 1 calotype
Print size 4. The rock is
probably the counterpart of the
fossil *stagonolepis*, also
photographed by Hill and
Adamson; see *Fossil*.

– DUKE

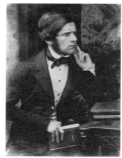

a 2 later calotypes
Print size 4.

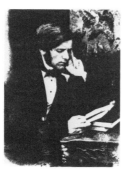

b 1 albumen
Print size 4.

Dr DUMBRECK
Probably William Dumbreck, MD

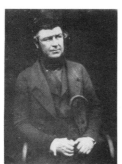

a 1 calotype
Print size 5.

WILLIE DUN
Golfer
See Group 62

– DUNCAN
Of Aberdeen

a 1 calotype
Print size 4.

b 1 calotype
Print size 4.

Dr DUNCAN

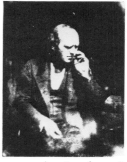

a 1 calotype
Print size 5.

Rev – DUNCAN
Of St Boswell's
See Group 86

**Rev Dr GEORGE JOHN CRAIG
DUNCAN** 1807–1869
Of Northshields and Greenwich;
English Presbyterian minister, son
of Rev Henry Duncan
*See also Group 87 and Presbytery
Group 2*

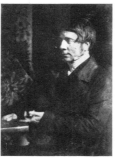

a 1 calotype
Print size 4.

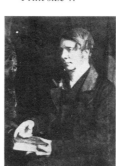

b 1 calotype
Print size 4.

Rev Dr HENRY DUNCAN
1774–1846 (died on 12 February)
Of Ruthwell, Moderator of the
General Assembly of the Church of
Scotland, 1836, Free Church
minister, founder of savings banks
*See also Group 87 and Presbytery
Group 2*

a 3 calotypes, 4 later calotypes (by
Alexander Inglis), 1 albumen
Print size 4.

JAMES DUNCAN
Of Perth; brother of Thomas
Duncan
See Groups 88 and 89

JOHN DUNCAN
Doctor of Music

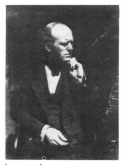

a negative, 1 modern print
Negative size 4, inscribed
'Duncan May 1/45 / ‡ DS / Gum
/ Str Brom'.

b 3 calotypes
Print size 4.

Rev Dr JOHN DUNCAN
1796–1870
Missionary in Pesth, Hungary,
Professor of Hebrew and Oriental
Languages at New College,
Edinburgh

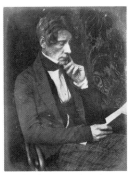

a 2 calotypes, 1 carbon
 Print size 4.

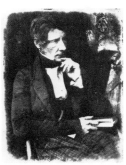

b 2 calotypes, 1 albumen
 Print size 4.

THOMAS DUNCAN 1807–1845
(died on 25 April)
Portrait, genre and history painter
See also Groups 88 to 90

a 2 calotypes, 1 later calotype
 Print size 4.

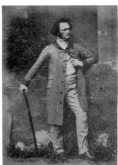

b 7 calotypes, 1 carbon
 Print size 4.

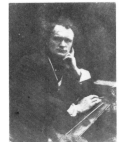

c 2 calotypes, 1 carbon
 Print size 5. Calotype used for
 the Disruption Picture and
 engraved for the *Art Union*,
 June 1847 by J Smyth as 'from a
 calotype from a painting by the
 artist'.

d negative, 1 modern print
 Negative size 4, inscribed 'Mr
 Duncan Ar. Standing / xxx'.

e negative, 1 modern print
 Negative size 5, inscribed 'Light
 / 230', hair, cravat, book, and
 perhaps hands, touched up in
 wash.

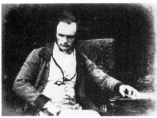

f 1 later calotype
 Print size 4.

**Rev WILLIAM WALLACE
DUNCAN** 1808–1864
Of Peebles; Free Church minister
See Group 87

J DUNDAS

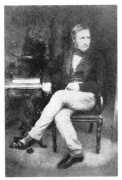

a 1 calotype
 Print size 4.

**ALEXANDER COLQUHON
STIRLING MURRAY
DUNLOP** 1798–1870
Church lawyer, leading Free
Churchman, Member of
Parliament
*See also Group 263 and Presbytery
Groups 12 to 14*

a 1 calotype
 Print size 5, touched up with
 wash.

HENRY DUNLOP 1799–1867
Of Craigton; Lord Provost of
Glasgow

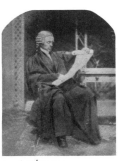

a negative, 1 modern print
 Negative size 5, inscribed
 'Dunlop / 1½ 150', waxed.

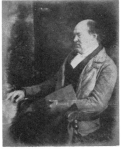

b 1 calotype
 Print size 4.

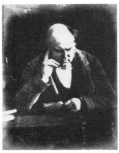

c 2 calotypes
 Print size 4. Calotype used for
 the Disruption Picture.

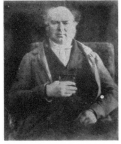

d 1 calotype
 Print size 5.

Rev JOHN DUNS 1820–1909
Of Torphichen; Professor of
Natural Science at New College,
Edinburgh

a 1 calotype
 Print size 4.

JAMES N DYMOCK
Of Dymock and Guthrie,
Edinburgh
See also Group 91

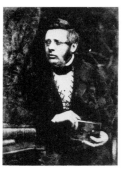

a 1 later calotype
 Print size 4.

Rev THOMAS DYMOCK
1806–1888
Of Perth; Free Church minister
*Confused with Rev John Harper,
q v*
See Presbytery Group 3

– EDMONDS
See Groups 191 and 200

Rev DANIEL EDWARD
Missionary to the Jews at Jassy,
Lemberg and Breslau
See Group 227

Called 'DAVID EDWARDS or PARKER'
See Group 92

JOHN ELDER 1783–1860
Of Walls, Shetland

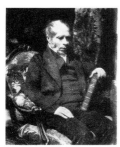

a 2 calotypes
 Print size 4.

Rev Dr ROBERT ELDER
1808–1892
Of St Paul's, Edinburgh; Free
Church minister
See Presbytery Groups 12 and 13

THOMAS ELDER

a negative, 1 modern print
 Negative size 4, inscribed 'Mr
 Tho. Elder Au. 29', hair
 touched up in wash, mark
 touched out in pencil.

WILLIAM WILLOUGHBY, 3rd EARL OF ENNISKILLEN
1807–1886
Vice-President of the Geology
Section of the British Association
*The following calotypes were taken
at the British Association meeting in
York*

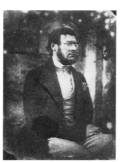

a negative, 1 modern print
 Negative size 4, inscribed 'Earl
 of Enniskillen Sept 28–44 / DF'.

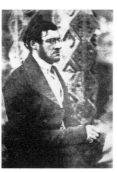

b negative, 1 calotype, 1 later
 calotype
 Negative size 4, inscribed 'York
 Earl of Enniskillen Sept 28-44.'

Captain CHARLES ETTY
died 1856 (aged 63)
Brother of William Etty, merchant
seaman and sugar planter in Java,
visited Edinburgh with his brother
and daughter on 16 and 17 October,
1844.

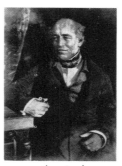

a negative, 3 calotypes
 Negative size 4, inscribed 'Capt
 Etty Octo 16–44 / xx Gum',
 waxed.

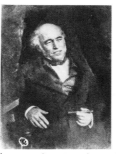

b negative, 1 modern print
 Negative size 4, inscribed 'Capt
 Etty Octo 16 44 / DF'.

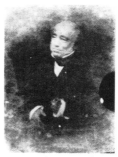

c negative, 1 modern print
 Negative size 4, inscribed 'Gu'.

WILLIAM ETTY 1787–1849
Artist, visited Edinburgh on 16 and
17 October, 1844
*A calotype of William Etty was
exhibited at the Royal Scottish
Academy in 1845*

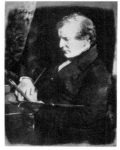

a 7 calotypes, 2 later calotypes
 Print size 4. Calotype used as a
 study for portraits of Etty now
 in the National Portrait Gallery,
 London and York Art Gallery.

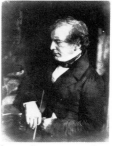

b 1 albumen, 2 carbons
 Print size 4.

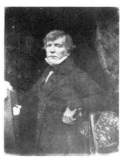

c 1 calotype
 Print size 3. Negative in
 Glasgow University Library
 inscribed 'Mr Etty Octo 16–44'.

EDWARD EVERITT 1794–1865
Unitarian clergyman, Secretary of State, President of Harvard College, Minister for the United States in Britain from 1841 to 1845
The following calotypes were taken during the British Association meeting in York in 1844

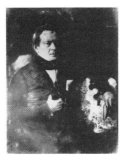

a negative, 1 modern print
Negative size 4, inscribed 'Sept 30 / DS', minor touching up in wash.

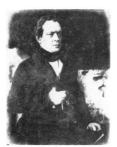

b 1 calotype
Print size 4.

Rev JAMES EWING 1810–1886
Of St Andrew's Church, Dundee; Free Church minister
See Presbytery Groups 8 and 9

Rev Dr JAMES FAIRBAIRN
1804–1879
Of Newhaven; Free Church minister
See Presbytery Groups 12 to 14 and Newhaven 56 and 57

Rev Dr PATRICK FAIRBAIRN
1805–1874
Of Saltoun; Principal of New College, Glasgow, 1856

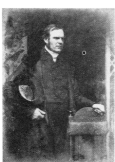

a 2 calotypes
Print size 4. Calotype used for the Disruption Picture.

Dr HUGH FALCONER
1808–1865
Palaeontologist and botanist, Superintendent of the Botanical Gardens in Edinburgh, 1852
The following calotypes were taken at the British Association meeting in York in 1844

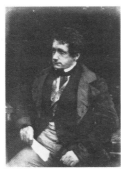

a negative, 1 calotype, 1 later calotype
Negative size 4, inscribed 'xx York Dr Falconer Octo 1–44', small marks touched out in wash.

b negative, 1 calotype
Negative size 4, inscribed 'Octo 2 / DF'. The negative is badly stained, probably with wax, and may not be the negative for this print.

Rev WILLIAM PATERSON FALCONER 1810–1886
Of Ladhope, Galashiels and Ferry Port on Craig; Free Church minister
See also Group 155

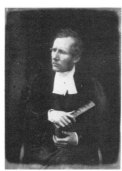

a 1 calotype
Print size 4.

– FARR
See Groups 95 and 96

– FERGUSON
See Groups 173 and 174

Dr FERGUSON

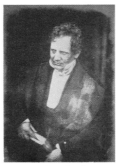

a negative, 1 calotype
Negative size 4, inscribed 'Dr Ferguson Sept 12 / D2 / St'.

Sir ADAM FERGUSON
1771–1851
Keeper of the Scottish regalia, friend of Sir Walter Scott
A calotype of Sir Adam Ferguson was exhibited at the Royal Scottish Academy in 1845

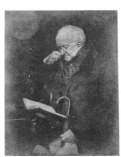

a 1 calotype, 2 later calotypes
Print size 4. Negative in Glasgow University Library.

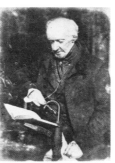

b 1 calotype, 1 carbon
Print size 4. Negative in Glasgow University Library dated September 12.

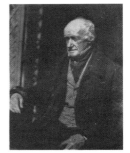

c 2 calotypes
Print size 5.

Rev JOHN FERGUSON 1805–1881
Of Bridge of Allan; Free Church minister
See also Presbytery Group 4

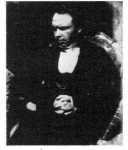

a 2 calotypes
Print size 4.

JAMES FILLANS 1808–1852
ARSA, sculptor
See Group 97

Rev THOMAS FINDLAY
1799–1875
Of West Kilbride; Free Church minister
See Presbytery Group 18

– FINLAY
Deerstalker in the employ of Campbell of Islay

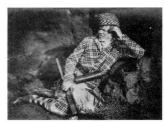

a 2 calotypes
Print size 4.

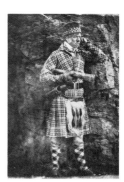

b 1 calotype
Print size 4.

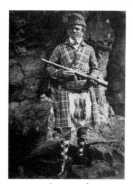

c negative, 1 calotype
Negative size 4, inscribed 'HY after . . . / ½ / Gum'; the inscription is partly obliterated because the negative has been stuck down in an album.

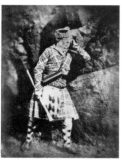

d 1 calotype or later calotype
Print size 2. Negative in Glasgow University Library dated April 17, 1845.

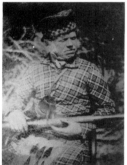

e 1 calotype
Print size 4.

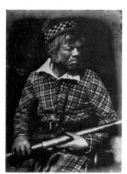

f 1 calotype
Print size 4.

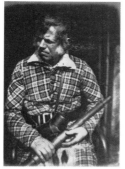

g 4 calotypes, 1 print in an unidentified process
Print size 4.

ARTHUR FINLAY
Son of Charles Finlay
See Groups 99 and 205

CHARLES FINLAY
See Groups 19 to 22

CHARLIE FINLAY
Son of Charles Finlay
See Group 205

JOHN HOPE FINLAY
1839–1907
Son of Charles Finlay, solicitor, Keeper of the General Register of Sasines [ie land register] of Scotland
See also Group 99

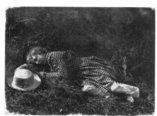

a 4 calotypes, 3 carbons
Print size 4.

– FINLAYSON (1)

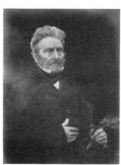

a negative, 1 later calotype
Negative size 4, inscribed 'ex 2h / DDF'.

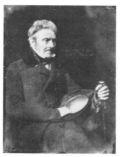

b negative, 1 modern print
Negative size 4, inscribed '[illegible] 15'.

– FINLAYSON (2)

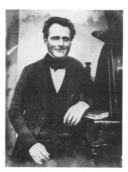

a negative, 1 calotype
Negative size 4, inscribed 'Mr Finlayson May 22 / ½ light [?] Gum / DF'. The larger book under Finlayson's elbow is *EVELYN'S MISCELLANEOUS WORKS.*

Rev Dr JOHN FLEMING
1785–1857
Of Clackmannan; Professor of Natural Philosophy at Aberdeen University, Professor of Natural Science at New College, Edinburgh

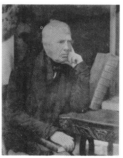

a 4 calotypes
Print size 4. Calotype used for the Disruption Picture.

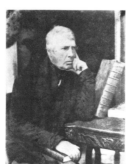

b 2 calotypes, 1 later calotype
Print size 4.

Called 'Rev – FOGGO'
See Presbytery Groups 12 to 14

Rev Dr JAMES FOOTE
1781–1856
Of East Church, Aberdeen; Free Church minister
See Presbytery Group 1

Dr FORBES
See Group 30

Professor EDWARD FORBES
1815–1854
Of King's College, London; naturalist and geologist
The following calotypes were taken at the British Association meeting in York in 1844

a negative, 1 calotype, 1 later calotype
Negative size 4, inscribed 'xxx Professor Ed Forbes Octo 2 / ¼ ac 304 / DF'.

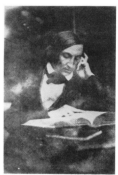

b negative, 1 calotype
Negative size 4, inscribed 'Prof Edward Forbes / 1¼ ac [304?]', waxed.

Rev Dr JOHN FORBES 1800–1874
Of St Paul's Glasgow; Free Church minister, mathematician
See also Groups 50 to 52

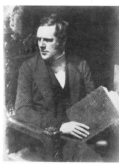

a 3 calotypes
Print size 4. Calotype used for the Disruption Picture.

– FORDYCE
Also called 'Dingwall Fordyce',
perhaps Alexander Dingwall
Fordyce died 1864, Captain in the
Royal Navy, Member of
Parliament for Aberdeen

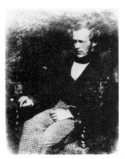

a negative, 1 modern print
 Negative size 4, inscribed
 'Fordyce', touched up on hair in
 brown wash.

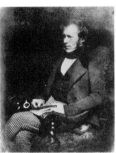

b negative, 1 later calotype
 Negative size 4, inscribed 'Mr
 Fordyce', touched up on hair in
 brown wash.

Sir JAMES FORREST 1780–1860
Baronet, Lord Provost of
Edinburgh

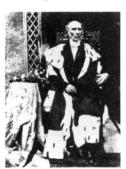

a negative, 2 calotypes
 Negative size 5, inscribed
 'Forrest / 1¼ 63 / 3u', slightly
 touched up in wash, waxed.

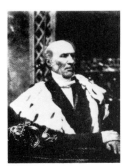

b 1 calotype
 Print size 5.

WILLIAM FORREST 1805–1889
ARSA, engraver

a negative, 1 modern print
 Negative size 4, inscribed 'Mr
 Aug 14 / 304 [or 204]', waxed.

b 1 calotype
 Print size 4.

– FORRESTER

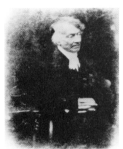

a negative, 1 modern print
 Negative size 4, inscribed
 'Forrester / ¾'.

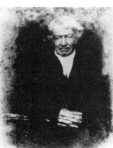

b negative, 1 modern print
 Negative size 4, inscribed 'Mr
 Forrester / D1', partly waxed.

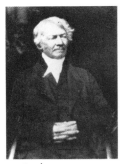

c 1 calotype
 Print size 5.

Dr FOULIS
See Groups 23 and 24

ROBERT FRAIN working from
1840s to 1870
Portrait painter

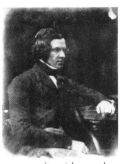

a negative, 1 later calotype
 Negative size 4.

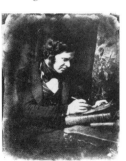

b negative, 1 modern print
 Negative size 4, inscribed 'Frain
 Apr 7 / ½ Gum / 304'.

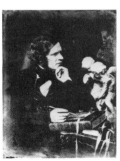

c negative, 1 modern print
 Negative size 4, inscribed 'Frain
 Apr 7 / ⅞ [?] / DS'.

– FRASER
See Groups 107 and 108

ALEXANDER FRASER
There may be a confusion with
William Fraser q v
See Presbytery Groups 12 to 14

**Professor ALEXANDER
CAMPBELL FRASER** 1819–1914
Professor of Logic and Metaphysics
at Edinburgh University
See also Groups 103 to 105

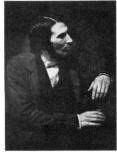

a 3 calotypes, 5 carbons
 Print size 4. Calotype used for
 the Disruption Picture.

PETER SCOTT FRASER
Bookseller and auctioneer
See also Groups 32, 106, 139, 142
and 213

a 1 calotype
 Print size 5.

**Rev THOMAS MACKENZIE
FRASER** 1822–1885
Of Yester, Singapore, Geelong and
Auckland; Free Church minister,
brother-in-law of Hugh Miller

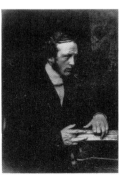

a negative, 1 calotype, 1 albumen
 Negative size 5, inscribed
 'Thomas Mck Fraser June 13/45
 / 15', waxed.

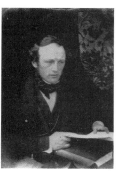

b negative, 1 albumen
Negative size 5, inscribed 'Mr
Mackenzie Fraser June 26/45 /
H11 [?]'.

WILLIAM FRASER 1805–1874
Solicitor, official witness to the
Deed of Demission
*See Presbytery Groups 12 to 14 and
19 to 22*

J R FYFE
Reporter for *The Witness* and, from
1846, parliamentary reporter for
The Times
See Presbytery Groups 23 to 25

– GABBIN

a negative, 1 calotype
Negative size 4, inscribed 'Mr
Gabbin June 3 / 306',
watermark and spots touched
out in wash.

b 1 calotype
Print size 4.

M (or W) GABBIN
Might be McGabbin

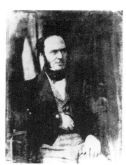

a negative, 1 modern print
Negative size 4, inscribed 'Mr
M [*or* W] Gabbin May 31 /
Gum', spots touched out in
wash.

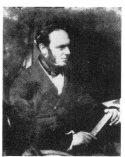

b negative, 1 modern print
Negative size 4, inscribed 'Mr
M [*or* W] Gabbin', spots
touched out in wash.

JAMES GALL
Publisher
See Newhaven 56

Captain GASTON

a negative, 1 albumen
Negative size 5, inscribed 'xxx
Captain Gaston July 6 / ½ fast
[*or* last]', waxed

– GERSDORP
See Group 228

Professor JAMES GIBSON
1799–1871
Professor of Church History and
Systematic Theology at New
College, Glasgow
See also Group 156

a 2 calotypes
Print size 4.

JOHN GIBSON 1790–1866
Sculptor

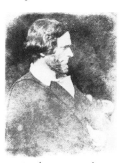

a 1 calotype, 1 calotype or later
calotype, 1 photogravure
Print size 4.

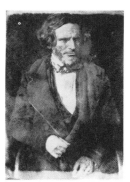

b 2 calotypes
Print size 4.

JOHN GIBSON 1813–1858
Inspector of Schools, headmaster of
Merchiston Castle School
See also Group 195

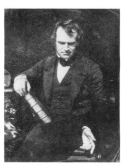

a 1 calotype, 6 carbons
Print size 4.

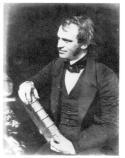

b 3 calotypes
Print size 4. Calotype used for
the Disruption Picture.

Rev WILLIAM GIBSON
1808–1867
Of Belfast; Irish Presbyterian
minister, established *The Banner of
Ulster* in 1842
See Group 255

Rev GEORGE GILFILLAN
1813–1878
Of Dundee; United Presbyterian
minister, author and literary critic
See also Group 109

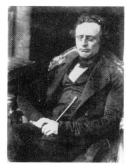

a negative, 2 calotypes
Negative size 4, inscribed
'Gilfillan May 23 44 / xxx / 23'.

Professor THOMAS GILLESPIE
1777–1844 (died on 11 September)
Professor of Humanity at St
Andrews University

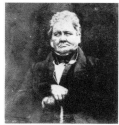

a 4 calotypes
Print size 6. Calotype probably
by John or Robert Adamson.

WILLIAM GILLESPIE
Of Leith

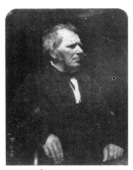

a 1 calotype
Print size 5.

Presumably JAMES GILLON
Wine and Spirit merchant of Leith
*Identified as 'Gillon, merchant of
Leith' in the album in New College,
Edinburgh*

a negative, 1 modern print
Negative size 4, inscribed
'Golan / Going [?] light',
headrest touched out and
trousers touched up in wash.

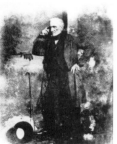

b negative, 1 modern print
Negative size 4, inscribed
'Golan'.

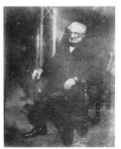

c 1 calotype
Print size 5.

Rev WILLIAM GILSTON
1792–1881
Of Carnock; Free Church minister
See Presbytery Groups 10 and 11

Sir JOHN GLADSTONE
1764–1851
Of Fasque; Baronet, East and West
India merchant, Member of
Parliament, philanthropist, father
of W E Gladstone

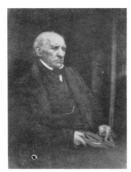

a 5 calotypes, 2 carbons
Print size 4.

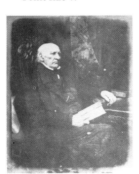

b 1 calotype
Print size 2. Negative in
Glasgow University Library
dated July 31, 1844.

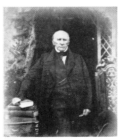

c 1 calotype
Print size 2, cut down. Negative
in Glasgow University Library
dated July 31, 1844.

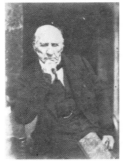

d negative, 1 calotype, 1 later
calotype
Negative size 4, inscribed
'Gladstone', small spots
touched out in wash, headrest
touched out in pencil.

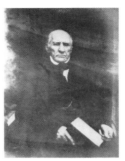

e 2 calotypes
Print size 4.

Rev – GOODSIR
See Rev James Smith

– GORDON
See Group 110

GORDON FAMILY
See Groups 111 to 113

GEORGE GORDON
Writing master at Madras College,
St Andrews

a negative, 1 modern print
Negative size 4, inscribed 'Mr
Gordon Aug 24–44 / 304', small
spots touched out in wash.

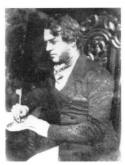

b negative, 1 calotype, 1 later
calotype
Negative size 4, inscribed 'Mr
Gordon Aug 24 44 / DF Last
Gum [*or* Sun]', headrest and
shadow of glasses touched out
in pencil.

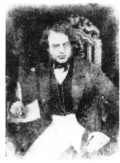

c negative, 1 modern print
Negative size 4, inscribed
'Gordon Aug 26 [*or* 24 *or* 20] /
100 $^{100}/_{1453}$'.

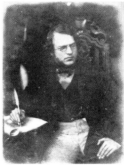

d negative, 1 calotype
Negative size 4, inscribed 'DF'.

JAMES GORDON
See Group 114

JOHN THOMSON GORDON
1813–1865
Sheriff of Midlothian
Also called ' – Campbell'
See Groups 115 and 116

Rev Dr ROBERT GORDON
1786–1853
Of the High Church, Edinburgh;
Moderator of the Church of
Scotland Assembly, 1841, Free
Church minister
*See also Presbytery Groups 12 and
13*

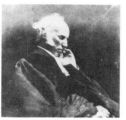

a 1 calotype, 1 later enlargement
 Print size 6.

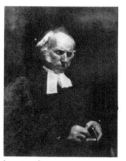

b 1 calotype
 Print size 5. Calotype used for
 the Disruption Picture.

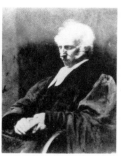

c 1 calotype
 Print size 5.

Rev WILLIAM GOVAN
1804–1875
Missionary in South Africa

a 3 calotypes
 Print size 4. Calotype used for
 the Disruption Picture.

– GRAHAM

a negative, 1 modern print
 Negative size 4, inscribed
 'Graham'.

PATRICK GRAHAM
See Presbytery Groups 12 to 14

– GRANGER
Perhaps an upholsterer

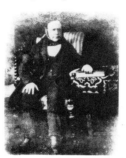

a negative, 1 modern print
 Negative size 4, inscribed 'Mr
 Granger uphol [?]'.

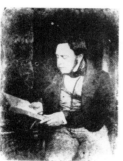

b negative, 1 modern print
 Negative size 4, inscribed 'Mr
 Granger Sept 19 / Str / Last /
 DF', small spots touched out in
 wash, headrest touched out in
 pencil.

Sir FRANCIS GRANT
1803–1878
Portrait painter, President of the
Royal Academy

a negative, 1 calotype, 1 carbon
 Negative size 4, inscribed 'xxx
 GRANT / DF', waxed,
 supports touched out in pencil.

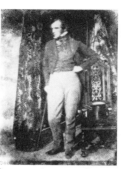

b negative, 1 modern print
 Negative size 4, inscribed
 'Francis Grant Esq Sept 12/45 /
 304', marks touched out in
 pencil.

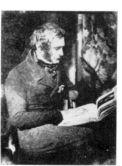

c negative, 1 modern print
 Negative size 4, inscribed 'x
 Francis Grant Esq Sept 12/45 /
 DS / ‡', small spots and headrest
 touched out in pencil, outline of
 hair drawn in.

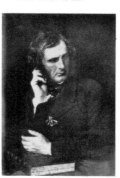

d 1 calotype, 1 later calotype, 2
 albumens, 1 photogravure
 Print size 4.

Rev ANDREW GRAY 1805–1861
Of the West Church, Perth; Free
Church minister
*A calotype of Rev Andrew Gray was
exhibited at the Royal Scottish
Academy in 1845*

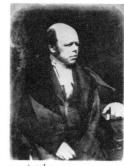

a 4 calotypes
 Print size 4. Calotype used for
 the Disruption Picture.

Captain CHARLES GRAY
1782–1851
Of the Royal Marines, song writer

a 2 calotypes
 Print size 4.

– GREIG

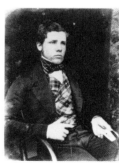

a negative, 1 modern print
 Negative size 4, inscribed 'xxx
 Greig', marks touched out in
 pencil.

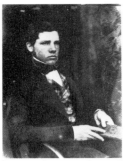

b negative, 1 modern print
 Negative size 4, inscribed 'xxx
 Greig', marks touched out in
 pencil.

ALEXANDER GREIG
1776–1857
Of Hallgreig; solicitor

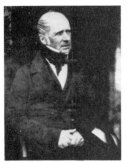

a 1 calotype
 Print size 5.

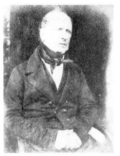

b 1 calotype
 Print size 5.

JAMES GREIG 1782–1859
Of Eccles; solicitor

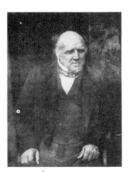

a 1 calotype
 Print size 5.

The Hon Sir FREDERICK WILLIAM GREY 1805–1878
Rear-Admiral

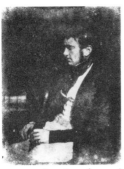

a negative, 1 modern print
 Negative size 4, inscribed 'York
 Capt The Hon F W Grey Octo
 1–44 / DF'.
 Calotype taken at the British
 Association meeting.

Rev Dr HENRY GREY
1778–1859
Of St Mary's, Edinburgh; Free
Church minister
*See also Presbytery Groups 12 and
13*

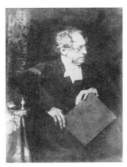

a 1 calotype
 Print size 4. Calotype used for
 the Disruption Picture.

b 1 calotype
 Print size 4.

Master GRIERSON
*Has been confused with John Hope
Finlay q v*

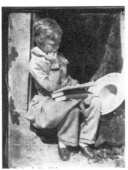

a 1 later calotype, 2 carbons
 Print size 4.

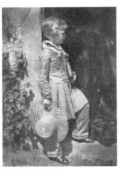

b 2 calotypes, 1 carbon
 Print size 4.

Rev Dr JAMES GRIERSON
1791–1875
Of Errol; Free Church minister,
Moderator of the Free Church
Assembly, 1855

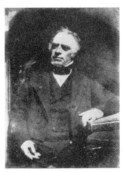

a 1 later calotype
 Print size 4. Calotype
 apparently used for the
 Disruption Picture with more
 extensive whiskers added.

– GROSVENOR

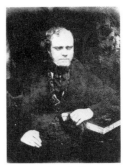

a negative, 1 albumen
 Negative size 4, 'Grosvenor /
 Hy [or HX] / 304', chemical
 marks touched out in pencil.

Sir WILLIAM ROBERT GROVE
1811–1896
Scientist, judge, Privy Councillor,
Vice President of the Royal Society,
1844

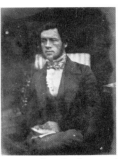

a negative, 1 calotype, 1 later
 calotype
 Negative size 4, inscribed 'York
 W R Grove Octo – 44 / DF',
 hair and coat touched up in
 pencil. Calotype taken at the
 British Association meeting.

– GULE
Or Girle

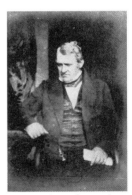

a negative, 1 later calotype
 Negative size 4, inscribed 'Mr
 Gule Octo 23 4 [4?] / DF'.

b negative, 1 calotype or later calotype
Negative size 4, inscribed 'Oct 23 / 306', mark and headrest touched out in pencil.

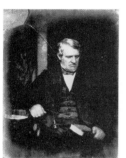

c negative, 1 later calotype (damaged)
Negative size 4, inscribed 'Mr Girle Octo 23 / DS', small marks on face and hands touched out in wash.

J W GULE

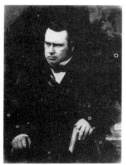

a negative, 1 calotype
Negative size 4, inscribed '[illegible] J W Gule / [DF?]', waxed, marks touched out in pencil.

GEORGE GUNN
Factor to the Duke of Sutherland

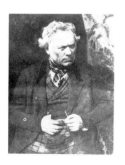

a 1 later calotype
Print size 4.

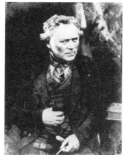

b 3 calotypes
Print size 4.

Dr WILLIAM MAXWELL GUNN
Of the High School, Edinburgh

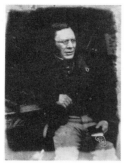

a 1 calotype
Print size 4.

Rev Dr THOMAS GUTHRIE
1803–1873
Of Greyfriars' Church, Edinburgh; leading Free Churchman, preacher, founder of 'ragged schools'
See also Groups 31, 80, 206 and 207 and Presbytery Group 14

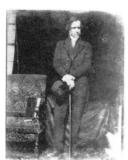

a 1 calotype
Print size 4.

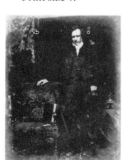

b 1 calotype
Print size 4.

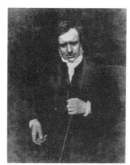

c 1 calotype, 4 later calotypes, 3 carbons
Print size 4.

ROBERT HALDANE 1772–1854
Principal of St Andrews University

a 1 later calotype, 1 carbon
Print size 4.

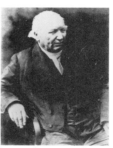

b 1 calotype, 1 albumen
Print size 4.

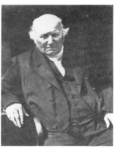

c 2 calotypes, 2 carbons
Print size 4.

C HALL
Or C Hale

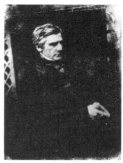

a negative, 1 modern print
Negative size 4, inscribed 'C Hall [*or* Hale] Esq July 31–44 / DF'.

– HAMILTON
See Group 121

JAMES HAMILTON 1799–1851
Of Ninewar
See also Group 42

a 1 calotype
Print size 4. Might not be the same sitter as in the following calotype.

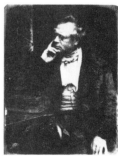

b 1 calotype
Print size 4. Calotype used for the Disruption Picture.

JOHN HAMILTON 1795–1847
(died on 2 September)
Advocate, leading Free Churchman
and elder
See also Groups 80, 206 and 207

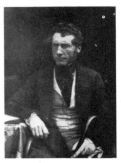

a 2 calotypes
 Print size 5.

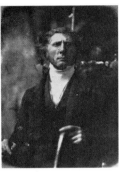

b 1 calotype
 Print size 5.

PETER HAMILTON died 1861
Architect

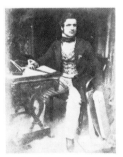

a 2 calotypes
 Print size 4.

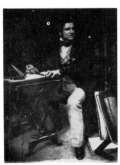

b 1 calotype
 Print size 4.

**Rev WILLIAM KING
HAMILTON** 1816–1887
Of Stonehouse; Free Church
minister

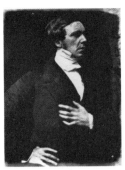

a 1 calotype
 Print size 4. Calotype used for
 the Disruption Picture.

**THOMAS CHALMERS
HANNA**
Grandson of Rev Dr Thomas
Chalmers
See Groups 63 to 66

Rev Dr WILLIAM HANNA
Of Skirling and of St John's,
Edinburgh; married Rev Dr
Thomas Chalmers' daughter,
Agnes or Ann, in 1836
See Group 114

Captain HARCOURT
*Presumably Octavius Cyril
Harcourt, Vice-Admiral 1861, son
of the Archbishop of York
The following calotypes were taken
during the British Association
meeting in York between 28
September and 4 October, 1844*

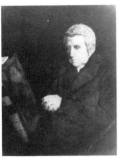

a negative, 1 modern print
 Negative size 4, inscribed
 'Captain Harcourt / 24 / G',
 stained.

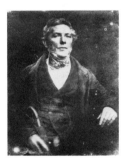

b negative, 1 later calotype
 Negative size 4, headrest
 touched out in pencil.

**EDWARD VERNON
HARCOURT** 1757–1847
Archbishop of York

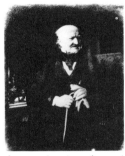

a negative, 2 calotypes, 1 carbon
 Negative size 4, inscribed
 'Archbishop of York / Octo 4',
 face and hands touched up in
 wash. Calotype taken at the
 British Association meeting in
 York in 1844.

JOHN HARDEN 1772–1847
Watercolourist

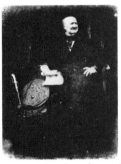

a negative, 1 modern print
 Negative size 4, inscribed
 'Harding Light'. John Harden
 wrote to his daughter on
 November 14, 1843 about being
 photographed. 'I sat 3 various
 attitudes + 3 portraits taken
 price £1.1. as not yet to be
 shown.' and 'Sir William Allan
 arranged my standing attitude',
 quoted in *John Harden of
 Brathay Hall 1772–1847*, by
 Daphne Foskett, 1974, p 52.
 From the coincidence in pose
 and properties between this
 calotype and *Sir William Allan
 c*, this is likely to be the
 photograph in question.

b negative, 1 modern print
 Negative size 4, support
 touched out in wash.

c negative, 1 modern print
 Negative size 4, support
 touched out in wash.

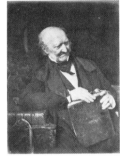

d negative, 1 modern print
 Negative size 4, inscribed 'xx
 Harding'.

e 1 calotype
 Print size 4.

f 1 calotype
 Print size 5.

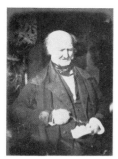

g negative, 1 calotype
Negative size 4, inscribed 'Mr
Harden March 20/45 / 304'.

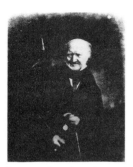

h negative, 1 modern print
Negative size 4, inscribed
'Harding – watercolourist',
marks on face touched out and
lines of jacket drawn in in wash.

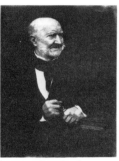

i negative, 2 calotypes
Negative size 4, inscribed 'Mr
Harding light / Harden Esq /
xxx', headrest touched out in
wash.

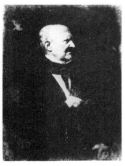

j negative, 1 modern print
Negative size 4, inscribed '?
Harding / D2'.

Rev JOHN HARPER 1802–1875
Of Bannockburn and Bothwell;
Free Church minister
*Has also been called Rev Thomas
Dymock and 'brother of James
Begg', ie William Begg of Falkirk.
One of the prints from an album has
'Rev John Harper' under the mount
and 'Rev Mr Dymock' on the page*

a 3 calotypes
Print size 4.

– HARVEY
Of Glasgow

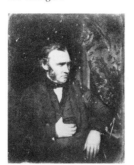

a 2 calotypes, 1 later calotype
Print size 4.

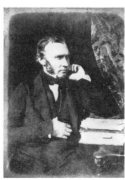

b 1 calotype
Print size 4.

Sir GEORGE HARVEY
1805–1876
Genre and landscape painter,
President of the Royal Scottish
Academy
*See also Group 140 and Edinburgh
66*

a negative, 1 calotype, 1 later
calotype
Negative size 4, hair and foot
touched up, spots on face
touched out in wash.

b negative, 1 modern print
Negative size 4, inscribed
'Harvey sitting / D2', headrest
and small spots touched out in
wash, waxed.

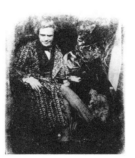

c negative, 1 modern print
Negative size 4, inscribed
'Harvey RSA', spots touched
out in wash.

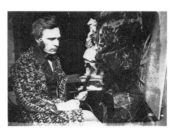

d negative, 1 calotype
Negative size 4, inscribed 'G
Harvey', spots touched out and
top edge touched in in wash,
waxed.

– HAY
Son of J Stuart Hay of Rockville
See Group 123

DAVID RAMSAY HAY 1798–
1866
Interior decorator and author,
friend of David Roberts

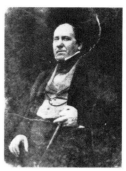

a negative, 1 modern print
Negative size 5, inscribed 'D R
Hay Esq / D6', waxed.

b negative, 1 calotype, 1 later
calotype
Negative size 5, inscribed 'D R
Hay / Hamilton Pyper,
Advocate; the second identity is
written in a later hand.

J STUART HAY
Of Rockville
See Group 123

JOSEPH HAYDN died 1856
Compiler of the *Dictionary of Dates*
and *Book of Dignities*

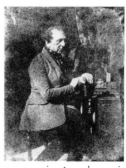

a negative 1 modern print
Negative size 4, inscribed
'Haydon Ap 20 / DDF'.

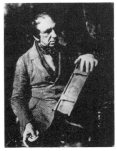

b negative, 1 modern print
Negative size 4, inscribed
'Hayden Ap 20 46', marks on
face touched out in pencil.

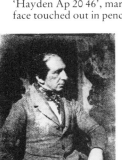

c negative, 1 modern print
Negative size 4, inscribed
'Haydn'.

Rev Dr JAMES HENDERSON
1797–1874
Of Glasgow; Free Church minister
See also Groups 51 and 52

a 2 calotypes
Print size 4. Calotype used for
the Disruption Picture.

JOHN HENNING 1771–1851
Sculptor
*See also Groups 71 to 75, 124 to 130,
Edinburgh 49, 51 and 66 and
Landscape 1, 5 and 6*

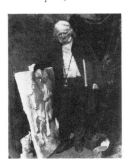

a 2 carbons
Print size 4. With a cast from the
Parthenon frieze.

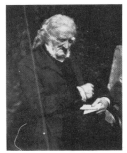

b 1 calotype, 2 carbons
Print size 4.

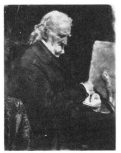

c 2 calotypes, 2 carbons
Print size 4.

d 2 calotypes
Print size 4.

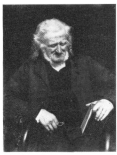

e 1 carbon
Print size 4.

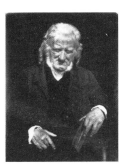

f 2 carbons
Print size 4.

g 9 calotypes, 3 carbons
Print size 4. The sitter is dressed
as Edie Ochiltree, the blue-gown
beggar from Sir Walter Scott's
The Antiquary. Negative in the
National Library of Scotland.

ROBERT MAITLAND HERIOT
Of Ramornie
See Groups 23 and 24

PHILIP HERMAN
Assistant missionary at the Free
Church in Jassy

a 1 carbon
Print size 4.

b negative, 1 modern print
Negative size 4, inscribed '¾ ex
1 [d?] Str / DF ex2ᵈ', marks and
support touched out in pencil.

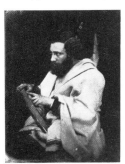

c negative, 1 modern print
Negative size 4, inscribed
'Herman / HV / 15 ¾ / Str',
mark touched out in pencil.

Probably Sir JOHN FREDERICK HERSCHEL
1792–1871
Baronet, astronomer, early
experimenter in photography

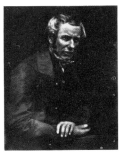

a 2 carbons
Print size 4. Calotype likely to
have been taken at the British
Association meeting in York
between 28 September and 4
October, 1844

Rev Dr WILLIAM MAXWELL HETHERINGTON 1803–1865
Professor of Apologetics and
Systematic Theology at New
College, Glasgow

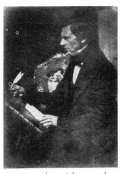

a negative, 2 later calotypes, 1
albumen
Negative size 4, inscribed 'Dr
Hetherington / 23 / 304'.

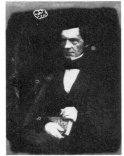

b 1 calotype
Print size 4.

Rev Dr HUGH HEUGH
1782–1846 (died on 10 June)
Of Stirling and Regent Place,
Glasgow; United Presbyterian
minister
See also Group 131

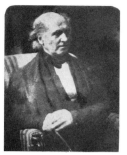

a 1 calotype
 Print size 4. Calotype used for
 the Disruption Picture.

– HEWITSON
See Group 132

Called 'HEWITSON'
*May be confused with the Hewitson
in Group 132*

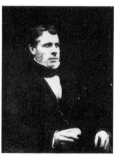

a 1 calotype
 Print size 4.

ALEXANDER HILL 1800–1866
Publisher and printseller, brother
of D O Hill

a 1 calotype
 Print size 5.

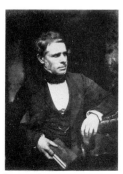

b 2 calotypes
 Print size 4.

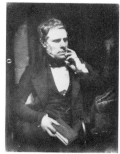

c 1 carbon
 Print size 4.

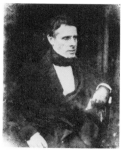

d negative, 1 modern print
 Negative size 4, inscribed 'Mr A
 Hill June 6 / DF', small spots on
 face touched out in wash.

DAVID OCTAVIUS HILL
1802–1870
Partner of Robert Adamson,
landscape painter, Secretary of the
Royal Scottish Academy
*See also Groups 27, 28, 32, 71 to 75,
90, 124, 125, 133 to 143, 203 and
204, Edinburgh 43 to 48, 50, 51, 54,
65 and 76 and Landscape 6*

a negative, 1 calotype
 Negative size 4.

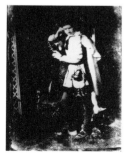

b negative, 1 modern print
 Negative size 4, inscribed 'D O
 Hill in Tournament Dress'. Hill
 may be dressed as a character
 from Sir Walter Scott.

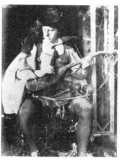

c 1 calotype
 Print size 5. See above.

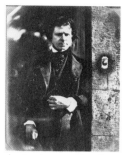

d 6 calotypes, 1 carbon
 Print size 4.

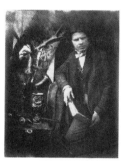

e negative, 1 carbon
 Negative size 4, inscribed
 'D. O. Hill / FINE'.

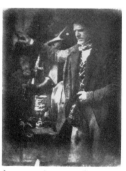

f negative, 1 carbon
 Negative size 4, inscribed
 'D. O. Hill / ¾ DS'.

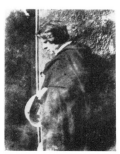

g negative, 1 modern print
 Negative size 4, inscribed
 'D O Hill / 29'.

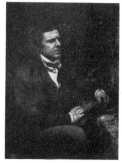

h negative, 1 carbon
 Negative size 4, inscribed
 'D. O. Hill'.

i negative, 1 modern print
 Negative size 4, inscribed
 'D. O. Hill / ¾ last'.

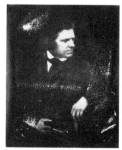

j negative, 1 carbon
 Negative size 4, inscribed
 'Mr D O Hill March 24/4[8?]',
 stained.

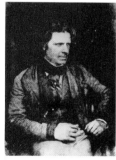

k negative, 1 modern print
 Negative size 5, inscribed
 'D O Hill'.

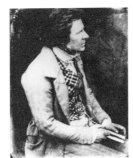

x 1 calotype
Print size 6.

l negative, 1 carbon
Negative size 4, inscribed
'D. O. Hill'.

p negative, 1 modern print
Negative size 4, inscribed 'xx
D. O. Hill', watermarked 'T
NASH'.

t negative, 1 calotype
Negative size 4, inscribed 'D O
Hill / DDF', spots on face and
hand touched out, lines of
turban touched in in pencil.

– **HIND** (1)

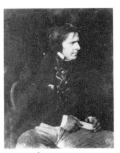

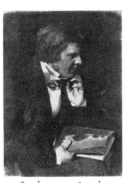
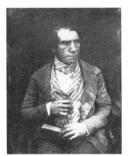

m 2 calotypes
Print size 5.

q negative, 1 modern print
Negative size 4, inscribed
'D. O. Hill / 15 ex1h', stained.

a negative, 1 calotype
Negative size 4, inscribed 'Hind
/ 24', chemical marks touched
out in pencil.

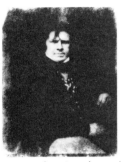
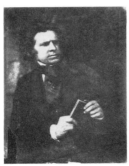
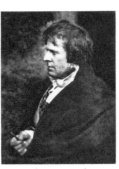

u 2 calotypes, 1 carbon
Print size 4.

– **HIND** (2)
See also Groups 144 and 145

n negative, 1 modern print
Negative size 4, inscribed
'? D O Hill'.

r 1 calotype, 2 carbons
Print size 4.

v 1 calotype, 2 photogravures
Print size 4. Negative in the
collection of Mr John Craig
Annan.

a negative, 1 modern print
Negative size 4, inscribed 'Mr
Hind Aug 15/45 / 15', chemical
marks touched out, hairline
touched in in pencil.

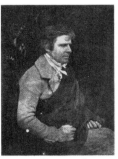
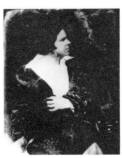
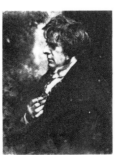
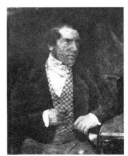

o negative, 1 carbon
Negative size 4, inscribed 'D O
Hill'.

s negative, 1 modern print
Negative size 4, inscribed 'D O
Hill Ap 20 / 30'.

w 1 calotype or later calotype, 2
carbons
Print size 4.

b negative, 1 modern print
Negative size 4, inscribed 'V300
G / ex1h Gum Y', chemical
mark touched out in pencil.

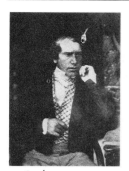

c 1 calotype
 Print size 4.

Rev STEPHEN HISLOP
1817–1863
Missionary to Nagpur in India,
naturalist

a 2 calotypes
 Print size 4.

JAMES MAITLAND HOG
1799–1858
Of Newliston; elder and
considerable benefactor of the Free
Church

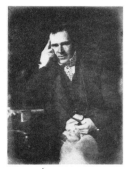

a 3 calotypes
 Print size 4. Calotype probably
 used for the Disruption Picture.

DAVID MILNE HOLME
1805–1890
Advocate

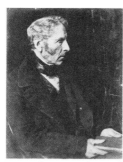

a 4 calotypes, 1 later calotype, 3
 carbons
 Print size 4. Negative in the
 collection of Mr John Craig
 Annan.

– HOPE

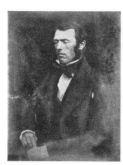

a negative, 2 later calotypes
 Negative size 4, inscribed
 '[illegible] Hope', mark touched
 out in pencil.

– HORAX

a negative, 1 modern print
 Negative size 4, inscribed 'Mr
 Horax Aug 23 4 []'.

ROBERT HORSBURGH
Factor to the Duke of Sutherland

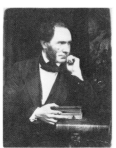

a 3 calotypes
 Print size 4.

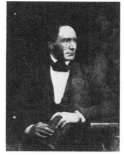

b negative, 1 modern print
 Negative size 4, inscribed
 'Horsburgh Apr 16'.

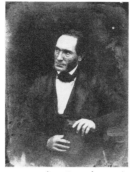

c negative, 1 modern print
 Negative size 4, inscribed
 'Horsburgh / 1h', spots touched
 out in pencil.

JOHN ADAM HOUSTON
1813–1884
RSA, landscape and history painter

a 1 calotype
 Print size 4.

– HUME

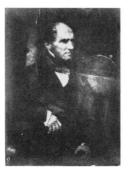

a negative, 1 later calotype
 Negative size 4, inscribed 'Mr
 Hume', spots on face touched
 out in wash.

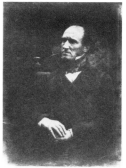

b negative, 1 modern print
 Negative size 4, inscribed 'Mr
 Home', small spots touched out
 in wash.

Professor JAMES HUNTER
died 1845
Professor of Logic and Rhetoric at
St Andrews University

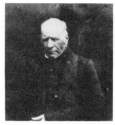

a 3 calotypes
 Print size 6. Inscription printed
 off from negative 'Dr H / [sh?] /
 1½ 58'. Calotype probably
 taken by John or Robert
 Adamson in St Andrews about
 1842.

JOHN HUNTER 1801–1869
Of Craigcrook; solicitor, Auditor
of the Court of Session, official
witness to the Free Church Deed of
Demission
See Presbytery Groups 19 to 22

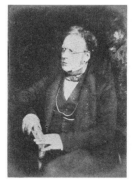

a negative, 2 calotypes, 2 later
 calotypes
 Negative size 4, inscribed 'xxx
 John Hunter / DF 111', marks
 touched out in pencil.

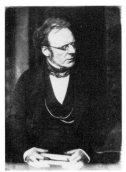

b 1 calotype
Print size 4.

Called 'Rev Mr HUNTY'

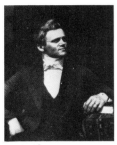

a 2 calotypes
Print size 5.

– INGLIS

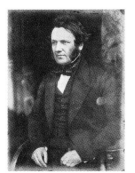

a 1 calotype, 1 later calotype
Print size 4.

b 1 albumen
Print size 4.

Dr JAMES INGLIS 1813–1851
Of Halifax; specialist in the
treatment of goitre
*For a possible patient of Dr Inglis,
see Unknown Woman 14*

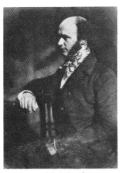

a negative, 6 calotypes
Negative size 4, inscribed 'Dr
Inglis Halifax Oct 2 / DF', stain
and headrest touched out in
pencil, waxed. Calotype taken
at the British Association
meeting in York in 1844.

JOHN INGLIS
Of Cupar

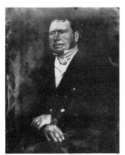

a negative, 1 modern print
Negative size 4.

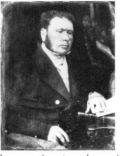

b negative, 1 modern print
Negative size 4, inscribed '15'.

c negative, 1 later calotype
Negative size 4, inscribed 'John
Inglis Esq Cupar / DD', partly
waxed.

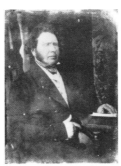

d negative, 1 modern print
Negative size 4, inscribed 'John
Inglis Esq Cupar Apr 23/45 / 15
/ ½', headrest touched out in
wash.

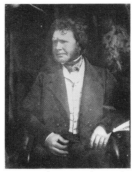

e negative, 1 modern print
Negative size 4, inscribed 'John
Inglis Esq 23 Apr/45 / ½ / 15',
marks touched out in pencil.

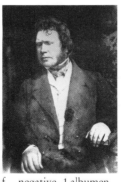

f negative, 1 albumen
Negative size 4, inscribed 'John
Inglis Esq Apr 23/45 / HY',
marks touched in pencil.

g negative, 1 calotype
Negative size 4, inscribed 'John
Inglis Esq Apr 23/45 / 15 / ½',
marks touched out in pencil.

WALTER FOGO IRELAND
Banker and railway promoter

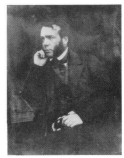

a negative, 1 modern print
Negative size 4, inscribed 'Fogo
Ireland Esq July 31 44 / DS'.

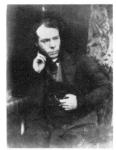

b negative, 2 calotypes
Negative size 4, inscribed 'W
Fogo Ireland Esq July 31 44 /
Gum', mark touched out in
pencil.

Dr DAVID IRVING 1778–1860
Biographer and Advocates'
Librarian

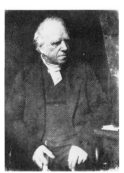

a 2 calotypes
Print size 4.

b 1 calotype
Print size 4.

JAMES, LORD IVORY
1792–1860
Solicitor General of Scotland, 1839, one of the Lords of Justiciary, 1849

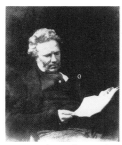

a negative, 1 later calotype, 1 albumen
 Negative size 5, inscribed 'L Ivory', waxed.

Rev JOHN JAFFRAY died 1855
Secretary of the Free Church Board of Missions
See Groups 146 and 147 and Presbytery Groups 21 and 22

ANDREW JAMESON 1811–1870
Sheriff-substitute of Edinburgh

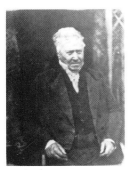

a 1 calotype
 Print size 4.

Rev CHARLES JAMESON
1807–1870
Of Pathhead; Free Church minister

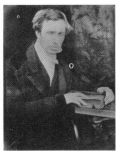

a negative, 1 later calotype
 Negative size 4, inscribed '15 / Gu'.

b 1 calotype
 Print size 4.

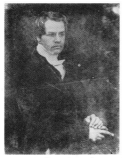

c negative, 1 modern print
 Negative size 4, hair and coat touched up in wash.

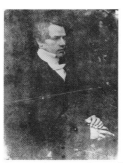

d negative, 1 modern print
 Negative size 4, inscribed '160', spots touched out in pencil.

– JEFFREY
See Presbytery Groups 12 and 13

Sir WILLIAM JOHNSTON
1802–1888
Lord Provost of Edinburgh, 1848 to 1851

a 1 calotype
 Print size 5. Calotype used for the Disruption Picture.

JOHN JOHNSTONE
Reporter for *The Witness* newspaper
See Presbytery Groups 23 to 25

Sir JOHN VANDEN-BEMPDE-JOHNSTONE 1799–1869
Baronet, son-in-law of the Archbishop of York

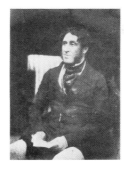

a negative, 1 calotype, 1 later calotype, 1 albumen
 Negative size 4, inscribed 'York Sir John Johnstone Octo 1–44 / G / 40', hair and face touched up in pencil and wash.

WILLIAM BORTHWICK JOHNSTONE 1804–1868
Landscape and history painter, first curator of the National Gallery of Scotland
See also Groups 133, 148 and 149

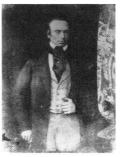

a negative, 1 modern print
 Negative size 4, inscribed 'Mr Johnston / Gum / [300?]', marks touched out in pencil.

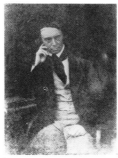

b negative, 1 calotype, 1 modern print
 Negative size 4, inscribed 'Johnston / 304 Gum'.

c 4 calotypes
 Print size 4.

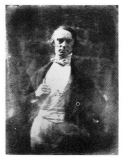

d negative, 1 modern print
 Negative size 4, inscribed 'Johnston / 18 [illegible]'.

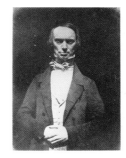

e negative, 1 calotype
 Negative size 4, inscribed 'xxx W Johnston July 22/45 / xxx Gum / DF 2h [illegible]', spots touched out in pencil, waxed.

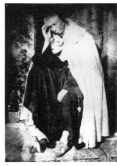

f negative, 1 modern print
 Negative size 4, inscribed 'xxx', small spots touched out in wash. Johnstone is dressed as one of the Monks of Kennaquhair from Sir Walter Scott's *The Abbot*.

g negative, 1 calotype
Negative size 4, inscribed 'xxx',
waxed.

Rev THOMAS JOLLY 1795–1859
Of Bowden; Free Church minister
See also Group 86

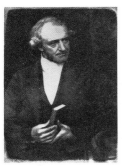

a 1 calotype
Print size 4. Calotype used for
the Disruption Picture.

Rev PETER JONES 1802–1856
or Kahkewaquonaby, Indian Chief
and missionary in Canada. On 27
July 1845, he preached in
Edinburgh and on 29 July, he
addressed a public meeting to raise
money for manual labour schools
designed to promote civilisation
and Christianity among the
Indians.

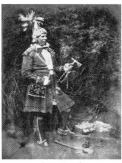

a negative, 3 calotypes
Negative size 4, inscribed 'Jones
/ 15 Gum', support touched out
in pencil, waxed.

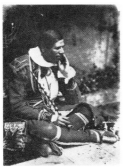

b negative, 2 calotypes
Negative size 4, inscribed
'JONES AU 4[5] / 15 / 2h du
s []', waxed.

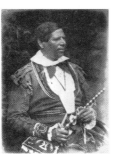

c negative, 3 calotypes
Negative size 4, inscribed
'Indian Chief Aug 4/45 / 15 / 2h
du [sc?] / Gum', waxed.

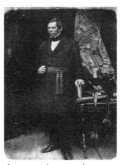

d negative, 1 calotype
Negative size 4, inscribed 'Rev
Jones / 15 / Gum', support
touched out in pencil, waxed.

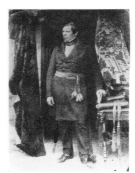

e negative, 1 modern print
Negative size 4, inscribed 'Rev
Mr Jones', marks touched out in
pencil.

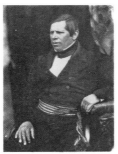

f negative, 1 modern print
Negative size 4, inscribed 'x Rev
Jones / 15', headrest touched
out in pencil, waxed.

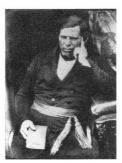

g negative, 1 modern print
Negative size 4, inscribed 'xx
JONES? / 15', marks touched
out in pencil. The sitter is
resting on *THE HOLY BIBLE*.

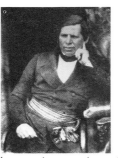

h negative, 1 modern print
Negative size 4, inscribed 'Rev
Mr Jones / DF'.

**Rev THOMAS HENSHAW
JONES** 1796–1860
Church of England minister

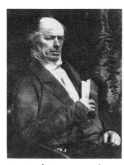

a 1 calotype, 1 carbon
Print size 4.

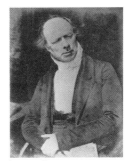

b 6 calotypes
Print size 4.

– KEITH
See also Group 236

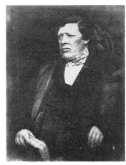

a 1 calotype
Print size 4.

Rev ALEXANDER KEITH
1791–1880
Of St Cyrus; Free Church minister,
writer on prophecy

a 5 calotypes
Print size 4.

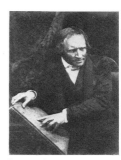

b 3 calotypes
Print size 4. Calotype used for
the Disruption Picture.

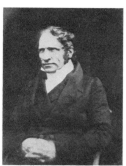

c 1 calotype, 1 albumen
 Print size 5. The calotype is
 dated under the mount May or
 August 1843.

Major KEMP
See Groups 150 and 151

GEORGE MEIKLE KEMP
1795–1844 (died on 6 March)
Architect of the Scott Monument
*A calotype of Kemp was exhibited at
the Royal Scottish Academy in 1844*

a 1 calotype
 Print size 4.

b 2 calotypes
 Print size 4.

JOHN KERMACK 1781–1860
Solicitor
See Groups 152 and 153

**WILLIAM RAMSAY
KERMACK** 1820–1883
Solicitor
See Groups 152 to 154

Dr KERR
See – Stevens

Rev STEWART KILLIN
See Group 155

Rev Dr ANDREW KING
1793–1874
Of St Stephen's, Glasgow;
Professor of Theology at the
Presbyterian College, Halifax,
Nova Scotia

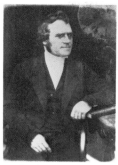

a 3 calotypes
 Print size 4.

Rev Dr DAVID KING 1808–1883
United Presbyterian minister,
Moderator of the United
Presbyterian Synod, 1864
See also Group 156

a negative, 1 modern print
 Negative size 4, inscribed 'Rev
 David King DD'. Image
 obscure.

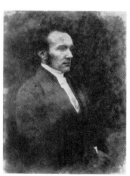

b 1 calotype
 Print size 5. Inscription printed
 off from negative 'Dr King
 [illegible] Glasgow 21 Oct
 1843'.

– KINLOCH
Of Park
See Groups 158 and 159

– KINNEAR

a 1 later calotype, 1 carbon
 Print size 4.

Rev JOHN KIRK 1795–1858
Of Arbirlot; Free Church minister
See Presbytery Group 3

WILLIAM KIRKALDY
Of Glasgow
Or 'Rev – Black of Kirkcaldy'

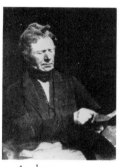

a 1 calotype
 Print size 5.

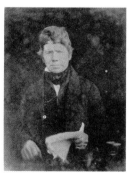

b negative, 1 later calotype
 Negative size 5, inscribed
 'Kirkaldy / Gum', marks
 touched out in pencil, waxed.

Dr ROBERT KNOX 1791–1862
Surgeon, anatomist and ethnologist

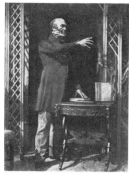

a 1 later calotype
 Print size 5. Negative in
 Glasgow University Library.

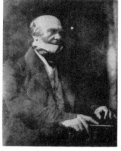

b 3 calotypes
 Print size 5.

– LAIDLAW
Newhaven fisherman
See Newhaven 42

DUGALD LAIDLAW

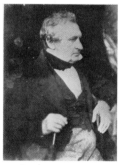

a 2 calotypes
 Print size 4.

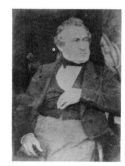

b 1 calotype
 Print size 4.

– LAING (1)
Or 'Laine'

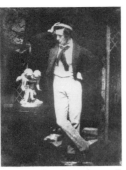

a negative, 1 modern print
Negative size 4, inscribed
'Laing / 304', support partly
touched out in wash.

b negative, 1 modern print
Negative size 4, inscribed
'Laing / DF', marks touched out
on jacket in pencil.

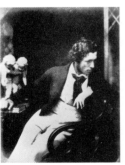

c 2 calotypes
Print size 4.

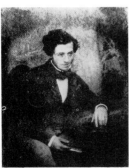

d negative, 1 modern print
Negative size 4, inscribed 'Laine
Light / 304', headrest touched
out in wash.

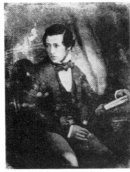

e negative, 1 modern print
Negative size 4, inscribed 'Lain
/ 304', headrest touched out in
wash, negative stained.

f negative, 1 modern print
Negative size 4, inscribed 'Lain
/ DF', hair slightly touched up
and attempt to touch out bad
stain on body in pencil.

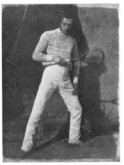

g 1 calotype
Print size 4.

– LAING (2)
Or 'Laine'

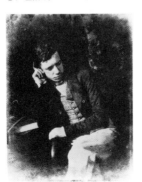

a negative, 1 modern print
Negative size 4, inscribed 'May
[*or* Aug] 28 Laine / Gum',
minor spots on face touched out
in wash.

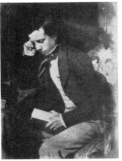

b negative, 1 calotype
Negative size 4, inscribed '25
Laine / 304'.

DAVID LAING 1793–1873
Antiquary

a 3 calotypes
Print size 4.

Rev Dr HUGH LAIRD
1764–1849
Of Portmoak; Free Church
minister

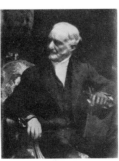

a 1 calotype
Print size 4. Calotype probably
used for the Disruption Picture.
Negative in Glasgow University
Library.

MOHUN LAL (aged 28 in 1844)
Accompanied Sir Alexander Burnes
to Kabul in 1832, came to Scotland
in 1844 to deliver Burnes' papers,
which he had rescued during the
fighting in Kabul in 1841, to
Burnes' father in Montrose. The
Edinburgh Evening Courant
reports him in Edinburgh for a few
days on 24 October 'dressed in a
magnificent Hindoo costume'.

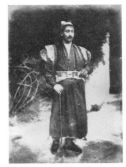

a negative, 1 calotype
Negative size 4, inscribed
'MOHUN LAL / DF', touched
up round foot in pencil.

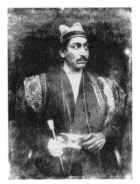

b negative, 1 calotype, 1 modern
print
Negative size 4, inscribed
'Mohun Lal / Gu'.

Rev JOHN LAMB 1796–1855
Of Kirkmaiden; Free Church
minister
See Group 81

– LANDALE
*Possibly Robert Landale of
Pitmedden, solicitor*

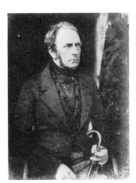

a negative, 1 later calotype
Negative size 4, inscribed
'LANDALE', headrest touched
out in pencil.

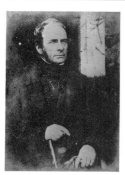

b negative, 1 later calotype
Negative size 4, inscribed
'Landale / DD2'.

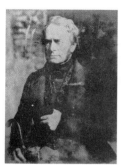

c negative, 1 calotype, 1 later
calotype
Negative size 4, inscribed
'Landale / 15', marks touched
out in pencil.

Rev DAVID
LANDSBOROUGH 1779–1854
Of Stevenston; Free Church
minister, natural historian with a
special interest in molluscs and
seaweeds
See Presbytery Group 18

– LANE
*Called 'John Lane', 'Dr Lane' and
'Edward William Lane', see note on
Group 163
See also Groups 160 to 163*

a negative, 6 calotypes
Negative size 4, inscribed
'Lewis, LANE? / 304 / 1½h
[SU ?]', support touched out in
pencil.

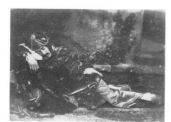

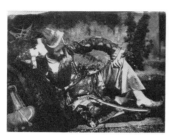

b negative, 3 calotypes
Negative size 4, inscribed 'xxx',
waxed.

c negative, 1 modern print
Negative size 4, inscribed
'LANE / 15', waxed.

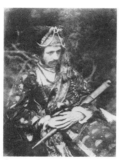

d 1 calotype
Print size 4, inscribed under
mount 'Mr John Lane'.

e negative, 1 modern print
Negative size 4, inscribed 'Lane
/ DF 1½h SU', marks touched
out in pencil.

Dr EDWIN LANKESTER
1814–1874
Professor of Natural History at
New College, London, Secretary of
the Zoology and Botany Section of
the British Association in 1844

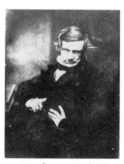

a negative, 1 modern print
Negative size 4, inscribed 'Dr
Lankester / 24', headrest
touched out in pencil. Calotype
presumably taken at the British
Association meeting in York
between 28 September and 4
October, 1844.

Dr ROBERT GORDON
LATHAM 1812–1888
Ethnologist and philologist

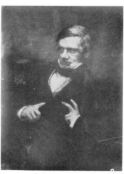

a 2 carbons, 1 print in an
unidentified process
Print size 4.

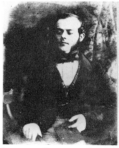

b 1 calotype, 1 carbon
Print size 4.

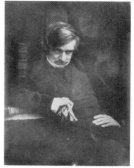

c 1 calotype, 1 carbon
Print size 4.

Dr LAVIES
Of London

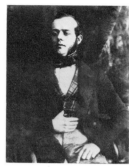

a negative, 1 modern print
Negative size 4, inscribed
'Lavies Feb 5 1847', small spots
touched out in pencil on face
and hands.

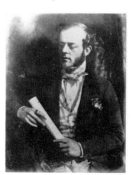

b negative, 1 modern print
Negative size 4, inscribed
'Lavies GAVIN?'; the second
identity is in a later hand.

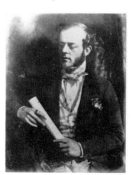

c negative, 1 calotype
Negative size 4, inscribed
'GAVIN', later inscription,
waxed.

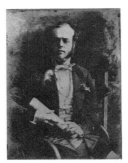

d negative, 1 calotype
Negative, inscribed 'GAVIN
[later inscription] / 33', area
over right shoulder shaded in in
pencil.

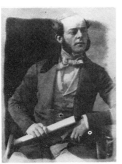

e negative, 1 calotype
Negative size 4, inscribed 'xxx',
waxed.

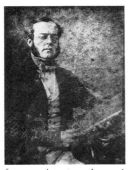

f negative, 1 modern print
Negative size 4, inscribed '2x /
GAVIN', later inscription.

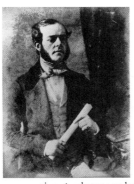

g negative, 1 calotype or later
calotype
Negative size 4, inscribed
'GAVIN / 2 x 3', later
inscription.

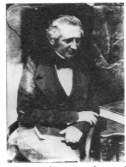

a negative, 1 modern print
Negative size 4, inscribed 'xxx
Leckie', spots on face and hands
touched out in pencil.

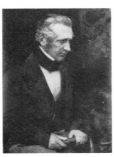

b 1 calotype, 1 carbon
Print size 4.

Dr LEE

a 1 negative, 1 modern print
Negative size 4, inscribed 'Dr
Lee / DF'. Image obscure.

Rev Dr JOHN LEE 1779–1859
Principal of Edinburgh University,
Moderator of the Assembly of the
Church of Scotland, 1843

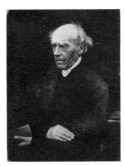

a 1 calotype
Print size 4.

b negative, 1 modern print
Negative size 4, inscribed
'Principal Lee March 22 45 /
304', small spots touched out on
face in wash.

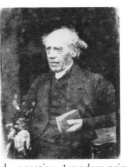

c negative, 1 modern print
Negative size 5, inscribed
'Principal Lee April 11/45', face
and jacket touched up in pencil.

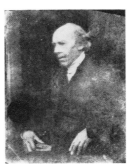

d negative, 1 modern print
Negative size 5, inscribed
'Principal Lee Apr 17/45',
marks on head touched out in
pencil and wash.

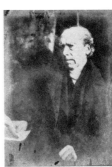

e negative, 1 modern print
Negative size 5, inscribed 'Lee /
DF', stained. Image obscure.

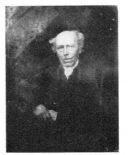

f negative, 1 modern print
Negative size 4, inscribed 'DF
LEE'. Image obscure.

g negative, 1 modern print
Negative size 4, inscribed 'April
1 / Lee [illegible]'. Image
obscure.

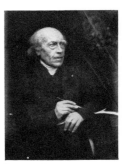

h 1 carbon
Print size 4.

i 1 calotype
Print size 4.

WILLIAM LEIGHTON
LEITCH 1804–1883
Landscape painter, watercolourist,
drawing master to Queen Victoria
See also Groups 148 and 149

a 1 calotype, 1 carbon,
 Print size 4. Leitch is dressed as
 one of the Monks of
 Kennaquhair from Sir Walter
 Scott's *The Abbot*.

b 4 calotypes
 Print size 4. Calotype
 sometimes called 'The House of
 Death'.

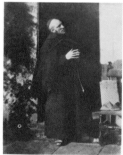

c 1 calotype
 Print size 4.

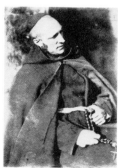

d 1 calotype
 Print size 4.

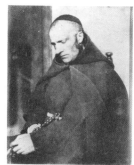

e 1 calotype
 Print size 4.

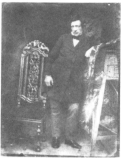

f negative, 1 modern print
 Negative size 4, inscribed 'no sal
 Gum 304 / str ¾'.

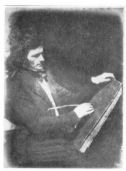

g 1 calotype
 Print size 4.

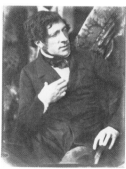

h 1 later calotype
 Print size 4.

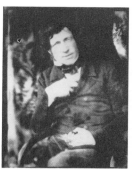

i negative, 1 modern print
 Negative size 4, inscribed 'xxx
 Leitch Sep 19 45 / 15 / Gum'.

j negative, 1 modern print
 Negative size 4, inscribed
 'smooth ex2h Gum', marks
 touched out in pencil.

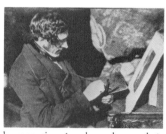

k negative, 1 carbon, damaged, 1
 modern print
 Negative size 4, inscribed 'xx
 W. L. Leitch / 202 / ex2h / 17',
 headrest touched out in pencil.

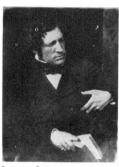

l 1 calotype
 Print size 4.

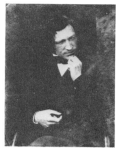

m negative, 1 modern print
 Negative size 4, inscribed '304 /
 ex2h Gum', watermark touched
 out in pencil.

Rev ALEXANDER LESLIE
1816–1878
Of Ladyloan; Free Church minister
See Presbytery Group 3

– LEWIS
See Groups 160 to 162

Rev GEORGE LEWIS 1803–1879
Of Dundee and Ormiston; Free
Church minister, editor of the
Scottish Guardian

a 6 calotypes
 Print size 4. The books under
 the sitter's arm are *CALVINI
 OPERA* and *BUNYAN'S
 WORKS*. Calotype used for the
 Disruption Picture.

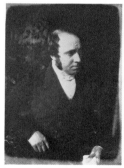

b 1 calotype
 Print size 4.

Rev JAMES LEWIS 1805–1872
Of Leith; Free Church minister,
son-in-law of James Wyld

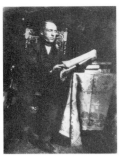

a negative, 1 modern print
 Negative size 5, inscribed 'xxx /
 LOUIS Leith / 3n', waxed.

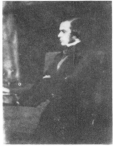

b 1 calotype
 Print size 4. Calotype used for
 the Disruption Picture.

ROBERT LINDLEY 1776–1855
Cellist, Professor at the Royal
Academy of Music
See Group 84

JAMES LINTON
Newhaven fisherman
See Newhaven 1, 2, 33 and 45

JOSEPH LISTER, Lord LISTER
1827–1912
*Lister was not officially in
Edinburgh until 1853, but the
calotype does resemble him as he
appears in an 1850's photograph by
James Good Tunny in the Scottish
National Portrait Gallery*

a 1 calotype
 Print size 5. 'Mr Lister'
 inscribed under the mount.

JOHN LISTON
Newhaven fisherman
See Newhaven 32

ROBERT LISTON 1794–1847
Surgeon, Professor of Clinical
Surgery at University College,
London

a 3 calotypes, 5 albumens, 3
 carbons
 Print size 4.

b 4 calotypes
 Print size 4.

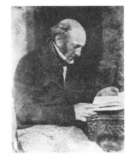

c 2 calotypes
 Print size 4.

WILLIE LISTON
Newhaven fisherman
See Newhaven 3

WILLIAM LITTLE
Of the Royal Institution,
Edinburgh

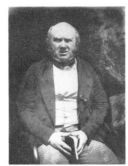

a 1 calotype
 Print size 4.

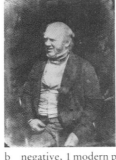

b negative, 1 modern print
 Negative size 4, inscribed 'Mr
 Little Aug 1/45 / Str brom / DS'.

**Professor ALEXANDER
LIZARS**
Of Aberdeen

a 3 calotypes
 Print size 4.

Called 'LOCKHART'
See William Blair

JOHN GIBSON LOCKHART
1794–1854
Author, biographer and son-in-law
of Sir Walter Scott

a 3 calotypes
 Print size 4.

b 1 calotype
 Print size 4. Negative in
 Glasgow University Library.

**Rev Dr LAURENCE
LOCKHART**
Of Inchinnan; Church of Scotland
minister

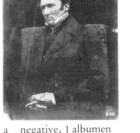

a negative, 1 albumen
 Negative size 5, inscribed 'Rev
 L Lockhart', waxed.

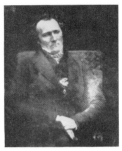

b 1 calotype
 Print size 5.

– LODER
Cellist
See Group 84

**ALEXANDER STUART
LOGAN** 1811–1862
Advocate, Sheriff of Forfarshire

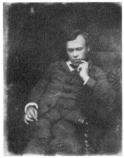

a negative, 3 calotypes
 Negative size 4, inscribed 'Mr
 Logan'.

J LOGIN
Or 'Logan'. Unlikely to be James Logan, author of The Scottish Gael or Celtic Manners, who was born about 1794.

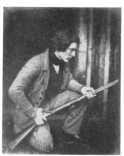

a negative, 1 calotype, 1 albumen
Negative size 5, inscribed 'J Login / JAMES LOGAN of the Scottish Gael', the second identity probably in a later hand, marks touched out in wash.

WILLIAM SPENCE LOGIN
born 1819 died after 1885
Of Orkney and Victoria; Free Church minister

a negative, 1 carbon
Negative size 4, inscribed 'Login June 1/46', mark touched out in pencil, waxed.

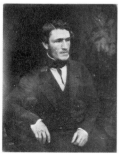

b negative, 1 carbon
Negative size 4, inscribed 'Login June 1/46 / 15', waxed.

CHARLES THOMAS LONGLEY 1794–1868
Bishop of Ripon, later Archbishop of York and of Canterbury
The following calotypes were taken at York during the British Association meeting in 1844. A calotype of the Bishop of Ripon was exhibited at the Royal Scottish Academy in 1845

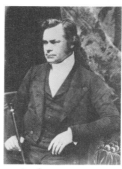

a negative, 1 calotype or later calotype
Negative size 4, inscribed 'York Bishop of Ripon Octo 1–4 [4]', small marks touched out on face in wash.

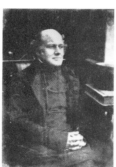

b negative, 1 calotype
Negative size 4, inscribed 'York Bishop of Ripon Octo 1–44', small spots and stock touched out in pencil.

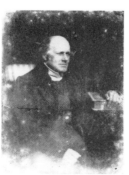

c negative, 1 modern print
Negative size 4, inscribed 'Dr Longley B. of Ripon / 24', torn.

Rev Dr JOHN LONGMUIR
1803–1883
Of Aberdeen; Free Church minister, geologist and philologist

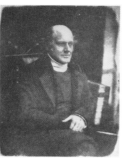

a 3 calotypes
Print size 4. Calotype used for the Disruption Picture.

Rev Dr ROBERT LORIMER
1765–1848
Of Haddington; leading Free Churchman

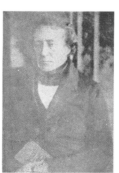

a 5 calotypes
Print size 5. Calotype used for the Disruption Picture.

MAURICE LOTHIAN
Solicitor

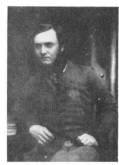

a 1 calotype
Print size 5, cut down.

CHARLES LUCAS
Cellist
See Group 84

Rev Dr JAMES LUMSDEN
1810–1875
Of Barry; Professor and Principal of the Free Church College, Aberdeen
See Presbytery Group 3

– LYELL (1)
Identity may be a confusion with ' – Lyell (2)'

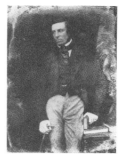

a negative, 1 modern print
Negative size 4, inscribed 'DF'.

b negative, 1 modern print
Negative size 4, inscribed '3200 [*or perhaps* Brod]'.

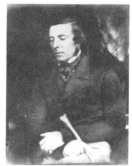

c negative, 2 later calotypes
Negative size 4, inscribed 'Sept 19/45 / 15', hair touched up in pencil.

– LYELL (2)

a 1 calotype
Print size 5.

Sir CHARLES LYELL 1797–1875
Geologist
See Group 71

Rev JOHN LYON died 1889
Of Broughty Ferry, Dundee; Free
Church minister
See also Group 166

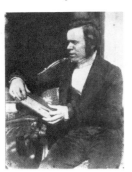

a 2 calotypes
 Print size 4.

Rev FINLAY MCALISTER
1805–1866
Of Crieff; Free Church minister

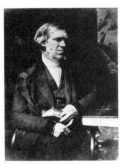

a 1 calotype
 Print size 4.

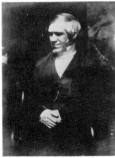

b 3 calotypes
 Print size 4.

Rev PETER MCBRIDE
1797–1846
Of Rothesay; Free Church minister

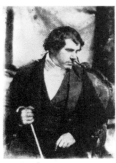

a 3 calotypes
 Print size 4. Calotype used for
 the Disruption Picture.

Rev Dr JAMES MCCOSH
1811–1891
Of Brechin; Free Church minister,
Professor of Logic and Moral
Philosophy at Queen's College,
Belfast, 1852, President of
Princeton, U S A, 1868

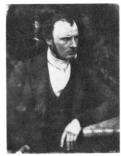

a 3 calotypes
 Print size 4.

Rev Dr THOMAS MCCRIE
1797–1875
Of London; United Secession and
later Free Church minister, church
historian

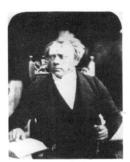

a 1 calotype
 Print size 5.

HORATIO MCCULLOCH
1805–1867
RSA, landscape painter

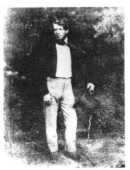

a negative, 1 modern print
 Negative size 4, inscribed '32',
 watermark and spots touched
 out in pencil.

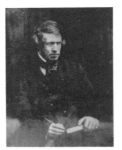

b 1 calotype
 Print size 5.

c 3 calotypes
 Print size 4.

d 1 albumen
 Print size 4.

**Rev Dr JAMES MELVILLE
MCCULLOCH** born 1801
Headmaster of Circus Place School,
Edinburgh

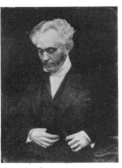

a 1 carbon
 Print size 4.

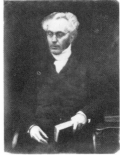

b 1 albumen, 1 carbon
 Print size 4.

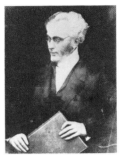

c negative, 3 calotypes
 Negative size 4, inscribed 'xx Dr
 Macculloch / Gu / 15', marks
 and headrest touched out in
 pencil.

JOHN MACDONALD
Reporter for *The Witness*
newspaper
See Presbytery Groups 23 to 25

Rev Dr JOHN MACDONALD
1779–1849
Of Ferintosh; leading Free
Churchman, known as 'The
Apostle of the North'

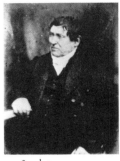

a 3 calotypes
 Print size 4. Calotype used for
 the Disruption Picture.

Rev ROBERT MACDONALD
1813–1893
Of Blairgowrie and North Leith;
Free Church minister, brother-in-
law of D O Hill

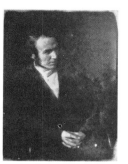

a 1 calotype
 Print size 4.

Rev – MCEWEN
Or 'Mr Ewen'
Of Helensburgh; United Secession
minister

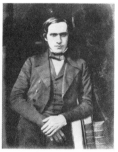

a 5 calotypes
 Print size 4.

**Rev Dr PATRICK
MACFARLANE** 1781–1849
Of Greenock, the richest living in
Scotland. Dr Macfarlane was the
first to sign the Deed of Demission

a 1 calotype
 Print size 4. Calotype used for
 the Disruption Picture.

**Rev ANGUS MACKINTOSH
MCGILLIVRAY** 1805–1873
Of Dairsie; Free Church minister

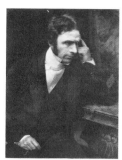

a 1 carbon
 Print size 4. Calotype used for
 the Disruption Picture.

Dr MCHARDY

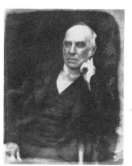

a 1 calotype
 Print size 4.

**Rev Dr MACKINTOSH
MACKAY** 1800–1873
Of Dunoon, Melbourne and
Sydney; Free Church minister,
Gaelic scholar

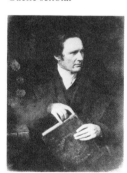

a 1 calotype
 Print size 4. The book in the
 sitter's hands is inscribed 'FREE
 CHURCH DUNOON', probably written on the
 negative. Calotype used for the
 Disruption Picture.

Rev Dr ANGUS MCKELLAR
born about 1780 died 1859
Of Pencaitland; Moderator of the
Assembly of the Church of
Scotland, 1840 and of the Free
Church, 1852

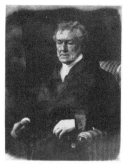

a 1 calotype
 Print size 4.

– MACKENZIE
See Group 172

Dr MCKENZIE
See also Groups 170 and 171

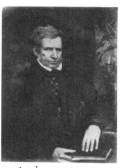

a 1 calotype
 Print size 4.

Sergeant MACKENZIE
Officer of the Free Church
Assembly
See Presbytery Groups 21 and 22

Captain MACKENZIE
Son of Henry Mackenzie

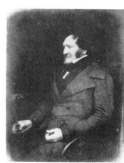

a negative, 1 later calotype
 Negative size 4, inscribed 'Capt
 Mackenzie July 9–44 / DF /
 Gum'.

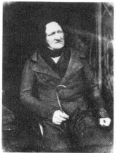

b negative, 1 calotype
 Negative size 4, inscribed 'Capt
 Mackenzie July 9–44 / DF /
 Gum', area at bottom of
 negative shaded in in pencil.

Rev ANDREW MACKENZIE
1801–1871
Of Penicuik; Free Church minister

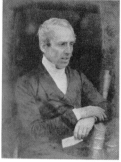

a 2 calotypes
 Print size 4.

**Rev HUGH MACKAY
MACKENZIE** 1771–1845 (died on
1 July)
Of Tongue; Free Church minister

a 2 calotypes, 1 later calotype
 Print size 4. The book in the
 sitter's hands is inscribed 'FREE
 CHURCH TONGUE 1842',
 presumably written on the
 negative. Calotype used for the
 Disruption Picture.

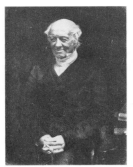

b 1 calotype
 Print size 4.

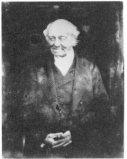

c negative, 1 modern print
 Negative size 4, inscribed '15'.
 Image obscure.

Rev JAMES MACKENZIE
1817–1869
Of Annan and Dunfermline; Free
Church minister
See Presbytery Group 2

Rev JOHN MACKENZIE
1813–1878
Of Ratho; son-in-law of Rev Dr
Thomas Chalmers

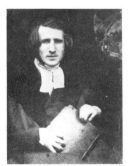

a 1 calotype
 Print size 4. Calotype used for
 the Disruption Picture.

JOHN BAN MACKENZIE
1796–1858
Piper to the Marquis of Breadalbane
and the Highland Society

a 1 calotype
 Print size 4.

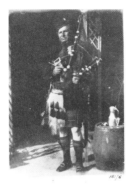

b 1 calotype
 Print size 4.

c 1 calotype
 Print size 4.

d 2 calotypes
 Print size 4. Calotype used as a
 study for Hill's painting
 'Edinburgh from the Castle,
 1847'.

JOHN MACKINTOSH

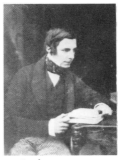

a 1 calotype
 Print size 5.

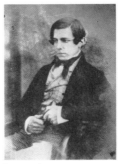

b 1 calotype
 Print size 5.

Professor Sir DOUGLAS
MACLAGAN 1812–1900
Surgeon General
See also Groups 253 and 254

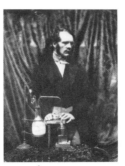

a 1 calotype
 Print size 5.

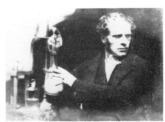

b 1 calotype
 Print size 5.

Rev JAMES MACLAGAN
1788–1852
Professor of Divinity at Free
Church College, Aberdeen
See also Groups 173 and 174

a 1 later calotype
 Print size 4.

KENNETH MACLEAY
1802–1878
RSA, miniature painter
See also Groups 176 to 180

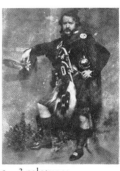

a 3 calotypes
 Print size 5.

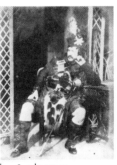

b 2 calotypes
 Print size 4.

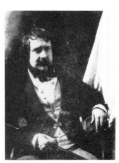

c negative, 1 modern print
 Negative size 5, inscribed
 'McClea'.

MACNEIL MACLEAY
Landscape painter, teacher of drawing, brother of Kenneth MacLeay

a negative, 1 modern print
 Negative size 4, inscribed 'MacNeil Macleay May 31 / DF'.

General MCLEOD
Perhaps Lt General Duncan McLeod 1780–1856

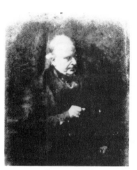

a negative, 1 modern print
 Negative size 4, inscribed 'General McLeod', small spots and headrest touched out in wash.

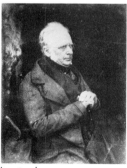

b 1 calotype
 Print size 4.

ANDREW MACLURE
Lithographer, of the firm Maclure, Macdonald and MacGregor; associated with Hill and James Drummond in producing drawings and lithographs for *Illustrations of the Principles of Toleration in Scotland* [no author or date, published after May 1846]

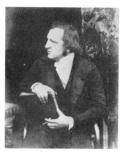

a 1 calotype
 Print size 4, cut down.

b 1 calotype
 Print size 5.

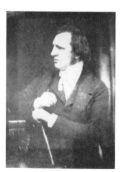

c 1 calotype
 Print size 5.

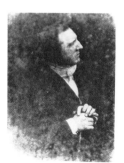

d negative, 1 modern print
 Negative size 5, inscribed 'Maclure Litho / exp + kept 22 [as?] in dark', small spots touched out in wash, waxed.

JAMES MCLURE
Of Glasgow; printseller

a negative, 1 modern print
 Negative size 4, inscribed 'Mr Maclure'.

b negative, 1 calotype
 Negative size 4, inscribed 'James McClure / 304', small spots touched out on face and hands in wash.

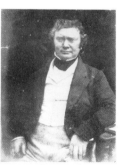

c negative, 1 calotype
 Negative size 4, inscribed 'JAMES McClure / DF', stained.

– MCMILLAN
Of Cardross
See Presbytery Groups 6 and 7

Rev SAMUEL MCMORINE
Headmaster of Watson's Hospital, Edinburgh

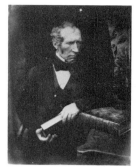

a negative, 1 calotype, 1 later calotype
 Negative size 4, inscribed 'xx Mr McMorran Mar 17/45 / 15', marks touched out in pencil.

WILLIAM MCNAB
Of the Royal Horticultural Garden

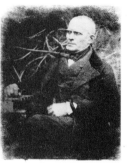

a negative, 1 modern print
 Negative size 4, inscribed 'Mr McNab / xxx'.

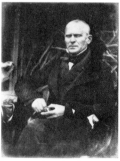

b negative, 1 calotype
 Negative size 4, inscribed 'xx McNab', small marks touched out in wash.

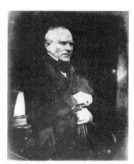

c negative, 1 calotype, 1 albumen
 Negative size 4.

Rev JOHN MACNAUGHTON
1807–1884
Of Paisley and Belfast; Free Church minister

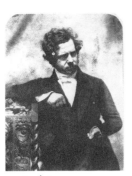

a 3 calotypes
Print size 5. Calotype used for the Disruption Picture.

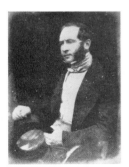

b 1 calotype
Print size 5.

– MCNEIL

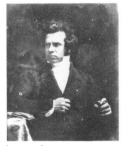

a negative, 1 calotype
Negative size 4, inscribed 'McNeil July 1 44'.

b *negative, 1 modern print*
Negative size 4, inscribed 'McNeil July 1 44 / [illegible] Gum'. Image obscure, not illustrated.

ARCHIBALD MCNEILL
1803–1870
Solicitor

a negative, 2 calotypes
Negative size 4, inscribed 'Mr Arch McNeil / 25 / 304', marks touched out in pencil, waxed and stained.

b 1 calotype
Print size 4.

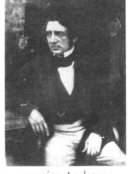

c negative, 1 calotype
Negative size 4, inscribed 'Arch McNeil Esq July 12–44 / DS', small spots touched out in wash.

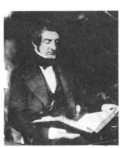

d 1 carbon
Print size 4, damaged, lower part missing.

e negative, 1 calotype, 1 modern print
Negative size 4, inscribed 'Arch McNeil Esq July 12–44 / DF'.

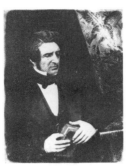

f 1 calotype
Print size 4.

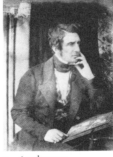

g 1 calotype
Print size 4.

Sir JOHN MCNEILL 1795–1883
Ambassador to the Court of Persia, Privy Councillor, Chairman of the Board to supervise the Poor Law Act, 1845, conservator of forests in Bombay

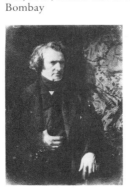

a negative, 1 modern print
Negative size 4, inscribed 'xxx Sir John McNeill Apr 15/45 / 217 / Gum'.

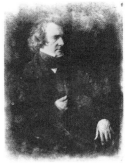

b negative, 1 later calotype, 1 modern print
Negative size 4, inscribed 'Sir John McNeill / 15', small spots touched out in wash.

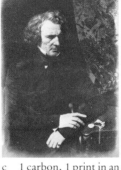

c 1 carbon, 1 print in an unidentified process
Print size 4.

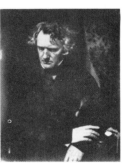

d 4 calotypes, 2 carbons
Print size 4. Negative in the National Library of Scotland, Borthwick collection.

PATRICK BOYLE MURE MACREDIE 1800–1868
Of Perceton; advocate, Free Churchman

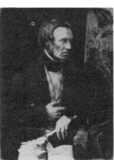

a 3 calotypes
Print size 4.

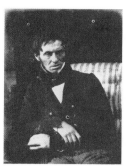

b 1 calotype
Print size 5, possibly cut down
from size 4.

**Rev DAVID [or DONALD]
MACVEAN**
Of Iona; Free Church minister

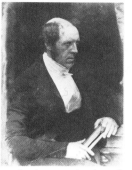

a 2 calotypes, 1 enlarged print in
an unidentified process
Print size 4.

EDWARD MAIN
See Groups 182 and 183

Rev Dr THOMAS MAIN
1816–1881
Of Kilmarnock and Free St Mary's,
Edinburgh; Moderator of the Free
Church Assembly, 1880

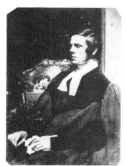

a 1 calotype, 1 later calotype
Print size 4. Calotype used for
the Disruption Picture.

**EDWARD FRANCIS
MAITLAND** 1803–1870
Lord Barcaple, Solicitor General
and Lord of Session

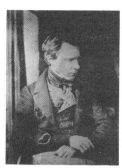

a 1 calotype
Print size 5.

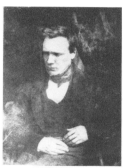

b 1 calotype
Print size 5.

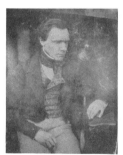

c 1 calotype
Print size 5.

JOHN MAITLAND 1803–1865
Accountant, Free Church elder

a negative, 1 calotype
Negative size 4, inscribed 'Sept
10 / M . . .? MAXWELL / DS',
mark touched out in pencil.

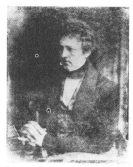

b negative, 1 modern print
Negative size 4, inscribed 'Mr
Aug 26 4 [5?] / DF / 100 [or
10D]'.

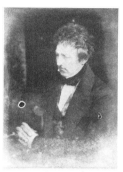

c negative, 1 calotype or later
calotype
Negative size 4, inscribed 'Mr
Aug 26 / xxx / MAITLAND',
spots on face touched out in
wash.

Dr MAK

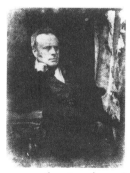

a negative, 1 modern print
Negative size 4, inscribed 'Dr
Mak July 16–44 / DF', drape
touched up in wash.

b negative, 1 modern print
Negative size 4, inscribed 'Dr
Mak July 16 / Gum', marks
touched out pencil and wash.

Dr MALCOLM
*Presumably Dr Robert Malcolm,
obstetrician*

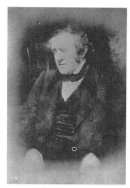

a 1 calotype
Print size 4.

Rev JAMES MARSHALL
1796–1855
Of the Tolbooth Church,
Edinburgh; Church of Scotland and
later, Church of England, minister

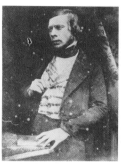

a 1 calotype
Print size 4.

**WILLIAM CALDER
MARSHALL** 1813–1894
RA, sculptor

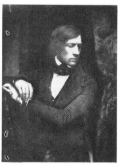

a 1 carbon
Print size 4.

Captain MARTIN
See Groups 23 and 24

Sir THEODORE MARTIN
1816–1909

Solicitor, author and translator, friend and literary collaborator of W E Aytoun as 'Bon Gaultier', worked in Edinburgh until June 1846. Owned two volumes of the calotypes now in the Victoria and Albert Museum

a 1 calotype
Print size 5.

– MATTHEW

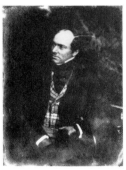

a negative, 1 modern print
Negative size 4, inscribed 'Matthew / Gum ¼'.

– MAXWELL (1)
John Harden q v wrote to his daughter on 14 November 1843, 'accompanied Maxwell A + John to Calton Hill Calotype Studio, to see Ms. portrait ‿ vr good', which may be a reference to this or the following sitter

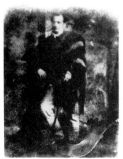

a negative, 1 modern print
Negative size 4, inscribed 'Maxwell'.

– MAXWELL (2)
See note on Maxwell (1)

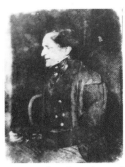

a negative, 1 modern print
Negative size 5, inscribed 'Maxwell', waxed.

– MEIGLE

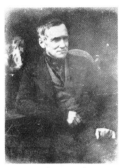

a negative, 1 calotype
Negative size 4, inscribed '[Meigle?] June 22–44', waxed.

Rev Dr JOHN SMYTHE MEMES
1795–1858

Of Hamilton; Church of Scotland minister, translated Daguerre's *History and Practice of Photogenic Drawing on the true principles of the Daguerrotype,* 1839

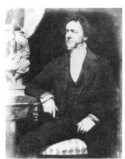

a negative, 1 calotype
Negative size 4, inscribed 'Dr Memes'.

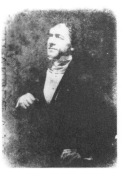

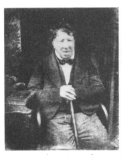

b negative, 1 modern print
Negative size 5, inscribed 'Dr Memes'.

– MERCER

a negative, 1 modern print
Negative size 4, inscribed 'xxx Mercer / 304'.

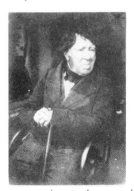

b negative, 1 modern print
Negative size 4, inscribed 'Mr Mercer July 10', cut and patched.

c negative, 1 calotype or later calotype
Negative size 4, inscribed 'Mr Mercer July 10 / DF [illegible]'.

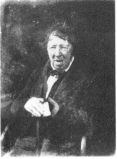

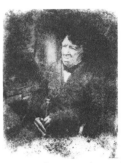

d negative, 1 calotype
Negative size 4, inscribed 'Mr Mercer July 18 / DS / Gum'.

e negative, 1 modern print
Negative size 4, inscribed 'Mercer / DF / Gum'. Image obscure.

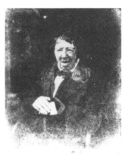

f negative, 1 modern print
Negative size 4, inscribed 'MERCER'. Image obscure.

g negative, 1 modern print
Negative size 4, inscribed 'Mr Mercer July 18 44 / DF', chemical mark touched out in pencil.

– MERSON
See Group 220

Dr WILLIAM METHVEN
Of St Andrews; naval surgeon

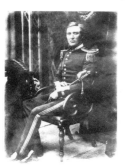

a 3 calotypes
 Print size 4.

– MILLER
Child of the Rev Ebenezer Miller
See Group 192

– MILLER
Child of Professor James Miller

a 1 carbon
 Print size 4.

b 1 calotype, 1 albumen
 Print size 4.

A MILLER
See Groups 191 and 200

Rev EBENEZER MILLER
1799–1857
Missionary in South Africa and
Bengal
See also Groups 192 and 193

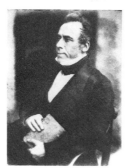

a 1 calotype
 Print size 4.

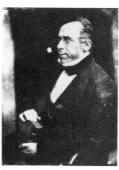

b negative, 1 modern print
 Negative size 4, inscribed '?
 Milne *Miller* Missionary'.

HUGH MILLER 1802–1856
Geologist and journalist, editor of
The Witness newspaper, strong
supporter of the Free Church
See also Groups 31 and 226

a 2 calotypes, 1 carbon
 Print size 5. This or the
 following calotype was taken in
 the Calton Cemetery and
 referred to in Miller's article
 'The Calotype': 'a bonneted
 mechanic rests over his mallet
 on a tombstone – his one arm
 bared above his elbow; the other
 wrapped up in the well-
 indicated shirtfolds and resting
 on a piece of grotesque
 sculpture –'. The article was
 published in *The Witness* on
 July 12, 1843 but it had 'been in
 type for upwards of a week'.

b 2 calotypes
 Print size 5.

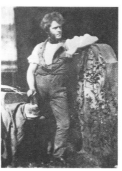

c 1 calotype, 1 later calotype, 1
 carbon
 Print size 2. Negative in
 Glasgow University Library.

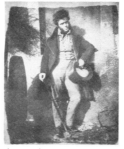

d 1 calotype, 2 carbons
 Print size 4.

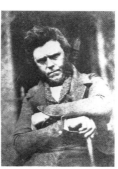

e 1 albumen
 Print size 5.

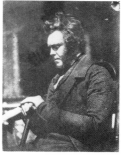

f 3 later calotypes
 Print size 5. Calotype used for
 the Disruption Picture.

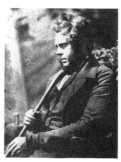

g 1 calotype
 Print size 5, inscription printed
 off from negative '[dark?]'.

Rev JAMES MILLER 1777–1860
Of Monikie; Free Church minister
*See also Group 193 and Presbytery
Groups 8 and 9*

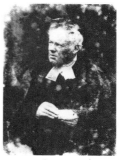

a negative, 1 modern print
 Negative size 5, inscribed 'Rev
 Miller Monikie May 29', waxed.

Professor JAMES MILLER
1812–1864
Professor of Surgery at Edinburgh,
orator and temperance reformer
See also Group 134

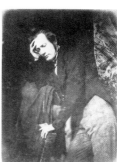

a 3 calotypes
 Print size 4.

JIMMY MILLER
Son of Professor Miller

a negative, 1 modern print
Negative size 4, inscribed 'Dr
Miller's son / 1½ DDF'.

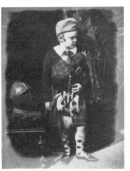

b negative, 6 calotypes
Negative size 4, inscribed
'[100?] / 15', support touched
out in pencil.

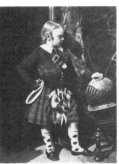

c 6 calotypes, 3 carbons
Print size 4.

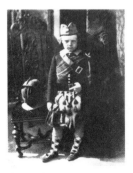

d 2 calotypes
Print size 4.

PETER MILLER
Banker

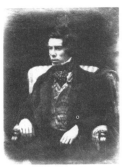

a 1 calotype
Print size 4.

Rev Dr SAMUEL MILLER
1810–1881
Of Monifieth; Free Church
minister, son of Rev James Miller
*See also Group 193 and Presbytery
Groups 8 and 9*

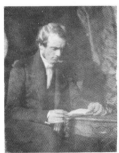

a 2 calotypes
Print size 4.

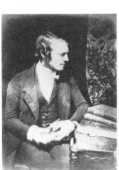

b 1 calotype, 1 carbon
Print size 4.

THOMAS MILLER
Of the Royal High School

a 3 calotypes
Print size 5. Calotype used for
the Disruption Picture.

– MITCHEL

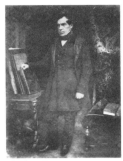

a negative, 1 calotype
Negative size 4, inscribed
'Mitchel'.

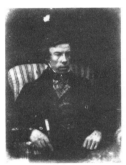

b negative, 1 calotype
Negative size 4, inscribed
'Mitchell'.

Captain MITCHEL

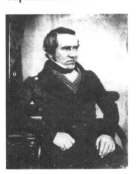

a negative, 1 modern print
Negative size 4, inscribed 'Capt
Mitchel / [D301?]', headrest
touched out in pencil.

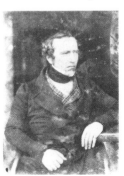

b negative, 1 calotype
Negative size 4, inscribed 'xxx',
waxed.

Rev – MOIR
*Likely to be Rev R Moir of Circus
Place School, Edinburgh
See Group 195*

Professor GEORGE MOIR
1800–1870
Professor of Rhetoric and Belles-
lettres at Edinburgh University,
advocate and author, member of the
Edinburgh Calotype Club

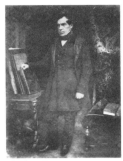

a 2 carbons
Print size 4.

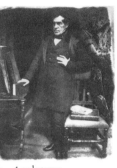

b 1 calotype
Print size 4.

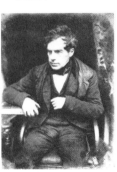

c 2 calotypes
Print size 4.

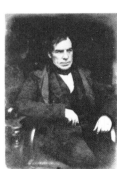

d 1 calotype, 1 later calotype
Print size 4. Apparently with a
camera on the table beside him.

ROBERT SCOTT MONCRIEFF
Of Ossoway
Also called William Scott Moncrieff of Newhalls

a 1 calotype
Print size 4. Negative in the collection of Mr John Craig Annan inscribed 'Mr Scott Moncrief June 22 44'.

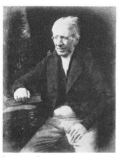

b 3 calotypes
Print size 4.

FREDERIC MONOD 1794–1863
Founder of the Free French Reformed Church. Came to Scotland with Dr D'Aubigné in 1845 and spoke to the Free Church Assembly on May 28 on behalf of the Evangelical Society of France

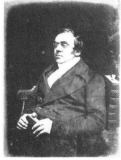

a 5 calotypes
Print size 4.

Major MONRO
Of Craiglockhart

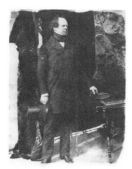

a negative, 1 calotype
Negative size 4, inscribed '15', support partly touched out in pencil.

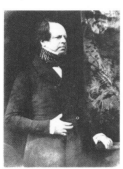

b 1 calotype or later calotype
Print size 4.

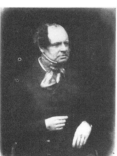

c negative, 1 later calotype
Negative size 4, inscribed 'Blackwood? / 15'.

Professor ALEXANDER MONRO 1773–1859
Professor of Anatomy at Edinburgh University

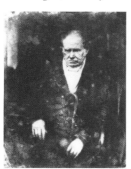

a 1 calotype, 1 carbon
Print size 4.

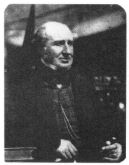

b negative, 1 modern print
Negative size 4, inscribed 'Dr Monro Aug 29 44 / DS', coat touched up in pencil.

c 6 calotypes, 2 photogravures
Print size 4.

GEORGE MONRO died 1882
Advocate
See also Group 196

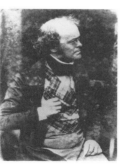

a negative, 1 modern print
Negative size 4, inscribed '36'.

ALEXANDER EARLE MONTEITH 1793–1861
Sheriff of Fife, leading Free Churchman and elder
See also Group 42 and Presbytery Groups 12 to 14

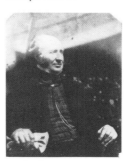

a 1 calotype
Print size 5. Calotype used for the Disruption Picture.

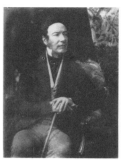

b 1 calotype
Print size 5.

Captain MONTGOMERY

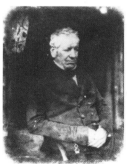

a negative, 1 calotype
Negative size 4, inscribed 'Capt Montgomery May 25–44 / turc brom / Gum / DS', marks touched out in wash.

GEORGE MOON
Of Russell Mill; manufacturer

a negative, 1 modern print
Negative size 4, inscribed 'Mr Moon Aug 23–44 / Mr Moon Russell Mill', headrest touched out in wash.

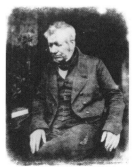

b negative, 1 modern print
Negative size 4, inscribed Mr Moon Aug 23–44 / very fine / Gum', headrest touched out and line of shoulders touched in in pencil.

JOHN MOON

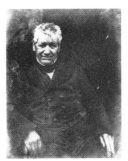

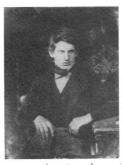

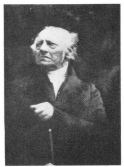

c negative, 2 calotypes
Negative size 4, inscribed 'Mr Moon Aug 23 / turc fixed / DF', area beside shoulder and shoulder shaded in pencil.

a negative, 1 modern print
Negative size 4, inscribed '304', lines of jacket drawn in and mark touched out in pencil.

e negative, 1 modern print
Negative size 4, inscribed 'John Moon Aug 28/45 / DF ¼ ex 2h / ex1h / ex½h', edge of arm shaded in in pencil.

Rev Dr GEORGE MUIRHEAD
1764–1847 (died on 5 April)
Of Cramond; Free Church minister
See also Groups 206 and 207 and Presbytery Groups 12 to 14

– MOORE
See Groups 197 to 199

Rev Dr JAMES MORGAN
1799–1873
Of Belfast; Irish Presbyterian minister
See also Group 200

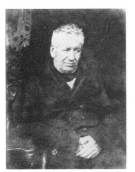

a 2 calotypes
Print size 5. Calotype used for the Disruption Picture.

General JOHN MUNRO
died 1858
Of Teaninch

d negative, 5 calotypes
Negative size 4, inscribed 'Mr Moon Aug 23–44 / xx / S. Gu [Gum?]', clothes darkened, outlines of clothes and table reinforced and spot touched out on hands in pencil.

b negative, 1 modern print
Negative size 4, inscribed 'John Moon Aug 29/45 / ex1h ¾ Gum 304', marks touched out in pencil, stained.

a 1 calotype
Print size 4.

Colonel MORISON
Of Bengal; involved in Indian missions
See Groups 201 and 202

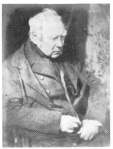

a 5 calotypes
Print size 4. Calotype used for the Disruption Picture.

– MURRAY
See Presbytery Groups 12 and 13

Presumably Rev Dr JOHN GRAY MURRAY 1820–1868
Of Auchencairn and Northshields; Free Church minister
Called 'Sir John Murray'
See Groups 103 to 105

TOM MORRIS 1821–1908
Golfer
See Group 62

Rev – MORRISON
Of Port Glasgow

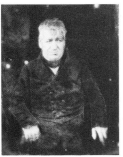

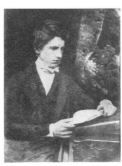

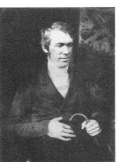

JOHN MURRAY 1808–1892
Publisher

e negative, 1 modern print
Negative size 4, inscribed 'Mr Moon Aug 23 44', lines of jacket drawn in in pencil.

c negative, 1 calotype, 1 later calotype
Negative size 4, inscribed 'Mr John Moon Sept 3/45 / ex1h Rough Gum / [Suth?]', jacket and hair reinforced and spots touched out in pencil.

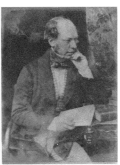

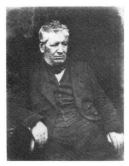

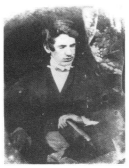

a negative, 2 calotypes
Negative size 4, inscribed '15', waxed.

a 2 calotypes, 1 albumen
Print size 4.

f 4 calotypes, 1 carbon
Print size 4.

d negative, 1 modern print
Negative size 4, inscribed 'DF G / ACG [illegible] ex 1h'.

GEORGE SHOLTO DOUGLAS, 17th EARL OF MORTON 1789–1858
See Group 228

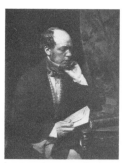

b 1 carbon, 1 print in an unidentified process
Print size 4.

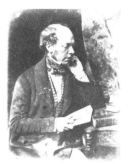

c 4 calotypes
Print size 4.

– MYLNE

a negative, 1 modern print
Negative size 4, inscribed 'Mr Mylne Aug 14 / DS', small spots touched out in wash.

b negative, 1 modern print
Negative size 4, inscribed 'Mr Mylne Aug 14 / 304', small spots touched out in wash.

Sir FRANCIS NAPIER, 10th LORD NAPIER 1819–1898
Of Napier and Ettrick; diplomat and Indian governor

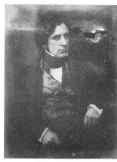

a 1 calotype
Print size 4.

MARK NAPIER 1798–1879
Advocate and historical writer, member of the Photographic Society of Scotland

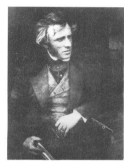

a negative, 1 calotype
Negative size 4, inscribed 'xxx Mark Napier Esq May 17/45 / 151', marks touched out in pencil.

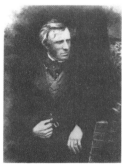

b negative, 1 calotype, 1 albumen
Negative size 4, inscribed 'xxx Mark Napier Esq May 19/45 / ½ 15', mark beside books touched out in pencil. The books are *BEAUMONT AND FLETCHER PLAYS* and Turner's *LIBER STUDIORUM*.

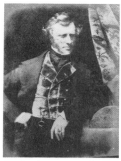

c 3 calotypes, 1 albumen
Print size 4.

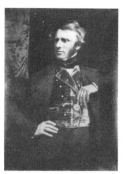

d 1 print, possibly an albumen
Print size 4.

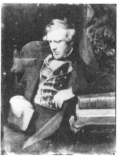

e negative, 1 modern print
Negative size 4, inscribed 'Mark Napier Esq / 8 2½ ex 1 day dull Str'.

WILLIAM NAPIER 1801–1849
Solicitor
See Groups 157 to 159 and 208 to 212

JAMES NASMYTH 1808–1890
Engineer, inventor of the steam hammer, friend of D O Hill
See also Landscape 4

a negative, 1 modern print
Negative size 4, inscribed 'xxx Nasmyth March 31 / DF', mark on arm touched out in pencil.

b 1 calotype
Print size 4.

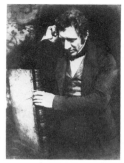

c 4 calotypes, 1 carbon
Print size 4.

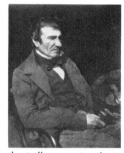

d 1 albumen, 2 carbons
Print size 4.

e 1 calotype, 1 albumen, 1 carbon
Print size 4.

DHANJIOBAI NAUROJI
1822–1908
Parsee convert, ordained as a minister of the Free Church, 11 December 1846, later a missionary at Bombay
See Group 146

– NEIL

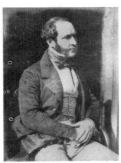

a negative, 1 calotype
Negative size 4, inscribed 'Neil May 31 / xxx / Gum Mc', small spots touched out in wash.

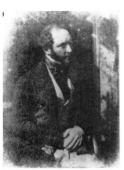

b negative, 1 modern print
Negative size 4, inscribed 'Neil May 31 / DF'.

Rev W NEILSON
See Rev Dr John Nelson

Rev Dr JOHN NELSON
1829–1878
Of Greenock and Northshields; Free Church minister
Also called 'Rev W Neilson'
See also Groups 103 to 105

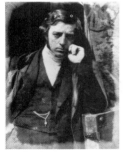

a 1 calotype
Print size 4. Calotype used for the Disruption Picture.

– NEWMAN

a negative, 2 later calotypes
Negative size 4, inscribed 'Mr Newman Octo 3 / st d1', support touched out in pencil.

Rev ROBERT BURNS NICHOLS 1815–1863
Of Galashiels; Free Church minister

a 1 calotype
Print size 4.

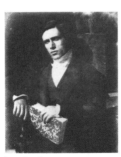

b 1 calotype
Print size 4.

Rev Dr MAXWELL NICOLSON
Or 'Nicholson'

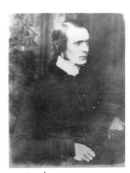

a 1 calotype
Print size 4.

WILLIAM NIELSON
Elder of the Secession Church in Glasgow

a negative, 1 calotype, 1 later calotype
Negative size 5, inscribed 'Mr William Nielson, Elder, Secession Church, Glasgow 21 Oct 1843', face and hands touched up in pencil.

PETER NIMMO

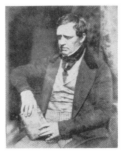

a 3 calotypes, 1 later calotype
Print size 4.

Rev WILLIAM NISBET died 1869
Of the Cowgate, Edinburgh; Free Church minister

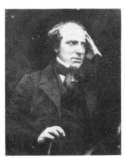

a 2 calotypes
Print size 5.

Rev ROBERT NIVEN
Missionary of the United Secession Church in South Africa

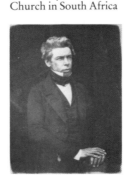

a 1 calotype
Print size 4.

Rev ANDREW NOBLE
1806–1882
Of Blairingone and London; Free Church minister
See Presbytery Group 4

SPENCER COMPTON, 2nd MARQUIS OF NORTHAMPTON
1790–1851
President of the Royal Society
The following calotypes were taken during the British Association meeting.

a negative, 1 calotype
Negative size 4, inscribed 'York Marquis of Northampton Sept 28–44', support, spots and lower edge touched out in wash.

b negative, 1 modern print
Negative size 4, inscribed 'York Marquis of Northampton Sept 28–44 / 24'.

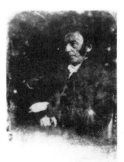

c negative, 1 modern print
Negative size 4, inscribed 'Marquis of Northampton / st / ¼ [AC?]'. Image obscure.

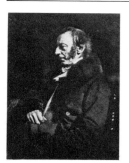

d 1 calotype, 1 photogravure
 Print size 4.

THOMAS NUSH

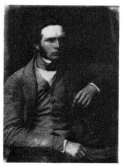

a 1 calotype
 Print size 4.

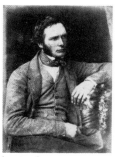

b 1 calotype
 Print size 4.

ARCHIBALD OGILVIE

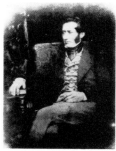

a negative, 1 modern print
 Negative size 4, inscribed 'Mr
 Arch Ogilvie', hair, face and
 drape touched up in wash.

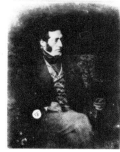

b negative, 1 modern print
 Negative size 4, inscribed 'A
 Ogilvie', small spots touched
 out in wash.

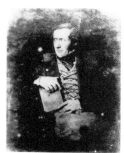

c negative, 1 modern print
 Negative size 4, inscribed
 'Ogilvie', hair touched up in
 pencil.

Rev Dr JOHN REID OMOND
1804–1892
Of Monzie; Free Church minister

a 1 calotype
 Print size 4.

W S ORR
See Group 213

– PALMER

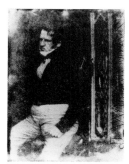

a negative, 1 modern print
 Negative size 4, inscribed 'Mr
 Palmer June 28 44 / 304 / Last
 Gum', spots touched out in
 wash.

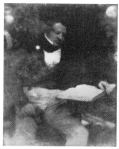

b negative, 1 modern print
 Negative size 4, inscribed 'Mr
 Palmer June 28 44 / DF
 [illegible] not [732?]'.

– PARKER
See Group 92

Rev Dr NATHANIEL PATERSON 1787–1871
Of St Andrew's Church, Glasgow;
Moderator of the Free Church
Assembly, 1850
See also Group 214

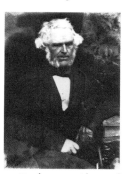

a 2 calotypes, 1 later calotype
 Print size 4.

– PAUL

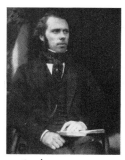

a 1 calotype
 Print size 5.

HENRY PAUL

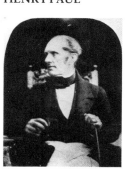

a 1 calotype
 Print size 5.

ROBERT PAUL 1788–1866
Manager of the Commercial Bank,
Free Church elder
See Presbytery Groups 21 and 22

CHARLES WILLIAM PEACH
1800–1886
Coastguard, naturalist and
geologist, friend of Hugh Miller

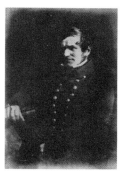

a 1 calotype, 2 carbons
 Print size 4.

– PEDDIE
Or 'Reddie' or 'Redding'
See Group 163

Dr PEDDIE
See Groups 215 and 216

JOHN DICK PEDDIE 1824–1891
Of Muckerach House, Inverness-
shire; architect, Member of
Parliament

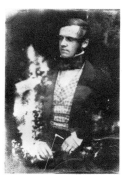

a negative, 1 calotype, 1 later
 calotype
 Negative size 4, inscribed 'John
 Dick Peddie'.

b 2 later calotypes, 1 carbon
 Print size 4.

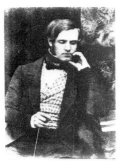

c negative on smooth, thin paper, may be a later photograph of the negative, 1 calotype, 2 later calotypes
Negative size 4.

Rev ANDREW PEEBLES
1817–1876
Of Arbroath, Colliston and Northshields; Free Church minister
See also Presbytery Group 3

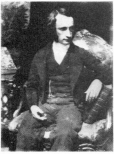

a 1 calotype
Print size 4.

Captain PEEL
Of the Scots Fusilier Guards

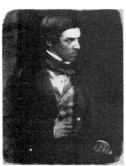

a 1 calotype, 1 later calotype, 1 albumen, 1 carbon
Print size 4.

– PETER (1)

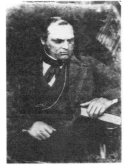

a negative, 1 modern print
Negative size 4, inscribed 'ex 2h', clothes shaded and drawn in in pencil.

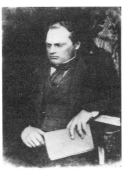

b negative, 1 modern print
Negative size 4, inscribed 'Mr Peter Sept 12 Str / 45 / DF', spots touched out in pencil.

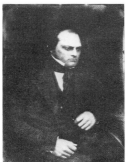

c negative, 1 modern print
Negative size 4, inscribed 'Peter May / ¼ 15', stain and headrest touched out in pencil.

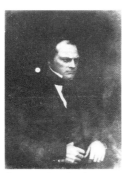

d negative, 1 calotype
Negative size 4, inscribed 'Peter May / ½ 15', headrest and stains touched out in pencil.

– PETER (2)

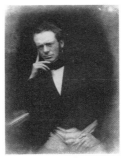

a negative, 1 later calotype
Negative size 4, inscribed 'Mr Peter / DF'.

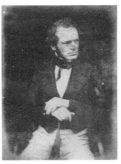

b negative, 1 calotype
Negative size 4, inscribed 'Mr Peter / 304', clothes and forehead shaded in, outlines of jacket, hair and umbrella drawn in in pencil.

ALEXANDER PETERKIN
1780–1846
Author and solicitor

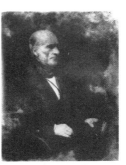

a negative, 3 carbons
Negative size 4, inscribed 'Peterkin / [304/1453?]', headrest and mark touched out in pencil.

Rev THOMAS PITCAIRN
1800–1854
Of Cockburn; Clerk of the Free Church Assembly

a 2 calotypes
Print size 5. Pose related to Hill's original design for the Disruption Picture.

Lieut-Col Sir HUGH LYON PLAYFAIR 1786–1861
Served in the Indian artillery, Provost of St Andrews
See also Group 62

a 1 calotype
Print size 6. Probably a calotype taken by Robert or John Adamson in St Andrews.

Sir LYON PLAYFAIR 1818–1898
1st Baron Playfair of St Andrews, Professor of Chemistry at the Royal Institute, Manchester and at Edinburgh University, Privy Councillor

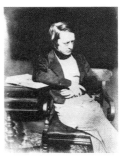

a 3 calotypes
Print size 4.

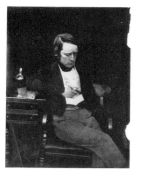

b 1 carbon
 Print size 4.

– PLUMMER

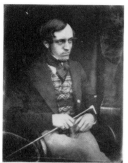

a negative, 1 carbon
 Negative size 4, inscribed
 'Plummer May 2/44 / 30'.

b negative, 1 modern print
 Negative size 4, inscribed
 'Plummer / DDF'.

Rev JOHN POLLOCK died 1855
Of Baldernock; Free Church
minister
See Presbytery Groups 6 and 7

Rev Dr JOHN PURVES died 1877
Of Jedburgh; Free Church minister
See Group 217

Dr WILLIAM PYPER 1797–1861
Of the High School, Edinburgh,
Professor of Humanity at St
Andrews from late 1844

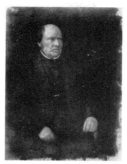

a 1 later calotype
 Print size 4.

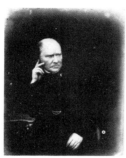

b negative, 1 later calotype
 Negative size 4, inscribed 'Dr
 Piper High School July 16 44',
 small spots on face and hands
 touched out in wash.

'R . . .'

a negative, 1 modern print
 Negative size 4, inscribed
 'R . . .?'.

b 1 carbon
 Print size 4.

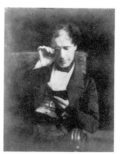

c negative, 1 modern print
 Negative size 4, inscribed
 'R . . .?'.

'J L R'

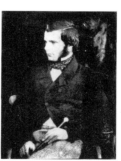

a 1 calotype or later calotype
 Print size 5. Mount inscribed
 'Daguerro-photography:–
 'Calotype' of J.L.R., looking at
 a book through an eyeglass;
 August, 1843 (in a broiling sun,)
 by Mr. D. O. Hill, on the
 Calton-Hill, Edinburgh.
 A perpetual "clean shirt". – sol
 fecit.'.

– RALPH

a negative, 1 modern print
 Negative size 4, inscribed
 'Ralph Octo 22/45 / ¼', mark
 and headrest touched out in
 pencil.

ROBERT BALFOUR WARDLAW RAMSAY
1815–1885
Of Whitehill
See also Groups 218 and 219
A large negative of this sitter, in
Glasgow University Library,
wearing the same clothes as in the
following calotypes, is dated August
8, 1845

a negative, 1 modern print
 Negative size 4, inscribed '304 /
 [h?]', stained.

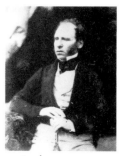

b negative, 2 calotypes, 1 later
 calotype
 Negative size 4, inscribed '15 /
 Gum', spots touched out in
 pencil, waxed.

WILLIAM RAMSAY
Newhaven fisherman
See Newhaven 32

– RANKINE
See Group 220

J (*or* I) RAP

a 1 calotype
 Print size 5. watermarked 1844.

– REDDIE
Or 'Redding'
See Peddie

HENRY REEVE 1813–1895
Editor of the *Edinburgh Review* from 1855

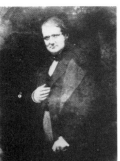

a negative, 1 modern print
Negative size 4, inscribed '15'.

b negative, 1 modern print
Negative size 4, inscribed '¼ Last [illegible] C 15', marks touched out in pencil, waxed.

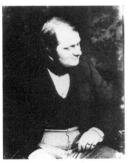

c negative, 1 calotype, 1 modern print
Negative size 4, inscribed 'Dr Reeves Octo 14/45 / ½ DD', marks touched out in pencil.

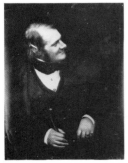

d 1 calotype, 2 later calotypes, 1 carbon
Print size 4.

Professor JOHN REID 1809–1849
Professor of Anatomy and Medicine at St Andrews

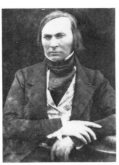

a 2 calotypes, 1 later calotype, 1 carbon, printed in reverse
Print size 4.

ROBERT REID 1776–1856
Architect

a 3 carbons
Print size 4.

JOHN (*or* B) RICHARDSON
See also Groups 208 to 212

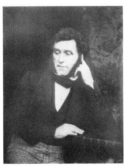

a 1 carbon
Print size 4.

Rev HENRY SCOTT RIDDELL
1798–1870
Shepherd and poet, confined in an asylum, 1841 to 1844

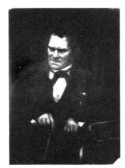

a 4 carbons
Print size 4.

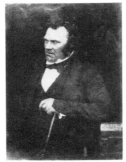

b negative, 1 modern print
Negative size 4, inscribed 'Revd. Riddle July 30/4 [] / DF', spots touched out in pencil.

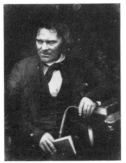

c negative, 1 modern print
Negative size 4, inscribed '304 Rev Scott Riddle / Str'.

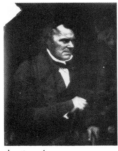

d 1 carbon
Print size 4.

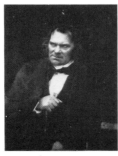

e 1 calotype
Print size 4.

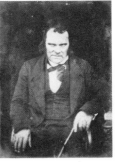

f negative, 1 calotype
Negative size 4, inscribed 'Scott Rev Mr Riddle July 30th/45 / 15 2h [du?] [su?]', marks touched out in pencil.

ROBERT STEPHEN RINTOUL
1787–1858
Editor of *The Spectator*

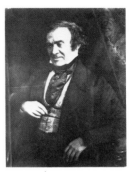

a 1 carbon
Print size 4.

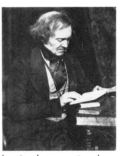

b 3 calotypes, 1 carbon, 1 photogravure
Print size 4.

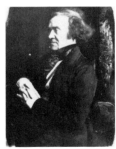

c 1 calotype
Print size 4.

ALEXANDER HANDYSIDE RITCHIE 1804–1870
RSA, sculptor
See also Groups 124 to 126

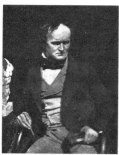

a 2 calotypes, 1 carbon
 Print size 4.

DAVID ROBERTS 1796–1864
RA, landscape painter, owned a
volume of Hill and Adamson's
calotypes

a 3 calotypes, 1 carbon
 Print size 4. Calotype taken in
 Greyfriars' Churchyard.

– ROBERTSON
See also Group 69

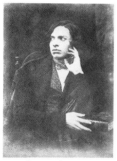

a 2 later calotypes
 Print size 4.

ALLAN ROBERTSON
1815–1859
Golfer
See Group 62

Dr DAVID ROBERTSON

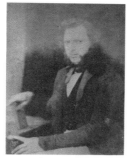

a 1 calotype
 Print size 5.

JOHN ROBERTSON
See Group 226

Rev JOHN ROBERTSON
1801–1866
Of Saline; Free Church minister
See Presbytery Groups 10 and 11

Rev M ROBERTSON
See Rev John Robson

PATRICK, Lord ROBERTSON
1794–1855
Judge, Senator of the College of
Justice
*A calotype of Lord Robertson was
exhibited in the Royal Scottish
Academy in 1845*

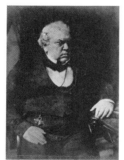

a 4 calotypes, 1 later calotype, 4
 carbons
 Print size 4.

b 1 carbon
 Print size 4.

PATRICK ROBERTSON

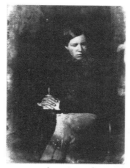

a negative, 1 modern print
 Negative size 4, inscribed
 'Patrick Robertson Jun', small
 spots touched out in wash.

W ROBERTSON
Sub-editor of *The Witness*
newspaper
See also Presbytery Groups 23 to 25

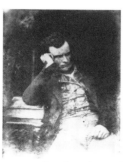

a negative, 1 modern print
 Negative size 4, inscribed 'May
 28 Mr Robertson / DF', small
 spots touched out in wash.

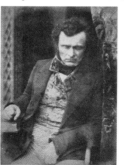

b negative, 1 calotype or later
 calotype
 Negative size 4, inscribed '28
 Robertson / Robertson
 (Witness Sub Editor) / Gum',
 small spots on face and hands
 touched out in wash.

Rev WILLIAM BRUCE ROBERTSON 1820–1886
Of Irvine; United Presbyterian
minister

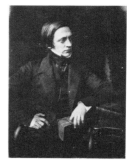

a 2 calotypes, 1 later calotype, 1
 carbon
 Print size 4. Calotype used for
 the Disruption Picture.

– ROBSON

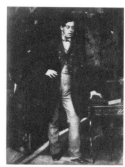

a negative, 2 calotypes
 Negative size 4, inscribed '¼ /
 15', support touched out in
 pencil, waxed.

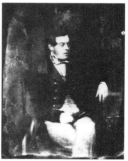

b negative, 1 modern print
 Negative size 4, inscribed 'D4',
 stained.

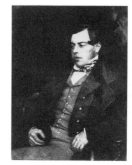

c negative, 1 modern print
 Negative size 4, inscribed
 'Robson / ¼ 15', marks touched
 out in pencil.

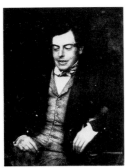

d negative, 1 modern print
Negative size 4, inscribed
'Robson Octo 16/45 / 15 ¼',
marks touched out and hair
touched up in pencil.

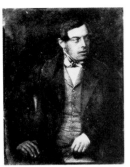

e negative, 1 modern print
Negative size 4, inscribed
'Robson Octo 16/45 / DF /
Gum ¼', coat, hair and face
touched up in pencil.

Rev JOHN ROBSON
Of Glasgow
*Or 'Rev M Robertson', also called
'Rev John Robertson'*

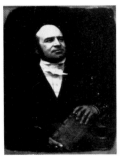

a 3 calotypes
Print size 4.

Captain ROLAND

a negative, 1 modern print
Negative size 4, inscribed 'xxx
Capt Roland 24 / DS'.

ADAM ROLLAND 1801–1890
Of Gask; solicitor

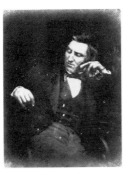

a 1 albumen, 1 carbon
Print size 4. Calotype used for
the Disruption Picture.

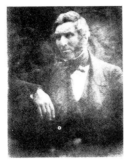

b negative, 1 albumen, 2 prints in
an unidentified process
Negative size 4, inscribed
'Adam Rolland Light 22 / 304'.

ALEXANDER ROSS
Deputy Governor in Bengal
See Groups 201 and 202

HENRY ROBERT
WESTENRA, 3rd BARON
ROSSMORE 1792–1860
Member of Parliament

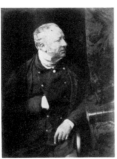

a 2 calotypes
Print size 4.

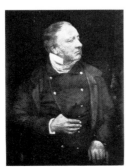

b 1 calotype, 1 carbon
Print size 4.

Rev Dr JOHN ROXBURGH
1806–1880
Of Dundee; Moderator of the Free
Church Assembly, 1867
See also Presbytery Groups 8 and 9

a 1 carbon
Print size 4.

JAMES HENRY ROBERT
INNES KER, DUKE OF
ROXBURGHE 1816–1879

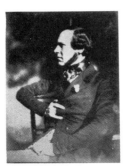

a 2 calotypes
Print size 4.

– RUSSELL

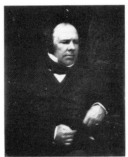

a 1 calotype, 1 carbon
Print size 4.

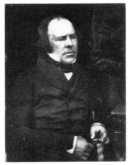

b 1 carbon
Print size 4.

Dr RUSSELL

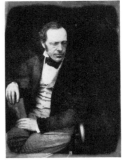

a 1 calotype
Print size 4.

ALEXANDER RUTHERFORD
Newhaven fisherman
See Newhaven 32

JAMES RUTHVEN, Lord
RUTHVEN 1777–1853

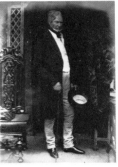

a 4 calotypes
Print size 4.

KARL HEINRICH SACH
1784–1875
Professor of Theology at the
University of Bonn, author of *Die
Kirche in Schottland*, 1844, and
made a special study of the Free
Church

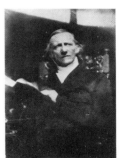

a 5 calotypes
Print size 5. Calotype used for
the Disruption Picture.

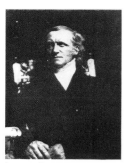

b 1 calotype
 Print size 5.

Captain St GEORGE
See Military 7 to 9

ADOLF SAPHIR 1831–1891
Hungarian Jewish convert, moved
to Edinburgh from Budapest and
became a Presbyterian minister
See Group 227

JOHN, KING OF SAXONY
1801–1873
See Group 228

JOHN CHRISTIAN SCHETKY
1778–1874
Marine painter to Queen Victoria
See also Groups 229 and 230

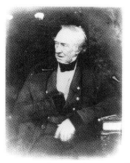

a negative, 1 calotype, 1 later
 calotype
 Negative size 4, inscribed 'xxx
 Mr S Jan 5/46 / [Dep?] D15',
 stained.

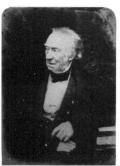

b 2 calotypes
 Print size 4.

Rev CHARLES SCHWARTZ
Jewish convert and missionary
among the Jews in Constantinople,
Berlin and Amsterdam for the
Church of England, ordained as a
Free Church missionary on May
16, 1844

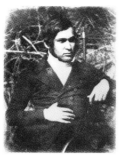

a 1 calotype
 Print size 4.

Rev Dr WILLIAM SCORESBY
1789–1857
Whaler, scientist and Arctic
explorer
*The following calotypes were
presumably taken at York during
the British Association meeting
between 28 September and 4
October, 1844*

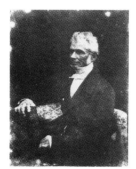

a negative, 1 modern print
 Negative size 4, inscribed 'Dr
 Scoresby', headrest touched out
 in wash.

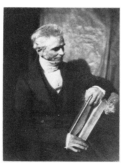

b 1 calotype, 1 carbon
 Print size 4.

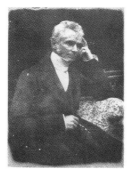

c 1 calotype
 Print size 4.

DAVID SCOTT 1806–1849
RSA, history and genre painter
See also Group 148

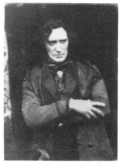

a negative, 1 calotype, 1
 photogravure
 Negative size 4, inscribed 'D
 Scott', head and shoulders
 touched up in pencil.

b negative, 2 calotypes
 Negative size 4, inscribed 'Scott
 May 22 / DS', small spots
 touched out in wash.

Rev JAMES SCOTT
born about 1800 died 1864
Of Dalmeny; Church of Scotland
minister
Or 'Rev Robert Scott of Cornwall'

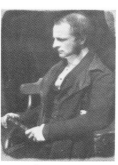

a 4 calotypes
 Print size 4.

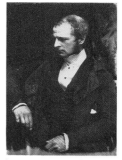

b 1 calotype
 Print size 4.

Rev ROBERT SCOTT
See Rev James Scott

Rev THOMAS SCOTT
Of Peel

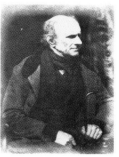

a 7 calotypes, 1 carbon
 Print size 4.

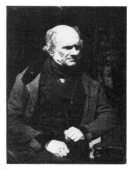

b negative, 1 modern print
 Negative size 4, inscribed 'xxx
 Mr Scott May 7/46 / 26 Gu'.

Rev WILLIAM SCOTT
1816–1885
Of St Mark's Glasgow; deposed in
1845 in the first case of heresy in the
Free Church

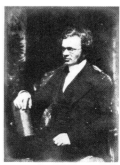

a 1 calotype
 Print size 4.

Perhaps WILLIAM BELL SCOTT 1811–1890
Poet and genre painter

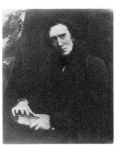

a 2 carbons
Print size 4.

CHARLES KIRKPATRICK SHARPE 1781–1851
Literary, artistic and musical amateur
See Groups 234 and 235

Probably RICHARD LALOR SHEIL 1791–1851
Dramatist and politician

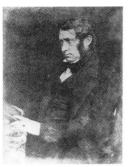

a negative, 1 calotype
Negative size 4, inscribed 'SHEIL'.

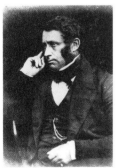

b 5 calotypes, 1 albumen
Print size 4.

J SIM
See Group 80

– SIMPSON
Or Dr Baker
See also Groups 237 to 239

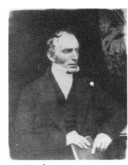

a negative, 1 modern print
Negative size 4, inscribed 'ex ¾ 300 / Gu', stained.

Dr SIMPSON
The following calotypes were taken during the British Association meeting

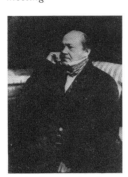

a 1 calotype, 1 carbon
Print size 4.

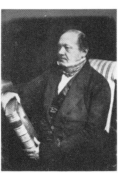

b negative, 1 calotype
Negative size 4, inscribed 'York Dr Simpson Octo 1 44', spot on mouth touched out in wash.

Rev DAVID SIMPSON 1795–1864
Of Aberdeen; Free Church minister

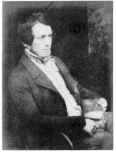

a 2 calotypes
Print size 4. Calotype used for the Disruption Picture.

JAMES SIMPSON 1781–1853
Advocate, author

a 1 calotype, 1 carbon
Print size 4.

Sir JAMES YOUNG SIMPSON 1811–1870
Surgeon, obstetrician and antiquary
Some doubt has been cast on the identity of this sitter but the portrait illustrated in the History of Scottish Medicine, *J D Comrie, vol II p 601 bears a close resemblance to the calotypes*
See also Groups 237 to 243

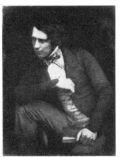

a 1 calotype, 2 carbons
Print size 4.

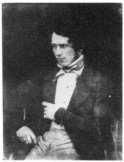

b negative, 2 calotypes
Negative size 4, inscribed 'Simpson Aug 11/45 / 15', spots touched out in pencil.

c negative, 1 modern print
Negative size 4, inscribed 'Simpson Aug 11/45 / 15', marks touched out in pencil.

GEORGE SIMSON 1791–1862
RSA, landscape painter, ran an institution for drawing, painting and sculpture, member of the Photographic Society of Scotland

a 1 calotype
Print size 5.

Captain SINCLAIR
Perhaps Captain Archibald Sinclair, born 1801
See Captain Wilkie

– SKENE
Reporter for the *Edinburgh Evening Courant*
See Presbytery Groups 23 to 25

WILLIAM FORBES SKENE
1809–1892
Solicitor, archaeologist and historian

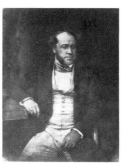

a 2 calotypes, 1 carbon
 Print size 4.

– SMITH (1)

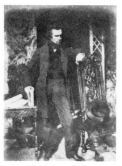

a negative, 1 calotype
 Negative size 4, inscribed
 'Smith Aug 24–44 / 304', hair
 slightly touched up in pencil.

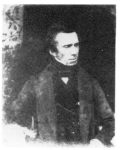

b negative, 1 calotype
 Negative size 4, inscribed
 'Smith Aug 24 44 / DF'. Lower
 part of negative defective and
 print cut down.

– SMITH (2)
See Groups 244 and 245

Sir CULLING EARDLEY SMITH 1805–1863
Member of Parliament, religious philanthropist, founder of the Evangelical Alliance in 1846

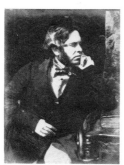

a 4 calotypes
 Print size 4.

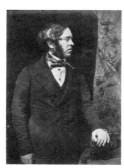

b negative, 2 calotypes
 Negative size 4, waxed.

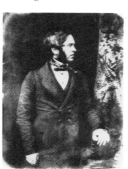

c negative, 1 modern print
 Negative size 4, waxed.

Rev JAMES SMITH 1806–1862
Of Dumbarton; Free Church minister
Also called 'Rev Mr Goodsir'
See Presbytery Groups 6 and 7

Rev SAMUEL SMITH
Of Borgue; Free Church minister

a 4 calotypes
 Print size 4.

Rev Dr JOHN SMYTH
1796–1860
Of St George's, Glasgow;
Moderator of the Free Church
Assembly, 1853
See also Groups 51 and 52

a negative, 2 calotypes
 Negative size 4, inscribed 'Rev
 Dr Smyth Glasgow / 23', marks
 touched out in pencil, waxed.

Dr GEORGE SMYTTAN
Of the Bombay Medical Board,
involved in Indian and colonial
missions

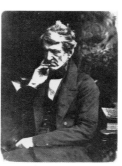

a 2 calotypes
 Print size 4.

Rev Dr ALEXANDER NEIL SOMERVILLE 1813–1889
Of Glasgow; travelled on missions
in India, Spain and Africa
See Group 217

Rev WILLIAM SORLEY
1803–1859
Of Selkirk; Free Church minister
See Group 86

ROBERT CUNNINGHAM GRAHAM SPEIRS 1797–1847
(died in December)
Advocate, Sheriff of Midlothian,
leading Free Churchman and elder,
prison reformer
See also Presbytery Groups 12 to 14

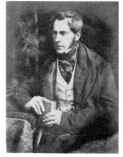

a 4 calotypes
 Print size 4. Calotype used for
 the Disruption Picture.

b 3 calotypes
 Print size 4.

Rev Dr ALEXANDER SPENCE
1804–1890
Of St Clement's, Aberdeen; Free
Church minister
See Presbytery Group 1

Professor JAMES SPENCE
1812–1882
Professor of Surgery at Edinburgh
University

a negative, 1 modern print
 Negative size 4, inscribed 'Dr
 Spence July 8–44 / 334', hair and
 arm touched up in wash.

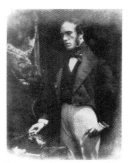

b	negative, 2 later calotypes
	Negative size 4, inscribed 'Dr
	Spence June 21 44 / DF',
	stained.

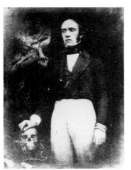

c	negative, 1 modern print
	Negative size 4, inscribed 'Dr
	Spence June 26 44 / DF'.

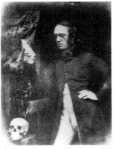

d	negative, 3 later calotypes
	Negative size 4.

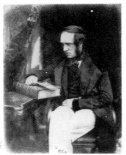

e	negative, 1 later calotype
	Negative size 4, inscribed 'Dr
	Spence July 16'

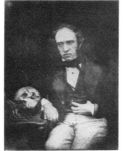

f	negative, 1 modern print
	Negative size 4, inscribed 'Dr
	Spence June 26–44 / Gum',
	small spots touched out in wash.

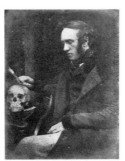

g	negative, 2 later calotypes
	Negative size 4, inscribed
	'SPENCE / 304'

h	negative, 1 later calotype
	Negative size 4, inscribed 'Dr
	Spence June 21 44', small spots
	touched out in wash.

MONTAGUE STANLEY
1809–1844 (died on 4 May)
ARSA, actor, landscape painter and
evangelist

a	1 later calotype
	Print size 5.

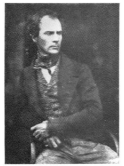

b	1 calotype
	Print size 5.

JAMES STARK
Of Dublin

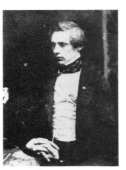

a	1 calotype
	Print size 5.

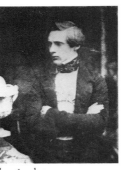

b	1 calotype
	Print size 5.

Rev JAMES STARK 1810–1890
Of Cartsburn and Greenock; Free
Church minister

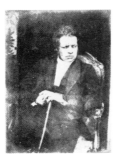

a	1 calotype, 1 later calotype
	Print size 4. Calotype used for
	the Disruption Picture.

Rev JOSEPH STARK
Of Kilfillan and Enniskillen; Free
Church minister

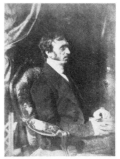

a	1 calotype
	Print size 4.

THOMAS KITCHENHAM
STAVELEY died 1860
Of the Royal Engineers, Member of
Parliament for Ripon
*The following calotypes were
presumably taken during the British
Association meeting in York in 1844*

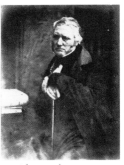

a	1 later calotype
	Print size 4.

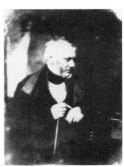

b	negative, 1 modern print
	Negative size 4, inscribed '24',
	marks touched out in pencil.

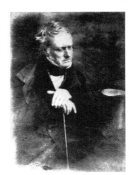

c	negative, 3 calotypes
	Negative size 4, inscribed 'xx
	Staveley Octo 3'.

– STEELE
See Group 246

JOHN STEELL
Carver and gilder

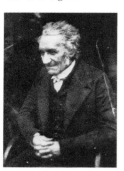

a negative, 1 modern print
Negative size 5, spots touched
out in pencil, waxed.

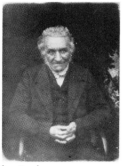

b 1 calotype
Print size 4.

Sir JOHN ROBERT STEELL
1804–1891
Sculptor, carved the statue of Sir
Walter Scott for the Monument

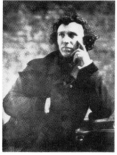

a 1 calotype, 1 carbon
Print size 4.

b negative, 1 modern print
Negative size 4, inscribed 'DF'.

– STEVENS
Or Dr Kerr
See Groups 247 to 249

JOHN STEVENS
born about 1793 died 1868
RSA, portrait and subject painter
*A calotype of John Stevens was
exhibited in the Royal Scottish
Academy in 1845*

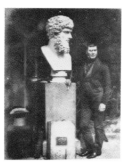

a 10 calotypes
Print size 4. The sculpted head is
Stevens's sculpture 'The Last of
the Romans'.

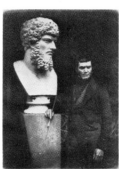

b negative, 15 calotypes
Negative size 4, inscribed 'Geo
Stevens RSA Aug 3 / 304 ¾ 68',
small spots touched out in wash.

Rev JAMES STEVENSON
1810–1865
Of Newton on Ayr; Free Church
minister, geologist
See also Presbytery Group 5

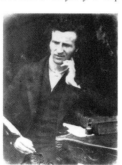

a 1 calotype
Print size 4.

JOHN STEVENSON
Of Leith

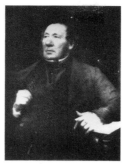

a 1 calotype
Print size 5.

– STEWART
Of Inchbrokie

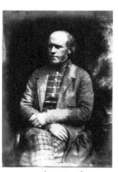

a negative, 1 calotype
Negative size 4, inscribed
'Stewart Inchbrakie / ex1h Gum
/ 15', marks and headrest
touched out in pencil.

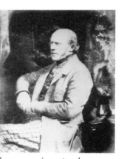

b negative, 1 calotype
Negative size 4, inscribed
'Stewart Esq Inchbreck Aug 21 /
ex1h / Gum 304', watermark
touched out in pencil.

Rev MICHAEL STIRLING
born about 1780 died 1865
Of Cargill; Free Church minister

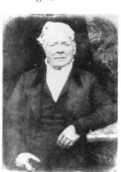

a 1 calotype
Print size 4.

b 1 calotype
Print size 4.

– STODDART
Of Gorgie

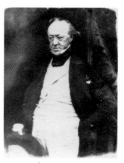

a 1 calotype
Print size 4.

**Rear Admiral PRINGLE
STODDART** 1768–1848

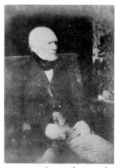

a negative, 1 later calotype
Negative size 4, inscribed
'Admiral Stoddart', headrest
and spots touched out in wash.

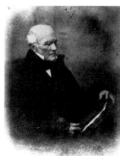

b negative, 1 later calotype
Negative size 4, inscribed 'S . . .
T . . .?', headrest touched out in
wash.

Rev – STRUTHERS
Of Hamilton; United Secession minister, Moderator of the Synod, 1843, attended the Free Church meeting in Glasgow, October 1843

a negative, 1 modern print
Negative size 4, inscribed 'Mr Struthers Hamilton / Light'.

CHARLES EDWARD STUART
1799–1880
Alias Charles Stuart Hay Allan, brother of John Sobieski Stuart
A calotype of Charles Edward Stuart was exhibited at the Royal Scottish Academy in 1844

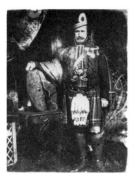

a 1 calotype
Print size 4.

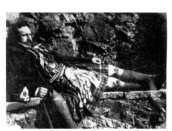

b 4 calotypes
Print size 4.

JOHN SOBIESKI STOLBERG STUART 1797–1872
Alias John Allen or John Hay Allan. Claimed descent from Prince Charles Edward and the Countess of Albany

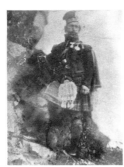

a 1 calotype
Print size 4.

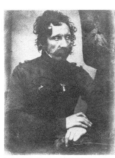

b 1 calotype
Print size 4.

Rev Dr ANDREW SUTHERLAND died 1867
Of St Andrew's Church, Dunfermline, and Gibraltar; Free Church minister

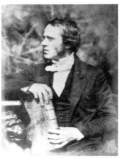

a 4 calotypes
Print size 4, inscription printed off from the negative 'June 1/45'.

Provost JOHN SWAN
Of Kirkcaldy

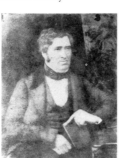

a 1 calotype
Print size 4.

– SWINTON

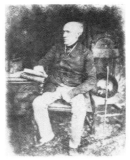

a negative, 1 modern print
Negative size 4, inscribed 'Swinton Aug 29', spots touched out in wash.

b negative, 1 modern print
Negative size 4, inscribed 'Swinton Aug 29 / DF Gum', stained.

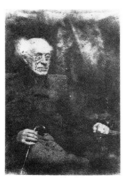

c negative, 1 modern print
Negative size 4, inscribed 'Swinton / D2', headrest touched out in wash.

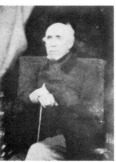

d negative, 1 calotype
Negative size 4, inscribed 'Swinton Light / D2'.

JAMES RANNIE SWINTON
1816–1888
Portrait painter

a negative, 1 calotype
Negative size 4, inscribed 'Swinton R Aug 29 44 / Gum'.

b negative, 1 modern print
Negative size 4, inscribed 'Swinton R Aug 29 / DF', hair touched up in pencil.

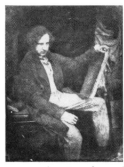

c negative, 1 modern print
Negative size 4, inscribed 'Swinton R / DF', hair, clothes and portfolio touched up in pencil and wash.

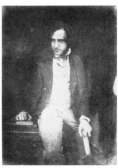

d negative, 1 calotype
Negative size 4, inscribed 'Swinton R Aug 29 / 304'.

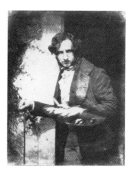

e negative, 1 modern print
 Negative size 4, inscribed
 'Swinton R Aug 29–44 / Gum',
 spots on face touched out in
 wash.

f *negative, 1 modern print*
 Negative size 4, inscribed 'DS /
 S'. Image obscure, not
 illustrated.

Rev JOHN SYM 1809–1855
Of Greyfriars' Church; Edinburgh,
Free Church minister
See Groups 60 and 61

**Professor ANDREW
SYMINGTON** 1785–1853
Professor of Theology at Glasgow,
Reformed Presbyterian minister
See also Group 251

a negative, 1 modern print
 Negative size 5, inscribed 'Dr
 Symington Glasgow', waxed.
 Calotype used for the
 Disruption Picture.

**Rev Dr WILLIAM
SYMINGTON** 1795–1862
Reformed Presbyterian minister,
succeeded Andrew Symington as
Professor of Theology
See also Group 251

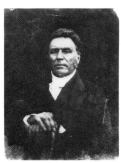

a negative, 1 modern print
 Negative size 5, inscribed 'Prof
 Symington Paisley', waxed.
 Calotype used for the
 Disruption Picture.

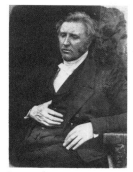

b 1 calotype
 Print size 4.

Rev – TAYLOR

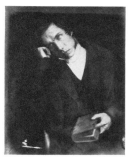

a 1 later calotype
 Print size 4.

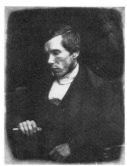

b 1 calotype
 Print size 4.

COOK TAYLOR
*The following calotypes were taken
during the British Association
meeting in York*

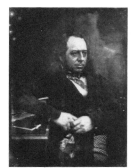

a negative, 1 modern print
 Negative size 4, inscribed
 'Cook Taylor Octo 3–44 / D6 /
 G', area beside head shaded out
 in pencil.

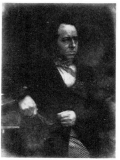

b 1 calotype
 Print size 4.

INNES TAYLOR

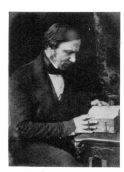

a 1 calotype
 Print size 4.

JOHN TAYLOR

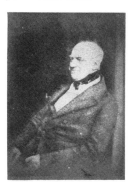

a 1 later calotype
 Print size 4.

Rev ROBERT TAYLOR
born 1824
Of Kirkurd; Free Church minister
See Groups 103 to 105

**Dr WILLIAM COOKE
TAYLOR** 1800–1849
Historical and educational author
and translator, advocate of national
education and free trade

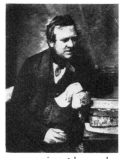

a negative, 1 later calotype, 1
 albumen
 Negative size 4, inscribed 'xxx
 Dr W Cooke Taylor Octo 3',
 headrest touched out in pencil.
 Calotype taken during the
 British Association meeting in
 York in 1844.

ALEXANDER THOMSON
1798–1868
Of Banchory; leading Free
Churchman

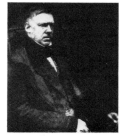

a 2 calotypes
 Print size 5.

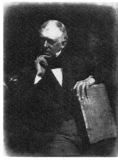

b 2 calotypes
 Print size 4. Calotype used for
 the Disruption Picture.

c 1 calotype, 1 later calotype
 Print size 4.

Professor ALLEN THOMSON
1809–1884
Biologist, Professor of Physiology at Edinburgh University, 1842 to 1848, Professor of Anatomy at Glasgow, 1848 to 1877
See also Groups 253 and 254

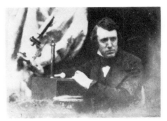

a 1 calotype
 Print size 5.

Rev JAMES THOMSON
1800–1871
Of Dollar and Muckhart; Free Church minister
See Presbytery Group 4

Rev JOHN THOMSON
See Group 252

LAWRENCE THOMSON
This may be two men, Lawrence and Thomson
See Group 252

Rev DAVID THORBURN
1805–1893
Of South Leith; Free Church minister
See Presbytery Groups 12 and 13

Rev JOSEPH THORBURN
1799–1854
Of the Free English Church, Inverness

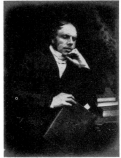

a 2 calotypes
 Print size 4. Calotype used for the Disruption Picture.

JAMES TOD died 1858
Of Deanston; solicitor

a negative, 1 calotype
 Negative size 4, inscribed 'Mr Todd July 18 / Gum', mark on sleeve touched out in pencil.

b negative, 1 modern print
 Negative size 4, inscribed 'Gum', stained.

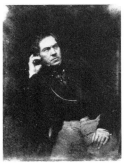

c negative, 1 modern print
 Negative size 4, inscribed 'Mr Todd July 12 44 / DF / Gum', marks touched out in pencil.

O W TREYEVANT
Or Napier
See Groups 208 to 212

GEORGE TROUP
Editor of *The Banner of Ulster*, the *Aberdeen Banner* and *The Witness*
See Group 255

Rev Dr WILLIAM KING TWEEDIE 1803–1863
Of the Tolbooth Church, Edinburgh; Free Church minister
See also Presbytery Groups 12 and 13

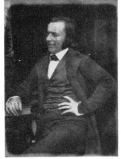

a 2 calotypes
 Print size 4. Calotype used for the Disruption Picture.

HENRY VINCENT 1813–1878
Chartist, parliamentary candidate

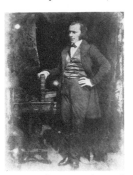

a negative, 1 modern print
 Negative size 4, inscribed 'Vincent', marks and bottom edge touched out in wash.

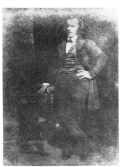

b negative, 1 modern print
 Negative size 4, inscribed 'Vincent / DF', spots on face touched out and line of hair touched in in pencil.

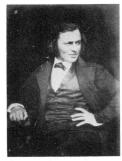

c negative, 1 calotype
 Negative size 4, inscribed 'Vincent', small spots touched out in wash.

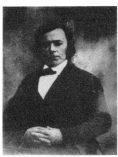

d negative, 1 calotype
 Negative size 4, inscribed 'Vincent / DF', hair touched up in wash.

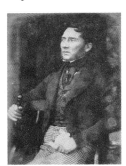

e 1 calotype
 Print size 5.

Captain WADE

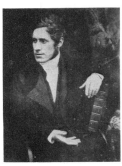

a negative, 1 calotype
 Negative size 4, inscribed 'Capt Wade Aug 26/45 / ex1h / 15 1½ Gu', spots on face and hands touched out in wash.

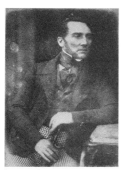

b 1 calotype
Print size 4.

WAINHOUSE
Or Muirhouse
See also Groups 240 to 243

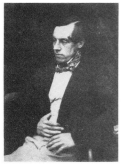

a negative, 1 calotype
Negative size 4, inscribed 'xxx
Wainhouse [*or* Muirhouse]
Aug 11/45 / 204'.

Rev Dr JAMES WALKER
1812–1891
Of Carnwath; Free Church
minister
See Groups 103 to 105

Rev JOHN AIKMAN
WALLACE 1802–1870
Of Hawick; Free Church minister

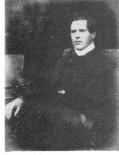

a 1 calotype
Print size 4.

– WATSON
See Group 110

– WAUCHOPE

a negative, 1 calotype
Negative size 4, inscribed
'Wauchope / Last / Gum'.

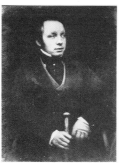

b negative, 1 modern print
Negative size 4, inscribed
'Waughope Dark / 324 / Gum'.

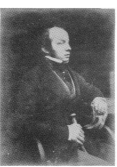

c negative, 1 calotype
Negative size 4, inscribed
'WAUCHOPE', spots on face
and hands touched out in wash.

– WELSH

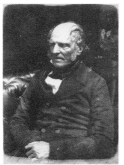

a 2 calotypes
Print size 4.

Rev Dr DAVID WELSH
1793–1845
Professor of Church History at
Edinburgh University, Professor of
Divinity at New College,
Edinburgh, Moderator of the
Assembly of the Church of
Scotland in 1843, read the Protest
and headed the walk-out
See also Groups 42, 60, 61 and 263

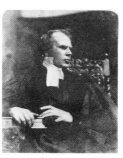

a 12 calotypes
Print size 5. Calotype used for
the Disruption Picture.

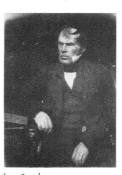

b 2 calotypes
Print size 4.

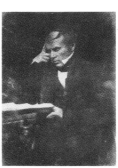

c 2 calotypes
Print size 4.

Perhaps Rev Dr WILLIAM
WELSH 1820–1892
Of Broughton and Mossfennan;
Free Church minister
See also Groups 103 to 105

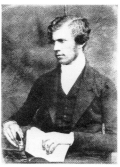

a 2 later calotypes
Print size 4.

FRANCIS CHARTERIS, 10th
EARL OF WEMYSS 1818–1914

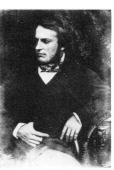

a 1 albumen
Print size 4.

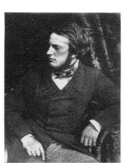

b 1 calotype, 1 later calotype, 1
carbon
Print size 4.

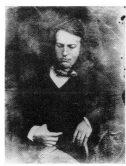

c negative, 1 modern print
Negative size 4.

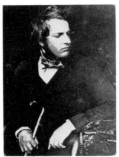

d 1 calotype
 Print size 4.

JOHN STUART–WORTLEY, 2nd BARON WHARNCLIFFE
1801–1855
See also Groups 269 and 270

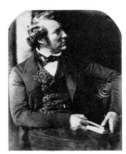

a 1 calotype
 Print size 4.

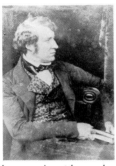

b negative, 1 later calotype
 Negative size 4, hair touched up
 in pencil, waxed.

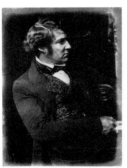

c 2 calotypes
 Print size 4. Negative in
 Glasgow University Library.

Rev ADAM WHITE 1808–1873
Of Orkney, North Isles; Free
Church minister

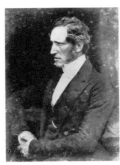

a 2 calotypes, 1 later calotype
 Print size 4. Calotype used for
 the Disruption Picture.

J (*or* T) WHITE
Of Haddington; presumably a
geologist

a negative, 1 calotype
 Negative size 5, inscribed
 'White', waxed. The sitter is
 holding a geologist's hammer.

*b negative, 1 modern print
 Negative size 5, inscribed 'Mr J
 [or T] White'. Image obscure,
 not illustrated.*

Dr WHYTE
Of Haddington
May be confused with J White

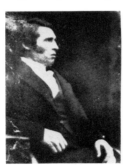

a 1 calotype
 Print size 4.

Rev Dr SAMUEL WILBERFORCE 1805–1873
Dean of Westminster, Bishop of
Oxford
*Note: either one of the following
photographs has been printed in
reverse (the hair parting is on
different sides of the head) or the
identity of one must be called into
question. Both calotypes were taken
during the British Association
meeting in York between 28
September and 4 October, 1844*

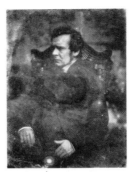

a 1 carbon
 Print size 4.

b 1 calotype or later calotype
 Print size 4.

– WILKIE
Of Trinity

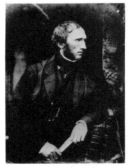

a negative, 1 modern print
 Negative size 4, inscribed 'xxx
 Mr Wilkie May 17/45 / 15',
 small spots touched out and hair
 touched up in wash. One of the
 books under the sitter's elbow is
 *BEAUMONT & FLETCHER
 PLAYS.*

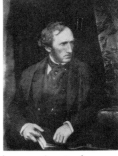

b negative, 1 calotype
 Negative size 4, inscribed 'xxx
 Mr Wilkie May 17/45 / 15 /
 Gum'.

c negative, 1 modern print
 Negative size 4, inscribed '136'.

Captain WILKIE
*Or Captain Sinclair. Has been
called 'John Ruskin'*

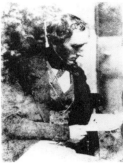

a 3 calotypes, 2 carbons
 Print size 4. Calotype taken in
 Greyfriars' Churchyard.

– WILKINSON
See also Groups 264 and 265

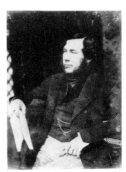

a negative, 2 calotypes
 Negative size 4, inscribed 'Mr
 Wilkinson May 22/45 / 15',
 small spots on hands and hair
 touched up in pencil.

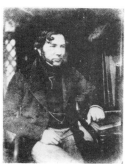

b negative, 1 modern print
Negative size 4, inscribed 'Mr
Wilkinson may 22/45 / 44 ½
Last [or fast] / HV [or Y]'.

– WILLIAMSON
Huntsman to the Duke of
Buccleuch
*A calotype of Williamson was
exhibited in the Royal Scottish
Academy in 1844*

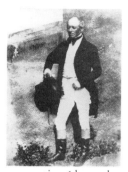

a negative, 1 later calotype
Negative size 4, inscribed
'Williamson Huntsman',
touched up in the top left corner
to make an apparent window
and ledge.

b negative, 1 modern print
Negative size 4, inscribed
'Williamson', headrest touched
out in wash.

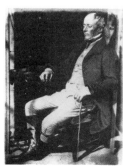

c 1 calotype
Print size 4.

Rev – WILSON
Of Dundee
*Perhaps Rev Joseph Wilson
1807–1873
See Presbytery Groups 8 and 9*

Rev DAVID WILSON 1810–1881
Of Fullarton, Ayr; Free Church
minister
See also Presbytery Group 18

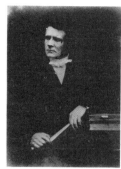

a 1 calotype
Print size 4.

JOHN WILSON 1774–1855
RA, marine painter

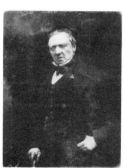

a negative, 1 calotype
Negative size 4, inscribed 'xxx
Wilson RA / ex¾h / 15', marks
touched out in wash on face and
hands.

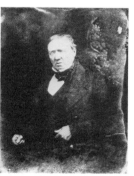

b negative, 1 modern print
Negative size 4, inscribed 'xxx
Wilson / 1½ 15', marks touched
out in pencil.

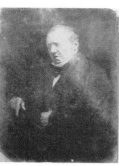

c negative, 1 later calotype
Negative size 4, inscribed '15
Gu'.

Rev Dr JOHN WILSON
1804–1875
Vice-Chancellor of the University
of Bombay

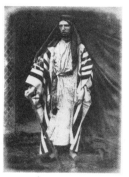

a 2 calotypes
Print size 4.

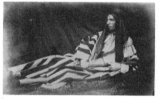

b negative, 1 calotype, 1 albumen
Negative size 4, inscribed 'DF
St', area round feet touched out
in wash

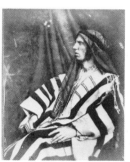

c negative, 1 calotype
Negative size 3, inscribed 'Dr
Wilson Sept 7', headrest
touched out in pencil.

Professor JOHN WILSON
1785–1854
'Christopher North', poet and
essayist, editor of *Blackwood's
Magazine*, Professor of Moral
Philosophy

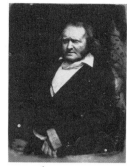

a 2 calotypes
Print size 4.

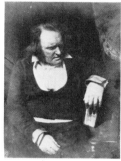

b 6 calotypes
Print size 4.

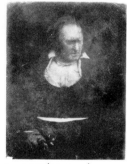

c negative, 1 carbon
Negative size 4, inscribed
'"Christopher North"', waxed.

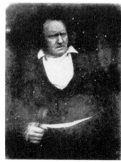

d negative, 3 carbons
Negative size 4, inscribed
'Professor Wilson March 29/45
/ DF'.

PATRICK WILSON
Of Arbroath

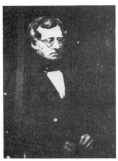

a 1 calotype
 Print size 5.

Rev THOMAS WILSON
died 1872
Of Friockheim; Free Church
minister
See Presbytery Group 3

Rev Dr WILLIAM WILSON
1808–1888
Of Carmylie and Free Mariners'
Church, Dundee
See Presbytery Group 3

Rev Dr JAMES JULIUS WOOD
1800–1877
Of Greyfriars' Church, Edinburgh;
Moderator of the Free Church
Assembly, 1857
*A calotype of James Julius Wood was
exhibited in the Royal Scottish
Academy in 1844*

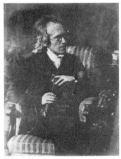

a (1) negative, 7 calotypes
 Negative size 4, inscribed
 'Revd John Julius Wood of
 Greyfriars Edin. Glasgow 22
 Oct 1843', the inscription on
 the cover of the book has been
 drawn in, the headrest
 touched out in wash.

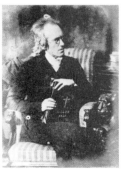

a (2) 1 calotype
 Earlier print from the same
 negative as a (1), with a
 different inscription drawn
 on the book.

JOHN GEORGE WOOD
1804–1865
Solicitor, Secretary of the Free
Church Committee for the
Conversion of the Jews, member of
the Photographic Society of
Scotland

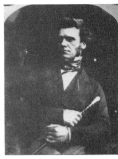

a 3 calotypes
 Print size 5.

Rev WALTER WOOD 1812–1882
Of Westruther and Elie; Free
Church minister
See also Groups 219 and 268

a negative, 2 calotypes
 Negative size 5, inscribed 'xx
 Rev W. Wood / Wood
 Westruther'.

Major WRIGHT
Of the Leith Fort Artillery
See Military 6, 9 and 10

JAMES WYLD
Of Gilston; Leith merchant, father-
in-law of John Stuart Blackie
See also Groups 201 and 202

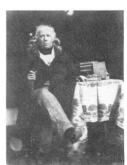

a negative, 2 later calotypes
 Negative size 5, inscribed 'Wyld
 / Sir D. Brewster [the second
 identity in a later hand]', waxed.

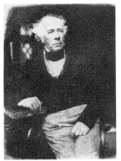

b 1 calotype
 Print size 4. Calotype used for
 the Disruption Picture.

Rev Dr JAMES AITKEN WYLIE
1808–1890
Sub-editor of *The Witness*
newspaper, Free Church minister

a 1 calotype
 Print size 4.

– YOUNG

a 2 calotypes
 Print size 4.

DAVID YOUNG
Newhaven fisherman
See Newhaven 4 and 23

Rev ROBERT YOUNG died 1865
Of Auchterarder; Church of
Scotland minister

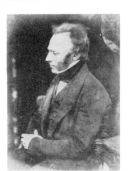

a negative, 1 later calotype
 Negative size 4, inscribed '1½ /
 15', marks on forehead touched
 out in pencil, stained.

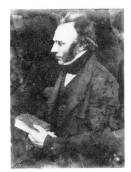

b 2 calotypes
 Print size 4.

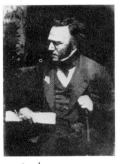

c 1 calotype
 Print size 4.

d 1 calotype
 Print size 4.

Unknown Men

UNKNOWN MAN 1

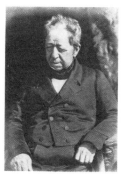

a 2 calotypes, 3 later calotypes, 1
 carbon
 Print size 4. Negative in the
 collection of Mr John Craig
 Annan.

UNKNOWN MAN 2

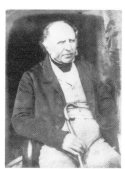

a 1 calotype
 Print size 4.

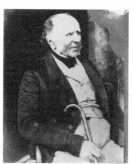

b 2 calotypes
 Print size 4.

UNKNOWN MAN 3

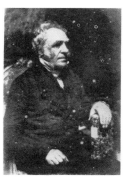

a 1 calotype
 Print size 4.

UNKNOWN MAN 4

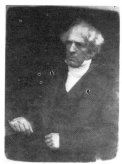

a 1 calotype
 Print size 4.

UNKNOWN MAN 5

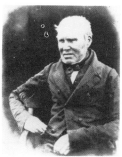

a negative, 1 albumen
 Negative size 4, waxed.

UNKNOWN MAN 6

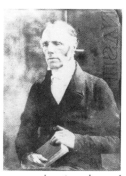

a negative, 1 calotype
 Negative size 4, inscribed 'DF /
 G', headrest touched out and
 lines of jacket drawn in in
 pencil.

UNKNOWN MAN 7

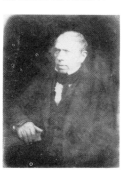

a 1 calotype
 Print size 4.

UNKNOWN MAN 8

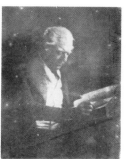

a negative, 1 carbon
 Negative size 4, inscribed 'Last
 [illegible] / 304', headrest and
 spots on book touched out,
 lines of jacket drawn in in
 pencil.

UNKNOWN MAN 9

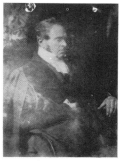

a negative, 1 modern print
 Negative size 4, inscribed 'May
 28 46 / 15', paper watermarked
 'NASH'.

UNKNOWN MAN 10

*a negative, 1 modern print
 Negative size 4, torn and image
 obscure, not illustrated.*

UNKNOWN MAN 11

*a negative, 1 modern print
 Negative size 4, inscribed '1h
 DF', badly stained and image
 obscure, not illustrated.*

UNKNOWN MAN 12

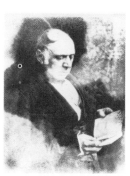

a negative, 1 modern print
 Negative size 4, inscribed
 'worth trying', paper
 watermarked 'T NASH'.

UNKNOWN MAN 13

a 1 calotype
 Print size 4.

UNKNOWN MAN 14

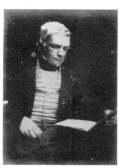

a 1 calotype
 Print size 4.

UNKNOWN MAN 15

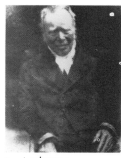

a 1 calotype
 Print size 5.

UNKNOWN MAN 16

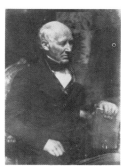

a 1 calotype
 Print size 5.

UNKNOWN MAN 17

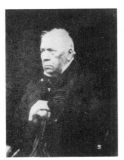

a 1 calotype
 Print size 5.

UNKNOWN MAN 18

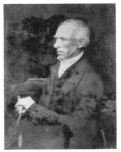

a 1 calotype
 Print size 4.

UNKNOWN MAN 19

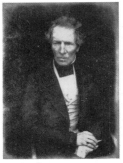

a 1 calotype
 Print size 4.

UNKNOWN MAN 20

a negative, 1 calotype
 Negative size 4, inscribed 'DF /
 ¼ A / York Octo 44', jacket
 shaded in and mark on leg
 touched out in pencil. Print cut
 down.

UNKNOWN MAN 21

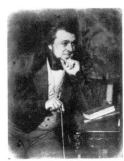

a negative, 1 modern print
 Negative size 4, inscribed 'Mr
 Octo 20/45 / ¼ Gum', marks
 touched out and lines of jacket
 drawn in in pencil. Paper
 embossed 'SUPERFINE
 BATH'.

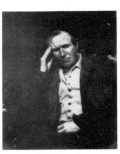

b 1 calotype, 1 carbon
 Print size 4.

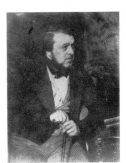

c 1 calotype
 Print size 4.

UNKNOWN MAN 22

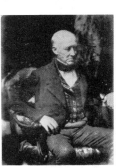

a 1 calotype
 Print size 4.

UNKNOWN MAN 23
See also Unknown Group 1

a negative, 1 modern print
 Negative size 4, inscribed 'June
 27 44 / Gum', spots on face
 touched out in wash.

UNKNOWN MAN 24

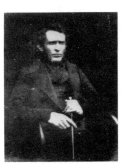

a 1 calotype
 Print size 5.

UNKNOWN MAN 25

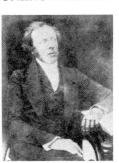

a 1 calotype
 Print size 5.

UNKNOWN MAN 26

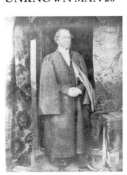

a 1 calotype
 Print size 4.

UNKNOWN MAN 27

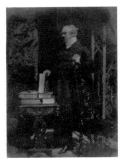

a 1 later calotype, 1 carbon
 Print size 4.

UNKNOWN MAN 28

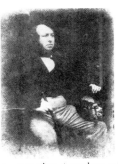

a negative, 1 modern print
 Negative size 4, inscribed
 '[7ch?] June 27 44 / DF'.

UNKNOWN MAN 29

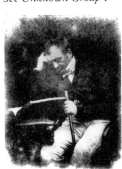

a 1 calotype
 Print size 5.

UNKNOWN MAN 30
See Unknown Group 1

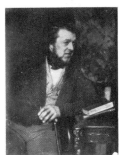

a negative, 1 modern print
 Negative size 4, inscribed 'DF'.

UNKNOWN MAN 31

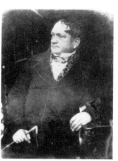

a negative, 1 modern print
Negative size 4, inscribed 'DI5 /
1h', marks touched out in
pencil.

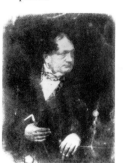

b negative, 1 modern print
Negative size 4, inscribed '1h
[DD5?]'.

UNKNOWN MAN 32

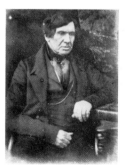

a 1 calotype or later calotype
Print size 4. Negative in the
collection of Mr John Craig
Annan.

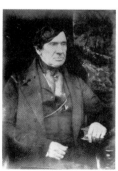

b 1 calotype
Print size 4.

UNKNOWN MAN 33

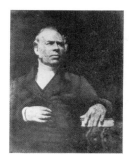

a 1 calotype
Print size 5.

UNKNOWN MAN 34

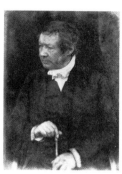

a negative, 1 later calotype
Negative size 4.

UNKNOWN MAN 35

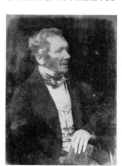

a 1 calotype
Print size 4.

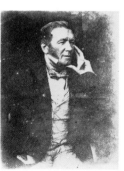

b 1 calotype or later calotype
Print size 4.

UNKNOWN MAN 36

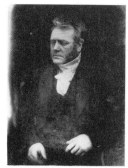

a 1 calotype
Print size 4.

UNKNOWN MAN 37

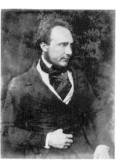

a 1 calotype
Print size 4. Negative in
Glasgow University Library.

UNKNOWN MAN 38

a 2 calotypes
Print size 5.

UNKNOWN MAN 39

a 1 calotype
Print size 4.

UNKNOWN MAN 40

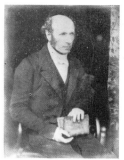

a 3 calotypes
Print size 4.

UNKNOWN MAN 41

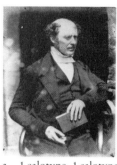

a 1 calotype, 1 calotype or later
calotype
Print size 4.

UNKNOWN MAN 42

a negative, 1 modern print
Negative size 5, inscribed 'D1'.

UNKNOWN MAN 43

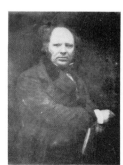

a 1 calotype
Print size 5.

UNKNOWN MAN 44

a negative, 1 calotype
Negative size 4, inscribed
'20–40 / DF'. The sitter is
holding a copy of *Blackwood's
Magazine*.

UNKNOWN MAN 45

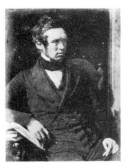

a 1 calotype
Print size 4.

UNKNOWN MAN 46

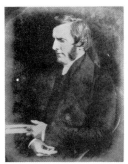

a 1 calotype
Print size 4.

UNKNOWN MAN 47

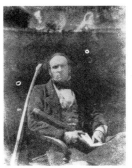

a negative, 1 modern print
Negative size 4, inscribed
'[Jn?]'. Image obscure.

UNKNOWN MAN 48

a negative, 1 modern print
Negative size 4, inscribed '15'.

UNKNOWN MAN 49

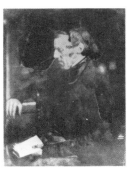

a negative, 1 modern print
Negative size 4, inscribed 'One
of the Secretaries / Qy R
Griffith? L. L. Boscawen
Ibbetson? Wm West? / DS',
stained. Image obscure.

UNKNOWN MAN 50

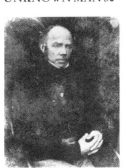

a negative, 1 modern print
Negative size 4.

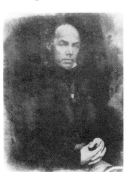

b negative, 1 print possibly an
albumen, 1 modern print
Negative size 4.

UNKNOWN MAN 51

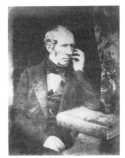

a negative, 1 modern print
Negative size 4, inscribed 'DF /
¼ F [illegible]'. Image obscure.

UNKNOWN MAN 52

a *negative, 1 modern print
Negative size 4. Image obscure,
not illustrated.*

UNKNOWN MAN 53

a *negative, 1 modern print
Negative size 4, inscribed 'DF /
[illegible] 2h / transp.', badly
stained. Image obscure, not
illustrated.*

UNKNOWN MAN 54

a *negative, 1 modern print
Negative size 4, inscribed
'DDF', badly stained. Image
obscure, not illustrated.*

UNKNOWN MAN 55

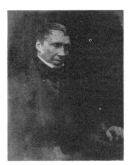

a 1 calotype
Print size 4.

UNKNOWN MAN 56

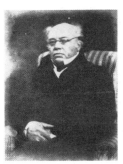

a 1 calotype
Print size 4.

UNKNOWN MAN 57

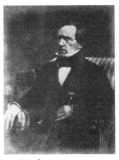

a 1 calotype
Print size 4.

UNKNOWN MAN 58

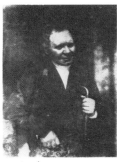

a 1 calotype
Print size 4.

UNKNOWN MAN 59

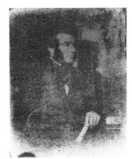

a 1 calotype
Print size 5.

UNKNOWN MAN 60

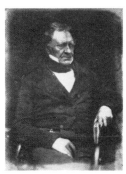

a 1 calotype
Print size 4.

UNKNOWN MAN 61

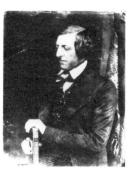

a negative, 1 modern print
Negative size 4, waxed.

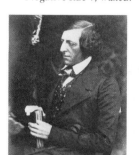

b 1 albumen
Print size 4.

UNKNOWN MAN 62

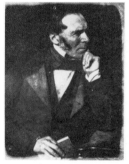

a 1 calotype
Print size 4.

UNKNOWN MAN 63

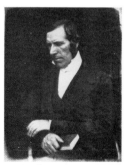

a 1 calotype
Print size 4.

UNKNOWN MAN 64

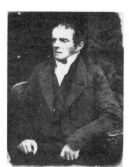

a 1 calotype
Print size 4.

UNKNOWN MAN 65

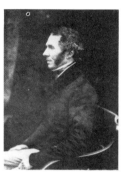

a 2 calotypes
Print size 5.

UNKNOWN MAN 66

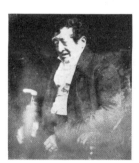

a 1 calotype
Print size 5.

UNKNOWN MAN 67

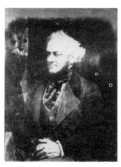

a 1 calotype
Print size 5.

UNKNOWN MAN 68

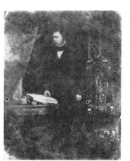

a negative, 1 modern print
Negative size 4, inscribed 'DS
[LL?] 1 / [teep?] Str'.
Image obscure.

UNKNOWN MAN 69

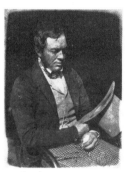

a 1 calotype
Print size 4.

UNKNOWN MAN 70

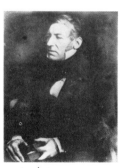

a 1 calotype
Print size 4. Negative in the
collection of Mr John Craig
Annan.

UNKNOWN MAN 71

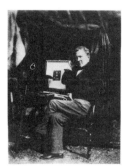

a 1 calotype
Print size 5.

UNKNOWN MAN 72

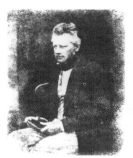

a negative, 1 modern print
Negative size 4.

UNKNOWN MAN 73

a 1 calotype
Print size 4.

UNKNOWN MAN 74

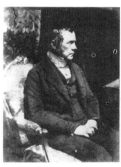

a 1 calotype
Print size 4.

UNKNOWN MAN 75

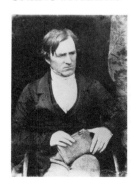

a 2 calotypes, 1 carbon printed in
reverse
Print size 4.

UNKNOWN MAN 76

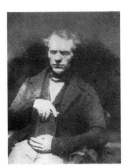

a 1 calotype
 Print size 5.

UNKNOWN MAN 77

a 1 calotype
 Print size 4.

UNKNOWN MAN 78

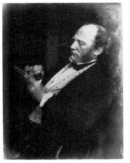

a negative, 1 later calotype
 Negative size 4, inscribed '[¼ ?]
 15', marks on face touched out
 in pencil.

UNKNOWN MAN 79

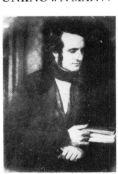

a 1 calotype
 Print size 5.

UNKNOWN MAN 80

a 2 calotypes
 Print size 4.

UNKNOWN MAN 81

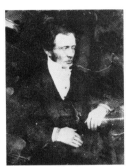

a 1 calotype
 Print size 4, torn and stained.

UNKNOWN MAN 82

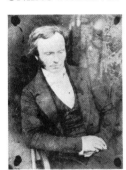

a 1 calotype
 Print size 4, stained.

UNKNOWN MAN 83

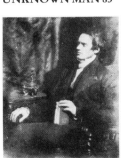

a 1 calotype
 Print size 5.

UNKNOWN MAN 84

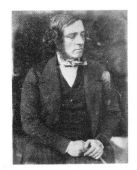

a 2 calotypes
 Print size 4.

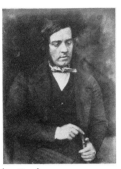

b 2 calotypes
 Print size 4.

UNKNOWN MAN 85

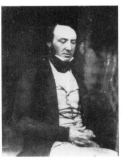

a 1 calotype
 Print size 5.

UNKNOWN MAN 86

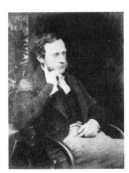

a 2 calotypes
 Print size 5.

UNKNOWN MAN 87

a negative, 1 later calotype
 Negative size 4, inscribed
 '[¹/₇?]'.

b 1 calotype
 Print size 4.

UNKNOWN MAN 88

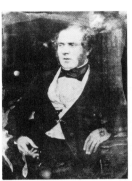

a negative, 1 modern print
 Negative size 4, inscribed '¼ 15
 / [Gum?]'.

UNKNOWN MAN 89

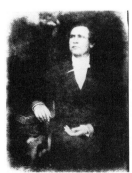

a negative, 1 modern print
 Negative size 4.

UNKNOWN MAN 90

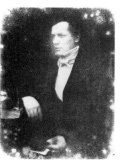

a negative, 1 modern print
Negative size 4, inscribed 'DF'.
Image obscure.

UNKNOWN MAN 91

a 1 calotype
Print size 4.

UNKNOWN MAN 92

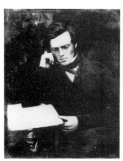

a negative, 1 modern print
Negative size 4, inscribed 'D1'.

UNKNOWN MAN 93

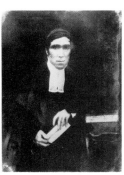

a negative, 1 modern print
Negative size 4, inscribed 'ex 3h
[au?] 15', hair and clothes
shaded in in pencil.

UNKNOWN MAN 94

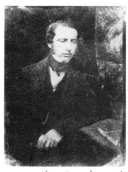

a negative, 1 modern print
Negative size 4.

b 1 later calotype
Print size 4.

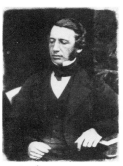

c 1 calotype
Print size 4.

UNKNOWN MAN 95

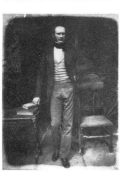

a 1 calotype
Print size 4.

UNKNOWN MAN 96

a 1 calotype
Print size 5.

UNKNOWN MAN 97

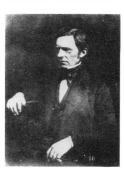

a 1 calotype
Print size 5.

UNKNOWN MAN 98

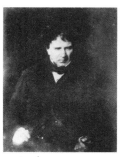

a 1 calotype
Print size 5.

UNKNOWN MAN 99

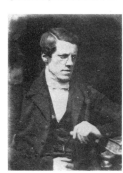

a 1 calotype
Print size 4.

UNKNOWN MAN 100

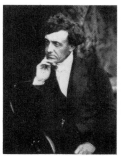

a 1 calotype, 1 carbon
Print size 4.

b 3 calotypes
Print size 4.

UNKNOWN MAN 101

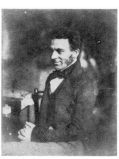

a 1 later calotype
Print size 4.

UNKNOWN MAN 102

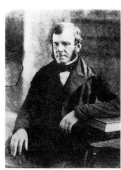

a negative, 1 modern print
Negative size 4, inscribed 'DDF
/ 2h [Gum?]', marks on face and
hands touched out in pencil,
torn.

UNKNOWN MAN 103

The following calotypes are likely to have been taken at the British Association meeting in York in 1844

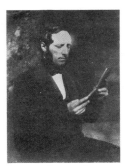

a negative, 1 calotype
Negative size 4, inscribed 'Octo 4 / DF / Gu', stain and headrest touched out in pencil.

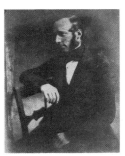

b negative, 1 later calotype
Negative size 4, inscribed 'Octo 4 / D6 / G', support touched out in pencil.

UNKNOWN MAN 104

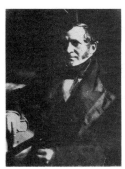

a negative, 2 calotypes
Negative size 4, inscribed 'DF / Octo 2'. Calotype may have been taken at the British Association meeting in York in 1844.

UNKNOWN MAN 105

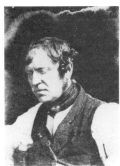

a 1 albumen
Print size 5, probably cut down from 4.

UNKNOWN MAN 106

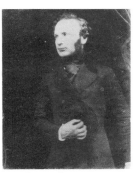

a 1 later calotype
Print size 4.

UNKNOWN MAN 107

a negative, 1 modern print
Negative size 4, inscribed 'DS'. Image obscure.

UNKNOWN MAN 108

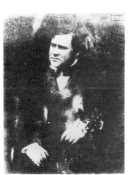

a negative, 1 modern print
Negative size 4, inscribed '58 / 1h', stained.

UNKNOWN MAN 109

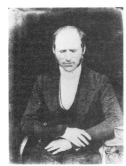

a negative, 1 modern print
Negative size 4, marks on face touched out in pencil.

UNKNOWN MAN 110

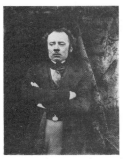

a negative, 1 modern print
Negative size 4, marks touched out in pencil, waxed.

b 1 calotype
Print size 4.

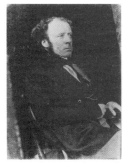

c 1 calotype, 1 later calotype
Print size 4.

UNKNOWN MAN 111

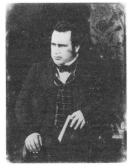

a negative, 1 modern print
Negative size 4, marks touched out in pencil, waxed.

UNKNOWN MAN 112

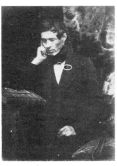

a 1 calotype
Probably print size 4, cut down.

UNKNOWN MAN 113

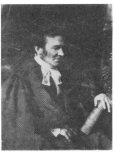

a 1 calotype
Print size 4.

UNKNOWN MAN 114

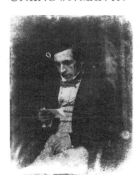

a negative, 1 modern print
Negative size 4, inscribed 'June 6 / 304'.

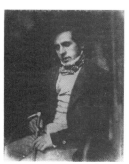

b negative, 1 modern print
 Negative size 4, inscribed 'June
 6 / Gum'.

UNKNOWN MAN 115

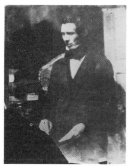

a negative, 1 modern print
 Negative size 4, inscribed 'DS',
 torn.

UNKNOWN MAN 116
Possibly J F Loder who played the viola

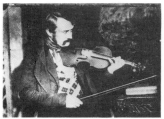

a negative, 1 modern print
 Negative size 4, inscribed '15 ¼
 cast [*or* last] / smooth ex¾ Gu',
 spots touched out in pencil.

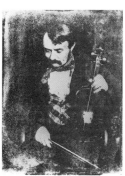

b negative, 1 modern print
 Negative size 4, inscribed 'DF /
 ex¾'.

UNKNOWN MAN 117

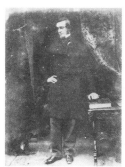

a 1 calotype
 Print size 4.

UNKNOWN MAN 118

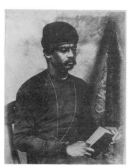

a 2 calotypes
 Print size 4.

b 1 calotype
 Print size 4.

UNKNOWN MAN 119

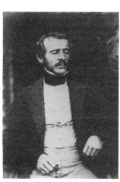

a 1 calotype
 Print size 5.

UNKNOWN MAN 120

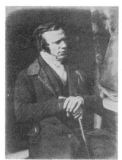

a 2 calotypes
 Print size 4.

UNKNOWN MAN 121

a 1 calotype
 Print size 4.

UNKNOWN MAN 122

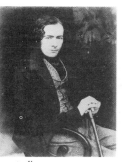

a 1 albumen
 Print size 4.

UNKNOWN MAN 123

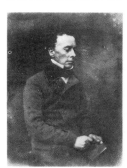

a negative, 1 later calotype
 Negative size 4, spots on face
 touched out in wash.

UNKNOWN MAN 124

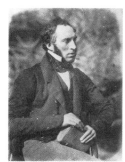

a negative, 1 late calotype
 Negative size 4, inscribed '30',
 spots touched out in pencil,
 torn.

UNKNOWN MAN 121

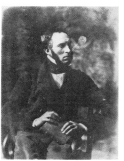

b 1 calotype
 Print size 4.

UNKNOWN MAN 125

a negative, 1 modern print
 Negative size 4, marks touched
 out in pencil.

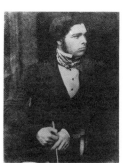

b negative, 1 modern print
 Negative size 4.

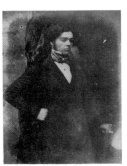

c negative, 1 calotype
Negative size 4.

UNKNOWN MAN 126

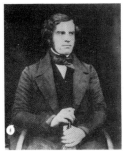

a 1 later calotype
Print size 5.

UNKNOWN MAN 127

a negative, 1 modern print
Negative size 4, inscribed 'July
9–44 / 304', spots touched out in
wash.

UNKNOWN MAN 128

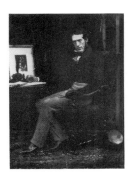

a 1 calotype
Print size 5. The framed
calotype on the table is of John
Ban Mackenzie, q v.

UNKNOWN MAN 129

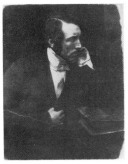

a 1 calotype
Print size 4.

UNKNOWN MAN 130

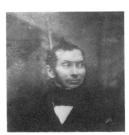

a 1 calotype
Print size 6. Unlikely to be a
calotype by Hill and Adamson;
might be by Robert Adamson
alone.

UNKNOWN MAN 131

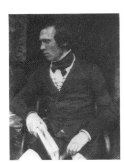

a 1 calotype
Print size 5.

UNKNOWN MAN 132

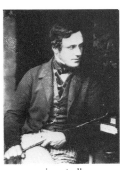

a negative, 1 albumen
Negative size 5, inscribed '15
J Logan', the identity is written
in a later hand, marks touched
out in pencil.

UNKNOWN MAN 133

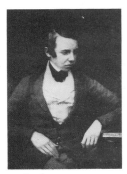

a 1 calotype
Print size 5.

UNKNOWN MAN 134

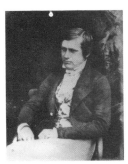

a 1 calotype
Print size 4.

UNKNOWN MAN 135

a 1 calotype
Print size 5.

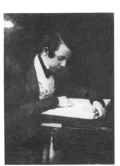

b 1 calotype
Print size 5.

UNKNOWN MAN 136

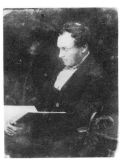

a negative, 1 modern print
Negative size 4.

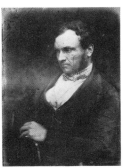

b negative, 3 calotypes
Negative size 4, inscribed '80',
watermark and spots touched
out in pencil.

UNKNOWN MAN 137

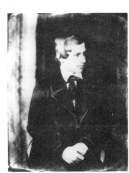

a 1 calotype
Print size 4.

UNKNOWN MAN 138

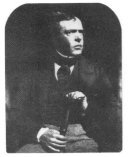

a negative, 1 modern print
Negative size 4, marks touched
out in pencil, waxed.

UNKNOWN MAN 139

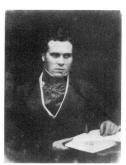

a negative, 1 later calotype
Negative size 4, spots and smear touched out in wash and pencil.

UNKNOWN MAN 140

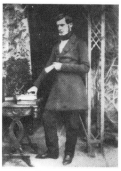

a 2 calotypes
Print size 5.

UNKNOWN MAN 141

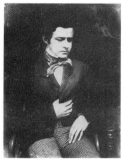

a negative, 1 calotype
Negative size 4, inscribed 'Mr Apr 20/44 / DDF', spots on face and hands touched out in pencil.

UNKNOWN MAN 142

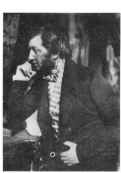

a 1 calotype
Print size 5.

UNKNOWN MAN 143

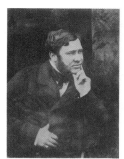

a negative, 1 calotype
Negative size 4, inscribed 'Mr Apr 16/46 / 15 / ½h', marks touched out and lines of coat drawn in in pencil.

UNKNOWN MAN 144

a 1 calotype or later calotype, 1 print in an unidentified process
Print size 4.

b 1 calotype or later calotype
Print size 5.

UNKNOWN MAN 145

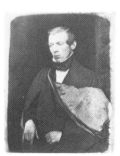

a 1 calotype
Print size 4.

UNKNOWN MAN 146

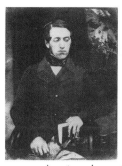

a negative, 1 modern print
Negative size 4, inscribed '¼ / [Ran?] 15', marks touched out in pencil.

UNKNOWN MAN 147

a negative, 1 modern print
Negative size 5, inscribed 'Ken Dem² 1m / 2½ 55'.

b negative, 1 later calotype
Negative size 5, inscribed '[Lon?] ³⁰⁴/₁₄₅₃ / ex / Glue / ½ 65', stained. Image obscure.

UNKNOWN MAN 148

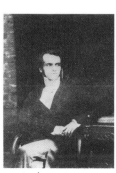

a 1 calotype
Print size 5.

UNKNOWN MAN 149

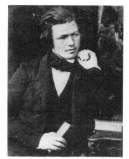

a 1 calotype
Print size 5.

UNKNOWN MAN 150

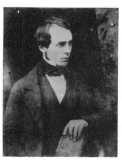

a 2 calotypes
Print size 4.

UNKNOWN MAN 151

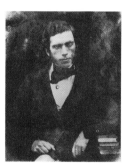

a negative, 1 modern print
Negative size 4, stained. Image obscure.

UNKNOWN MAN 152

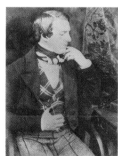

a negative, 2 calotypes
Negative size 4, watermark, headrest and spots touched out in pencil, waxed, torn.

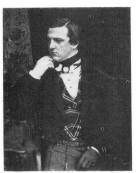

b negative, 1 modern print
Negative size 4, spots touched
out and jacket shaded in in
pencil, waxed.

UNKNOWN MAN 153

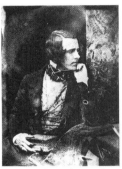

a negative, 2 later calotypes
Negative size 4.

b 1 albumen, 3 carbons
Print size 4.

UNKNOWN MAN 154

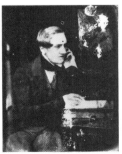

a negative, 1 modern print
Negative size 4, inscribed 'June
2/46', stained.

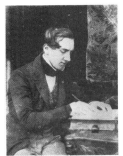

b 1 later calotype
Print size 4.

UNKNOWN MAN 155

a negative, 1 later calotype
Negative size 4, inscribed 'Mr
Artist March 29/45 / fine 10 134
Last Gum', top of hair and
sleeve shaded in in pencil.

UNKNOWN MAN 156

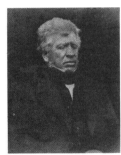

a 1 calotype or later calotype
Print size 101 × 75 mm,
possibly size 6 cut down.
Calotype probably taken by
John or Robert Adamson.

UNKNOWN MAN 157

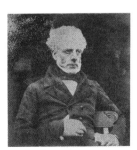

a 1 calotype
Print size 6. Calotype probably
taken by John or Robert
Adamson.

UNKNOWN MAN 158

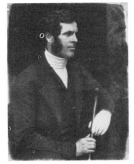

a 1 calotype
Print size 4.

UNKNOWN MAN 159

a *1 calotype*
Print size 4. Damaged print,
face obliterated, not illustrated.

UNKNOWN MAN 160

a *negative, 1 modern print*
Negative size 4, inscribed 'DS'.
Image obscure, not illustrated.

UNKNOWN MAN 161

a *negative, 1 modern print*
Negative size 4. Image obscure,
not illustrated.

UNKNOWN MAN 162

a *negative, 1 modern print*
Negative size 4. Image obscure,
not illustrated.

Women

*The catalogue of Women serves also
as an index to the groups and figures
in the landscapes*

Daughters of the MARQUIS OF ABERCORN
See Groups 1 and 2

LOUISA JANE RUSSELL, MARCHIONESS, and later DUCHESS, OF ABERCORN
died 1905

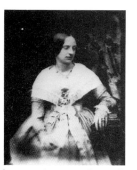

a negative, 1 calotype
 Negative size 4, inscribed 'Hon Aug 21 / ex ¾ Gu / 15', small marks touched out in wash.

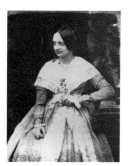

b negative, 1 modern print
 Negative size 4, inscribed 'Lady Aug 21/45 / 15 ex ¾', small marks touched out in wash.

LADY ABERCROMBY
Or Hon Mrs Abercromby

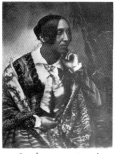

a 2 calotypes, 3 carbons
 Print size 4.

Miss ADAM

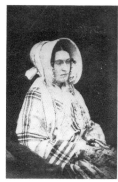

a negative, 1 print in an unidentified process
 Negative size 5, inscribed 'Miss Adam', minor spots and headrest touched out in wash.

Mrs ADAMSON
Mother of John and Robert Adamson
See Groups 7 and 8

Mrs ALEXANDER ADAMSON
See Groups 5 to 8

Miss ISABELLA ADAMSON
See Mrs Isabella Bell

Mrs JOHN ADAMSON
Née Alexander
See also Groups 7 and 8

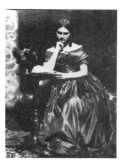

a 1 calotype
 Print size 4.

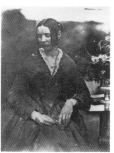

b 1 carbon
 Print size 4.

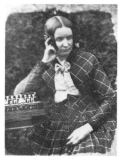

c 1 calotype
 Print size 4. A knee accordion is on the table beside the sitter.

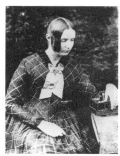

d negative, 1 modern print
 Negative size 4, inscribed '160'.

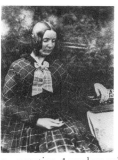

e negative, 1 modern print
 Negative size 4, headrest touched out in pencil, waxed.

Miss MELVILLE ADAMSON
See Groups 5 to 8

Miss ALEXANDER
See Mrs John Adamson

Mrs ALISON
See Groups 9 to 11

Mrs ANDERSON
Wife of Colonel Anderson

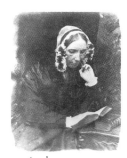

a 1 calotype
 Print size 4.

b 2 carbons
 Print size 4.

Hon Misses ANNESLEY
The seven daughters of Viscount Valentia
See Groups 12 to 15

Hon EVA ANNESLEY
Daughter of Viscount Valentia
See Groups 12 to 15

Hon FRANCES ANNESLEY
Daughter of Viscount Valentia
See Groups 12 to 15

Hon MATHILDA ANNESLEY
Daughter of Viscount Valentia, married John Holmes, 1845
See Groups 12 to 15

Hon NEA ADA ARTHUR ROSE D'AMOUR ANNESLEY
Daughter of Viscount Valentia, married Hercules Robinson, 1846
See Groups 12 to 15

Miss ELIZABETH ARMSTRONG
See Mrs Elizabeth Kermack

Madame D'AUBIGNE
Presumably the wife of Dr Jean D'Aubigné

a 1 calotype
 Print size 4.

Miss GRIZEL BAILLIE

a 1 calotype
 Print size 4. Negative in Glasgow University Library.

Mrs BAINES
See Groups 16 and 17

Misses BAINES
Three daughters of the curator of
York Museum
See Groups 16 and 17

Miss BALFOUR
Daughter of Rev Lewis Balfour
See Groups 25 and 26

**Mrs HENRIETTA SCOTT
(SMITH) BALFOUR** died 1844
Wife of Rev Lewis Balfour
See Groups 25 and 26

Miss BANKS
See Mrs Fleming

Miss BARCLAY
See also Group 29

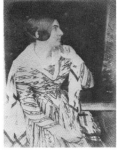

a 1 carbon
 Print size 4.

Miss BARKER

a 4 calotypes
 Print size 4.

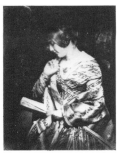

b negative, 1 modern print
 Negative size 4, inscribed 'Miss
 May 3/45 / 15'.

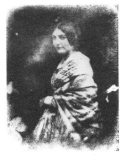

c negative, 1 modern print
 Negative size 4, inscribed '304
 514 [*or* 719 upside down]'.

Mrs BARKER
See also Group 30

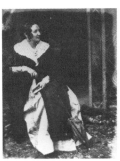

a negative, 1 calotype
 Negative size 4, inscribed 'Mrs
 Barker June 28 44 / Gum', small
 spots and edge touched up in
 wash.

Mrs ISABELLA (BURNS) BEGG
1771–1858
Sister of Robert Burns

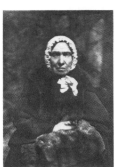

a 2 calotypes, 1 albumen, 2
 carbons
 Print size 4.

b 5 calotypes, 4 carbons
 Print size 4.

Miss BELL (1)

a 1 calotype
 Print size 6.

Miss BELL (2)

a 1 calotype
 Print size 4.

b 2 calotypes, 2 carbons
 Print size 4.

c 3 calotypes
 Print size 4.

d 1 calotype
 Print size 4.

Mrs BELL

a 1 later calotype
 Print size 4.

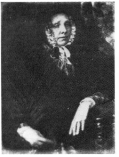

b 1 calotype
 Print size 4. Negative in
 Glasgow University Library
 dated September 29, 1845.

Miss ALEXINA BELL
See Lady Alexina Moncrieff

**Mrs ISABELLA MORRISON
(ADAMSON) BELL**
Sister of Robert Adamson, wife of
Col Oswald Bell
See also Groups 7, 8 and 36

a 5 calotypes
 Print size 4.

Mrs BERTRAM

a 1 calotype
 Print size 4.

b 1 calotype
 Print size 4. Negative in
 Glasgow University Library.

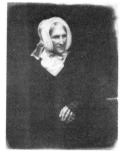

c 2 carbons, 1 gum print
 Print size 4.

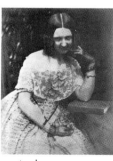

d 1 calotype
 Print size 4.

Miss BINNEY
Later Mrs James Webster
See also Groups 37 to 39

a 4 calotypes
 Print size 4.

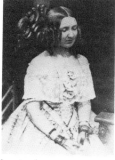

b 1 calotype
 Print size 4.

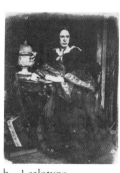

c 1 later calotype
 Print size 4.

Miss BINNEY
Later Mrs Marrable
See Groups 37 to 39

Mrs BLACKIE
See Group 41

Lady JULIET (MCPHERSON) BREWSTER 1786–1850
Daughter of James 'Ossian' McPherson, wife of Sir David Brewster

a 1 calotype
 Print size 4.

b 1 carbon
 Print size 4. Image obscure, not illustrated.

Miss MARGARET BREWSTER
See Mrs Margaret Gordon

Misses BROWN
See Groups 43 and 44

Mrs BROWN
Wife of Dr Brown
See Groups 45 to 47

Miss BRUCE
See Groups 58 and 59

Mrs BRUCE
See also Groups 58 and 59

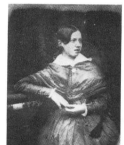

a negative, 1 modern print
 Negative size 4, marks touched out and lines of clothes shaded in in pencil.

LOUISA, DUCHESS OF BUCCLEUCH 1836–1912
See Lady Louisa Hamilton

Miss ISABELLA BURNS
1771–1858
See Mrs Isabella Burns Begg

Miss A CAMPBELL
See Groups 176 and 177

Miss L CAMPBELL
See Groups 176 and 177

Miss M CAMPBELL
See Groups 176 and 177

Mrs ISABELLA (DYCE) CAY
Wife of Robert Dundas Cay

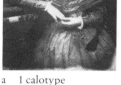

a 1 calotype
 Print size 4.

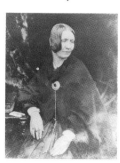

b 1 calotype
 Print size 4.

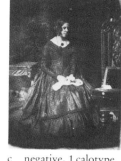

c negative, 1 calotype
 Negative size 4, inscribed 'turc Brom Mrs R D Cay March 11–45 / 18 Slight Brown / [teep?] / [illegible] No 12', small spots touched out in wash.

Mrs CHARLES CHALMERS
See Group 67

Miss ANNE CHALMERS
See Mrs Anne Hanna

Miss ELIZABETH CHALMERS
Later Mrs Watson
See also Group 67

a 1 calotype
 Print size 4.

Miss FRANCES CHALMERS
1827–1863
See Groups 64 to 66

Miss GRACE CHALMERS
1819–1851
See Groups 64 to 66

Miss HELEN CHALMERS
See Groups 64 to 66

Perhaps Mrs JOHN CHALMERS
See also Group 68

a 1 carbon, 1 gum print
 Print size 4.

Mrs THOMAS CHALMERS
See Groups 64 to 66

Mrs ELIZABETH (COCKBURN) CLEGHORN
Daughter of Lord Cockburn, wife of Thomas Cleghorn
See Groups 71 to 74, 127 and 128

Miss COCHRANE

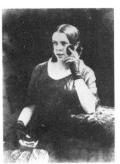

a negative, 3 calotypes
Negative size 4, inscribed 'Miss Cochrane May 7 [*or* 8, one written over the other] /46 / Gu / DF'.

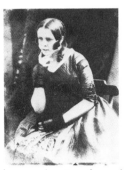

b negative, 1 modern print
Negative size 4, inscribed 'Miss Cochrane May 7/46 /30'.

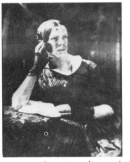

c negative, 1 modern print
Negative size 4, inscribed '15 / [11a?]'.

Miss COCKBURN
See Groups 72 and 73

Miss ELIZABETH COCKBURN
See Mrs Elizabeth Cleghorn

Mrs ELIZABETH (MACDOWALL) COCKBURN
Wife of Henry, Lord Cockburn
See Groups 71 to 75 and Landscape 4

MARY COMBE
Newhaven fishwife
See Newhaven 56

Lady COWAN
Wife of John, Lord Cowan
See Groups 77 to 79

Miss COWAN
Daughter of John, Lord Cowan
See Group 77

Miss CRAMPTON
Of Dublin

a 1 calotype, 2 carbons
Print size 4.

b 1 carbon
Print size 4.

BESSY CROMBIE
Newhaven fishwife
See Newhaven 56

Misses DIXON
See Group 83

Misses DOUBIGGAN
See Misses Hamilton

Miss DRYSDALE

a 1 carbon
Print size 4.

Mrs MARY (GRAY) DUNCAN
Widow of Rev Robert Lundie, wife of Rev Henry Duncan

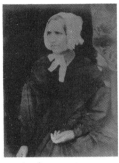

a 1 calotype
Print size 4.

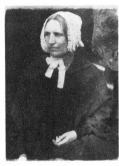

b 1 calotype
Print size 4.

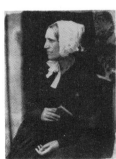

c 1 calotype
Print size 4. Calotype used for the Disruption Picture.

BEATRIX, COUNTESS OF DURHAM 1835–1871
See Lady Beatrix Hamilton

Mrs DYMOCK

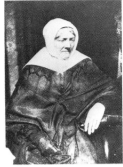

a 1 calotype
Print size 5.

Lady ELIZABETH (RIGBY) EASTLAKE 1809–1893
Author and critic, married Sir Charles Eastlake in 1849
See also Groups 221 to 225

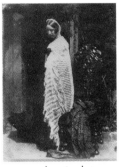

a negative, 1 calotype
Negative size 4, inscribed 'Miss Rigby Light', line of skirt drawn in in wash.

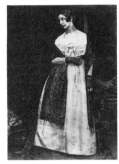

b 1 gum print
Print size 4.

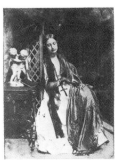

c negative, 3 calotypes
Negative size 4, inscribed 'Miss Rigby', line of bottom edge touched in and small star drawn in in wash over the sitter's head. Calotype has been called 'A Reverie'.

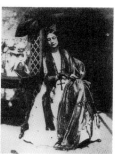

d 2 calotypes
Print size 5.

e negative, 1 modern print
Negative size 5, inscribed 'Miss
Rigby / D6'.

f negative, 1 calotype, 1 modern
print
Negative size 4, inscribed 'Miss
Rigby'.

g 2 calotypes, 1 gum print
Print size 4.

h negative, 1 modern print
Negative size 4, inscribed 'Miss
Rigby'.

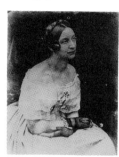

i 4 calotypes
Print size 4.

j 2 calotypes
Print size 5.

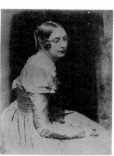

k 4 calotypes, 1 carbon
Print size 4.

l 1 calotype
Print size 4.

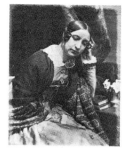

m 19 calotypes
Print size 4.

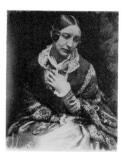

n 2 calotypes, 1 carbon
Print size 4.

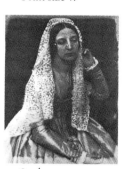

o 2 calotypes
Print size 4.

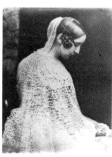

p 1 calotype, 1 carbon
Print size 4.

Miss ETTY
Daughter of Captain Charles Etty
*The following calotypes were
presumably taken on 16 October
1844 (see Charles Etty)*

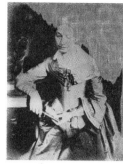

a 1 calotype
Print size 4. The sitter is holding
a telescope.

b 1 carbon
Print size 4.

Mrs FAIRBAIRN
Wife of Rev James Fairbairn
See Newhaven 57

Miss FARNIE
See Groups 93 and 94

Miss HARRIET FARNIE
See Groups 93, 94, 100 and 101

Mrs FARR
See Groups 95 and 96

Miss FILLANS
Daughter of James Fillans
See Groups 97 and 98

Miss WILHELMINA FILLANS
Daughter of James Fillans, later
Mrs Parker
See also Groups 97 and 98

a 1 calotype, 2 carbons, 1
photogravure
Print size 4.

b negative, 1 modern print
Negative size 4.

Mrs CHARLES FINLAY
See also Groups 102 and 205

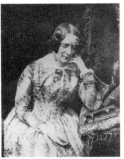

a negative, 1 modern print
Negative size 4, inscribed 'Mrs Finlay', spots on face touched out in pencil.

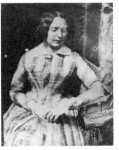

b negative, 1 modern print
Negative size 4, inscribed 'Mrs Finlay', spots touched out in pencil.

MARION FINLAY
Newhaven fishwife
See Newhaven 36 and 47

Miss MARY FINLAY

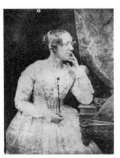

a negative, 1 modern print
Negative size 4.

b negative, 1 calotype
Negative size 4, inscribed 'Miss Finlay'.

Miss SOPHIA FINLAY
Daughter of Charles Finlay
See Groups 99 to 102 and 205

Mrs FLEMING
Née Banks

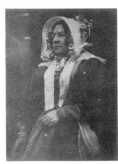

a negative, 1 later calotype
Negative size 5.

Mrs BARBARA (JOHNSTONE) FLUCKER
Newhaven fishwife
See Newhaven 9 to 12 and 37

JANET FRASER
Stocking-weaver. She gave a piece of land to the Free Church to build a church on in the village of Thornhill which was otherwise entirely owned by the Duke of Buccleuch who was opposed to the Free Church

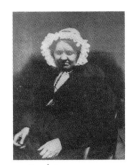

a 1 calotype
Print size 5.

Mrs JUSTINE (MONRO) GALLIE
Daughter of Charles Monro, wife of William Gallie
See also Groups 29, 37 and 196

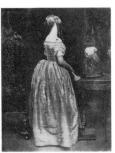

a 3 calotypes, 2 carbons
Print size 4.

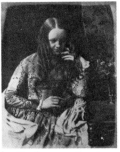

b 9 calotypes, 1 carbon
Print size 4.

c *negative, 1 modern print*
Negative size 4, badly stained.
Image obscure, not illustrated.

Mrs GARSTON
See Miss Mackenzie

Miss GLYNNE
Actress and dramatic reader
Has been called 'Miss Rigby'

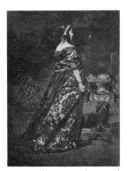

a 1 calotype, 1 later calotype, 1 photogravure
Print size 4.

Mrs GORDON
See Groups 111 to 113

Mrs MARGARET MARIA (BREWSTER) GORDON
Daughter of Sir David Brewster, wife of Rev Robert Gordon

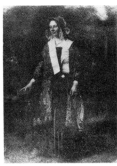

a negative, 1 modern print
Negative size 5, inscribed 'Miss [rs? *above*] Gordon Aug 10 / DF', bonnet slightly touched up in wash, waxed.

b 1 calotype
Print size 4.

Mrs MARY (WILSON) GORDON
Daughter of Professor John Wilson, wife of John Thomson Gordon
See Groups 115 and 116

CLEMENTINA STIRLING GRAHAM 1782–1877
Author, song-writer and impersonator of old ladies

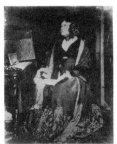

a negative, 1 modern print
Negative size 4, inscribed '24 sp [*or* sh]'.

Mrs GRANGER

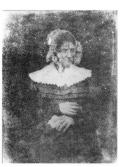

a negative, 1 modern print
Negative size 4, inscribed 'Mrs Granger Sept 19 / 304', headrest and spots touched out in wash. Image obscure.

Lady ISABELLA (NORMAN) GRANT
Wife of Sir Francis Grant

a 1 calotype
Print size 4.

b 1 carbon
Print size 4.

Miss GRIERSON (1)
See also Groups 117 and 118

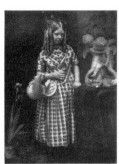

a 3 carbons
Print size 4.

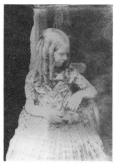

b negative, 1 modern print
Negative size 4, inscribed 'Miss Grierson / 304', spots on face and hands touched out in pencil.

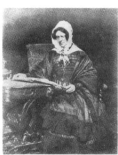

c negative, 1 modern print
Negative size 4, torn.

Miss GRIERSON (2)
See Groups 117 and 118

Mrs ANNE (BURNS) GUTHRIE
1810–1899
Daughter of Provost Burns of Brechin Cathedral, wife of Rev Thomas Guthrie

*a negative
Negative size 4. Image obscure, not illustrated.*

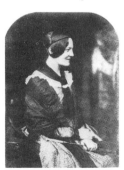

b 1 calotype, 1 later calotype
Print size 4. The later calotype is ¾ length but appears to be an enlargement rather than a different image.

Mrs ELIZABETH (JOHNSTONE) HALL
Newhaven fishwife
See Newhaven 13 and 14

Misses HAMILTON
*Or Misses Doubiggan
See Groups 119 and 120*

Mrs HAMILTON
See Groups 119 and 121

Lady BEATRIX HAMILTON
1835–1871
Daughter of the Marquis of Abercorn, later Countess of Durham
See Groups 1 and 2

Lady HARRIET HAMILTON
1834–1892
Daughter of the Marquis of Abercorn, later Countess of Lichfield
See Groups 1 and 2

Lady LOUISA HAMILTON
1836–1912
Daughter of the Marquis of Abercorn, later Duchess of Buccleuch
See Groups 1 and 2

Miss HANDYSIDE
See Group 122

Mrs HANDYSIDE
See Group 122

Mrs ANNE (CHALMERS) HANNA 1813–1891
Daughter of Rev Dr Thomas Chalmers, wife of Rev William Hanna
See also Groups 64 to 66

a 1 calotype
Print size 4. Calotype taken in the grounds of Merchiston Castle School, probably used for the Disruption Picture.

b 2 calotypes, 1 carbon
Print size 4.

Mrs HARCOURT (1)
Perhaps a daughter-in-law of the Archbishop of York

a negative, 1 calotype
Negative size 4, inscribed 'Octo 4 / Gum', the miniature in the sitter's hand drawn in or reinforced in pencil.

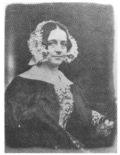

b 1 carbon, 1 gum print
Print size 4.

Mrs HARCOURT (2)
Perhaps a daughter-in-law of the Archbishop of York

a negative, 1 modern print
Negative size 4, inscribed 'Octo 4 / H. / DF', hair touched up and support touched out in wash.

b negative, 1 modern print
Negative size 4, inscribed 'Bishopthorpe xxx Octo 4', area behind head and hair touched up in pencil.

Mrs FRANCES (MCBANE) HENDERSON

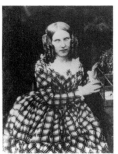

a negative, 1 modern print
Negative size 4, inscribed 'Miss Frances McBane'.

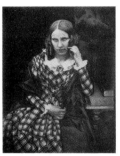

b 1 calotype, 1 carbon
Print size 4.

CHARLOTTE HILL 1839–1862
Daughter of D O Hill, wife of W Scott Dalgleish
See also Group 141

a negative, 1 calotype
Negative size 4, inscribed 'Charlotte Hill June 6', waxed, small spots touched out in wash.

b 2 calotypes, 3 carbons
Print size 4. Calotype known as 'Prayer', traditionally called 'Charlotte Hill', but from the length of the hair it would have to be dated some years after Adamson's death.

Mrs HIND
See also Groups 144 and 145

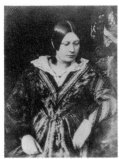

a negative, 1 calotype
Negative size 4, inscribed 'Mrs Hind Aug 28 / ex1h / 304', spots touched out and hair and dress touched up in pencil.

Mrs HISLOP

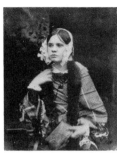

a negative, 1 modern print
Negative size 4, inscribed 'Mrs Hislop Octo 17 / D6', chemical marks touched out in pencil and wash.

b negative, 1 modern print
Negative size 4, inscribed 'Mrs Hislop Octo 17 / DS', small spots touched out on hands in wash and headrest touched out in pencil.

c negative, 1 modern print
Negative size 4, inscribed 'DF', stained.

Hon Mrs MATHILDA HOLMES
See Hon Mathilda Annesley

Miss HORNER
See Groups 72 and 73

Miss MARY HORNER
See Lady Mary Lyell

Mrs ANNA (BROWNELL MURPHY) JAMESON
1794–1860
Art historian and essayist

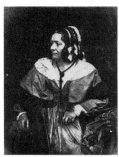

a 21 calotypes, 2 photogravures
Print size 4.

Mrs ELIZA (FIELD) JONES
born 1804
Wife of Rev Peter Jones

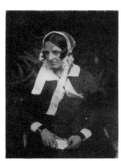

a negative, 1 calotype
Negative size 4, inscribed 'Mrs Jones Aug 4/45 / DF / Str', marks and headrest touched out in pencil.

Miss KEMP (1)
See also Groups 150 and 151

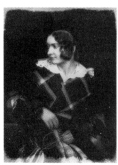

a 1 calotype
Print size 4.

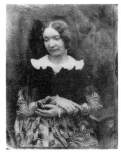

b negative, 1 modern print
Negative size 4, inscribed 'D15'. May not be the same sitter as the previous calotype.

Miss KEMP (2)
See also Groups 150 and 151

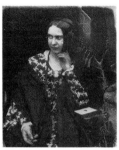

a 2 calotypes
Print size 4.

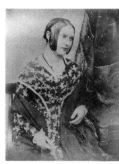

b 2 calotypes
Print size 4.

Miss KEMP (3)
See also Groups 150 and 151

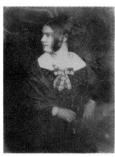

a negative, 1 modern print
Negative size 4, inscribed 'D15'. Image obscure. Another negative of the same sitter in Glasgow University Library is dated January 5, 1846.

Miss CATHERINE KEMP
See also Groups 150 and 151

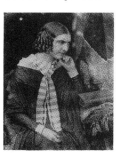

a negative, 1 modern print
 Negative size 4.

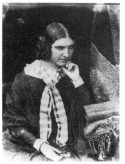

b negative, 1 calotype
 Negative size 4, spots on face
 and hands and stain behind head
 touched out in pencil.

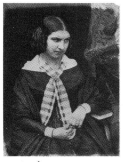

c 1 calotype
 Print size 4.

**Mrs ELIZABETH
(ARMSTRONG) KERMACK**
Married William Ramsay Kermack
on 2 June, 1846
See Group 154

Mrs KERR
See Mrs Stevens

Mrs KINLOCH
Of Park. Née Napier
See also Groups 157 to 159

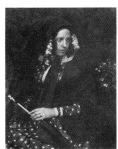

a 3 carbons
 Print size 4.

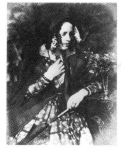

b 3 calotypes
 Print size 4.

**HARRIET, COUNTESS OF
LICHFIELD** 1834–1892
See Lady Harriet Hamilton

Misses LIDDLE
See Group 164

ANNIE LINTON
Newhaven fishwife
See Newhaven 20 and 24

Mrs LIZARS

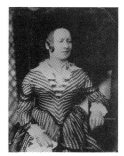

a negative, 1 modern print
 Negative size 4, inscribed 'Mrs
 Lizars / 15¼ / Gu', headrest
 touched out in pencil.

b negative, 1 modern print
 Negative size 4, inscribed 'Mrs
 Lizars / DD / ½ Gu', spots
 touched out in pencil.

Miss LOCKHART
Has been called 'Miss Hope'

a negative, 1 calotype
 Negative size 4, inscribed '15 /
 ¼ Gu', waxed.

b negative, 1 albumen
 Negative size 4, inscribed 'Miss
 Lockhart Octo 16/45 / DF / ¼
 [last?] Gum', spots touched out
 in pencil.

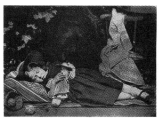

c negative, 1 modern print
 Negative size 4, inscribed 'Miss
 Lockhart Octo 16/45 15 /
 Gum [or Amm]', spots and
 headrest touched out in pencil.

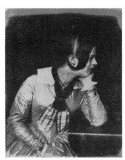

d 1 calotype
 Print size 4. Negative in
 Glasgow University Library.

Mrs LOGAN (1)
Wife of Alexander Stuart Logan
See Group 165

Mrs LOGAN (2)
Newhaven fishwife
See Newhaven 35 and 54

Miss ELIZABETH LOGAN
Daughter of Alexander Stuart
Logan
See also Group 165

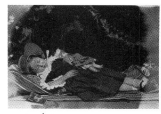

a 1 calotype
 Print size 4.

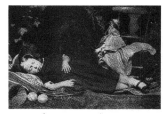

b 1 calotype, 2 carbons
 Print size 4.

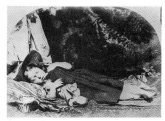

c 1 calotype, 1 carbon
 Print size 4.

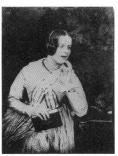

d 2 calotypes
 Print size 4.

e negative, 1 modern print
 Negative size 4, inscribed '160',
 image obscure.

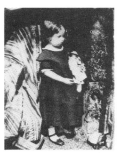

f negative, 1 modern print
Negative size 4, waxed.

Mrs MARGARET (DRYBURGH) LYALL
Newhaven fishwife
See Newhaven 36, 47 and 56

Lady MARY (HORNER) LYELL
Daughter of Leonard Horner, wife of Sir Charles Lyell
See Groups 72 and 73

Miss AGNES MCBANE
Or MacBean

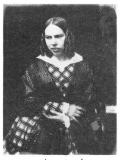

a negative, 1 calotype
Negative size 4, inscribed '15', waxed.

Miss ELIZABETH MCBANE
or MacBean

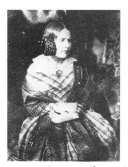

a negative, 1 modern print
Negative size 4, inscribed 'Miss Elizabeth McBane / DF', headrest touched out in pencil.

Miss FRANCES MCBANE
See Mrs Frances Henderson

Miss MCCANDLISH
Later Mrs Rishton

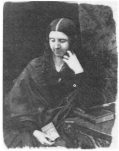

a 2 calotypes
Print size 4.

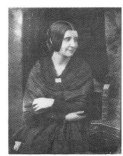

b 2 carbons
Print size 4.

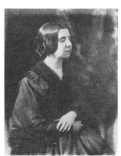

c 1 calotype
Print size 4.

Perhaps a Miss MCCANDLISH

a negative, 1 modern print
Negative size 4.

Miss MARGARET MCCANDLISH
See also Groups 129, 130 and 167 to 169

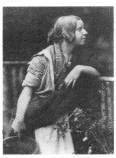

a 1 calotype, 1 albumen, 5 carbons
Print size 4.

Miss MARY MCCANDLISH
See also Groups 167 to 169

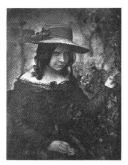

a 1 calotype, 4 carbons, 1 photogravure
Print size 4.

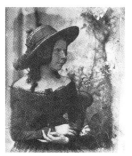

b 1 calotype
Print size 4.

Miss JANE MACDONALD

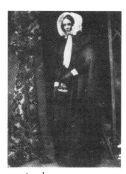

a 1 calotype
Print size 5.

Miss ELIZABETH MACDOWALL
See Mrs Elizabeth Cockburn

Miss MACKENZIE
Later Mrs Garston
See also Groups 170 and 171

a negative, 1 modern print
Negative size 4, inscribed 'Miss Mackenzie May 3/45 / 15 ¼', area round head shaded in and spots touched out in pencil.

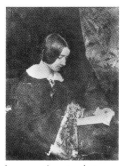

b negative, 1 calotype
Negative size 4, inscribed 'Miss Mackenzie May 3/45 / 15 ¼', area round arm shaded in and spots touched out in pencil.

Miss MACKENZIE
Later Mrs Wyllie
See Groups 170 and 171

Mrs ELIZABETH (CHALMERS) MACKENZIE born 1816
See Groups 64 and 66

Miss MCLEAN
See Group 175

Mrs MACLEAY
Wife of Kenneth MacLeay
See Groups 176 to 180

Lady ELIZA (WILSON) MCNEILL died 1868
Wife of Sir John McNeill
See Group 181

Miss MCNEILL
Daughter of Sir John McNeill
See also Group 181

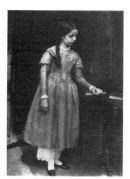

a 1 carbon
 Print size 4.

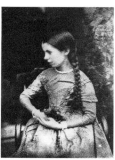

b negative, 1 modern print
 Negative size 4, inscribed 'Miss
 McNeill dau of Sir John M.
 218', small spots touched out in
 pencil.

Miss JULIET MCPHERSON
1786–1850
See Lady Juliet Brewster

Mrs MAIN
See Groups 182 and 183

Mrs MARRABLE
See Miss Binney

Miss MARSHALL
See also Groups 184 and 190

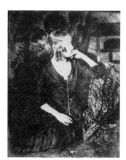

a negative, 1 modern print
 Negative size 4, inscribed '½ h /
 D15', image obscure.

Misses MARSHALL
See Groups 184 to 190

Hon Miss FOX MAULE
See Group 121

Miss MELVILLE
*Has been called 'Miss Melville
Adamson'*

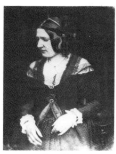

a negative, 1 modern print
 Negative size 5, inscribed 'Miss
 Melville March 25', small spots
 touched out in wash.

b negative, 1 modern print
 Negative size 4, inscribed '13'.

Miss MILLER
Daughter of Rev Ebenezer Miller
See Group 192

Mrs MILLER
Wife of Rev Ebenezer Miller
See Group 192

Miss MILLER
Or Mrs Miller

a negative, 1 modern print
 Negative size 4, inscribed 'Miss
 [or Mrs, *one written over the
 other*] Miller / D1', drape,
 hands and parts of dress and hair
 touched up in wash.

Mrs D MILLER
Or Mrs Dr Miller

a negative, 1 modern print
 Negative size 4, inscribed 'Mrs
 D [*or* Dr] Miller Sept 19 / DS'.

AGNES MILNE
Daughter of James Alexander Milne
See Groups 194 and 256 to 259

Miss ELLEN MILNE
Daughter of James Alexander Milne
See also Groups 194 and 256 to 259

a negative, 1 modern print
 Negative size 4, inscribed '15'.

Miss MITCHELL
See Group 175

**Lady ALEXINA (BELL)
MONCRIEFF** died 1874
See Group 35

Miss JUSTINE MONRO
See Mrs Gallie

Miss MOORE (1)
See also Groups 197 to 199

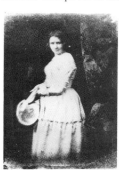

a negative, 1 modern print
 Negative size 4, inscribed 'DF'.

Miss MOORE (2)
See Groups 197 to 199

Miss ISABELLA MORRIS
See Groups 203 to 205

Miss PATRICIA MORRIS
See also Groups 203 to 205

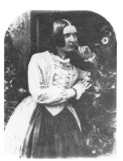

a 4 calotypes
 Print size 4.

**Miss ANNA BROWNELL
MURPHY** 1794–1860
See Mrs Anna Jameson

Mrs MARIAN MURRAY
Wife of John Murray, the publisher
*Has been called 'the Countess of
Stair'*

a 4 calotypes, 1 later calotype, 3
 carbons
 Print size 4.

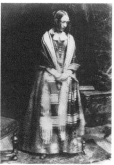

b 1 calotype, 1 carbon
 Print size 4.

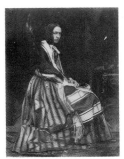

c 4 calotypes, 2 carbons
 Print size 4.

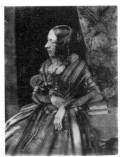

d 1 carbon
 Print size 4.

Miss MURRAY
Sister of John Murray, the
publisher

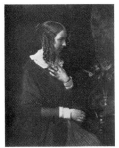

a 3 calotypes, 8 carbons
 Print size 4.

Miss NAPIER
See Mrs Kinloch

Mrs NAPIER (1)

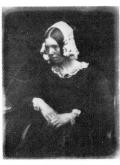

a negative, 1 calotype
 Negative size 4.

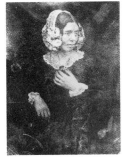

b negative, 1 modern print
 Negative size 4, inscribed '35'.

Mrs NAPIER (2)
See Group 157

Mrs CARNIE NOBLE
Newhaven fishwife
See Newhaven 56

Mrs OGILVIE

a negative, 1 modern print
 Negative size 4, inscribed 'Mrs
 Ogilvie', small spots touched
 out in wash.

b negative, 1 modern print
 Negative size 4, inscribed 'Mrs
 Ogilvie', spots touched out in
 wash and pencil, lines of dress
 and umbrella reinforced in
 pencil.

Miss ANNE PALGRAVE
1777–1872
See Mrs Anne Rigby

Mrs WILHELMINA PARKER
See Miss Wilhelmina Fillans

Mrs PEDDIE
See also Groups 215 and 216

a 1 calotype
 Print size 4.

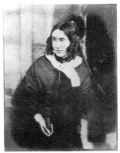

b 1 later calotype or calotype
 Print size 4.

Miss PHILLIPS
See also Group 175

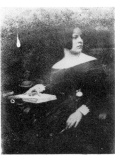

a negative, 1 modern print
 Negative size 4, inscribed 'Miss
 Phillips', hair touched up in
 pencil.

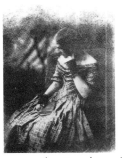

b negative, 1 modern print
 Negative size 4, inscribed 'Miss
 Phillips / D1', spots touched out
 in wash.

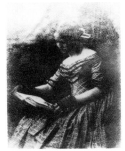

c negative, 1 modern print
 Negative size 4, inscribed 'Miss
 Phillips Light / Kept ½ hour',
 headrest touched out in wash.
 Image obscure.

d *negative, 1 modern print
 Negative size 4, inscribed 'Miss
 Phillips / D2'. Image obscure,
 not illustrated.*

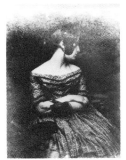

e negative, 1 modern print
 Negative size 4, inscribed 'Miss
 Phillips / D2', spots touched out
 in pencil.

f negative, 1 modern print
 Negative size 4, inscribed 'Miss
 Phillips', lines of dress drawn in
 in wash.

g *negative, 1 modern print
 Negative size 4, inscribed 'Miss
 Phillips'. Image obscure, not
 illustrated.*

'MISS R . . . ?'

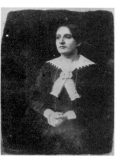

a negative, 1 calotype
Negative size 4, inscribed 'Miss R . . .? Light Octo 19 / DS', lines of hair and sleeve drawn in in pencil.

b negative, 1 modern print
Negative size 4, inscribed 'Octo 19 / DF'.

Mrs GRACE (FINLAY) RAMSAY
Newhaven fishwife
See Newhaven 36 and 47

Miss RENNIE

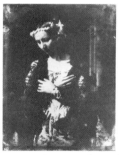

a negative, 1 modern print
Negative size 4, spots on face and hands touched out in wash.

b 4 carbons
Print size 4.

c negative, 1 modern print
Negative size 4, small spots on face and hands touched out in wash.

Miss RIGBY (1)
See Groups 222 and 223

Miss RIGBY (2)

a negative, 1 modern print
Negative size 4, inscribed 'Miss Rigby / D2'.

Mrs ANNE (PALGRAVE) RIGBY 1777–1872
See also Group 221

a 2 calotypes, 3 carbons
Print size 4.

b 3 calotypes, 1 carbon
Print size 4.

c 3 calotypes, 2 carbons
Print size 4.

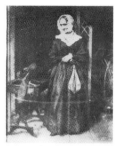

d 1 calotype, 1 carbon
Print size 4.

e 1 calotype
Print size 5.

f 11 calotypes, 2 carbons
Print size 4.

g 3 calotypes
Print size 4.

h 4 calotypes, 2 carbons, 2 photogravures
Print size 4.

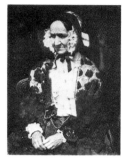

i 3 carbons
Print size 4.

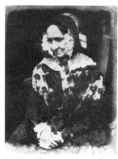

j 2 calotypes, 2 carbons
Print size 4.

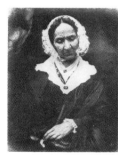

k 2 carbons
Print size 4.

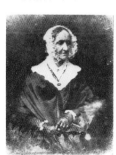

l negative, 1 modern print
Negative size 5, inscribed 'Mrs Rigby'.

Miss ELIZABETH RIGBY
1809–1893
See Lady Elizabeth Eastlake

Miss MATILDA RIGBY
See Mrs Matilda Smith

Miss ROBERTSON

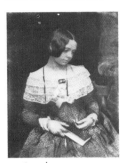

a 3 carbons
 Print size 4.

Hon Mrs NEA ROBINSON
See Hon Nea Annesley

Miss ROSS (1)

a negative, 1 modern print
 Negative size 4, inscribed 'Miss
 Ross', details of hair and shawl
 drawn in in pencil.

Miss ROSS (2)
See Group 262

**Lady MARY HAMILTON
(CAMPBELL) RUTHVEN**
1789–1885
Wife of James, Lord Ruthven

a negative, 4 calotypes, 1 calotype
 or later calotype, 2 carbons, 1
 photogravure
 Negative size 4, inscribed 'Lady
 Ruthven / 264 / 178', waxed.

b 2 carbons
 Print size 4.

Miss SCHETKY (1)
*Probably Mary Schetky born about
1786, died 1877, sister of John
Christian Schetky*

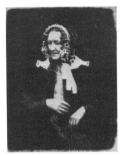

a 1 calotype
 Print size 4.

Miss SCHETKY (2)
*Presumably a daughter of John
Christian Schetky
See also Groups 229 and 230*

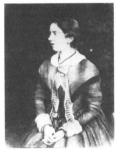

a negative, 1 modern print
 Negative size 4, inscribed 'Miss
 S Jan 5/46 / DF / Gu', headrest
 touched out in pencil and minor
 spots touched out in wash.

Miss SCOTT (1)
See Groups 231 to 233

Miss SCOTT (2)
See also Groups 231 to 233

a negative, 2 calotypes
 Negative size 4, inscribed 'DF'.

b negative, 1 calotype
 Negative size 4, inscribed 'Miss
 Scott / D15 Fine / 2h Gu'.

Mrs SCOTT

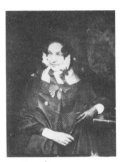

a 6 carbons
 Print size 4.

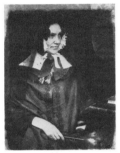

b 1 calotype, 1 carbon
 Print size 4.

**Lady ALICIA ANNE
(SPOTTISWOODE) SCOTT**
died 1900
Wife of Lord John Scott

a 1 calotype, 1 carbon
 Print size 4. The calotype has
 lines of writing drawn on the
 book in wash.

Mrs SETON
Newhaven fishwife
See Newhaven 54

Mrs SHANKER

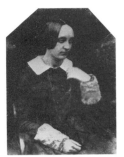

a 1 calotype, 3 carbons
 Print size 4.

Miss SHAW (1)

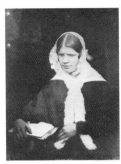

a negative, 1 modern print
 Negative size 4, inscribed 'Miss
 Shaw Octo 17 / DS', small spots
 touched out in wash.

Miss SHAW (2)
See Group 236

Mrs SHAW

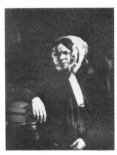

a 4 carbons
 Print size 4.

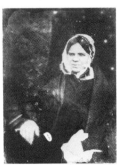

b Negative, 1 modern print
 Negative size 4, inscribed 'DF',
 stained.

Miss A SHAW

a negative, 1 modern print
Negative size 4, inscribed 'xxx
Miss A Shaw Octo / 24'.

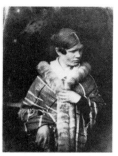

b negative, 1 modern print
Negative size 4, inscribed 'xxx
Miss A Shaw Octo / DS', lines
of hand and book drawn in in
pencil.

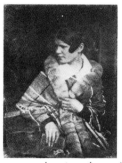

c negative, 1 modern print
Negative size 4, inscribed 'Miss
A Shaw Octo / 304'.

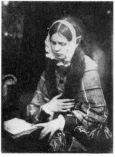

d negative, 1 modern print
Negative size 4, inscribed 'Miss
Shaw Octo 17 / DF', chemical
marks touched out in pencil
behind head.

Mrs SIMPSON
See Groups 237 and 238

SIMPSON Children
See Groups 237 and 238

Mrs SMITH
See Groups 244 and 245

Mrs MATILDA (RIGBY) SMITH
See also Groups 222 and 223

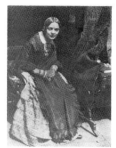

a 6 calotypes, 2 carbons
Print size 4.

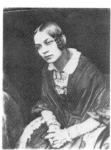

b 2 calotypes, 1 carbon
Print size 4.

Miss STEEL(E) (1)
See also Group 246

a negative, 1 modern print
Negative size 4, inscribed
'Steel Apr [11?] 46 / 20'.

Miss STEEL(E) (2)
See Group 246

Mrs STEVENS
Or Mrs Kerr
See Groups 247 to 249

Mrs STODDART
See Group 250

Miss THOMSON
Of Australia; later Mrs McAdam

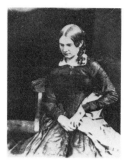

a 3 calotypes
Print size 4.

Mrs WALKER

a negative, 1 modern print
Negative size 4, inscribed 'xxx
Mrs Walker'.

Miss WATSON
Niece of D O Hill
See Groups 256 to 259

Mrs ELIZABETH WATSON
See Miss Elizabeth Chalmers

Mrs MARY (HILL) WATSON
Sister of D O Hill
*See also Groups 256, 257, 259 and
260*

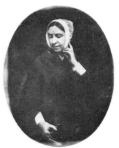

a 1 calotype
Print size 4.

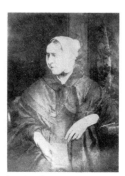

b 1 calotype
Print size 4.

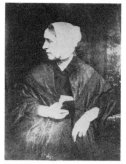

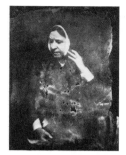

c 5 calotypes
Print size 4.

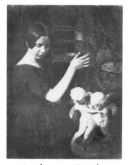

d negative, 1 modern print
Negative size 4, inscribed '½',
stained.

Miss MARY WATSON
Niece of D O Hill
See also Groups 256 to 260 and 262

a 1 calotype, 2 carbons
Print size 4.

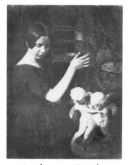

b 1 calotype or later calotype
Print size 4.

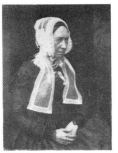

c 1 calotype
 Print size 4.

Miss SARAH WATSON
Niece of D O Hill
See Groups 33 and 256 to 258

Miss SUSAN WATSON

b negative, 1 modern print
 Negative size 4, inscribed 'Mrs
 Wilkinson May 21/45 / ½ Last
 [*or* fast] Gum / 15', stained,
 headrest touched out in pencil.
 Negative paper stamped
 'London Superfine'.

b 2 carbons
 Print size 4.

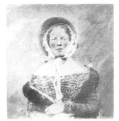

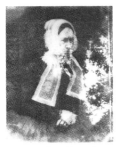

a 1 calotype, hand-coloured in
 watercolour
 Print size 6.

Mrs WEBSTER
See Miss Binney

**Lady GEORGINA RYDER,
BARONESS WHARNCLIFFE**
died 1884
Daughter of the Earl of Harrowby
See also Groups 269 and 270

c negative, 1 modern print
 Negative size 4, stained.

Misses WILSON
See Groups 266 and 267

Miss ELIZA WILSON
See Lady Eliza McNeill

JEANIE WILSON
Newhaven fishwife
See Newhaven 15 to 17 and 24

Miss MARY WILSON
Daughter of Professor John Wilson
See Mrs Mary Gordon

Mrs AGNES (SCOTT) WOOD
Wife of Rev Walter Wood
See Groups 268

c negative, 1 modern print
 Negative size 4, inscribed 'Mrs
 Wilkinson May 21/45'.

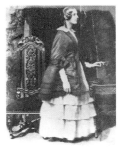

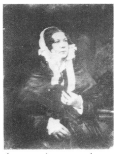

**Mrs MARGARET
(CHALMERS) WOOD**
1823–1902
See Groups 64 to 66

Mrs WYLLIE
See Miss Mackenzie

a 2 calotypes
 Print size 4.

Mrs WILKINSON
See also Groups 264 and 265

d negative, 1 modern print
 Negative size 4, inscribed 'Mrs
 Wilkinson May 19/45 / DF',
 chemical marks touched out and
 lines of dress touched in in
 pencil.

Mrs WILLIAMSON

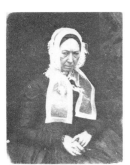

a 1 calotype, 1 carbon
 Print size 4. On the back of the
 calotype which is stuck down in
 the original album is inscribed
 'A very ugly picture for so
 pretty a face D M A'.

a 1 calotype, 3 carbons
 Print size 4.

Unknown Women

UNKNOWN WOMAN 1

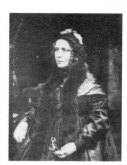

a 1 calotype
 Print size 5.

UNKNOWN WOMAN 2

a negative, 1 carbon, 1 print in an
 unidentified process
 Negative size 4.

b 1 carbon
 Print size 4.

UNKNOWN WOMAN 3

a 1 carbon, 1 print in an
 unidentified process
 Print size 4.

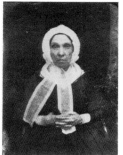

b 1 carbon
 Print size 4.

UNKNOWN WOMAN 4

a 1 calotype
 Print size 5.

UNKNOWN WOMAN 5

a 1 carbon, 1 photogravure
 Print size 4.

b 4 carbons
 Print size 4. Inscription printed
 off from negative 'Mrs Nov 23'.

UNKNOWN WOMAN 6

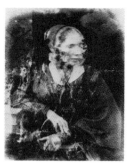

a negative, 1 modern print
 Negative size 4, stained.

UNKNOWN WOMAN 7

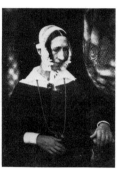

a 1 carbon
 Print size 4.

b *negative, 1 modern print
 Negative size 4, inscribed 'DS ¼
 last* [or *fast*] */ Gum* [or *Amm*]'.
 Image obscure, not illustrated.

UNKNOWN WOMAN 8

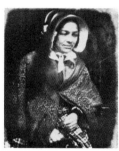

a 1 calotype
 Print size 4.

UNKNOWN WOMAN 9

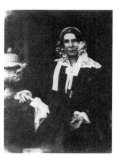

a 1 calotype
 Print size 5.

UNKNOWN WOMAN 10

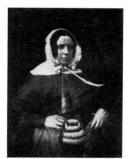

a 1 carbon
 Print size 4.

UNKNOWN WOMAN 11

a 2 carbons
 Print size 4.

UNKNOWN WOMAN 12

a 1 carbon
 Print size 4.

b 3 carbons
 Print size 4.

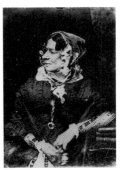

c negative, 1 print in an
 unidentified process
 Negative size 4.

UNKNOWN WOMAN 13

a 1 calotype
 Print size 4.

UNKNOWN WOMAN 14

a 1 later calotype
 Print size 4. This calotype of a
 woman with a serious goitre
 may have been taken for Dr
 James Inglis, an expert on
 goitre. See 'Early Photography,
 Goitre and James Inglis' by G M
 Wilson, *British Medical
 Journal*, 14 April 1973,
 pp 104–5.

UNKNOWN WOMAN 15

a negative, 1 modern print
 Negative size 4.

UNKNOWN WOMAN 16

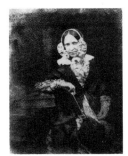

a negative, 1 modern print
 Negative size 4, inscribed 'July
 5 / DS'.

UNKNOWN WOMAN 17

a negative, 1 modern print
 Negative size 4. Image obscure.

UNKNOWN WOMAN 18

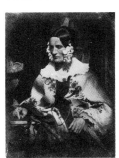

a negative, 1 carbon
 Negative size 4, spots and
 supports touched out in pencil.

UNKNOWN WOMAN 19

a negative, 1 modern print
 Negative size 4, inscribed '15'.

UNKNOWN WOMAN 20

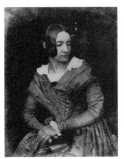

a negative, 1 calotype
 Negative size 4, inscribed 'Nov
 24/45 / DF / Gu ¼', spots on
 face and hands touched out in
 wash.

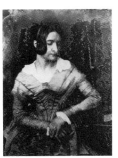

b negative, 1 modern print
 Negative size 4, inscribed 'C [*or*
 O] Ɓ L P G 22', stained.
 Negative paper stamped
 'London Superfine'.

UNKNOWN WOMAN 21

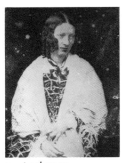

a 1 calotype
 Print size 5.

UNKNOWN WOMAN 22

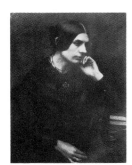

a 1 carbon, 1 photogravure
 Print size 4.

UNKNOWN WOMAN 23

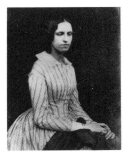

a 1 calotype, 1 gum print
 Print size 4.

UNKNOWN WOMAN 24

a 1 calotype
 Print size 4.

UNKNOWN WOMAN 25

a negative, 1 carbon
 Negative size 4, inscribed '15'.

b 1 carbon
 Print size 4.

UNKNOWN WOMAN 26

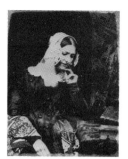

a 1 calotype
Print size 4.

UNKNOWN WOMAN 27

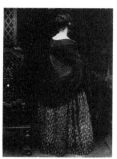

a 2 carbons
Print size 4.

UNKNOWN WOMAN 28

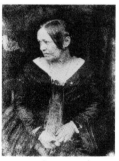

a negative, 1 modern print
Negative size 4, inscribed '160'.
Image obscure.

UNKNOWN WOMAN 29

a negative, 1 modern print
Negative size 4.

UNKNOWN WOMAN 30

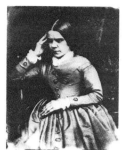

a negative, 1 modern print
Negative size 4, inscribed '350'.

b 2 carbons
Print size 4.

UNKNOWN WOMAN 31

a negative, 1 print in an
unidentified process
Negative size 4, inscribed 'D2
Gum'.

UNKNOWN WOMAN 32

a 1 calotype
Print size 5.

UNKNOWN WOMAN 33

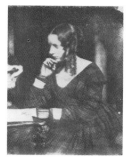

a 1 calotype
Print size 5.

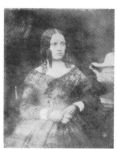

b 1 calotype
Print size 5.

UNKNOWN WOMAN 34

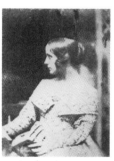

a 1 calotype
Print size 5.

UNKNOWN WOMAN 35

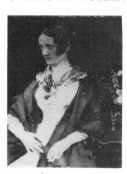

a 1 calotype
Print size 5.

UNKNOWN WOMAN 36

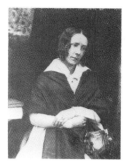

a 1 calotype
Print size 5.

UNKNOWN WOMAN 37

a 2 calotypes
Print size 4.

UNKNOWN WOMAN 38

a negative, 1 modern print
Negative size 4, inscribed 'Light
face / D2', stained.

UNKNOWN WOMAN 39

a 1 calotype
Print size 4.

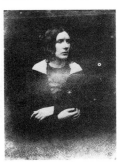

b negative, 1 modern print
Negative size 4, inscribed 'DDF
/ 1h Gu [or Am]'.

UNKNOWN WOMAN 40

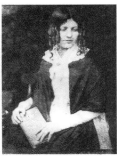

a negative, 1 modern print
Negative size 5, inscribed 'Miss
Aug 5', spots touched out in
wash.

UNKNOWN WOMAN 41

a negative, 1 modern print
Negative size 4. Image obscure.

UNKNOWN WOMAN 42

a negative, 1 modern print
Negative size 4, inscribed 'Nov
15/44', marks touched out in
pencil.

UNKNOWN WOMAN 43
See also Unknown Group 9

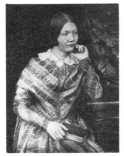

a negative, 1 modern print
Negative size 4, inscribed 'Gum
[or Sum] / 15', stained at the top,
waxed.

UNKNOWN WOMAN 44
See also Unknown Group 36

a negative, 1 modern print
Negative size 4. The broken
column appears in other
calotypes taken at York
between 28 September and 4
October, 1844.

UNKNOWN WOMAN 45
See also Unknown Group 36

a negative, 1 calotype
Negative size 4, inscribed 'Sept
30 4[4] / DF', head support
touched out in pencil. Calotype
taken at York.

b *negative, 1 modern print
Negative size 4, badly stained,
inscribed 'DF'. Image obscure,
not illustrated.*

UNKNOWN WOMAN 46

a 1 calotype
Print size 5.

UNKNOWN WOMAN 47

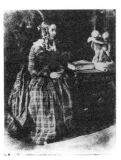

a negative, 1 modern print
Negative size 4, inscribed 'May
27 Miss / Gum'.

UNKNOWN WOMAN 48

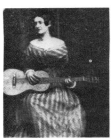

a 1 calotype
Print size 5.

UNKNOWN WOMAN 49

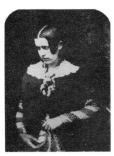

a 1 calotype
Print size 4.

UNKNOWN WOMAN 46 [sic]

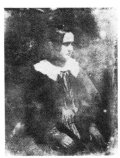

b 2 calotypes, 2 carbons
Print size 4.

UNKNOWN WOMAN 50

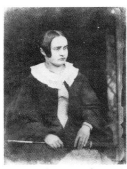

a negative, 1 modern print
Negative size 4, inscribed 'DF /
24'. Image obscure.

UNKNOWN WOMAN 51

a negative, 1 modern print
Negative size 4, inscribed 'Miss
/ Gum'.

Unknown Children

UNKNOWN CHILD 1

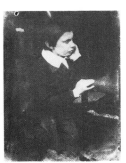

a 1 carbon
 Print size 4.

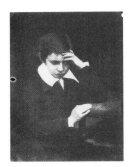

b negative, 1 modern print
 Negative size 4, inscribed
 'BREWSTER / June 6 / $^5/_8$ / DS'.

UNKNOWN CHILD 2

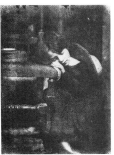

a negative, 1 modern print
 Negative size 4. Image obscure.

UNKNOWN CHILD 3

a negative, 1 modern print
 Negative size 4, inscribed '6 U
 [or W] $^{17}/_{33}$ 999'. Image obscure.

UNKNOWN CHILD 4

a 1 later calotype
 Print size 4.

Groups

For fuller details of the individuals in the groups, where known, see the catalogue under Men or Women. The sitters in each group are listed left to right

GROUP 1
Daughters of the Marquis of
Abercorn; the Ladies Harriet,
Beatrix and Louisa Hamilton

negative, 1 modern print
Negative size 4, inscribed 'Group
of Marquis of Abercorns Children
Nov 16 44 / DF'.

GROUP 2
As above

negative, 1 modern print
Negative size 4, inscribed 'Marquis
of Abercorns Children Nov 16 44 /
DF [or 8] Last', small spots touched
out in wash.

GROUP 3
Robert and Alexander Adamson

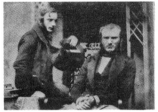

1 calotype
Print size 5. May be by John
Adamson.

GROUP 4
As above

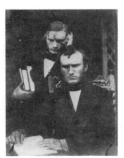

negative, 1 later calotype
Negative size 5, inscribed '1¼ 62 /
5', waxed. May be by John
Adamson.

GROUP 5
The Adamson family; Dr John
Adamson, unknown woman,
perhaps Mrs Alexander Adamson,
Alexander Adamson, Miss Melville
Adamson and Robert Adamson

2 calotypes
Print size 4.

GROUP 6
As above

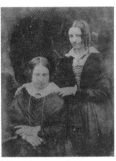

1 calotype
Print size 4.

GROUP 7
The Adamson family; standing,
Alexander and Robert Adamson,
Colonel and Mrs Bell, seated, John
Adamson, Miss Melville, perhaps
Mrs Alexander Adamson, Mrs
Adamson senior and Mrs John
Adamson

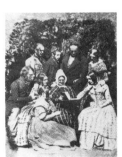

1 calotype
Print size 4.

GROUP 8
The Adamson family; behind, Miss
Melville Adamson, Alexander, Mrs
John and John Adamson, in front,
Robert Adamson, Mrs Bell, Mrs
Adamson senior, Colonel Bell and
perhaps Mrs Alexander Adamson

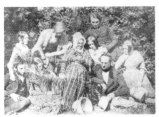

1 calotype
Print size 4.

GROUP 9
Mrs Alison and Miss –

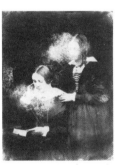

Negative, 1 calotype
Negative size 4, inscribed 'Mrs
Alison and Miss Apr 17–/45 / Gum
/ DS', hair and area round it
touched up, spots touched out in
pencil, waxed.

GROUP 10
As above

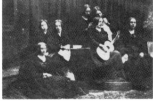

Negative, 1 modern print
Negative size 4, inscribed 'Gum'.

GROUP 11
Miss – and Mrs Alison

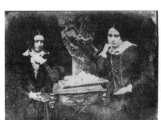

Negative, 1 modern print
Negative size 4, inscribed 'xx Miss
April 17/45 Mrs Alison / Gum'.

GROUP 12
The Hon Misses Annesley,
daughters of Viscount Valentia

Negative, 1 modern print
Negative size 4.

GROUP 13
As above

Negative, 1 modern print
Negative size 4.

GROUP 14
As above

1 calotype
Print size 5a.

GROUP 15
As above

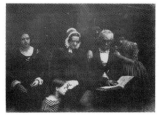

1 calotype
Print size 5a.

GROUP 16
The family of Mr Baines, curator of
York Museum. Calotype taken in
October, 1844.

1 calotype, 1 carbon
Print size 4.

GROUP 17
As above

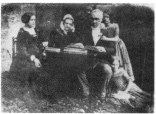

Negative, 1 modern print
Negative size 4, inscribed 'Octo 3 / 88 / D6 / G', headrests touched out in pencil, waxed.

GROUP 18
George and William Baker

Negative, 1 calotype
Negative size 4, inscribed 'Messrs Baker Aug 28/45 / William Baker George Baker / ex1h'.

GROUP 19
George and William Baker and C Finlay

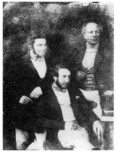

Negative, 1 modern print
Negative size 4, inscribed 'C. Finlay G. Baker Wm / h'.

GROUP 20
As above

Negative, 1 calotype
Negative size 4, inscribed 'Wm Baker George Baker C. Finlay / 15 / h'.

GROUP 21
As above

Negative, 1 modern print
Negative size 4, inscribed 'C. Finlay Wm. B. George B. / Finlay + c / 304 / Gu'.

GROUP 22
C Finlay, William Baker and George Baker

1 calotype, 1 albumen, 1 carbon
Print size 4.

GROUP 23
James Balfour, Captain Martin, Robert Maitland Heriot, Dr Foulis, unknown man and – Douglas

2 calotypes
Print size 5.

GROUP 24
James Balfour, Captain Martin, Robert Maitland Heriot, unknown man, Dr Foulis and – Douglas

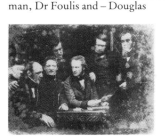

Negative, 1 modern print
Negative size 4, marks touched out in wash, waxed.

GROUP 25
Mrs Balfour, Rev Lewis Balfour and Miss Balfour

Negative, 1 modern print
Negative size 5, inscribed 'Mrs Balfour Revd L Balfour and Miss Balfour / D', waxed.

GROUP 26
As above

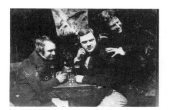

1 calotype
Print size 5.

GROUP 27
James Ballantine, Dr George Bell and D O Hill. Calotype known as 'Edinburgh Ale'

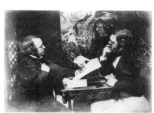

3 calotypes, 1 later calotype
Print size 4.

GROUP 28
James Ballantine, D O Hill and Dr George Bell

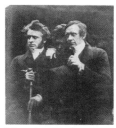

2 calotypes
Print size 4.

GROUP 29
Miss Barclay and Mrs Gallie

1 calotype, 3 carbons
Print size 4.

GROUP 30
Mrs Barker and Dr John Forbes

Negative, 1 modern print
Negative size 4, inscribed '? Barker / D300'.

GROUP 31
Rev Dr James Begg, Hugh Miller and Rev Dr Thomas Guthrie

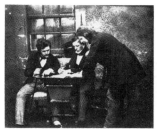

Negative, 3 calotypes, 1 carbon
Negative 126 × 115 mm, inscribed 'Begg Guthrie', waxed.

GROUP 32
Dr George Bell, Peter Fraser and D O Hill

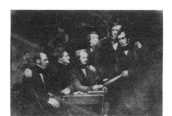

1 calotype, 1 later calotype, 1 carbon
Print size 4.

GROUP 33
Dr George Bell and Miss Sarah
Watson

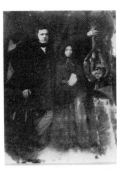

Negative, 1 modern print
Negative size 4, inscribed 'Dr Bell
Sarah Watson Sept 29/45 / DF',
waxed. Image obscure.

GROUP 34
Dr George Bell and 2 unknown
women

1 carbon, 1 print in an unidentified
process
Print size 4.

GROUP 35
Dr George Bell, Alexina, Lady
Moncrieff and Rev Thomas Bell

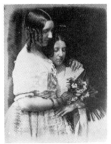

4 calotypes
Print size 4.

GROUP 36
Colonel Oswald Bell and Mrs
Isabella Bell

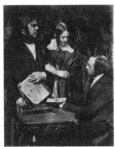

Negative, 1 modern print
Negative size 4, marks touched out
in pencil.

GROUP 37
Misses Binney and Mrs Justine
Gallie

2 calotypes
Print size 4.

GROUP 38
Misses Binney

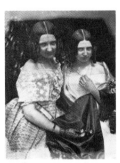

5 calotypes
Print size 4.

GROUP 39
As above

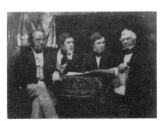

2 calotypes, 2 carbons
Print size 4.

GROUP 40
Messrs Black and Messrs Dill

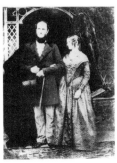

Negative, 1 later calotype
Negative size 5, inscribed 'Dill
Black / Messrs Dills + Blacks',
headrest touched out in wash,
waxed.

GROUP 41
3 unknown men standing, perhaps
Mrs Blackie seated and John Blackie
seated

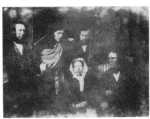

Negative, 1 modern print
Negative size 4, inscribed 'Blackie ?
John Blackie Senr + c – ', waxed.
Image obscure.

GROUP 42
Marquis of Breadalbane, Sir David
Brewster, Rev Dr David Welsh,
James Hamilton and Alexander
Earle Monteith

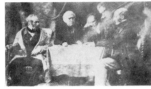

1 calotype, 1 later calotype
Print size 4.

GROUP 43
Mr and Misses Brown

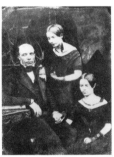

Negative, 1 modern print
Negative size 4, inscribed 'Mr
Brown + family / B.', marks
touched out pencil.

GROUP 44
As above

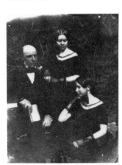

Negative, 1 calotype
Negative size 5, inscribed 'Mr +
Misses Brown March 30/46 / DF',
mark touched out in pencil.

GROUP 45
Dr and Mrs Brown

Negative, 1 calotype, 1 albumen,
1 carbon
Negative size 4, inscribed 'Mr +
Mrs Sept 15/45 / DF ex2h / Gum',
hair, hat and trouser leg reinforced
in pencil.

GROUP 46
As above

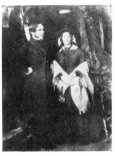

Negative, 1 modern print
Negative size 4, inscribed 'str / DF
ex2h'. Image blurred.

GROUP 47
As above

Negative, 1 modern print
Negative size 4, inscribed 'Mr +
Mrs / DF / [¼?]'.

GROUP 48
Rev Alexander Watson Brown, Mr Brown and unknown man

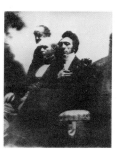

Negative, 1 modern print
Negative size 5, inscribed '20–15 / (40) / 24', waxed.

GROUP 49
Mr Brown and Rev Alexander Watson Brown

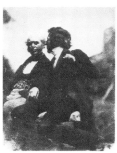

Negative size 5, inscribed '1½ 65 / Brown Brown', waxed.

GROUP 50
Professor Robert James Brown and Rev Dr John Forbes

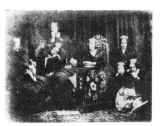

1 calotype
Print size 3. Negative in Glasgow University Library.

GROUP 51
Professor Robert James Brown, 2 unknown men, Rev Dr James Henderson, Rev Dr John Forbes and Rev Dr John Smyth

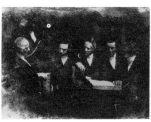

Negative, 1 modern print
Negative size 4, inscribed '23', waxed. Image obscure.

GROUP 52
As above

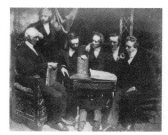

1 calotype
Print size 3.

GROUP 53
Sir Richard Brown and Rev R Brown

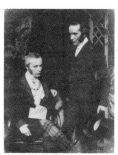

1 calotype, 1 albumen
Print size 4.

GROUP 54
Rev R and Sir Richard Brown

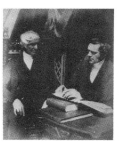

Negative, 1 albumen
Negative size 4, inscribed 'R Brown Sir James Brown Octo 23 / DF', waxed.

GROUP 55
– Brown, Rev R Brown and unknown man

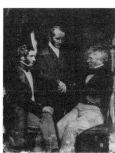

Negative size 4, inscribed '[DF?]', supports touched out in pencil, waxed.

GROUP 56
Unknown man, – Brown and Rev R Brown

2 later calotypes, 1 carbon
Print size 4.

GROUP 57
Rev R Brown and – Brown

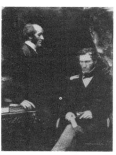

Negative, 1 modern print
Negative size 4, inscribed 'Brown Rev Brown Sept 15/45 / ex2h / DF', marks touched out in pencil, waxed.

GROUP 58
Mr, Miss and Mrs Bruce

Negative, 1 albumen
Negative size 4, inscribed 'Mr Bruce, Miss Bruce + Mrs Bruce', watermark and support touched out in pencil, waxed.

GROUP 59
As above

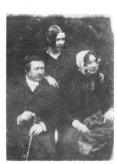

2 calotypes
Print size 4.

GROUP 60
Rev Dr John Bruce, Rev John Sym and Rev Dr David Welsh

1 calotype, 1 later calotype
Print size 4.

GROUP 61
As above

1 later calotype
Print size 4.

GROUP 62
Captain David Campbell, Allan Robertson, Tom Morris, Bob Andrews, Sir Hugh Playfair and Watty Alexander

4 later calotypes
Print size 4.

GROUP 63
Rev Dr Thomas Chalmers and Thomas Chalmers Hanna. Calotype taken in 1844 in the garden of Merchiston Castle and used by D O Hill as the basis of a painting (now in the Scottish National Portrait Gallery)

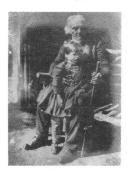

4 calotypes
Print size 2. Negative in Glasgow University Library.

GROUP 64
Mrs Mackenzie, Mrs Wood, Miss Frances Chalmers, Miss Helen Chalmers, Thomas Hanna, Mrs Chalmers and Rev Dr Thomas Chalmers seated, standing Miss Grace Chalmers and Mrs Hanna

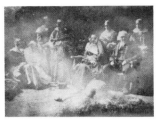

1 calotype or later calotype
Print size 3. Negative in Glasgow University Library.

GROUP 65
As above

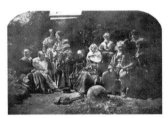

1 calotype
Print size 3. Negative in Glasgow University Library.

GROUP 66
Mrs Wood, Mrs Mackenzie, Thomas Hanna, Miss Frances Chalmers and Miss Helen Chalmers, Mrs Chalmers and Rev Dr Thomas Chalmers seated, Miss Grace Chalmers and Mrs Hanna standing behind

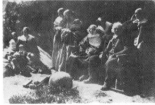

1 calotype
Print size 3.

GROUP 67
Miss Chalmers, Thomas Chalmers (indistinct figure), John Chalmers, Miss Elizabeth Chalmers, unknown girl presumably a Miss Chalmers, Charles Chalmers, Mrs Chalmers and David Chalmers. Calotype taken in 1844 in the garden of Merchiston Castle

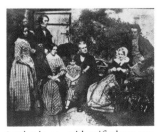

1 print in an unidentified process
Print size 3.

GROUP 68
John Chalmers, presumably with his son and Mrs Chalmers

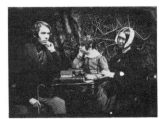

Negative, 1 modern print
Negative size 4, inscribed 'D [F?]'.

GROUP 69
Rev Thomas Clark and – Robertson

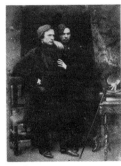

2 calotypes
Print size 4.

GROUP 70
Rev Dr Robert Burns, unknown man and Rev Dr Patrick Clason

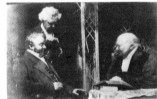

Negative, 1 albumen
Negative size 5, headrest touched out in pencil.

GROUP 71
A picnic at Bonaly. Perhaps John Henning, group of 4 women possibly including Mrs Cleghorn, perhaps Mrs Cockburn, Lord Cockburn, Charles Lyell and D O Hill

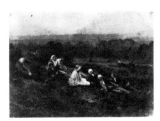

4 calotypes
Print size 4.

GROUP 72
Group at Bonaly Towers. D O Hill, John Henning, unknown man, woman and boy in doorway, perhaps Miss Horner, Mrs Cockburn, Miss Cockburn and perhaps Lady Lyell, Mrs Cleghorn and unknown woman on the stairs and Lord Cockburn

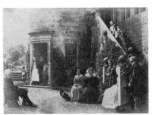

23 calotypes, 1 later waxed calotype
Print size 4. Negative in Glasgow University Library

GROUP 73
Group at Bonaly Towers. John Henning, unknown man, boy and woman, perhaps Miss Horner, perhaps Lady Lyell, D O Hill, Miss and Mrs Cockburn, Mrs Cleghorn and another woman on the stairs and Lord Cockburn

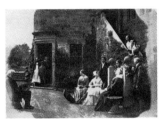

16 calotypes
Print size 4.

GROUP 74
Bonaly Towers with a group of 10, including John Henning, Mrs Cockburn, Lord Cockburn, Mrs Cleghorn and D O Hill

4 calotypes
Print size 4.

GROUP 75
Bonaly Towers with D O Hill, Mrs Cockburn, perhaps Lady Lyell, 3 unknown women, unknown man, John Henning, unknown woman, Lord Cockburn and Sir George Harvey

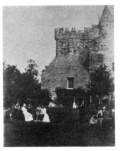

4 calotypes
Print size 4.

GROUP 76
John Connell and a girl, perhaps Miss Connell

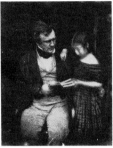

Negative, 1 modern print
Negative size 4, inscribed 'Mr Connel / DS'. Image obscure.

GROUP 77
John, Lord Cowan and his family

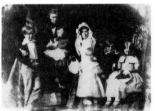

Negative, 1 modern print
Negative size 5, inscribed 'Cowan family', waxed.

GROUP 78
John, Lord Cowan, his wife and 2 sons

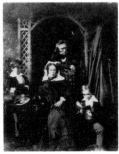

Negative, 1 albumen
Negative size 5, inscribed 'Cowan family / 5', waxed.

GROUP 79
As above

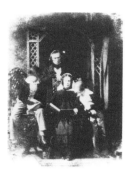

Negative, 1 modern print
Negative size 5, inscribed '? Cowan
No: There seems to be six children
in the Cowan family [in a later
hand] / 5', waxed.

GROUP 80
Rev Dr William Cunningham, Rev
Dr James Begg, Mr J Sim, or John
Hamilton, and Rev Dr Thomas
Guthrie

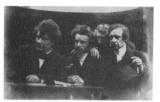

3 calotypes
Print size 5a.

GROUP 81
Rev George Davidson and Rev
John Lamb. Calotype used for the
Disruption Picture

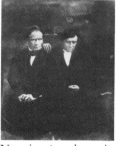

Negative, 1 modern print
Negative size 5, supports and mark
touched out in wash, waxed.

GROUP 82
Mr Dickson and 2 unknown
women

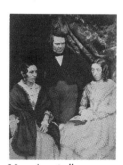

Negative, 1 albumen
Negative size 4, inscribed 'Group
Mr Dickson Sep/45 / 15', marks and
support touched out in pencil.

GROUP 83
Misses Dixon

Negative, 1 modern print
Negative size 4, inscribed 'Misses
Dixon'.

GROUP 84
Domenico Dragonetti, Robert
Lindley and perhaps Charles Lucas.
Calotype may have been taken
when the musicians were in
Edinburgh for the opening of the
New Music Hall in the Assembly
Rooms in George Street on 13
October 1843

Negative, 1 calotype
Negative size 5, inscribed 'Loder
[Loder was a violinist so the
identity may be wrong] Linney
Dragonetti / Musicians Light'.

GROUP 85
Charles and George Drysdale

3 calotypes
Print size 4.

GROUP 86
Rev – Duncan, Rev Thomas Jolly
and Rev William Sorley. Calotype
used for the Disruption Picture

Negative, 1 modern print
Negative size 4, inscribed 'Duncan
Jolly Sorley / DF', spots touched
out in wash, waxed. Image obscure.

GROUP 87
Rev William Wallace Duncan, Rev
Dr George John Craig Duncan and
Rev Dr Henry Duncan

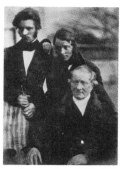

1 calotype
Print size 4.

GROUP 88
James and Thomas Duncan

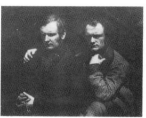

1 calotype, 1 carbon
Print size 5.

GROUP 89
As above. Figure of James Duncan
used for the Disruption Picture

2 calotypes
Print size 5.

GROUP 90
Unknown man, Thomas Duncan,
D O Hill and unknown man

1 calotype or later calotype
Print size 4.

GROUP 91
Unknown woman, James Dymock
and unknown man

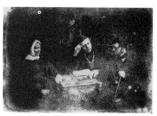

Negative, 1 modern print
Negative size 4. Image obscure.

GROUP 92
Man called 'David Edwards or
Parker' and unknown boy

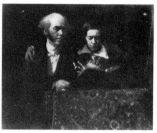

Negative, 1 calotype
Negative size 5, waxed.

GROUP 93
Harriet Farnie and Miss Farnie

2 calotypes
Print size 4.

GROUP 94
As above

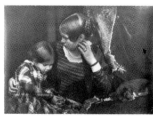

3 carbons
Print size 4.

GROUP 95
Mr and Mrs Farr

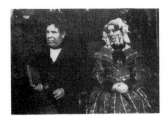

1 calotype
Print size 5.

GROUP 96
As above

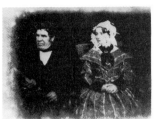

Negative, 1 modern print
Negative size 4, inscribed 'Mr and Mrs Farr'.

GROUP 97
Miss Wilhelmina Fillans, Miss Fillans and James Fillans

2 calotypes, 1 carbon, 1 photogravure
Print size 4.

GROUP 98
Miss Fillans and Miss Wilhelmina Fillans

Negative, 1 modern print
Negative size 4. Image obscure.

GROUP 99
Arthur, John Hope and Sophia Finlay. Calotype known as 'At the Minnow Pool'

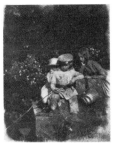

5 calotypes, 1 printed in reverse, 1 photogravure, 1 carbon
Print size 4.

GROUP 100
Sophia Finlay and Harriet Farnie

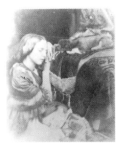

3 calotypes, 1 albumen
Print size 4.

GROUP 101
As above

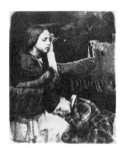

1 calotype
Print size 4.

GROUP 102
Perhaps Sophia Finlay and Mrs Charles Finlay

1 carbon
Print size 4.

GROUP 103
Professor Alexander Campbell Fraser, Rev James Walker, Rev Robert Taylor, Rev John Murray, Rev John Nelson, Rev Dr William Welsh

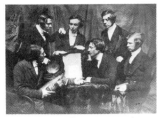

Negative, 3 calotypes, 1 carbon
Negative size 3, supports and watermark touched out in pencil, waxed.

GROUP 104
Professor Alexander Campbell Fraser, Rev James Walker, Rev Robert Taylor, Rev John Murray, Rev Dr William Welsh and Rev Dr John Nelson

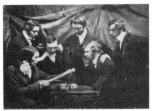

Negative, 1 later calotype, 1 carbon
Negative size 4, inscribed 'May 27/46', supports touched out in pencil, waxed.

GROUP 105
As above

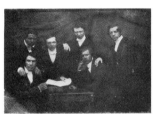

1 carbon
Print size 4.

GROUP 106
Peter Scott Fraser and Dr John Burt

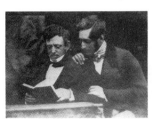

2 calotypes, 1 calotype or later calotype
Print size 5.

GROUP 107
– Fraser and – Dornoch; since there was a Fraser of Dornoch at this period, this may be Messrs Fraser of Dornoch.

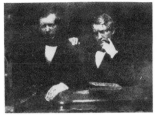

Negative, 1 modern print
Negative size 5, inscribed 'x Dup. Fraser + Dornoch / D6', waxed.

GROUP 108
As above

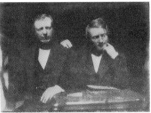

Negative, 1 calotype
Negative size 5, inscribed 'Fraser / Dark / Messrs Fraser Dornoch', waxed.

GROUP 109
Rev George Gilfillan and Dr Samuel Morrison Brown

Negative, 1 calotype, 1 albumen
Negative size 4, inscribed 'Dr Sam Brown + / Dr J Brown + Mr Gilfillan', right edge extended in wash.

GROUP 110
– Gordon, unknown man and – Watson

Negative, 2 later calotypes
Negative size 5, inscribed '20.15n5 / (40) / Gordon Watson', waxed.

GROUP 111
Mrs Gordon and her family

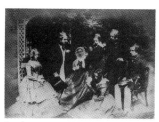

2 calotypes
Print size 2. Negative in Glasgow
University Library.

GROUP 112
As above

Negative, 1 calotype
Negative size 4, inscribed 'Mrs
Gordons Family Group', waxed.

GROUP 113
As above

Negative, 1 calotype
Negative size 4, inscribed 'Mrs
Gordons Family Group / DF
Gum', waxed.

GROUP 114
James Gordon, unknown man and
– Cowan

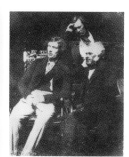

1 calotype
Print size 5.

GROUP 115
Mr and Mrs John Thomson
Gordon

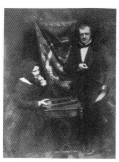

1 calotype, 1 later calotype cut
down
Print size 3.

GROUP 116
As above

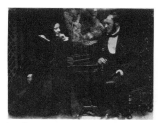

1 calotype
Print size 3. Negative in Glasgow
University Library dated 8 August
1845.

GROUP 117
Misses Grierson

1 calotype, 1 carbon
Print size 4.

GROUP 118
As above

4 calotypes
Print size 4.

GROUP 119
Mrs Hamilton and Misses
Doubiggan (*or* Hamilton)

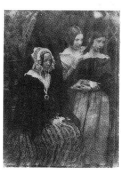

Negative, 1 modern print
Negative size 4, inscribed 'Aug [*or*
May] 28 Mrs Hamilton and Misses /
Gum', marks touched out in pencil
and wash.

GROUP 120
Misses Doubiggan (*or* Hamilton)

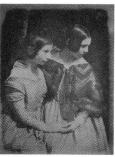

1 calotype
Print size 4.

GROUP 121
Mr Hamilton, Miss Fox Maule and
Mrs Hamilton

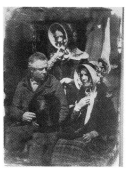

Negative, 1 modern print
Negative size 4, inscribed 'Mr +
Mrs Hamilton + 26 / Gum',
supports touched out in wash,
waxed.

GROUP 122
Mrs and Miss Handyside

Negative, 1 modern print
Negative size 5, inscribed 'Mrs
Handiside + Miss Handiside', lines
of hair touched in in pencil, waxed.

GROUP 123
J Stuart Hay of Rockville and his
son

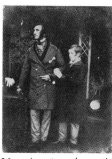

Negative, 1 modern print
Negative size 4, inscribed 'Hay Esq
+ Son of Rockville Nov 9–44 / DF'.

GROUP 124
John Henning, Alexander
Handyside Ritchie and D O Hill

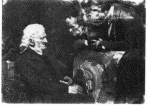

1 calotype cut down, 1 carbon
Print size 4.

GROUP 125
As above

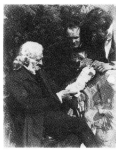

21 calotypes, 1 printed in reverse
Print size 4. Negative in the
collection of Mr John Craig Annan
on loan to the Science Museum,
London.

GROUP 126
John Henning and Alexander Handyside Ritchie

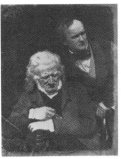

5 calotypes, 1 printed in reverse, 1 carbon, 1 photogravure
Print size 4.

GROUP 127
Mrs Cleghorn and John Henning as Miss Wardour and Edie Ochiltree from Sir Walter Scott's *The Antiquary*

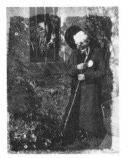

1 calotype
Print size 4.

GROUP 128
As above

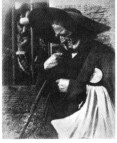

6 calotypes, 1 cut down
Print size 4.

GROUP 129
John Henning with a group, possibly including Miss Margaret McCandlish

Negative, 1 modern print
Negative size 4, inscribed '306', waxed.

GROUP 130
John Henning with 6 women and girls including Miss Margaret McCandlish

1 later calotype
Print size 4.

GROUP 131
2 unknown men, Rev Dr Hugh Heugh and unknown man

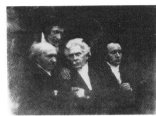

Negative, 1 modern print
Negative size 5, inscribed 'Light Group of Dr Heugh . . .', waxed.

GROUP 132
– Hewitson and – Dickson

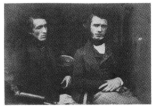

1 later calotype
Print size 4.

GROUP 133
D O Hill and William Borthwick Johnstone

3 calotypes, 1 carbon
Print size 4.

GROUP 134
D O Hill and Professor James Miller. Calotype known as 'The Morning After "He greatly daring dined".' The second part of the title is a pun based on the verse on Phaeton's gravestone which ended 'He, greatly daring, died', in Ovid's *Metamorphoses*

Negative, 3 calotypes, 2 later calotypes
Negative size 4, inscribed 'Professor Miller and Mr D O Hill', supports and spots touched out in pencil, waxed.

GROUP 135
D O Hill and Dr George Bell

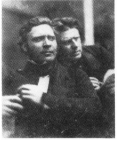

Negative, 1 modern print
Negative size 6, inscribed 'Hill + Harvey', waxed.

GROUP 136
Dr George Bell and D O Hill

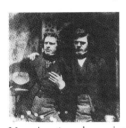

Negative, 1 modern print
Negative size 5, inscribed 'D O Hill'. Image obscure.

GROUP 137
D O Hill and Dr George Bell

1 calotype
Print size 4.

GROUP 138
As above

Negative, 1 calotype, 1 modern print
Negative size 4, inscribed 'D O Hill Dr Bell June 7/46', spots touched out in pencil.

GROUP 139
Peter Scott Fraser and D O Hill

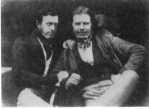

1 later calotype
Print size 5.

GROUP 140
Sir George Harvey and D O Hill

Negative, 1 later calotype
Negative size 147 × 114 mm, perhaps size 5 cut down, inscribed 'Harvey', waxed.

GROUP 141
Charlotte Hill and D O Hill

Negative, 1 modern print
Negative size 5, inscribed 'Mr D O Hill + Chatty', waxed.

GROUP 142
Peter Scott Fraser, D O Hill and Dr George Bell

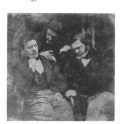

Negative, 2 later calotypes, 1 albumen
Negative size 6, waxed.

GROUP 143
Mediaeval group with D O Hill on the right

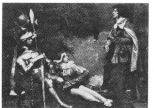

Negative, 1 calotype cut down, 1 modern print
Negative size 4, inscribed 'D2', lines of cloak reinforced in blue watercolour.

GROUP 144
Mr and Mrs Hind

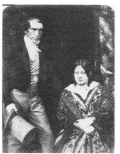

Negative, 3 calotypes
Negative size 4, inscribed 'Hind / 15 / ex1h', man's hair and jacket touched up and marks touched out in pencil.

GROUP 145
As above

Negative, 1 modern print
Negative size 4, inscribed 'Mr + Mrs Hind / ex1h 304', jacket touched up and watermark touched out in pencil.

GROUP 146
Rev John Jaffray and Dhanjiobai Nauroji. Figure of Nauroji used for the Disruption Picture

4 calotypes
Print size 4.

GROUP 147
Rev John Jaffray with 3 unknown women

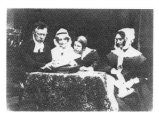

Negative, 1 albumen
Negative size 5, inscribed 'Jaffray / 24', waxed.

GROUP 148
William Borthwick Johnstone, William Leighton Leitch and David Scott as 'The Monks of Kennaquhair' from Sir Walter Scott's *The Abbot*

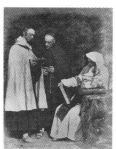

4 calotypes
Print size 3.

GROUP 149
William Borthwick Johnstone and William Leighton Leitch as 'The Monks of Kennaquhair'

1 calotype
Print size 3.

GROUP 150
Major and Misses Kemp

Negative, 1 modern print
Negative size 4, inscribed 'Group of Mr + Misses Kemp Jan 5/46 / HD', small spots touched out in wash.

GROUP 151
As above

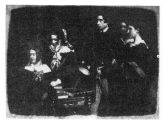

1 calotype
Print size 4.

GROUP 152
John Kermack and William Ramsay Kermack

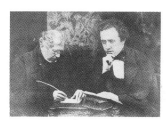

Negative, 1 calotype
Negative size 4, inscribed 'John Kermack R Kermack [in a later hand] / Wm Kermack / 30 / Gum', marks touched out in pencil.

GROUP 153
As above

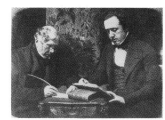

1 calotype
Print size 4.

GROUP 154
William Ramsay Kermack and Mrs Elizabeth Kermack

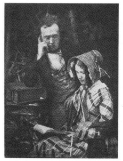

1 carbon
Print size 4.

GROUP 155
Rev Stewart Killin and Rev William Paterson Falconer

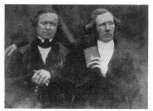

Negative, 1 later calotype
Negative size 5, inscribed 'Rev Stewart Killin Rev Falconer Ladhope Galashiels', small spots and headrest touched out in wash, waxed.

GROUP 156
Unknown man, Professor James Gibson and Rev Dr David King

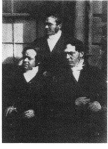

2 calotypes
Print size 4.

GROUP 157
Mrs Kinloch, William Napier and Mrs Napier

2 calotypes
Print size 4.

GROUP 158
William Napier and Mrs and Mr Kinloch

Negative, 1 calotype
Negative size 4, inscribed 'Napiers', supports touched out in pencil, waxed.

GROUP 159
As above

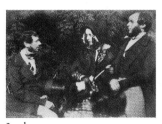

3 calotypes
Print size 4.

GROUP 160
– Lane and – Lewis

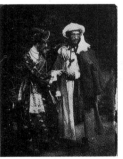

Negative, 1 modern print
Negative size 4, inscribed 'LANE + –', supports touched out in pencil, waxed.

GROUP 161
As above

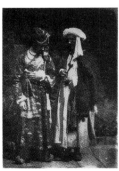

Negative, 1 calotype
Negative size 4, inscribed 'LEWIS? LANE? / 15 / Gum', support touched out in pencil, waxed.

GROUP 162
As above

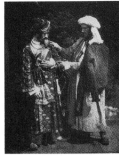

Negative, 1 modern print
Negative size 4, inscribed 'Lane "Arabian Nights" [in a later hand] / [Suth?] / Smooth', marks and supports touched out in pencil.

GROUP 163
– Lane and – Peddie (*or* Reddie *or* Redding). Calotype known as 'Afghans' or 'Circassian Armour'. *The Edinburgh Evening Courant*, 24 April 1843, reported a fancy dress ball at the Assembly Rooms which included 'Mr Lane, an Affghan' and, on 20 March 1843, a fancy dress ball given by Sir Neil Douglas including 'Mr C Rreddie [*sic*] – As an Affghan – chain armour'

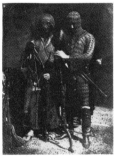

8 calotypes
Print size 4.

GROUP 164
Misses Liddle

Negative, 1 albumen
Negative size 4, inscribed 'Mrs Liddle May 22–44 / Misses Liddel Leith / DF', area touched up in wash.

GROUP 165
Mrs Logan and Miss Elizabeth Logan

Negative, 1 calotype, 1 carbon
Negative size 4, inscribed '160', waxed.

GROUP 166
Unknown man and Rev John Lyon

1 calotype
Print size 4.

GROUP 167
Margaret and Mary McCandlish

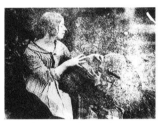

Negative, 1 modern print
Negative size 4. Image obscure.

GROUP 168
As above. Calotype called 'The Gowan [ie daisy]'. Margaret is tickling her sister's neck with a daisy

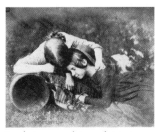

3 calotypes or later calotypes
Print size 4.

GROUP 169
Mary and Margaret McCandlish

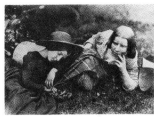

2 calotypes
Print size 4.

GROUP 170
Dr Mackenzie, Mrs Garston and Mrs Wyllie

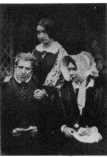

Negative, 1 calotype
Negative size 4, inscribed 'Dr Mackenzie's family group May 3/45 / ex Kept ex 1 hour / ¾ 304', marks touched out in pencil.

GROUP 171
As above

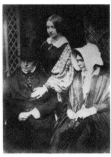

3 calotypes, 1 albumen
Print size 4.

GROUP 172
8 unknown men and – Mackenzie, second from right

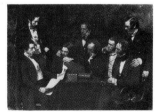

7 calotypes
Print size 3. Negative in Glasgow University Library.

GROUP 173
– Ferguson and Rev James MacLagan

Negative, 1 modern print
Negative size 5, inscribed 'McLaggan + Ferguson', marks touched out in wash, waxed. Image obscure.

GROUP 174
5 men with – Ferguson and Rev James MacLagan seated on left

Negative, 1 modern print
Negative size 5, marks touched out in wash, waxed.

GROUP 175
Miss McLean, Miss Mitchell and Miss Phillips

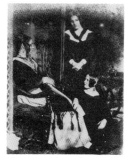

Negative, 1 modern print
Negative size 4, inscribed 'Miss Phillips, Miss McLean, Miss Mitchell / D1'.

GROUP 176
Miss L Campbell, Mrs MacLeay, Miss A Campbell, Kenneth MacLeay and Miss M Campbell

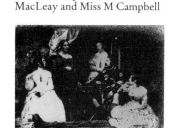

Negative, 1 modern print
Negative size 4, inscribed 'Misses Campbell + Mr McLea / 24'.

GROUP 177
Mrs MacLeay, Miss L Campbell, Miss A Campbell, Kenneth MacLeay and Miss M Campbell

Negative, 1 calotype, 1 albumen
Negative size 4, inscribed 'Misses Campbell + Mr + Mrs McLea'.

GROUP 178
Perhaps Mrs MacLeay and Kenneth MacLeay

Negative, 1 modern print
Negative size 4, inscribed 'McLea / D1'.

GROUP 179
Kenneth MacLeay and perhaps Mrs MacLeay

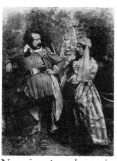

Negative, 1 modern print
Negative size 4, inscribed 'Kenneth McLea / D1', support touched out in wash, waxed.

GROUP 180
As above

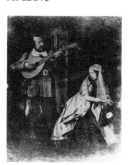

Negative, 1 modern print
Negative size 4, inscribed 'D1'.

GROUP 181
Lady McNeill and Miss McNeill

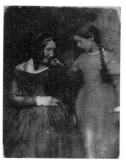

Negative, 1 calotype
Negative size 4, inscribed 'Lady McNeill and Daughter', mark and support touched out in pencil, waxed.

GROUP 182
Edward Main, – Main and Mrs Main

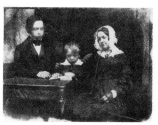

Negative, 1 modern print
Negative size 5, inscribed 'Mains', waxed.

GROUP 183
As above

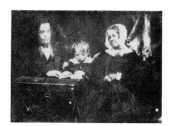

Negative, 1 modern print
Negative size 5, inscribed 'Edw / Main / [MW?]', waxed.

GROUP 184
Misses Marshal

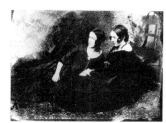

Negative, 1 modern print
Negative size 4, inscribed 'Misses Marshal Apr 46 / 15', marks touched out in pencil.

GROUP 185
As above

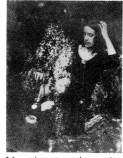

Negative, 1 modern print
Negative size 4, inscribed 'DDF / ½h', stained. Image obscure.

GROUP 186
As above

1 carbon
Print size 4.

GROUP 187
As above

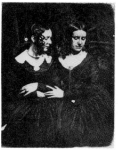

1 calotype
Print size 4.

GROUP 188
As above

Negative, 1 modern print
Negative size 4, inscribed 'Honble Misses Anneslie [in a later hand] / ½h / 30'.

GROUP 189
As above

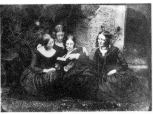

Negative, 1 modern print
Negative size 4, inscribed 'D15 /
½ h'.

GROUP 190
As above

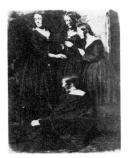

1 calotype
Print size 4.

GROUP 191
Rev John Allan, A Miller,
– Edmonds and unknown man

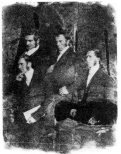

Negative, 1 modern print
Negative size 4, inscribed 'Rev Mr
Allen, Miller, Edmonds Nov 20 /
DF', supports and marks touched
out in pencil, waxed.

GROUP 192
Rev Ebenezer Miller and his family

2 calotypes, 2 carbons
Print size 4.

GROUP 193
Rev James Miller and Rev Samuel
Miller

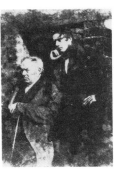

Negative, 1 modern print
Negative size 5, inscribed 'Rev Mr
+ Sam Miller', marks touched out
and edges touched up in wash.

GROUP 194
Miss Ellen and Miss Agnes Milne

6 calotypes, 1 carbon
Print size 4.

GROUP 195
Rev – Moir and John Gibson

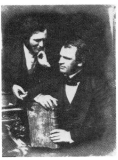

4 calotypes
Print size 4.

GROUP 196
George Monro and Mrs Justine
Gallie

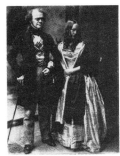

1 calotype, 2 carbons
Print size 4.

GROUP 197
– Moore and Misses Moore

Negative, 1 modern print
Negative size 4, inscribed 'Group
of Misses + Mr Moore Apr 16 /
DS'. Image obscure.

GROUP 198
As above

Negative, 1 modern print
Negative size 4, inscribed 'Group
of Misses Apr 16/45 / 200'.

GROUP 199
As above

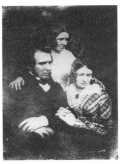

Negative, 1 modern print
Negative size 4, inscribed 'Group
of Misses Apr 16/45 / 30 [4?]'.

GROUP 200
Rev John Allan, Rev Dr James
Morgan, A Miller standing, 2
unknown men and – Edmonds

Negative, 1 modern print
Negative size 4, inscribed 'Rev Mr
Morgan, Allen, Miller, Edmonds
Nov 20 44', supports touched out in
wash, waxed.

GROUP 201
Colonel Morison, Robert Cadell,
James Wyld and Alexander Ross.
Figure of Ross used for the
Disruption Picture

Negative, 1 calotype
Negative size 5, inscribed 'Group
Wild Morison Cadde Ross
[illegible, perhaps Esq]'.

GROUP 202
Colonel Morison, Alexander Ross,
James Wyld and Robert Cadell

Negative, 1 modern print
Negative size 5, inscribed 'Wyld
Caddel Morrison / 24', headrest
touched out in wash, waxed.

GROUP 203
Miss Patricia and Miss Isabella
Morris and D O Hill

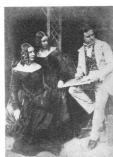

4 calotypes
Print size 4.

GROUP 204
D O Hill, Miss Isabella and Miss Patricia Morris

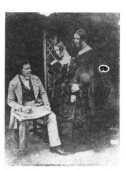

Negative, 1 modern print
Negative size 4, inscribed 'Miss I + P Morris Mr D O Hill / DF'.

GROUP 205
Miss Sophia Finlay, Charlie Finlay, Charles Finlay, Miss Patricia Morris, Miss Isabella Morris on the ground and Mrs Charles Finlay

Negative, 1 albumen
Negative size 5, inscribed '76 / Kept / Finlays / Morris'.

GROUP 206
Rev Dr George Muirhead, Rev Dr William Cunningham, Rev Dr James Begg, John Hamilton and Rev Dr Thomas Guthrie

Negative, 5 calotypes, 1 later calotype
Negative size 92 × 110mm, waxed.

GROUP 207
As above

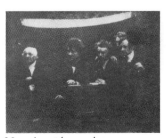

Negative, 1 later calotype
Negative 93 × 114 mm. Image obscure.

GROUP 208
O W Treyevant (*or* Napier), William Napier and B (*or* John) Richardson

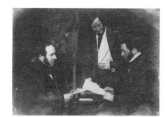

3 calotypes, later calotype, 1 albumen
Print size 4.

GROUP 209
As above

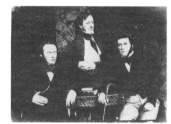

1 calotype, 1 later calotype, 1 albumen
Print size 4.

GROUP 210
William Napier, O W Treyevant and B Richardson

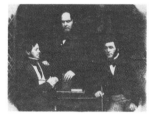

1 calotype
Print size 4.

GROUP 211
O W Treyevant, B Richardson and William Napier

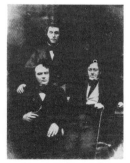

1 calotype, 1 later calotype
Print size 4.

GROUP 212
B Richardson, O W Treyevant and William Napier

1 later calotype
Print size 4.

GROUP 213
W S Orr and Peter Scott Fraser

1 calotype
Print size 4.

GROUP 214
Rev Dr Nathaniel Paterson seated and 2 unknown men

Negative, 1 modern print
Negative size 5, inscribed 'Cowan', waxed.

GROUP 215
Dr and Mrs Peddie.

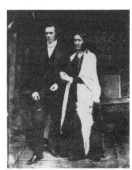

Negative, 1 modern print
Negative size 4, inscribed 'Dr + Mrs Peddie Apr 2/46'.

GROUP 216
As above

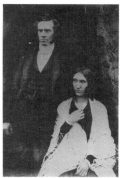

Negative, 1 albumen
Negative size 4, inscribed 'Dr + Mrs Peddie Apr 2 46', marks on face and hands touched out in pencil.

GROUP 217
Rev Dr John Purves, Rev Dr Alexander Somerville and Rev Dr Horatius Bonar

2 calotypes, 1 later calotype
Print size 4.

GROUP 218
3 unknown men, Robert Balfour Wardlaw Ramsay, perhaps – Douglas, unknown man and James Balfour

Negative, 1 modern print
Negative size 5, waxed.

GROUP 219
4 unknown men, Robert Balfour Wardlaw Ramsay, – Douglas, James Balfour and perhaps Rev Walter Wood

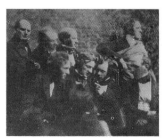

Negative 1 calotype
Negative size 5, waxed.

GROUP 220
– Rankine and Merson

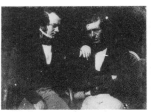

Negative, 1 modern print
Negative size 5, inscribed 'Rankine Merson', waxed.

GROUP 221
Mrs Anne Rigby and Lady Elizabeth Eastlake

11 calotypes, 6 carbons
Print size 4.

GROUP 222
Miss Rigby, Lady Elizabeth Eastlake and Mrs Matilda Smith

Negative, 1 modern print
Negative size 4, inscribed 'Misses Rigby', lines of the dark dresses drawn in in wash.

GROUP 223
As above

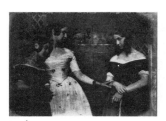

1 calotype
Print size 4.

GROUP 224
2 unknown women and Lady Elizabeth Eastlake

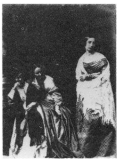

Negative, 1 calotype
Negative size 4, inscribed 'Misses Light Miss Rigby'.

GROUP 225
Lady Elizabeth Eastlake and unknown woman

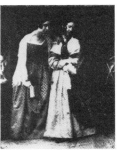

1 calotype
Print size 5.

GROUP 226
John Robertson and Hugh Miller

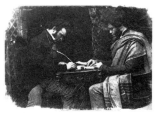

2 calotypes, 2 later calotypes
Print size 4.

GROUP 227
Rev Daniel Edward and Adolph Saphir

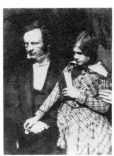

1 calotype
Print size 4.

GROUP 228
– Gersdorp, John, King of Saxony, unknown man, the Earl of Morton, Wyndam Anstruther and Sir Ralph Anstruther. Calotype taken by Adamson's assistant, in his absence, on 2 August 1844 (see Introduction).

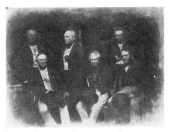

Negative, 3 calotypes, 1 later calotype
Negative size 4, inscribed '[Gersdorp?] King of Saxony Earl of Morton Sir Ralph Anstruther', supports and marks touched out in pencil.

GROUP 229
John Christian Schetky and Miss Schetky

1 calotype
Print size 4. Negative in Glasgow University Library dated 5 January 1846 and with foliage drawn in at the top of the trellis.

GROUP 230
Miss Schetky and John Christian Schetky

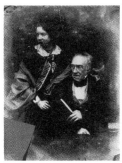

1 calotype
Print size 4, damaged at bottom left corner.

GROUP 231
Possibly Misses Scott

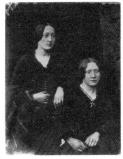

4 carbons
Print size 4.

GROUP 232
As above

1 calotype, 1 carbon
Print size 4.

GROUP 233
As above

Negative, 1 modern print
Negative size 4.

GROUP 234
Charles Kirkpartick Sharpe and unknown man

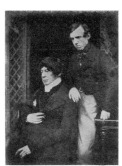

1 calotype
Print size 4.

GROUP 235
Unknown man and Charles
Kirkpatrick Sharpe

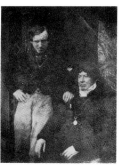

2 calotypes, 3 in an unidentified
process
Print size 4.

GROUP 236
Miss Shaw and – Keith

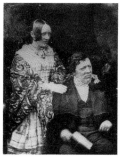

Negative, 1 modern print
Negative size 4, inscribed 'Miss
Shaw Mr Keith Sept 25/45 / ¼ / 15',
stain partly touched out in pencil.

GROUP 237
Mrs Simpson, Sir James Young
Simpson, 2 Simpson children,
unknown woman and – Simpson,
(*or* Baker)

Negative, 1 modern print
Negative size 4, inscribed 'Mrs
Simpson + Family Aug 21 / 15 ex¾
/ Gum', small spots touched out on
faces in wash.

GROUP 238
Simpson boy, Mrs Simpson, –
Simpson, unknown woman, Sir
James Young Simpson and Simpson
girl

Negative, 1 modern print
Negative size 4, inscribed 'Mrs
Simpson + Family Aug 21/45 / DS
ex¾ / Gum', spots touched out in
pencil and wash.

GROUP 239
Sir James Young Simpson and –
Simpson (*or* Dr George Baker)

Negative, 7 calotypes
Negative size 4, inscribed 'ex 1h',
marks touched out in pencil,
waxed.

GROUP 240
Sir James Young Simpson and –
Wainhouse (*or* Muirhouse)

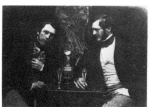

Negative, 10 calotypes, 1 albumen
Negative size 4, inscribed 'Simpson
Wainhouse', minor spots touched
out in pencil, waxed.

GROUP 241
As above

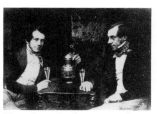

Negative, 1 calotype
Negative size 4, inscribed 'Simpson
Wainhouse Aug 11/45', marks
touched out in pencil.

GROUP 242
As above

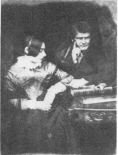

Negative, 1 modern print
Negative size 4, inscribed 'Simpson
Wainhouse Aug 21 / [304?] ex¾',
marks touched out in pencil.

GROUP 243
– Wainhouse and Sir James Young
Simpson

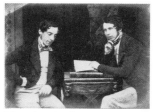

Negative, 1 calotype
Negative size 4, inscribed 'DF /
Gu', spots touched out in pencil.

GROUP 244
– Smith and Mrs Smith

Negative, 1 modern print
Negative size 4, inscribed 'Mr +
Mrs Smith Apr / 45 / DS / Gu',
marks touched out in pencil and
wash.

GROUP 245
Mrs and – Smith

Negative, 1 modern print
Negative size 4, inscribed 'Gum',
marks touched out in pencil.

GROUP 246
Steele children

Negative, 1 modern print
Negative size 4, inscribed 'Group
of Steele's Children Apr 16/45 / 26'.

GROUP 247
Mrs and – Stevens (*or* Mrs and Dr
Kerr)

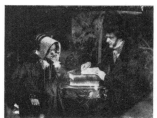

4 calotypes, 1 albumen, 1 carbon
Print size 4.

GROUP 248
As above

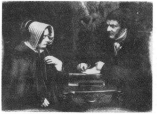

1 calotype
Print size 4.

GROUP 249
As above

Negative, 1 modern print
Negative size 4, inscribed '¼ c15 /
Str'. Image obscure.

GROUP 250
2 unknown women (perhaps Misses Stoddart) and Mrs Stoddart

Negative, 1 modern print
Negative size 5, inscribed 'Mrs Stoddart', waxed.

GROUP 251
Professor Andrew Symington and Rev Dr William Symington

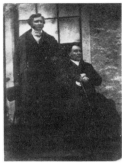

Negative, 1 later calotype
Negative size 5, inscribed 'Dr Symington Glasgow + Professor Symington Paisley. Reformed Presbyterians / Glasgow 21 Oct 1843', waxed.

GROUP 252
Lawrence Thomson, unknown man (*or* – Lawrence and – Thomson) and Rev John Thomson

Negative, 1 albumen
Negative size 4, inscribed 'Lawrence Thomson Rev John Thomson July 29', minor spots touched out in wash.

GROUP 253
Professor Sir Douglas Maclagan and Professor Allen Thomson

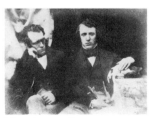

Negative, 1 calotype
Negative size 4, inscribed 'Dr Thomson + McLaggan / 24'.

GROUP 254
As above
Negative, 1 modern print
Negative size 4, inscribed '? Thomson + McLaggan'.
Image obscure, not illustrated.

GROUP 255
George Troup and William Gibson

1 calotype
Print size 4.

GROUP 256
Miss Watson, Miss Sarah Watson, Mrs Mary Watson, Miss Mary Watson, Agnes Milne and Ellen Milne

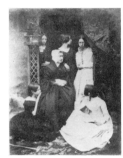

1 calotype
Print size 4.

GROUP 257
As above, with unknown boy

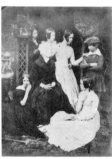

1 calotype
Print size 4.

GROUP 258
Miss Ellen Milne, Miss Mary Watson, Miss Watson, Miss Agnes Milne and Sarah Wilson

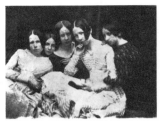

1 calotype, 1 carbon
Print size 4.

GROUP 259
Mrs Mary Watson, Miss Agnes Milne, Miss Mary Watson, Miss Watson, Miss Ellen Milne

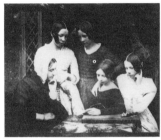

1 albumen
Print size 88 × 110 mm.

GROUP 260
Miss Mary Watson and Mrs Mary Watson

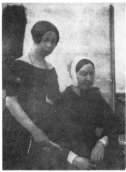

Negative, 1 calotype
Negative size 4, inscribed 'Mrs + Miss Watson Apr 9/45 / ¾ / 15', marks and supports touched out in pencil.

GROUP 261
Called 'Misses Watson'

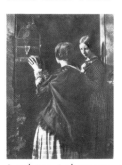

2 carbons, 1 photogravure
Print size 4.

GROUP 262
Miss Mary Watson and Miss Ross

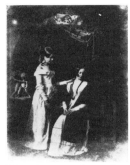

Negative, 1 modern print
Negative size 4, inscribed 'Miss Mary Watson + Miss Ross', small spots on face and hands touched out in wash.

GROUP 263
Alexander Murray Dunlop and Rev Dr David Welsh

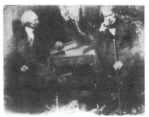

2 later calotypes
Print size 3. Negative in Glasgow University Library dated 13 June 1844.

GROUP 264
– Wilkinson and Mrs Wilkinson

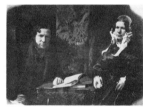

1 calotype
Print size 4.

GROUP 265
Captain Costorphine, unknown man, Mrs Wilkinson and Mr Wilkinson

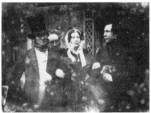

Negative, 1 modern print
Negative size 4, inscribed 'Group of Mr + Mrs Wilkinson Capt Costorphine May 14/45 / ½ 15'. Image obscure.

GROUP 266
Misses Wilson

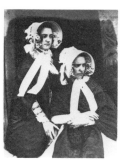

1 calotype
Print size 4.

GROUP 267
As above

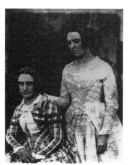

1 calotype
Print size 4.

GROUP 268
Perhaps Mrs Agnes Wood and Rev
Walter Wood

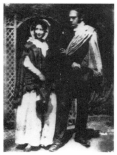

Negative, 1 modern print
Negative size 5, inscribed '165',
waxed.

GROUP 269
John Stuart-Wortley, Baron
Wharncliffe and Georgina,
Baroness Wharncliffe

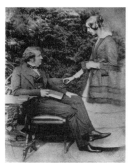

3 calotypes
Print size 4.

GROUP 270
Baroness and Baron Wharncliffe

3 calotypes, 1 albumen, 1 carbon
Print size 4.

Unknown Groups

UNKNOWN GROUP 1

1 calotype
Print size 4.

UNKNOWN GROUP 2

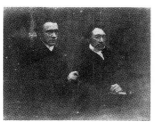

Negative, 1 later calotype
Negative size 5, supports touched
out in wash, waxed. Image obscure.

UNKNOWN GROUP 3

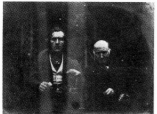

Negative, 1 later calotype
Negative size 5, waxed. Image
obscure.

UNKNOWN GROUP 4

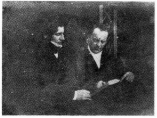

Negative, 1 later calotype
Negative size 5, inscribed 'D1',
waxed.

UNKNOWN GROUP 5

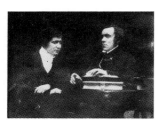

Negative, 1 modern print
Negative size 5, inscribed '24',
waxed.

UNKNOWN GROUP 6

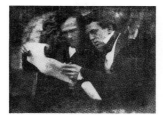

Negative, 1 modern print
Negative size 5, inscribed '12',
marks touched out in wash, waxed.

UNKNOWN GROUP 7

*Negative, 1 modern print
Negative size 5, inscribed 'D1',
waxed. Image obscure, not
illustrated.*

UNKNOWN GROUP 8

*Negative, 1 modern print
Negative size 5, marks touched out
in wash, waxed. Image obscure, not
illustrated*

UNKNOWN GROUP 9

1 later calotype, 1 carbon
Print size 4.

UNKNOWN GROUP 10

2 carbons
Print size 4.

UNKNOWN GROUP 11

1 calotype, 1 carbon
Print size 4.

UNKNOWN GROUP 12

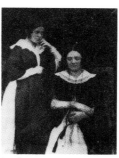

1 calotype
Print size 5.

UNKNOWN GROUP 13

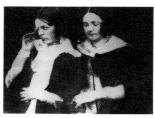

1 calotype
Print size 5.

UNKNOWN GROUP 14

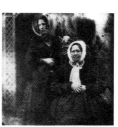

Negative, 1 modern print
Negative size 6, waxed.

UNKNOWN GROUP 15

2 calotypes
Print size 5.

UNKNOWN GROUP 16

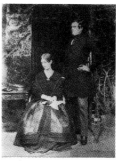

1 calotype
Print size 5.

UNKNOWN GROUP 17

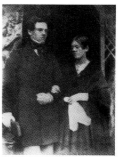

Negative, 1 calotype
Negative size 5, mark touched out
in pencil.

UNKNOWN GROUP 18

3 later calotypes
Print size 5.

UNKNOWN GROUP 19

Negative, 1 modern print
Negative size 4, hair touched up in
pencil, waxed.

UNKNOWN GROUP 20

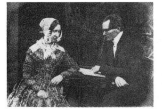

Negative, 1 modern print
Negative size 4, inscribed '[Pris?]',
waxed.

UNKNOWN GROUP 21

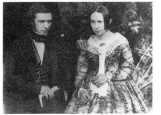

1 calotype
Print size 4.

UNKNOWN GROUP 22

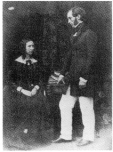

Negative, 2 calotypes
Negative size 4, inscribed '15 /
Gum', headrest touched out in
wash, waxed.

UNKNOWN GROUP 23

Negative, 1 modern print
Negative size 4, inscribed 'DF /
Gum'. Image obscure.

UNKNOWN GROUP 24

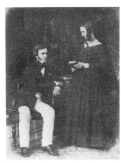

3 calotypes
Print size 4.

UNKNOWN GROUP 25

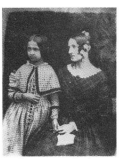

1 calotype, 1 print in an
unidentified process
Print size 4.

UNKNOWN GROUP 26

Negative, 1 modern print
Negative size 4, inscribed 'D15 /
1½h'. Image obscure.

UNKNOWN GROUP 27

Negative, 1 modern print
Negative size 4, inscribed 'D15'.

UNKNOWN GROUP 28

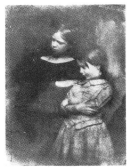

Negative, 1 modern print
Negative size 4. Image obscure.

UNKNOWN GROUP 29

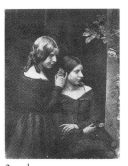

2 carbons
Print size 4.

UNKNOWN GROUP 30

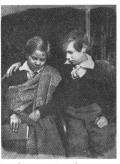

1 calotype, 1 carbon
Print size 4.

UNKNOWN GROUP 31

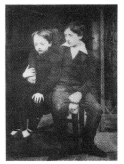

1 calotype
Print size 5.

UNKNOWN GROUP 32

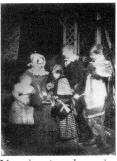

Negative, 1 modern print
Negative size 4, inscribed 'Mrs
Family Group March 26/45 /
Starch'.

UNKNOWN GROUP 33

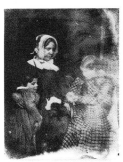

Negative, 1 modern print
Negative size 4, inscribed 'thick
Gum / 2926'. Image obscure.

UNKNOWN GROUP 34

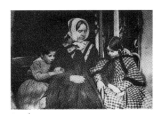

1 calotype
Print size 5.

UNKNOWN GROUP 35

1 calotype, 1 carbon
Print size 4.

UNKNOWN GROUP 36

Calotype taken at York between 28
September and 4 October, 1844

Negative, 1 modern print
Negative size 4, inscribed 'Gu'.

UNKNOWN GROUP 37

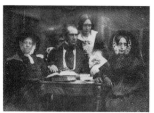

Negative, 1 modern print
Negative size 5, headrest touched
out in pencil.

UNKNOWN GROUP 38

Negative, 1 modern print
Negative size 5, inscribed '25 24',
hair and faces touched up in pencil,
waxed. Image obscure.

UNKNOWN GROUP 39

Negative, 1 modern print
Negative size 5a, waxed.

UNKNOWN GROUP 40

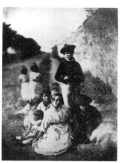

Negative, 1 modern print
Negative size 4, inscribed 'D2',
clothes touched up in wash, waxed.
Image obscure.

UNKNOWN GROUP 41

Negative, 1 modern print
Negative size 4, inscribed 'ex ¾ Gu
/ ¼ 15'. Image obscure.

UNKNOWN GROUP 42

Negative, 1 modern print
Negative size 4, inscribed '15'.

UNKNOWN GROUP 43

Negative, 1 modern print
Negative size 4, inscribed '15 ¼',
support and spots on faces touched
out and clothes touched up in
pencil.

UNKNOWN GROUP 44

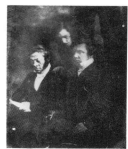

1 later calotype, 1 carbon
Print size 4.

UNKNOWN GROUP 45

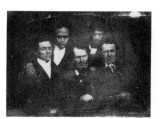

Negative, 1 modern print
Negative size 5, clothes and top
edge touched up in wash, waxed.

UNKNOWN GROUP 46

Negative, 1 albumen
Negative size 5, inscribed
'Annesley Group'.

UNKNOWN GROUP 47

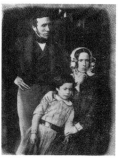

1 calotype
Print size 4.

UNKNOWN GROUP 48

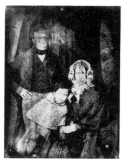

Negative, 1 modern print
Negative size 4, inscribed '¼ 15',
stained. Image obscure.

UNKNOWN GROUP 49

Negative, 1 modern print
Negative size 4, inscribed '1h'.

UNKNOWN GROUP 50

1 calotype
Print size 5.

UNKNOWN GROUP 51

1 calotype
Print size 5.

UNKNOWN GROUP 52

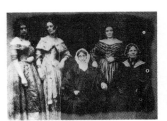

1 calotype
Print size 4.

UNKNOWN GROUP 53

1 calotype
Print size 4.

UNKNOWN GROUP 54

Negative, 1 modern print
Negative size 4, inscribed 'Mr
Family Group Dark Aug 26 / Last
Gum'. Image obscure.

UNKNOWN GROUP 55

Negative, 1 modern print
Negative size 4, inscribed 'Mr
Family Group Aug 26 / Last Amm
[or Gum]'.

UNKNOWN GROUP 56

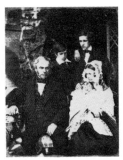

1 calotype
Print size 4.

UNKNOWN GROUP 57

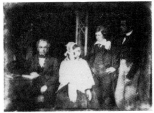

Negative, 1 modern print
Negative size 4, inscribed 'Group
of Mr + Mrs + two sons Aug 26
44'.

Presbytery Groups

For fuller details of the individuals in the groups, where known, see the catalogue under Men

PRESBYTERY GROUP 1
Aberdeen Presbytery. Rev Dr
Alexander Spence, unknown man,
Rev Dr Alexander Dyce Davidson,
Rev Dr James Bryce, Professor
Alexander Black and Rev Dr James
Foote

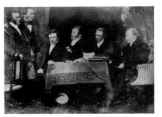

2 calotypes, 2 later calotypes, 1
albumen
Print size 4, inscription printed off
from negative 'D. O. Hill + R.
Adamson ft. Presbytery of
Aberdeen Taken at Glasgow
[illegible]'.

PRESBYTERY GROUP 2
Annan Presbytery. Unknown man,
Rev Hugh McBryde Brown,
perhaps Rev George Duncan,
perhaps Rev James Mackenzie and
Rev Dr Henry Duncan

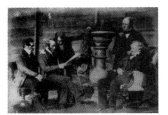

1 calotype, 1 print in an
unidentified process
Print size 4.

PRESBYTERY GROUP 3
Arbroath Presbytery. Perhaps Rev
Dr William Wilson, Rev John Kirk
seated, Rev Thomas Dymock
standing, man called 'Lord Provost
Austin Arlinton' standing, Rev Dr
James Lumsden seated, Rev
Thomas Wilson standing, Rev
Andrew Peebles seated, Rev
Alexander Leslie standing

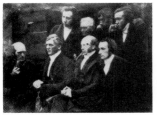

2 negatives, 1 apparently a copy of
the other, 2 calotypes, 1 later
calotype, 4 carbons.
Negative size 5, inscribed 'Group
Arbroath Presbytery Light',
headrest touched out in wash,
waxed.

PRESBYTERY GROUP 4
Auchterarder Presbytery. Rev
Andrew Noble, Rev James
Carment, Rev John Ferguson, Rev
James Thomson and 2 unknown
men standing. Figures of Noble,
Carment and Thomson used for the
Disruption Picture

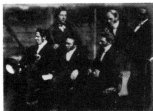

Negative, 1 calotype, 1 later
calotype, 1 carbon
Negative size 4, inscribed
'Presbytery of Auchterarder
Glasgow 22 Oct 1843', supports
and mark touched out in wash.

PRESBYTERY GROUP 5
Ayr Presbytery. 16 men including
Rev James Stevenson seated second
from left. Third seated figure used
for the Disruption Picture but not
identified

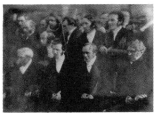

Negative, 1 calotype, 1 albumen
Negative size 4, inscribed
'Presbytery of Ayr', waxed.

PRESBYTERY GROUP 6
Dunbarton Presbytery. Rev
William Alexander, – McMillan of
Cardross, Rev James Smith (or
Goodsir] and Rev John Pollock.
Figures of Alexander, Smith and
Pollock used for the Disruption
Picture but wrongly identified in
the key which is confused at this
point

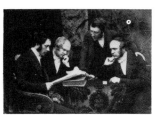

4 calotypes, 1 later calotype, 1
albumen
Print size 4.

PRESBYTERY GROUP 7
Dunbarton Presbytery.
– McMillan, Rev William
Alexander, Rev James Smith and
Rev John Pollock

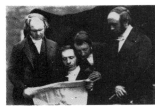

2 calotypes, 1 albumen
Print size 4.

PRESBYTERY GROUP 8
Dundee Presbytery. Unknown
man standing, Rev James Ewing
seated, unknown man standing,
Rev James Miller seated, unknown
man standing, Rev Dr John
Roxburgh, 3 unknown men and
Rev Dr Samuel Miller seated

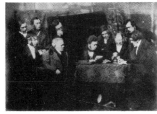

Negative, 2 calotypes, 1 carbon
Negative size 4, inscribed 'D. O.
Hill RSA Presbytery of Dundee.
Taken at Glasgow. 22 Oct 1843. R
Adamson Ft.', waxed.

PRESBYTERY GROUP 9
Dundee Presbytery. As above

1 later calotype
Print size 4, inscription printed off
from negative 'D. O. Hill RSA
Presbytery of Dundee Taken at
Glasgow 22 Oct 1843 R. Adamson
Ft.'

PRESBYTERY GROUP 10
Dunfermline Presbytery. Perhaps
Rev John Robertson, 2 unknown
men, Rev William Gilston and Rev
Thomas Doig. Figures of Gilston,
Doig and possibly Robertson used
for the Disruption Picture

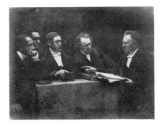

Negative, 1 later calotype, 1
albumen
Negative size 5, inscribed
'Presbytery of Dunfermline. Done
at Glasgow. A.D. 1843. 21 Oct.',
small spots touched out in wash,
waxed.

PRESBYTERY GROUP 11
Dunfermline Presbytery. As above

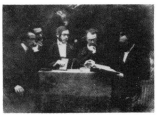

Negative, 1 modern print
Negative size 5, inscribed
'Presbytery of Dunfermline.
Glasgow 21 Oct A.D. 1843.'

PRESBYTERY GROUP 12
Edinburgh Presbytery. Seated, Rev
Dr Robert Elder, Rev Dr Patrick
Clason, Alexander Earle Monteith,
Robert Cunningham Graham
Speirs, Rev Dr George Muirhead,
Rev Dr Thomas Chalmers, Rev Dr
John Bruce, Rev Dr James Begg,
Rev Dr Robert Gordon, Rev Dr
Henry Grey; standing, Alexander
Dunlop, Rev Alexander Watson
Brown, Patrick Graham, – Murray,
2 unknown men, Alexander (or
William) Fraser, Rev Dr William
Tweedie, Rev – Foggo, Charles
Chalmers, Rev James Fairbairn,
– Jeffrey and Rev David Thorburn

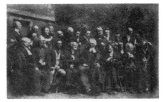

Negative, 2 calotypes, 1 later
calotype
Negative size 5a, waxed.

PRESBYTERY GROUP 13
Edinburgh Presbytery. As above

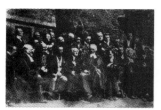

Negative, 1 modern print
Negative size 5a, inscribed 'no 3 –
30 – 5', slightly touched up in wash.

PRESBYTERY GROUP 14
Edinburgh Presbytery. Seated, Rev
Dr Patrick Clason, Alexander Earle
Monteith, Robert Cunningham
Graham Speirs, Rev Dr George
Muirhead, Rev Dr Thomas
Chalmers, Rev Dr John Bruce;
standing, Alexander Dunlop, Rev
Alexander Watson Brown,
unknown man, Professor James
Bannerman, Patrick Graham,
unknown man, Alexander Fraser,
Rev Dr Thomas Guthrie, perhaps
Rev – Foggo, unknown man,
Charles Chalmers, Rev Dr James
Begg and Rev James Fairbairn

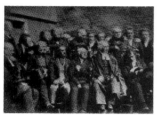

Negative, 2 calotypes
Negative size 4, inscribed 'Large
group of ministers', marks touched
out in wash, waxed.

PRESBYTERY GROUP 15
Fordyce Presbytery. 4 unknown
men

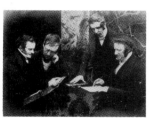

Negative, 2 albumens, 1 carbon
Negative size 4, inscribed
'Presbytery Fordyce May 29/46
[*or* 4]', marks on faces touched out
in pencil, waxed.

PRESBYTERY GROUP 16
Fordyce Presbytery. As above

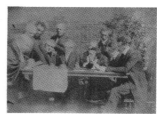

Negative, 1 albumen, 1 modern
print
Negative size 4, inscribed
'Presbytery of Fordyce / 21'.

PRESBYTERY GROUP 17
Called 'Glasgow Presbytery'. 6
unknown men.

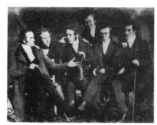

1 calotype
Print size 4.

PRESBYTERY GROUP 18
Irvine Presbytery. Rev Matthew
Dickie, Rev David Arthur, Rev
Thomas Findlay, Rev David
Wilson, Rev David Landsborough

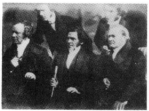

Negative, 2 calotypes, 2 carbons
Negative size 4, inscribed 'D. O.
Hill R.S.A. Presbytery of Irvine
Glasgow 22 Oct 1843 + R.
Adamson Ft.', top and side edges
drawn in in wash.

PRESBYTERY GROUP 19
Free Church committee. Rev Dr
Patrick Clason seated, perhaps
William Fraser standing, unknown
man, Charles Chalmers, unknown
man, John Hunter, unknown man,
Rev Alexander Watson Brown and
3 unknown men

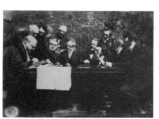

Negative, 2 later calotypes
Negative size 5, inscribed 'mz [*or
possibly* neg] 30–5', waxed.

PRESBYTERY GROUP 20
Free Church committee. As above

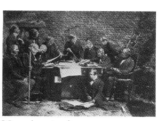

Negative, 1 calotype, 2 later
calotypes
Negative size 4, inscribed
'Committee of the Church', waxed.

PRESBYTERY GROUP 21
Free Church committee. Perhaps
Sergeant Mackenzie, unknown
man, Rev Dr Patrick Clason, James
Crawford, William Fraser, perhaps
Rev John Jeffray, W G Clark
kneeling on ground, unknown
man, Robert Paul, unknown man
and Archibald Bonar

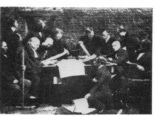

2 calotypes
Print size 123 × 174 mm.

PRESBYTERY GROUP 22
Free Church committee. As above

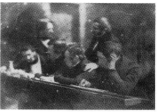

Negative, 1 calotype
Negative size 5, waxed.

PRESBYTERY GROUP 23
The reporters' table. John
Johnstone seated, John
MacDonald, Rev Andrew
Cameron, W Robertson, – Skene,
and J R Fyfe

1 calotype
Print size 5.

PRESBYTERY GROUP 24
The reporters' table. – Skene
standing, W Robertson, J R Fyfe,
John Johnstone, John MacDonald
and Rev Andrew Cameron

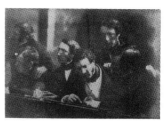

1 calotype
Print size 4.

PRESBYTERY GROUP 25
The reporters' table. As in
Presbytery Group 23

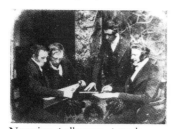

Negative, 1 later calotype, 1
modern print
Negative size 5, inscribed
'Reporters / 25 20 40 [*or* 60]'.

Military

MILITARY 1
Sergeant and Private of the 42nd
Gordon Highlanders. Calotype
known as 'The Porthole', taken in
April 1846 in Edinburgh Castle

3 calotypes, 1 carbon
Print size 4.

MILITARY 2
Piper and drummer of the 42nd
Gordon Highlanders. Calotype
taken in April 1846 in Edinburgh
Castle

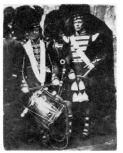

1 calotype
Print size 4.

MILITARY 3
Group of 42nd Gordon
Highlanders. Calotype taken in
April 1846 in Edinburgh Castle

1 calotype
Print size 4.

MILITARY 4
Sergeant of the 42nd Gordon
Highlanders reading the orders of
the day. Calotype taken in April
1846 in Edinburgh Castle

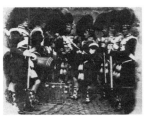

1 calotype
Print size 4. Negative in the
collection of the University of New
Mexico.

MILITARY 5
42nd Gordon Highlanders in
Edinburgh Castle. Calotype taken
in April 1846

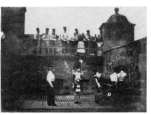

1 calotype
Print size 4.

MILITARY 6
Major Wright of the Leith Fort
Artillery

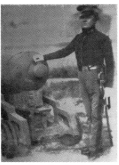

Negative, 1 calotype
Negative size 4, inscribed 'xxx
Major Wright', edges and spots
touched up in wash.

MILITARY 7
Captain St George of the Leith Fort
Artillery

Negative, 1 albumen
Negative size 4, inscribed 'St
George / D2'.

MILITARY 8
Captain St George and Major
Crawford of the Leith Fort
Artillery

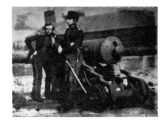

1 calotype
Print size 4.

MILITARY 9
Major Crawford, Major Wright,
Captain St George and Captain
Bortingham of the Leith Fort
Artillery

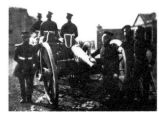

1 calotype
Print size 4.

MILITARY 10
Unknown officer, three mounted
soldiers, Major Wright, possibly
Captain Bortingham and Major
Crawford

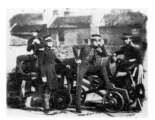

1 calotype
Print size 4.

MILITARY 11
Leith Fort with artillery

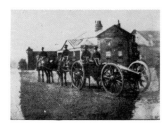

1 calotype
Print size 4.

Edinburgh

EDINBURGH 1

The High Street with John Knox's house

15 calotypes
Print size 4.

EDINBURGH 2

The High Street with John Knox's house

1 calotype
Print size 4.

EDINBURGH 3

John Knox's house

1 calotype
Print size 4.

EDINBURGH 4

The High Street, White Horse Close

1 calotype
Print size 4, sky touched up in watercolour.

EDINBURGH 5

The General Assembly Hall of the Free Church during building with the Castle and the church of Tolbooth St John in the background

3 calotypes
Print size 4.

EDINBURGH 6

The General Assembly Hall during building

3 calotypes
Print size 1. Negative in Glasgow University Library dated 9 September 1844.

EDINBURGH 7

Edinburgh Castle from the south-west

1 calotype
Print size 4, edge touched up in wash.

EDINBURGH 8

Edinburgh Castle, the Half Moon Battery

1 calotype
Print size 4.

EDINBURGH 9

Princes Street with the Scott Monument

7 calotypes
Print size 4.

EDINBURGH 10

The Scott Monument during building

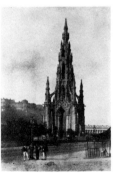

2 calotypes
Print size 4.

EDINBURGH 11

The Scott Monument. A variant negative in the collection of Glasgow University Library is dated 2 May 1845

6 calotypes
Print size 4.

EDINBURGH 12

Masons working on a carved griffin for the Scott Monument

2 calotypes
Print size 4.

EDINBURGH 13

Masons working on the ornament for the Scott Monument

1 carbon
Print size 4.

EDINBURGH 14

Masons levering up a carved leaf capital for the Scott Monument

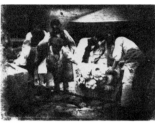

1 carbon
Print size 4.

EDINBURGH 15

The Royal Institution, later the Royal Scottish Academy

1 calotype
Print size 4.

EDINBURGH 16

The Royal Institution with the Castle in the background

4 calotypes
Print size 4.

EDINBURGH 17

View along Princes Street from the roof of the Royal Institution
1 calotype
Print size 4. Image obscure, not illustrated.

EDINBURGH 18
Register House from Waterloo
Place

1 calotype
Print size 4.

EDINBURGH 19
Lady Glenorchy's Chapel during
demolition, on the site of Waverley
Station

2 calotypes
Print size 4.

EDINBURGH 20
The Orphan Hospital during
demolition, on the site of Waverley
Station

2 calotypes
Print size 4.

EDINBURGH 21
Trinity College Chapel and
Hospital, with Calton Hill in the
background

1 print in an unidentified process
Print size 4. Negative in Glasgow
University Library.

EDINBURGH 22
The Political Martyrs' Memorial in
the Calton Hill Cemetery. The
foundation stone was laid 29
August 1844

1 calotype
Print size 4. Negative in Glasgow
University Library.

EDINBURGH 23
Calton Hill, the Playfair and
Peninsular Monuments

1 calotype
Print size 161 × 116 mm, perhaps
size 5 cut down.

EDINBURGH 24
Calton Hill, the Dugald Stewart
Monument

2 calotypes
Print size 4.

EDINBURGH 25
Calton Hill, the Dugald Stewart
Monument

2 calotypes
Print size 5.

EDINBURGH 26
Calton Hill, the Dugald Stewart
Monument

1 calotype
Print size 5.

EDINBURGH 27
Calton Hill, the Burns Monument

2 calotypes
Print size 6.

EDINBURGH 28
Calton Hill, the Burns Monument

1 calotype
Print size 170 × 131 mm, may be
size 4 cut down. May not be by Hill
and Adamson.

EDINBURGH 29
George Street, the portico of the
National Commercial Bank

1 calotype
Print size 4.

EDINBURGH 30
Statue of the 4th Earl of Hopetoun
in the forecourt of the Royal Bank
of Scotland, St Andrew Square

1 calotype
Print size 3.

EDINBURGH 31
St Andrew Square, the Bank of
Scotland

1 calotype
Print size 4.

EDINBURGH 32
The Royal High School

1 calotype
Print size 5.

EDINBURGH 33
The Royal High School

3 calotypes
Print size 4.

EDINBURGH 34
The Royal High School

2 calotypes
Print size 4.

EDINBURGH 35
Laying the foundation stone of
New College in 1846

Negative, 1 modern print
Negative size 4.

EDINBURGH 36
Heriot's Hospital

1 calotype
Print size 108 × 139 mm. May not
be by Hill and Adamson.

EDINBURGH 37
Heriot's Hospital

1 calotype
Print size 103 × 161 mm. May not
be by Hill and Adamson.

EDINBURGH 38
Merchiston Castle School.
Calotype presumably taken in 1844

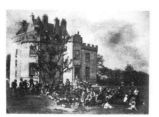

2 calotypes
Print size 3. Negative in Glasgow
University Library.

EDINBURGH 39
The ruins of Greyfriars' Church

1 calotype
Print size 4.

EDINBURGH 40
The ruins of Greyfriars' Church

1 calotype
Print size 4.

EDINBURGH 41
Greyfriars' Churchyard, east side

1 calotype
Print size 5.

EDINBURGH 42
Greyfriars' Churchyard,
monuments on east side including
Dennistoun and Naismith
monuments

1 calotype
Print size 5.

EDINBURGH 43
Greyfriars' Churchyard,
Dennistoun, Bethune and Naismith
monuments. Seated man, possibly
D O Hill, with 2 small children on
the Naismith monument

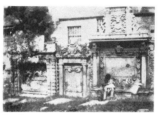

2 calotypes
Print size 5.

EDINBURGH 44
Greyfriars' Churchyard, Naismith,
Bethune, Dennistoun and perhaps
the Purves monument. Reclining
man in foreground may be Thomas
Duncan

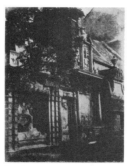

3 calotypes
Print size 4.

EDINBURGH 45
Greyfriars' Churchyard, including
the Naismith, Bethune and
Dennistoun monuments

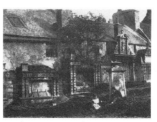

4 calotypes, 2 carbons
Print size 4.

EDINBURGH 46
Greyfriars' Churchyard, the
Dennistoun monument

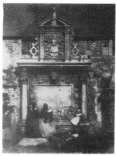

3 calotypes
Print size 5.

EDINBURGH 47
Greyfriars' Churchyard, the
Dennistoun monument with D O
Hill, his nieces the Misses Watson
and an unknown man. Calotype
known as 'The Artist and the
Gravedigger'

5 calotypes, 3 carbons
Print size 4.

EDINBURGH 48
Greyfriars' Churchyard, the
Dennistoun monument with
D O Hill and his nieces

Negative, 9 calotypes
Negative size 4, waxed.

EDINBURGH 49
Greyfriars' Churchyard, the Dennistoun monument with the Misses Watson and John Henning

3 calotypes
Print size 4.

EDINBURGH 50
Greyfriars' Churchyard, the Naismith monument with Thomas Duncan and D O Hill

11 calotypes
Print size 4.

EDINBURGH 51
Greyfriars' Churchyard, the Naismith monument with 2 unknown men, John Henning and D O Hill

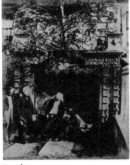

8 calotypes
Print size 4.

EDINBURGH 52
Greyfriars' Churchyard, the McCulloch monument and the spire of the church of Tolbooth St John in the background

2 calotypes
Print size 5.

EDINBURGH 53
Greyfriars' Churchyard, the McCulloch monument

2 calotypes
Print size 4.

EDINBURGH 54
Greyfriars' Churchyard, the Martyrs' Memorial and the McCulloch monument. The figures may be D O Hill and Miss Watson

34 calotypes, 1 printed in reverse
Print size 4.

EDINBURGH 55
Greyfriars' Churchyard, the Martyrs' Memorial

1 calotype
Print size 113 × 102 mm. May not be by Hill and Adamson.

EDINBURGH 56
Greyfriars' Churchyard, unknown group at the Martyrs' Memorial

Negative, 1 modern print
Negative size 4.

EDINBURGH 57
Greyfriars' Churchyard, the Bannatyne monument

1 calotype
Print size 4.

EDINBURGH 58
Greyfriars' Churchyard, a group of tombs with the Foulis monument on the right

1 calotype
Print size 5.

EDINBURGH 59
Greyfriars' Churchyard, a group of tombs including the Foulis monument with an unknown man reclining centre

1 calotype
Print size 5.

EDINBURGH 60
Greyfriars' Churchyard, the Byres monument. Calotype dated 'August 1843'

2 calotypes
Print size 4.

EDINBURGH 61
Greyfriars' Churchyard, the Byres monument

5 calotypes, 1 carbon
Print size 4.

EDINBURGH 62
Greyfriars' Churchyard, Heriot's Hospital in the background, the Paton monument at right

3 calotypes
Print size 5.

EDINBURGH 63

Greyfriars' Churchyard, a group of monuments including the Chalmers and Jackson monuments with Edinburgh Castle in the background

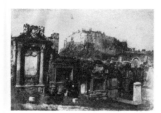

3 calotypes
Print size 5.

EDINBURGH 64

Similar to the above with a man and woman seated on the grass

1 calotype
Print size 5.

EDINBURGH 65

Greyfriars' Churchyard, a group of monuments including the Paton and Chalmers monuments, with Heriot's Hospital in the background and D O Hill seated on the monument. Calotype dated 'September 1843'

1 calotype
Print size 4.

EDINBURGH 66

Similar to the above with 4 figures including George Harvey and possibly John Henning

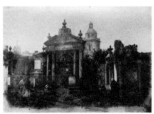

1 calotype
Print size 4.

EDINBURGH 67

Similar to the above with a seated man and a standing boy

1 calotype
Print size 4.

EDINBURGH 68

Similar to the above, with a seated man and boy and a standing man

1 calotype
Print size 4.

EDINBURGH 69

Similar to the above with a man seated on a tombstone

1 calotype
Print size 4.

EDINBURGH 70

View across Greyfriars' Churchyard to the Castle

1 calotype
Print size 5. Image obscure.

EDINBURGH 71

Greyfriars' Churchyard, the Tod monument

5 calotypes
Print size 5.

EDINBURGH 72

Greyfriars' Churchyard, the Henderson monument with the Young monument behind. Calotype dated 'August 1843'

1 calotype
Print size 4.

EDINBURGH 73

Greyfriars' Churchyard, the Young and Henderson monuments

1 calotype
Print size 5.

EDINBURGH 74

Greyfriars' Churchyard, the Mackenzie tomb with 2 men, 1 possibly D O Hill

2 calotypes
Print size 4.

EDINBURGH 75

Greyfriars' Churchyard, the Mackenzie tomb

1 calotype
Print size 4.

EDINBURGH 76

Greyfriars' Churchyard with Heriot's Hospital in the background. 2 figures bent over camera in right foreground

2 calotypes
Print size 4.

EDINBURGH 77

Greyfriars' Churchyard, Mylne's monument

5 calotypes
Print size 4.

EDINBURGH 78

Greyfriars' Churchyard, Mylne's monument

1 calotype
Print size 4. May not be by Hill and Adamson.

EDINBURGH 79
Greyfriars', the inner churchyard
and Covenanters' prison

2 calotypes
Print size 5.

Newhaven

NEWHAVEN 1
James Linton

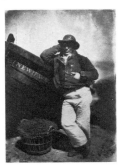

5 calotypes
Print size 4.

NEWHAVEN 2
James Linton

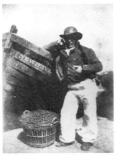

20 calotypes, 1 later calotype,
printed in reverse
Print size 4.

NEWHAVEN 3
Willie Liston. Calotype called
'Redding [ie preparing] the line'

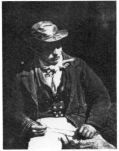

5 calotypes, 4 carbons
Print size 4.

NEWHAVEN 4
David Young

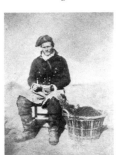

2 calotypes
Print size 5.

NEWHAVEN 5
Unknown man

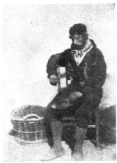

1 calotype
Print size 5.

NEWHAVEN 6
Calotype called 'A Newhaven
Pilot'. A calotype of this title was
exhibited in the Royal Scottish
Academy in 1845

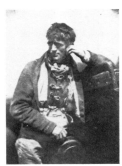

2 carbons
Print size 4.

NEWHAVEN 7
Unknown man

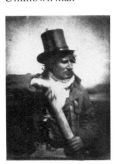

3 carbons
Print size 4.

NEWHAVEN 8
Unknown boy. Calotype called
'His faither's breeks' or 'King
fisher'

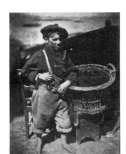

Negative, 30 calotypes, 1 later
calotype, 2 carbons
Negative size 4, waxed.

NEWHAVEN 9
Mrs Barbara (Johnstone) Flucker

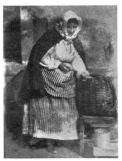

7 calotypes, 2 carbons
Print size 4.

NEWHAVEN 10
Mrs Flucker

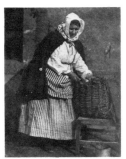

4 calotypes
Print size 4.

NEWHAVEN 11
Mrs Flucker

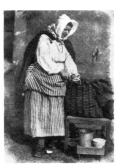

4 calotypes
Print size 4.

NEWHAVEN 12
Mrs Flucker

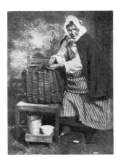

1 calotype, 2 carbons
Print size 4.

NEWHAVEN 13
Mrs Elizabeth (Johnstone) Hall

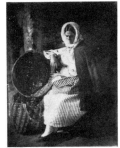

6 calotypes, 4 carbons
Print size 4.

NEWHAVEN 14
Mrs Hall

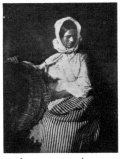

7 calotypes, 6 carbons
Print size 4.

NEWHAVEN 15
Jeanie Wilson

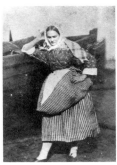

2 calotypes
Print size 4.

NEWHAVEN 16
Jeanie Wilson

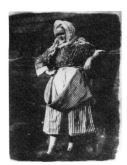

1 calotype
Print size 4.

NEWHAVEN 17
Jeanie Wilson. Calotype sometimes called 'Love Reverie'

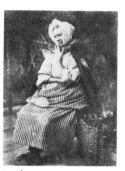

4 calotypes
Print size 4.

NEWHAVEN 18
Unknown woman

1 calotype
Print size 4.

NEWHAVEN 19
Unknown woman

2 calotypes, 1 later calotype
Print size 4.

NEWHAVEN 20
Annie Linton

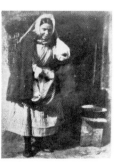

2 calotypes
Print size 4.

NEWHAVEN 21
Unknown woman

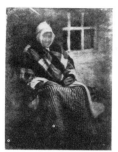

Negative, 1 modern print
Negative size 4, inscribed 'D2'.

NEWHAVEN 22
Unknown woman

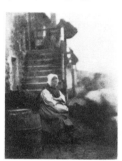

1 calotype
Print size 4. Negative in Glasgow University Library.

NEWHAVEN 23
David Young and unknown man

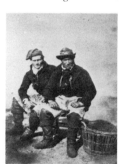

3 calotypes
Print size 5.

NEWHAVEN 24
Jeanie Wilson and Annie Linton

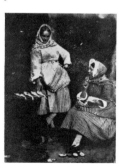

4 calotypes, 1 carbon
Print size 4.

NEWHAVEN 25
Mrs Elizabeth (Johnstone) Hall and unknown woman

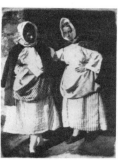

1 calotype
Print size 4.

NEWHAVEN 26
Unknown woman

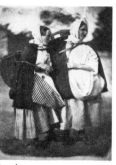

2 calotypes
Print size 4.

NEWHAVEN 27
Unknown woman and perhaps Mrs Elizabeth (Johnstone) Hall

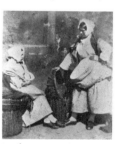

2 calotypes
Print size 3. Negative in Glasgow University Library.

NEWHAVEN 28
Unknown woman and perhaps Mrs Hall

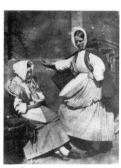

2 calotypes
Print size 3. Negative in Glasgow University Library.

NEWHAVEN 29
Unknown woman

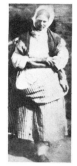

1 calotype
Print size 249 × 96 mm, presumably cut down from size 2 or 3.

NEWHAVEN 30
Unknown child and woman

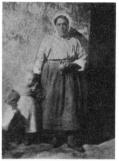

1 calotype or later calotype
Print size 4.

NEWHAVEN 31
Unknown boy and man

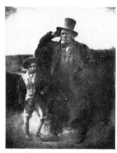

2 carbons
Print size 4.

NEWHAVEN 32
Alexander Rutherford, William Ramsay and John Liston

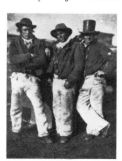

12 calotypes, 3 carbons, 1 print in an unidentified process, printed in reverse
Print size 4.

NEWHAVEN 33
2 unknown men and James Linton

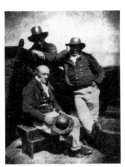

1 later calotype, 2 carbons
Print size 4.

NEWHAVEN 34
Unknown boys. Calotype called 'The Fry'

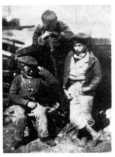

2 calotypes, 2 carbons, 1 print in an unidentified process
Print size 4.

NEWHAVEN 35
Mrs Logan and 2 unknown women. Calotype used as a study for Hill's painting of 'Edinburgh from the Castle, 1847'

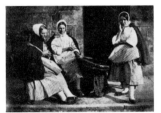

4 calotypes, 1 carbon
Print size 4.

NEWHAVEN 36
Marion Finlay, Mrs Margaret (Dryburgh) Lyall and Mrs Grace (Finlay) Ramsay. Calotype called 'The Letter'

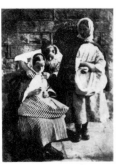

9 calotypes, 4 carbons
Print size 4.

NEWHAVEN 37
2 unknown women and Mrs Barbara (Johnstone) Flucker

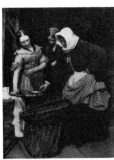

1 carbon
Print size 4. Negative sold in Sotheby's, Belgravia, 26 June 1975.

NEWHAVEN 38
3 unknown women

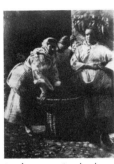

2 calotypes, 1 print in an unidentified process signed or inscribed 'A. E.', presumably 'Andrew Elliot'
Print size 4.

NEWHAVEN 39
2 unknown women and – Laidlaw

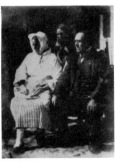

6 calotypes
Print size 4.

NEWHAVEN 40
Unknown group

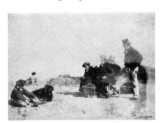

1 calotype
Print size 5.

NEWHAVEN 41
2 English yachtsmen, unknown boy, David Young and unknown man

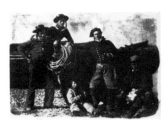

12 calotypes, 1 later calotype, 1 carbon
Print size 4.

NEWHAVEN 42
Unknown boy, 4 unknown men, – Laidlaw and unknown man

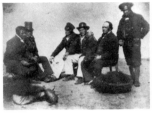

Negative, 1 later calotype
Negative size 4, inscribed '24', top edge and chemical mark touched out in wash.

NEWHAVEN 43
Unknown men

1 carbon
Print size 4.

NEWHAVEN 44
Unknown men

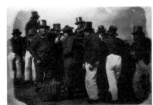

2 calotypes
Print size 4.

NEWHAVEN 45
3 unknown boys and James Linton

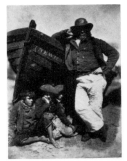

16 calotypes, 1 later calotype, 3 carbons
Print size 4.

NEWHAVEN 46
Unknown group

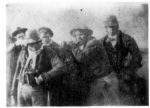

1 later calotype, 1 carbon, 1 print in an unidentified process
Print size 4.

NEWHAVEN 47
2 unknown women, Mrs Margaret (Dryburgh) Lyall, Marion Finlay and Mrs Grace (Finlay) Ramsay

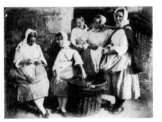

7 calotypes, 3 carbons
Print size 4.

NEWHAVEN 48
Mrs Grace Ramsay and 4 unknown women

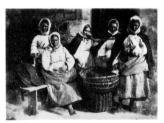

4 calotypes, 3 carbons
Print size 4.

NEWHAVEN 49
Unknown women

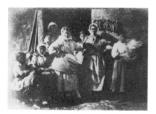

2 calotypes, 1 later calotype, 2 carbons
Print size 4.

NEWHAVEN 50
Unknown women

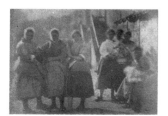

1 calotype
Print size 4.

NEWHAVEN 51
Unknown boys

11 calotypes, 1 carbon
Print size 4.

NEWHAVEN 52
Unknown children

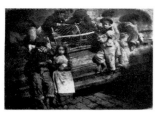

2 calotypes, 1 carbon
Print size 4.

NEWHAVEN 53
A Newhaven pilot and his family

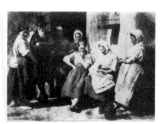

18 calotypes, 3 carbons
Print size 4.

NEWHAVEN 54
Mrs Logan, Mrs Seton and 2 unknown men

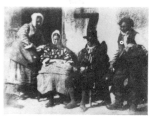

12 calotypes
Print size 4. Negative in Glasgow University Library.

NEWHAVEN 55
Unknown group, the standing man second from the right is probably the pilot

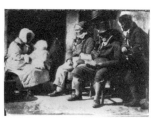

1 calotype, 1 carbon
Print size 4.

NEWHAVEN 56
Mrs Carnie Noble, unknown woman, Bessy Crombie, Mary Combe, Mrs Margaret (Dryburgh) Lyall, Rev Dr James Fairbairn and James Gall. Calotype called 'The Pastor's Visit'

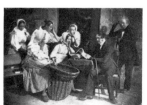

2 calotypes, 4 carbons
Print size 4.

NEWHAVEN 57
Bessy Crombie, Mrs Carnie Noble, Mrs Fairbairn, Rev Dr James Fairbairn, unknown woman, Mary Combe, unknown woman and Mrs Margaret Lyall

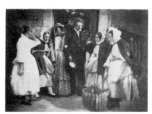

1 calotype, 5 carbons
Print size 4.

NEWHAVEN 58
Unknown group

1 later calotype, 1 carbon
Print size 4.

NEWHAVEN 59
Unknown group

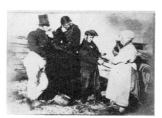

1 later calotype, 1 carbon
Print size 4.

NEWHAVEN 60
Unknown group

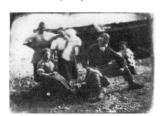

1 later calotype, 1 carbon
Print size 4.

NEWHAVEN 61
Unknown group

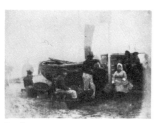

1 calotype
Print size 5.

NEWHAVEN 62
Newhaven beach

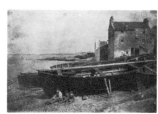

21 calotypes
Print size 4.

NEWHAVEN 63
Newhaven street

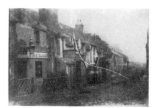

3 calotypes
Print size 4.

NEWHAVEN 64
Newhaven street

2 calotypes
Print size 4.

NEWHAVEN 65
Newhaven houses

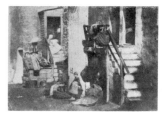

2 calotypes
Print size 4.

St Andrews

ST ANDREWS 1
General view of St Andrews
looking down North Street, taken
from St Rule's Tower

2 calotypes
Print size 5.

ST ANDREWS 2
View from the beach

5 calotypes
Print size 4.

ST ANDREWS 3
View from the beach

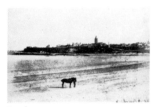

2 calotypes
Print size 4.

ST ANDREWS 4
View from the beach

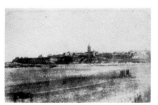

3 calotypes
Print size 4.

ST ANDREWS 5
The Castle

9 calotypes
Print size 4.

ST ANDREWS 6
The Castle

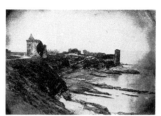

2 calotypes, 5 carbons
Print size 4.

ST ANDREWS 7
The Castle

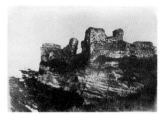

3 calotypes
Print size 4.

ST ANDREWS 8
The Castle

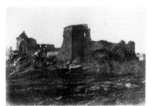

12 calotypes
Print size 4.

ST ANDREWS 9
The Castle

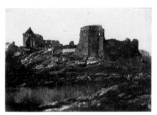

Negative, 8 calotypes
Negative size 4, sky shaded out in
pencil.

ST ANDREWS 10
The Castle

6 calotypes, 2 carbons
Print size 4.

ST ANDREWS 11
The Fore Tower of the Castle

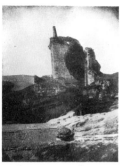

2 calotypes, 2 carbons
Print size 4.

ST ANDREWS 12
The Fore Tower of the Castle

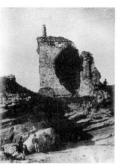

3 calotypes
Print size 4.

ST ANDREWS 13
The Fore Tower of the Castle

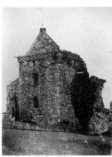

3 calotypes
Print size 4.

ST ANDREWS 14
The Fore Tower of the Castle, with
2 men leaning against the wall

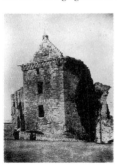

1 calotype
Print size 4.

ST ANDREWS 15
St Andrew's Cathedral, the East
Gable and St Rule's Tower

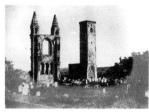

1 calotype
Print size 4.

ST ANDREWS 16
St Andrew's Cathedral, the East
Gable and St Rule's Tower

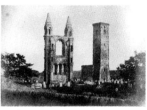

2 calotypes
Print size 4.

ST ANDREWS 17
St Andrew's Cathedral, the East
Gable and St Rule's Tower

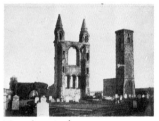

Negative, 4 calotypes
Negative size 4, areas of sky
touched out in pencil.

ST ANDREWS 18
St Andrew's Cathedral, the
graveyard, East Gable and St Rule's
Tower

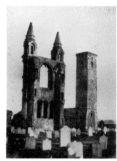

2 calotypes, 3 carbons
Print size 4.

ST ANDREWS 19
St Andrew's Cathedral, the graveyard, East Gable and St Rule's Tower

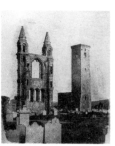

2 calotypes
Print size 4.

ST ANDREWS 20
St Andrew's Cathedral, East Gable

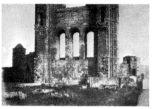

8 calotypes
Print size 4.

ST ANDREWS 21
St Andrew's Cathedral, the West Front and South Aisle

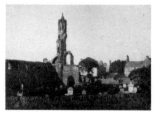

1 calotype, 3 carbons
Print size 4.

ST ANDREWS 22
St Andrew's Cathedral, the West Front and South Aisle

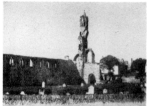

1 calotype
Print size 4.

ST ANDREWS 23
St Andrew's Cathedral, West Front

1 calotype
Print size 4.

ST ANDREWS 24
St Andrew's Cathedral, the East Gable seen over the outer wall

1 calotype
Print size 4.

ST ANDREWS 25
St Andrew's Cathedral, the East Gable seen over the outer wall

5 calotypes
Print size 4. Negative in Glasgow University Library.

ST ANDREWS 26
The 'Pends', entrance to the Cathedral precinct

8 calotypes, 2 carbons
Print size 4.

ST ANDREWS 27
The 'Pends', with a man and horse-drawn cart

4 calotypes, 1 carbon
Print size 4. Two of the calotypes have the blurred figures of the man and horse touched up in wash.

ST ANDREWS 28
The 'Pends', with a man and boy

4 calotypes
Print size 4.

ST ANDREWS 29
The Abbey Wall

2 calotypes
Print size 4.

ST ANDREWS 30
The Abbey Wall, with a man standing centre

4 calotypes, 1 carbon
Print size 4.

ST ANDREWS 31
The Harbour

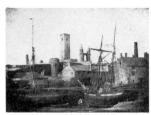

3 calotypes, 2 carbons
Print size 4.

ST ANDREWS 32
The Harbour, with a boy seated centre foreground and 2 carts in the middle ground

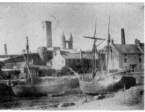

1 calotype
Print size 4. Negative in Glasgow University Library.

ST ANDREWS 33
The Harbour

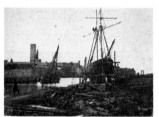

2 calotypes
Print size 4. On one calotype, the central figure, who has moved during the photograph, has been touched in.

ST ANDREWS 34
The Harbour

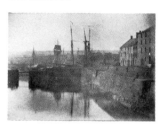

2 calotypes
Print size 4.

ST ANDREWS 35
North Street, Fishergate, women and children baiting the lines

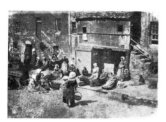

3 calotypes
Print size 4.

ST ANDREWS 36
North Street, Fishergate, women and children baiting the lines

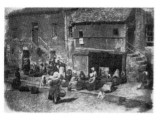

1 calotype, 1 later calotype, 2 carbons, 1 photogravure
Print size 4.

ST ANDREWS 37
North Street

1 calotype
Print size 4.

ST ANDREWS 38
The College Church of St Salvator, looking west along North Street. Note: the low wall in front of the Church was demolished in the 1840s, so the calotypes with the wall pre-date those without. The calotype was taken before 1845, when a parapet was added to the tower

Negative, 8 calotypes
Negative size 4, sky shaded out in pencil.

ST ANDREWS 39
The College Church of St Salvator, looking east along North Street

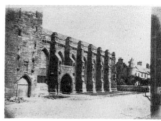

2 calotypes
Print size 4. Negative in Glasgow University Library.

ST ANDREWS 40
The College Church of St Salvator, looking east along North Street

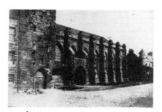

1 calotype
Print size 4.

ST ANDREWS 41
The College Church of St Salvator, looking east along North Street, with a man seated on the pile of stones at left

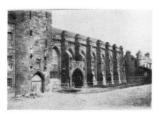

5 calotypes
Print size 4.

ST ANDREWS 42
The College Church of St Salvator

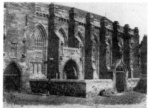

5 calotypes
Print size 4. Negative in Glasgow University Library.

ST ANDREWS 43
The College Church of St Salvator

1 calotype
Print size 5, trimmed. May not be by Hill and Adamson.

ST ANDREWS 44
The College Church of St Salvator

1 calotype
Print size 5. May not be by Hill and Adamson.

ST ANDREWS 45
United College, old building

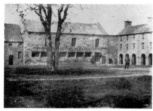

4 calotypes
Print size 4.

ST ANDREWS 46
United College, old building

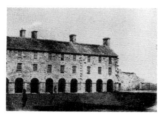

3 calotypes
Print size 4.

ST ANDREWS 47
United College, east side of quadrangle

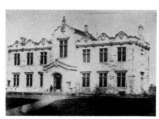

2 calotypes
Print size 4.

ST ANDREWS 48
South Street, the east end with the Roundel and the Cathedral ruins partly visible

8 calotypes, 1 carbon
Print size 4.

ST ANDREWS 49
South Street facing north-east with the spire of the Town Church visible over the roofs

3 calotypes
Print size 4.

ST ANDREWS 50
South Street facing north-west

1 calotype
Print size 4.

ST ANDREWS 51
South Street facing north-west

1 calotype
Print size 4.

ST ANDREWS 52
Blackfriars' Chapel

5 calotypes
Print size 4.

ST ANDREWS 53
Blackfriars' Chapel from South
Street

3 calotypes
Print size 4.

ST ANDREWS 54
Blackfriars' Chapel from South
Street

1 calotype
Print size 4.

ST ANDREWS 55
Madras College

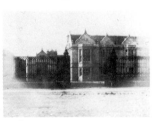

1 calotype
Print size 4.

ST ANDREWS 56
Madras College from the inner
quadrangle

6 calotypes
Print size 4.

ST ANDREWS 57
Madras College

5 calotypes
Print size 4.

ST ANDREWS 58
The West Port, with a wheelbarrow
in the gateway and a standing man
to right

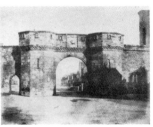

2 calotypes
Print size 4.

ST ANDREWS 59
The West Port

Negative, 6 calotypes
Negative size 4, inscribed 'West
Port / 1h DF / Gu', sky shaded out
in pencil.

ST ANDREWS 60
The Spindle Rock

3 calotypes
Print size 4.

ST ANDREWS 61
The Spindle Rock

4 calotypes
Print size 4.

ST ANDREWS 62
The Spindle Rock with a man and 2
women centre and a boy or man on
horseback by the rock

4 calotypes
Print size 4.

ST ANDREWS 63
The Spindle Rock with a boy on
horseback centre left

1 calotype
Print size 4.

ST ANDREWS 64
The Spindle Rock with a boy on
horseback centre left

2 calotypes
Print size 4.

ST ANDREWS 65
The Spindle Rock

2 calotypes
Print size 4.

ST ANDREWS 66
The Spindle Rock

1 calotype
Print size 4.

ST ANDREWS 67
The Spindle Rock, with a figure
seated at the base

1 calotype
Print size 4.

ST ANDREWS 68
Unidentified ruin, probably in St Andrews

1 calotype
Print size 4.

Note: the following calotypes of St Andrews are early prints taken by John and Robert Adamson

ST ANDREWS 69
The Fore Tower of the Castle

1 calotype
Print size 6, watermark '[1]839', waxed.

ST ANDREWS 70
St Andrew's Cathedral, East Gable and St Rule's Tower

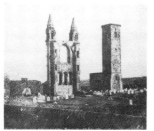

7 calotypes
Print size 6.

ST ANDREWS 71
St Andrew's Cathedral, West Front and South Aisle

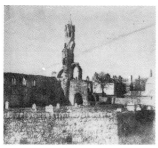

3 calotypes
Print size 6.

ST ANDREWS 72
St Andrew's Cathedral, West Front and South Aisle. Taken at a different time of day from, and slightly further to left of, the previous calotype

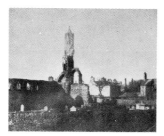

2 calotypes
Print size 6.

ST ANDREWS 73
The College Church of St Salvator with one man leaning against the side wall and another leaning against the front

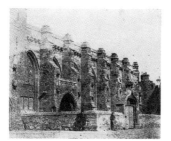

1 calotype
Print size 6.

ST ANDREWS 74
College Church with 2 men leaning against the front wall

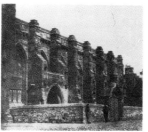

1 calotype
Print size 6.

ST ANDREWS 75
St Mary's College

1 calotype
Print size 6.

ST ANDREWS 76
South Street with W Smith's chemist shop and the Town Church

1 calotype
Print size 6, inscription printed off from negative 'J.A. St Andrews [Febr?] – 10th – 18 []'.

ST ANDREWS 77
Blackfriars' Chapel with a standing man in the foreground and 2 figures seated by the railings

1 calotype
Print size 6.

ST ANDREWS 78
Blackfriars' Chapel

Negative, 13 calotypes
Negative size 6, inscribed 'T [or 1]h 1¼ $\frac{60}{am}$', sky touched out in dark wash and pencil.

ST ANDREWS 79
Blackfriars' Chapel with 2 figures seated by the railings

1 calotype
Print size 6.

ST ANDREWS 80
Madras College

1 calotype
Print size 6.

ST ANDREWS 81
The West Port

1 calotype
Print size 6.

Landscape

LANDSCAPE 1
Bonaly Towers, home of Lord
Cockburn. The foreground group
includes John Henning

2 calotypes
Print size 4.

LANDSCAPE 2
Bonaly Towers. The group includes
John Henning

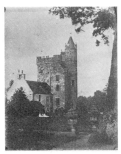

10 calotypes
Print size 4.

LANDSCAPE 3
Bonaly Towers

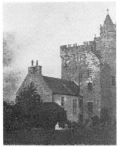

Negative, 1 carbon, 1 print in an
unidentified process
Negative size 4, inscribed 'Bonaly –
Lord Cockburn's House / ²⁰/₁'.

LANDSCAPE 4
The garden at Bonaly. The group
on the left includes John Henning
and Mrs Cockburn, on the right,
Lord Cockburn and James
Nasmyth
Also called Craigcrook

1 calotype
Print size 4. Negative in Glasgow
University Library.

LANDSCAPE 5
The Lodge at Bonaly with John
Henning dressed as Edie Ochiltree
See also Groups 127 and 128

4 calotypes
Print size 4.

LANDSCAPE 6
A field at Bonaly with D O Hill and
John Henning

2 calotypes
Print size 4.

LANDSCAPE 7
The drying green at Bonaly.

2 calotypes
Print size 4.

LANDSCAPE 8
Durham Cathedral

1 calotype
Print size 2. Calotype taken on the
expedition to York at the end of
September or beginning of
October, 1844.

LANDSCAPE 9
Linlithgow from the railway station
with the Town Hall in the left
background, St Michael's Church
centre and the Palace to the right

2 calotypes
Print size 1. One print
watermarked '1843'.

LANDSCAPE 10
Linlithgow from the railway station
with the Town Hall, St Michael's
Church and the Palace in the centre
background

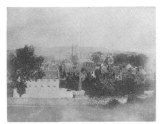

1 calotype
Print size 1, watermarked '1843'.

LANDSCAPE 11
Linlithgow from above the railway
line

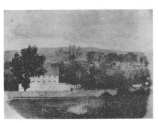

1 calotype
Print size 4.

LANDSCAPE 12
Linlithgow Town Hall and
fountain

1 calotype
Print size 1.

LANDSCAPE 13
Linlithgow, St Michael's Church

4 calotypes, 1 carbon
Print size 4.

LANDSCAPE 14
Linlithgow Palace, niches over the
Grand Entrance

Negative, 19 calotypes
Negative size 4, top edge touched
up in pencil, waxed.

LANDSCAPE 15
Roslin Chapel

2 calotypes
Print size 4.

LANDSCAPE 16
Roslin Chapel

1 calotype
Print size 5.

LANDSCAPE 17
Roslin Chapel

1 calotype
Print size 5.

LANDSCAPE 18
Roslin Chapel, east end

2 calotypes
Print size 5.

LANDSCAPE 19
Roslin Chapel, east end, with the stone roof of the crypt in the foreground

1 calotype
Print size 5.

LANDSCAPE 20
Roslin Chapel, south side

Negative, 2 calotypes
Negative size 5, inscribed 'S.E. bit of chapel dark / 14 [*or* '16']'.

LANDSCAPE 21
Roslin Chapel, piscina on north transept

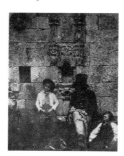

1 calotype
Print size 4.

LANDSCAPE 22
Roslin Chapel, piscina on north transept

Negative, 1 modern print
Negative size 4, inscribed 'Roslin D2'.

LANDSCAPE 23
Roslin Chapel, upper storey

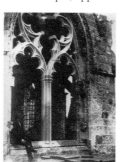

4 calotypes
Print size 5.

LANDSCAPE 24
Roslin Chapel interior

1 calotype
Print size 5.

LANDSCAPE 25
Roslin Castle

2 calotypes
Print size 5.

LANDSCAPE 26
Road and trees in Roslin

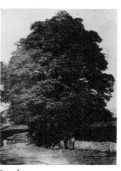

3 calotypes
Print size 5.

LANDSCAPE 27
Unidentified abbey

2 calotypes
Print size 4.

LANDSCAPE 28
Ballochmyle Viaduct, central span. This and the following 7 calotypes were probably taken by Hill during Adamson's last illness or after his death in late 1847 or early 1848. The last stone of the Viaduct was laid on 12 March, 1848. Hill used these calotypes as studies for 2 pictures of the Viaduct. 'The Braes and Bridge of Ballochmyle' was exhibited at the Royal Scottish Academy in 1848

1 calotype
Print size 4.

LANDSCAPE 29
Ballochmyle Viaduct, central span and side arch

1 calotype
Print size 4.

LANDSCAPE 30
Ballochmyle Viaduct, part of central span and side arches

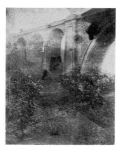

1 calotype
Print size 4.

LANDSCAPE 31
Ballochmyle Viaduct, side arches

1 calotype
Print size 4.

LANDSCAPE 32
Ballochmyle Viaduct, part of central span and side arches
1 calotype
Print size 4. Image obscure, not illustrated.

LANDSCAPE 33
Study of rock and trees, presumably at Ballochmyle

2 calotypes, 1 printed in reverse
Print size 4.

LANDSCAPE 34
Study of rock and trees, presumably at Ballochmyle

1 calotype
Print size 4.

LANDSCAPE 35
Study of branches, presumably at Ballochmyle

1 calotype
Print size 4.

LANDSCAPE 36
Study of bracken, presumably at Ballochmyle

1 calotype
Print size 4.

LANDSCAPE 37
Colinton Manse and weir, with part of the old mill on the right

3 calotypes
Print size 4.

LANDSCAPE 38
Colinton weir, with part of the manse at the top right

2 calotypes
Print size 4.

LANDSCAPE 39
Burnside, Fife
Also called the River Almond and the Water of Leith

5 calotypes, 1 carbon
Print size 4.

LANDSCAPE 40
Redford Bridge

2 calotypes, 1 printed in reverse
Print size 4. Negative in Glasgow University Library.

LANDSCAPE 41
Tree and fence, perhaps at Colinton

2 calotypes
Print size 4.

LANDSCAPE 42
A boy and a beech tree in Colinton Wood

3 calotypes
Print size 4.

LANDSCAPE 43
A group of trees, perhaps Colinton Wood

1 calotype
Print size 4.

LANDSCAPE 44
Fence and trees in Colinton Wood. In the British Library album this calotype is titled 'At Lord Dunfermline's, Colinton'

22 calotypes
Print size 4.

LANDSCAPE 45
Ivy-covered tree at Colinton. In the British Library album this calotype is titled 'The Fairy Tree at Colinton'

Negative, 15 calotypes, 1 carbon, 1 waxed print
Negative size 4.

LANDSCAPE 46
Hedge in an unidentified garden

2 calotypes
Print size 4.

Art

ART 1
Painting by Thomas Duncan of *Wishart dispensing the Sacrament before his execution*. This picture was bought by Alexander Hill at the sale of Duncan's collection on 21 June 1845

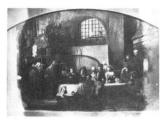

1 calotype
Print size 4.

ART 2
Painting by William Etty of *The Dance*. This picture was on exhibition at the Royal Scottish Academy in 1847

6 calotypes
Print size 4.

ART 3
Unidentified landscape painting

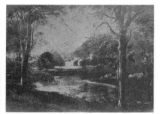

1 calotype
Print size 4.

ART 4
Painting of *Robert Hodson Cay* by Sir Henry Raeburn. This picture belonged to Sheriff John Cay in 1863 when it was exhibited in the Royal Scottish Academy

Negative, 2 calotypes
Negative size 5, inscribed 'Painting of Cay March 15 / [Coat?] 21 ×', small marks on face touched out in pencil.

ART 5
The same as Art 4
Negative
Negative size 4, inscribed '½ / [15?]'. Not illustrated.

ART 6
The same as Art 4
Negative
Negative size 4, inscribed '15'. Not illustrated.

ART 7
The same as Art 4
Negative
Negative size 5, inscribed '15 / 2 [illegible, might be 'w d' or '105']'. Not illustrated.

ART 8
Painting of the Holy Family

2 calotypes
Print size 118 × 100 mm, perhaps size 5 cut down.

ART 9
Engraving of *Las Meninas* by Velasquez

2 calotypes
Print size 5.

ART 10
Engraving of *St Elizabeth of Hungary* by Velasquez

1 calotype
Print size 5.

ART 11
Engraving of a portrait thought to be of his wife by Velasquez

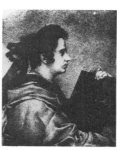

Negative, 1 calotype
Negative size 135 × 109 mm. Image size 79 × 63 mm.

ART 12–14
Engraving of *Las Lanzas*, the surrender of Breda, by Velasquez

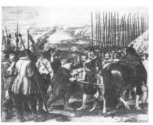

92 calotypes
Print size 5. Prints taken from 3 different negatives, image size 99 × 120 mm, 102 × 123 mm and 113 × 137 mm.

ART 15
Engraving of *Las Hilanderas*, the spinners, by Velasquez

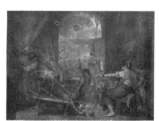

1 calotype
Print size 5.

ART 16
Statue of Sir Walter Scott by Sir John Robert Steell before it was placed in the Scott Monument

4 calotypes
Print size 4.

ART 17
As above

1 calotype
Print size 4.

ART 18
Sculpted bust of Charlotte, Duchess of Buccleuch

1 calotype
Print size 4.

ART 19
Sculpted bust of an unknown man

1 calotype
Print size 5.

ART 20
Sculpted bas-relief

1 calotype
Print size 4.

ART 21
The Charteris door from Amisfield

1 calotype
Print size 4.

ART 22
Group of Indian (?) figures

Negative, 1 modern print
Negative inscribed 'figures / ex 2h /
D15'.

ART 23
As above

Negative, 1 modern print
Negative size 4, inscribed '¼ / 2h'.

Armour

ARMOUR

negative, 1 modern print
Negative size 4, inscribed 'Armour
/ 1½'.

Fossil

FOSSIL
Stagonolepis robertsoni found in
1844, now in Elgin museum. For
counterpart see *Patrick Duff*. A
lithograph after this calotype was
published by Agassiz in 1844–5 in
*Poissons Fossiles du Vieux Grès
Rouge*

2 calotypes
Print size 4.